THE JEROME AND RITA GANS COLLECTION OF ENGLISH SILVER
ON LOAN TO THE VIRGINIA MUSEUM OF FINE ARTS

BY

JOSEPH R. BLISS

669
BLI

30010000016226

22.95

Duc

4-10-08

Read

CONTENTS

ACKNOWLEDGMENTS

Countless individuals have contributed in diverse ways to the realization of this catalogue. Naturally, my greatest debt of gratitude is to Jerome and Rita Gans of New York City, who diligently and carefully assembled over the course of several decades the distinguished collection of English silver documented in this publication. It has been an honour to work with this knowledgeable couple, and I will always be grateful for the confidence they have placed in my work.

From the outset co-operation and support was received from many people on the staff of the Virginia Museum of Fine Arts. Special appreciation is due Paul N. Perrot, former Director and now the Director of the Santa Barbara Museum of Art, who initially introduced me to Rita and Jerome Gans and made it possible for their collection to be lent on a long-term basis to the Virginia Museum. His successor, Katharine Lee, has been instrumental in seeing this project through to completion. The talents of two other staff members, Diana Dougherty, Curatorial Secretary, and Ronald H. Jennings, Chief Photographer, were indispensable, as were those of Nancy Nichols, Assistant Registrar, and Elizabeth Yevich, Library Assistant.

Research was conducted mainly at the Library of Congress, Washington, The New York Public Library, The British Museum Library, and the National Art Library, London, and I would like to acknowledge the cheerful assistance of their staffs. Appreciation is also extended to Meg Sweet, Archivist at the Archive of Art and Design, Victoria and Albert Museum, London, who patiently introduced me to the Parker and Wakelin/Garrard Ledgers preserved at that institution.

A number of specialists in the silver trade were of invaluable help in offering expertise, supplying comparative photographs, or granting access to their photograph or catalogue inventories. Those based in New York include Kevin Tierney, Ian Irving and Wendy A. Hunt of Sotheby's, Anthony Phillips, Christopher Hartop and Julia A. Halpin of Christie's, and Eric Shrubsole. Equally hospitable were their London counterparts including Stephen Clarke of Christie's, Peter Waldron of Sotheby's, Timothy B. Schroder of Partridge PLC, Alastair Dickenson of Asprey PLC, Roger Malins, Anne Weston, and Paul Barnett of Garrard and Company, Ltd.

Museum officials and others, both here and abroad, responded affirmatively and graciously to a variety of requests ranging from simple to complex. They are as follows: Jessie McNab, Metropolitan Museum of Art; Ellenor M. Alcorn, Museum of Fine Arts, Boston; Henry Hawley, Cleveland Museum of Art; Bonita La Marche, Detroit Institute of Arts; Beth Carver Wees, Sterling and Francine Clark Art Institute; Ralph Collier, Campbell Museum; Phillip M. Johnston, Museum of Art, Carnegie Institute; Ian Wardropper and Ghenete Zelleke, Art Institute of Chicago; Diane Hart, Yale University Art Gallery; Karla Klein Albertson, Institute of Egyptian Art and Archaeology, Memphis State University; Edward Rider, Proctor and Gamble Company; Dean Walker, Philadelphia Museum of Art; Dietrich von Bothmer, Metropolitan Museum of Art; Charles Venable, Dallas Museum of Art; David Revere McFadden, Cooper-Hewitt Museum; Bryding Adams, Birmingham Museum of Art; Martin Chapman, Los Angeles County Museum of Art; Beverly Carter, Washington; Ben Whitaker, Gulbenkian Foundation; Helen Valentine, Royal Academy of Arts; Helen Clifford, University of Essex; Timothy Wilson, Ashmolean Museum; Elaine Barr, London; Roger Custance, Winchester College; James Lomax, Temple Newsam House; David Beasley, Goldsmiths' Hall; Jonathan Voak, Apsley House; Sir Geoffrey de Bellaigue, Surveyor to the Queen's Works of Art; Camilla Gordon Lennox, The Royal Collection; P.J.C. Crouch and Sandra Beech, Worshipful Company of Broderers; Camilla Costello, Country Life Library; Terrance Lane, National Gallery of Victoria; Vittorio Mezzomonaco, Pinacoteca Civico, Forli; Helmut Trnek, Kunsthistorisches Museum; Rainer Schoch, Germanisches Nationalmuseum.

Philippa Glanville and her staff in the Metalwork Department at the Victoria and Albert Museum were especially accommodating. John D. Davis, Curator of Metalwork, at The Colonial Williamsburg Foundation kindly agreed to provide the general introduction, and a special debt of gratitude to Colin M. Levene of M. P. Levene Ltd.

To all of them, I express my utmost thanks and respect. In conclusion, some family members and close friends endured with infinite patience and good humor what must have been endless hours of preoccupation and negligence on my part.

J. R. B.

We wish to express our gratitude to Robert Routh of Thome Silversmiths, New York City, who has maintained this collection. His energy, knowledge, and enthusiasm are truly remarkable, and we are most fortunate to have the privilege to call him our friend.

Jerome and Rita Gans

INTRODUCTION

Jerome and Rita Gans have imbued this glorious collection with a highly discriminating sense of focus and selection. Their intent has not been simply to broadly represent changing fashions in taste or the development of an array of domestic forms over time. Rather, they have focused on the highest level of London production during the most creative period in English silver. At the core of the collection are major attainments of two of England's greatest silversmiths, Paul de Lamerie and Paul Storr. Emphasized is the richly ornamented and sculpturesque work of these two masters of craft and art. As we shall see, there are striking similarities and contrasts between de Lamerie's rich rococo creations and the eclecticism of Storr's nineteenth-century work. To see this collection, either in person or through the illustrations in this catalog, is to be aware of the Gans' exceptional discernment for quality and to share in their affectionate understanding of these remarkable objects.

They selected Anthony Nelme's great ginger jar of 1692 (no. 1) as the imposing preface to the collection. It is in the Anglo-Dutch style of much English silver of the last four decades of the seventeenth century. Its thin-walled body and cover are sumptuously chased with cherubs and classical heads amidst lush vegetation that frames atmospheric scenes from classical antiquity. This fashionable Dutch baroque convention of decoratively framed vignettes prefigures de Lamerie's imaginative use of this pictorial device a half century later.

By the time Nelme fashioned this ambitious work, French influence was definitely in the ascendancy. France, under Louis XIV, became the arbiter of taste and refinement in the domestic arts of western Europe. Louis's repressive policies towards the Protestants culminated in the Revocation of the Edict of Nantes in 1685, which forced their expulsion from France and had the unwitting effect of the dramatic spread and popularization of French taste and technical approach throughout Europe. Between 40 and 50,000 Huguenots settled in England in the late seventeenth century. By 1700, about half that number lived within the area of modern Greater London, centered in Soho and Spitalfields. Many specialized in the luxury trades and professions that serviced the upper and growing middle classes as silversmiths, cabinetmakers, carvers and gilders, upholsterers, gunsmiths, engravers, jewelers and watchmakers, silk weavers, tailors and wigmakers, and manufacturers of lace and fans, shoes, gloves, and hats, among other things. They provided a rich infrastructure of ideas and skills that played a major role not only in reordering English taste but in revitalizing English trades.

The Huguenot infusion occurred at an advantageous time in English history. Marlborough's military triumphs and the Treaty of Utrecht in 1713 signalled England's emergence as a major player in European affairs. Trade and national wealth burgeoned during the first half of the eighteenth century. Provincial cities grew dramatically in size and sophistication, as did the upper middle and middle classes. There was, especially after 1715, a house-building boom on all levels and a greatly enlarged production of all sorts of fashionable goods to satisfy these new and growing demands.

In the more ordered interiors of classical articulation and balance of the first half of the century, we see greater refinement in manners and dress. We see more open and affectionate pleasure in family and in genteel association with others. Polite activities, such as tea drinking and dining, became increasingly organized social rituals and the vehicles for genteel association. Their elaborate outfitting had profound effect on the productions of silversmiths, potters, and cabinetmakers, alike.

The greatest of the Huguenot silversmiths was Paul de Lamerie. Born in Holland of French émigré parents in 1688, he was raised in London, was fortunate to serve his apprenticeship under Pierre Platel, one of the most skilled of the early Huguenots, and entered his first mark in 1713. Between then and his death in 1751, he built up what must have been the largest silver business in London of its day. Not only was his firm large and dominant, but it was also immensely creative. His major works, of which there is such an extraordinary sequence in the Gans Collection, reveal his genius and virtuosity in achieving a highly personal synthesis of successive French fashions with English taste and in integrating form and varied ornament, often with an overall dazzling effect.

De Lamerie and his Huguenot brethren possessed not only greater technical skills than those of most native English makers but also a quite different approach to baroque design. They were instrumental in determining the character of late baroque taste, what we often call today the Queen Anne style. They favored plain forms of elegant and controlled curvilinear outline, hammered up out of heavy metal, and they relied on the restrained use of applied ornament, both cast and cut from sheet, to enrich the otherwise plain surfaces of their wares.

The Huguenot makers promoted the use of the baluster or vase form for hollowware. They introduced casters of this shape in the 1690s. A young Paul de Lamerie handled this form with clear mastery in his large sugar caster of 1719 (no. 2). Here, bold molding sequences, allied with repeats of pierced bands in the cover and of leaves around the lower part of the body, regulate and lend nobility to the purity of its form. Notice one detail, the alternate vertical band of piercing in the cover consisting of a double line with diamond-shaped breaks at regular intervals, and then look at the cast appliqués on the cover and body of his two-handled covered cup (no. 3), where you see the greater articulation of this type of French-derived interlaced strapwork.

The Huguenot makers were primarily responsible for the final development of the large two-handled covered cup. By the early decades of the eighteenth century, it had become a highly important form both for presentation and display. De Lamerie's splendid example of 1724 is exceptional in its resolute clarity and unity. When you look at it, your eye and mind easily accepts its totality in a single glance.

These strong, balance forms of essentially plain surfaces and a deep-seated sense of mass are at the heart of English late baroque silver. They maintain, especially in the hands of de Lamerie and the Huguenots, an amazing coherence into the mid-1740s. We see this in de Lamerie's capacious, plain mug of 1733 (no. 7) with its broad baluster body. This simplicity was not just a function of expense, but also a matter of sensibility and preference on the part of many, even those who could very well afford the more elaborate neo-Palladian and rococo silver of the 1730s and early 40s.

De Lamerie's large, handsome square salver with indented corners of 1727 (no. 4) is of a type that ultimately derives from oriental lacquer. It is superbly engraved with formal borders of interlaced strapwork. Look at how these discrete borders with their cross-hatched or diapered panels are regulated by the even placement of masked cartouches in the center of each side and those for family crests in the corners. Let your eye move around the border. See how the cartouches with their flanking diapered panels provide strong alternations and how the pendant leaves below each cartouche lead the eye inward to the engraved arms in the center within their figural cartouche. Everything is bound into a lucid, coherent unity.

The decoration of de Lamerie's extraordinary gilt basin and ewer (no. 9), fashioned nine years later in 1736 evidences the emergence of the rococo taste. These ensembles are one of the great baroque ceremonial forms, intended for display on the buffet or sideboard. This example is certainly of baroque scale and animation. The rim of the basin is strongly bound by bold scrolls hung with swags of fruit and flowers alternating with cherubs that are seemingly floating on clouds of matting. There is the new cadence and flow of the rococo, less a parade and more a sinuous dance of twisting scrolled and naturalistic elements.

The same is also true of the ewer. It is every bit as strongly and massively baroque in its form as the basin, but look at the cast appliqués around the lower part of the body. They are no longer of the rigid strapwork type, seen earlier on de Lamerie's two-handled covered cup, but are of naturalistic leaf form, swaying, twisting, and overlapping in the winds of change.

In de Lamerie's basket (no. 14) of three years later, made in 1739, we have now stepped fully into the rococo world. Even though de Lamerie tends to be bold and assertive in his statement of form and in his choice and orchestration of ornament, he could with considerable flair display a more delicate touch. What a graceful and elegant object this is with its relatively slender cast elements — handle, rim, apron, and feet — creating a repetition of exuberant rhythms and binding and supporting its body that is broadly pierced with playful designs. Such baskets were referred to as "bread baskets" in the eighteenth century, though we know from pictorial sources that they were also often used for fruit. They were among the most popular rococo dining accessories. Well over fifty by de Lamerie, alone, are known.

One of the delights of de Lamerie's work is the numerous instances of subtly conceived and exquisitely executed detail. Look at his stunning pair of tea canisters with a matching sugar box of 1738 (no. 11) and the delicacy and refinement of their superbly chased borders. Here we see fully realized the rococo transformation of the earlier baroque interlaced strapwork. The straps are now ribbon-like scrolls amidst a lush tumble of flowers and shells with eagles and masks.

With his large covered cup (no. 17), we reach the apogee of rococo expression in English silver. It is one of several produced in de Lamerie's shop in 1742. It is brilliant both in conception and execution. De Lamerie must have chosen intentionally this soft and amorphous body form to support, but not to upstage, the utterly rich extravagance of its complex decorative scheme. This is conceived as a series of dense cartouches of flowered and fruited scrolls framing on either side of the body presiding cherubs of Olympian proportions poised before bucolic landscapes with vineyards. The smaller cartouches of the cover reveal demi-cherubs upholding horns and others grape vines. Benign lions lazily peer out through those of the base. There is such a rich layering of planes and such flights of the imagination. Unlike de Lamerie's earlier cup that your mind's eye so easily accepted at a single glance, here you are meant just to let your eyes wander through the fantasy world of the rococo and to be delighted at the upward-gazing lizard atop the grape clusters of the cover's finial or the avuncular satyr keeping a protective eye on the playful cherubs below on either side of the body.

The exoticism of chinoiserie decoration was also a natural part of rococo fantasy. De Lamerie's superb pair of tea canisters (no. 59) date from the year of his death in 1751. Like the cup, their surfaces are enriched with a series of elaborate scrolled cartouches, providing windows for us to glimpse robed Chinese figures appropriately gathering tea in landscapes that never were, as well as lesser frames for pagodas and flowers.

The faithful rendering of marine creatures is another important expression of rococo naturalism. De Lamerie's scallop shells of 1734 (no. 8), probably intended for butter or oysters, are cast and chased so realistically that one feels that they actually came from the very depths or were at least found thrown up on a sandy beach.

The tea kettle of 1749 (no. 29) is a veritable tour-de-force of rococo marine naturalism. It is not the work of de Lamerie but of one of his most inventive colleagues, James Shruder. Little is known of the background of this shadowy smith, though it is thought that he may have been a German émigré and possibly a modeler for de Lamerie. The body is handsomely chased with scenes of Neptune sailing his small boat on a swirling and dolphin-leaping sea and being pulled by dolphins in his chariot. Its dramatic cast spout features a triton astride a seahorse sounding his conch shell. The cast apron of the stand is of seashells and seafoam with playful dolphins forming the legs.

The second of the great makers, so brilliantly represented in this collection, is Paul Storr. He registered his first independent mark in 1793. The world of the silversmith that he entered was quite different than that for Paul de Lamerie in 1713. The fashionable suppliers of silverwares at the upper end of the London trade were becoming large entrepreneurial concerns in the modern sense, retailing goods from a number of sources. The greatest of these was the firm that became Rundell, Bridge & Rundell in 1805. Immensely important to their patronage and success was their appointment as Goldsmith and Jeweller to the King in 1797. Their business flourished, and a contemporary source relates that "in the course of the years 1806, 1807, and 1808, so great were the orders on Mr. Rundell, that without any exaggeration, upwards of one thousand hands were constantly employed in manufacturing for that firm."[1] This included workmen in every specialty, as well as a large staff of designers and modelers to develop important commissions, as well as product lines. It is just at this time in 1807 that Paul Storr was taken on as a partner in the manufacturing side of Rundell's, where he directed operations at the Dean Street workshops in Soho until 1819, after which he established his own independent firm. This was Rundell's heyday, in which Storr played such an important role.

Stylewise, things were changing as well. By century's end, the delicate neo-classical manner of Robert and James Adam was wearing thin and had lost much of its charm. Even George III complained in 1800 that they had "introduced too much of neatness and prettiness."[2] But the King was less of a factor in fashion than his eldest son, George Augustus Frederick, Prince of Wales, who would serve as the Prince Regent from 1811 until his accession to the throne in 1820. Unlike his father, he was immensely social and extravagant beyond belief. A friend of Beau Brummell, he was an influential leader in men's dress. When he achieved his majority in 1783, he was given Carlton House, which he did over at great expense for his lavish entertaining. Though decorated largely in the French neo-classical taste, its Gothic and Chinese rooms anticipate the eclecticism and exoticism of his Brighton Pavilion and of early-nineteenth-century taste in general. He had brilliant judgment in aesthetic matters, at least, and he dramatically and importantly enlarged the royal collections, not only in pictures and sculpture but also in furniture, porcelain, and silver.

What is most representative of elevated taste in the first decades of the new century are the large and weighty dinner services, as well as the candlesticks and candelabra and the wine coolers and other drinking accessories used with them in fashionable dining. They are expressive not only of personal wealth but also of national glory. Their grandeur symbolizes Britain's military triumphs in the Napoleonic Wars and her expanding power in the world. The reappearance from about 1810 of sculpturesque marine elements in salts and sauceboats, centerpieces and tureens is indicative not only of revived rococo naturalism but also of Britain's indisputable naval supremacy after the Battle of Trafalgar in 1805.

The more systematic excavation and publication of classical artifacts, as well as their collection and study by an increasing number of serious-minded antiquarians, both in England and elsewhere, led to a reappraisal of neo-classicism and its intent. Careful efforts were made, especially in important objects, to replicate with greater fidelity both ancient forms and ornament. Engraved plates from publications by Piranesi and others were extremely useful to regency designers (no. 50). Even in more modest objects, obvious attention was paid to classical precedent. The direct use of an ancient Greek wine jug and rhyton or drinking horn, for instance. is apparent in Storr's handsome jug of 1809 (no. 34) and in his unusual stirrup cup of 1834 (no. 63).

Earlier, we saw the apogee of rococo expression in de Lamerie's great cup. In Storr's magnificent gilt Theocritus Cup of 1811 (no. 36), we have one of the great essays in this Greco-Roman style. John Flaxman, the sculptor, designed it for Rundell's, not after an actual vase or an engraving of one in Piranesi or elsewhere, but from the lyrical description of a cup and the scenes depicted on it from the First Idyll of Theocritus, which is quoted in the text.

Early-nineteenth-century taste involved much more than the undistracted pursuit of proper Greco-Roman forms and ornament. From the first years of the century, a variety of revived historical styles were being practiced at the same time. Lord Nelson's victory at the Battle of the Nile in 1798 and the publications of Thomas Hope, among others, spurred a vogue for objects in the Egyptian style, such as Storr's elegant sugar dish and cream ewer of 1806 (no. 31).

Designers and silversmiths ranged far and wide for inspiration, reviving Gothic and Renaissance styles as the century progressed, but they paid their greatest attention to the French and English rococo of the eighteenth century.

Storr's stately set of four large candlesticks of 1808 (no. 33) in the formal French rococo taste are beautifully detailed and brilliantly finished. They ultimately derive from a design by Meissonier. They are to be greatly admired, even if they might appear less dynamic and somewhat stiff in comparison with their French prototypes.

Only on very rare occasions does English rococo revival silver capture the character and sense of animation of its eighteenth-century source. There is perhaps no better illustration of this than Robert Garrard II's breathtaking pair of candelabra of 1825 (no. 69). They are not just based on similar ones of the 1750s by the great French master, Thomas Germain, but they are suffused with that same illusive sense of lightness and gaiety. This important firm was to succeed Rundell, Bridge, and Rundell as Goldsmiths and Jewellers to the King in 1830, an appointment that they hold to this day.

But what is more representative of Regency eclecticism is Storr's splendid group of four gilt candlesticks of 1814 (no. 40). Even though there are allusions throughout these to candlesticks of the mid eighteenth century, notably those of de Lamerie, there is no confusing the two. Indeed, it was not Storr's intent to simply copy an earlier pattern. If he had wanted to, he would have done so. In the stiffness of their elements and in their dense and somewhat static ornament, he was being responsive to current fashions and sensibilities.

This is not meant as a criticism, for they certainly succeed on their own terms, as do his pairs of sauceboats (no. 47) and entrée dishes (no. 48), both of 1817, both of which are enhanced, as their early-nineteenth-century owners would agree, by their evocation of an earlier style. This creative process of imitation was to remain at the heart of nineteenth-century silver.

John D. Davis, Senior Curator
The Colonial Williamsburg Foundation

1. Culme, 1977, p. 60.
2. *Ibid*, p. 63.

CATALOGUE OF THE COLLECTION

ANTHONY NELME

Anthony Nelme (c. 1660-1722)

Anthony Nelme was the most prominent of the native English makers to have been well established before the arrival and impact of the Huguenot silversmiths and to have worked with equal ease and success after the transition into the new century. He was born the son of John Nelme of Muchmerkle in Hertfordshire. He began his apprenticeship in London under Richard Rowley in 1672 and later was turned over to Isaac Deighton. He was made free on January 16, 1679/80 and commenced work shortly thereafter. He was active in the affairs of the Goldsmiths' Company, being made an Assistant to the Court of the Goldsmiths in 1703, Fourth Warden in 1717 and Second Warden in 1722, the year of his death. By 1685 he had established his shop at Amen Corner, Ave Maria Lane, in the City of London, which he retained throughout his career. He acquired a second shop not far from Goldsmiths' Hall on Foster Lane in 1691. He was clearly one of London's leading silversmiths by the early 1690s, for he received a royal commission in 1694 for an elaborate and ambitious pair of gilt altar candlesticks for St. George's Chapel, Windsor. Measuring over forty inches in height, their complex balustroidal stems are enriched with formal leafage and cherubs' heads are poised on the knees of their boldly voluted legs with their bases chased with the emblems of the Garter and scenes of St. George and the Dragon. Between 1697 and 1704 he made silver, mainly sets of candlesticks and snuffers, for the Board of Ordinance for government use. Nelme was one of the signatories of a petition in 1697 protesting the practice of English makers sponsoring the work of unfree Huguenots for assay and marking and of the alleged use by these "aliens and foreigners" of excessive solder. It is ironic that some of Nelme's more important work, like that of Benjamin Pyne, another party to the petition, exhibits strong Huguenot influence raising the question as to whether they had Huguenot journeymen in their employ. Illustrative of this are a pair of sconces of 1704 with narrow backplates of architectural design with interlaced strapwork decoration and a pair of splendid pilgrim bottles of 1715 at Chatsworth with formal cast and applied, as well as chased, ornament. His tureen of 1703 appears to be the earliest English example of a basically French object then. Nelme produced throughout his career an impressive body of straightforward domestic wares reflecting his English background and sensibilities. (Grimwade, 1976; Honour, 1971)

Cat. No. 1

GINGER JAR

Silver
Marks:
1. London, 2. sterling standard, 3. 1693-94,
4. maker's mark of Anthony Nelme (Grimwade,
no. 68), marked on the top of the lid and on the
neck of the vase; engraved on the bottom: NO.
1. 12. P. 94.3
Height: 23¼ in. (59 cm.)
Weight: 167 oz., 2 dwt. (4740 gm.)
Scratch weight: 170-4

Provenance:
John Dunn-Gardner, Esq., London.
Christie's, London, 29 April 1902.
J. Pierpont Morgan.
Sotheby Parke Bernet, New York, 30/31
October–1 November 1947, lot 478.
Sotheby's, London, 20 October 1966, lot 165.
Brissenden.
Sotheby's, London, 13 June 1983, lot 17.
S. J. Phillips, Ltd., London.

Exhibited:
London, Grosvenor House Antiques Fair, 15-24
June 1989.

Published:
Jones, 1908, pp. XXXI-XXXII, 31, plate 27.
Brett, 1986, p. 148, no. 551.
Art and Auction, September 1989, p. 178.
*Grosvenor House Antiques Fair, 1989
Handbook*, p. 63.

Description and Construction

Large ovoid vase thinly gauged with lobed
slip-on cover in the form of an Oriental porcelain
jar; body raised and embossed with foliated
scrolls, Roman emperors based on ancient coin
effigies, seated figures grasping swags, and
mythological scenes of Romulus and Remus,
Aeneas, Ascanius, and Anchises fleeing Troy,
and Mettius Curtius within guilloche panels
headed by goddess masks; lower areas contain
putti flanked by charging satyr-like creatures
and leopards; mouldings separate the base,
shoulder, and neck all with acanthus sprays; lid
with boys swinging on garlands, fruit and
vegetable festoons,and classical medallions of
a warrior, a woman, and a boy; scrolls radiating
from the modern finial.

Dutch influence on the decorative arts in England after the Restoration in 1660 was a natural offshoot of
the close commercial ties shared between these two countries. One of the leading effects on the
reinvigorated goldsmith's trade was the introduction into England of decorative motifs and embossing
and matting techniques by immigrant silversmiths from Holland, as well as the importation by the Dutch
East India Company of Oriental porcelains long envied by Westerners. Indeed, Queen Mary II is known
to have been a zealous collector of these Far Eastern curiosities, and a minimum of 3.2 million pieces,
both Chinese and Japanese, reached European shores between 1602 and 1682 alone.[1]

continued

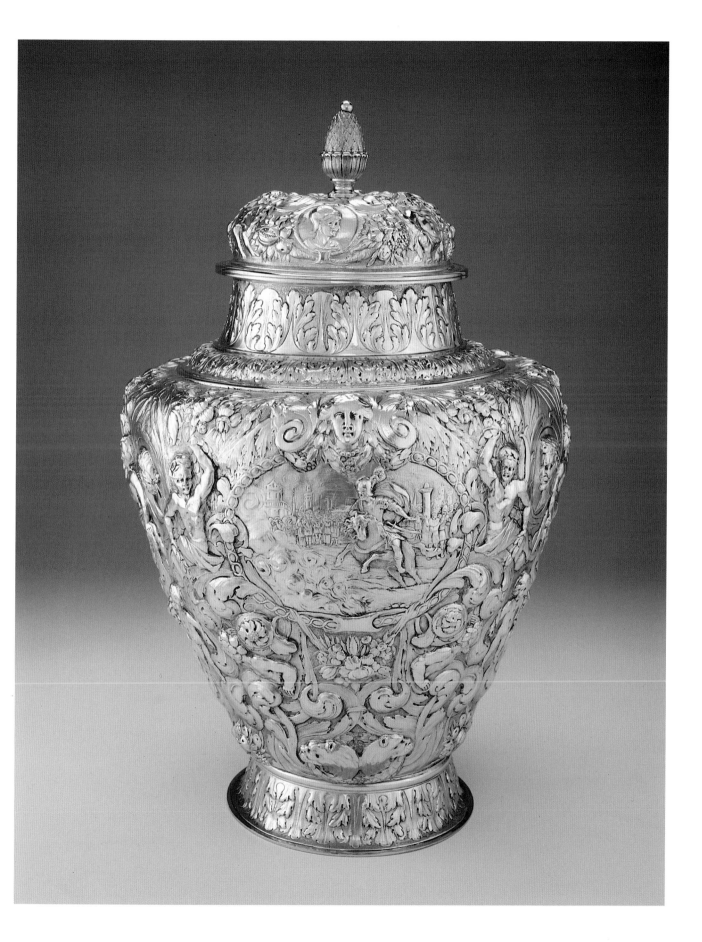

The shape of this robust vase is elaborately chased with ornamental motifs inspired by Chinese porcelain ginger jars or Dutch pottery copies. Both were commonly arranged together en masse on fireplace mantelpieces in Holland and elsewhere as seen in a print by Daniel Marot (1661-1752) depicting a Netherlandish interior of about 1700 (figure 1).[2] In England, too, these non-functional jars were often executed in matching pairs as the numeral 1 engraved on the underside of the one published here implies. Many of these ginger jars were evidently also executed in conjunction with a limited number of related but smaller vases which functioned collectively as a "garniture de cheminèe" or "garniture de table", in other words, as a chimney-piece or table centerpiece of courtly magnificence.

If the shape of the jar is Oriental, the craftsmanship and decorative elements are stringently European. Embossed and punched with cherubs and acanthus foliage in the manner usually classified as characteristically Dutch, it is supplemented by relief scenes probably contingent upon prints or bronze plaquettes of North European origin.[3] The vocabulary additionally absorbs Italian features like the classical busts and the satyr-like figures, the latter resembling those in the pattern books of Polifilo Zancarli (active ca. 1628-1636) and similar friezes occur in the engraved work of Stefano della Bella (1610-1664).[4]

Other superb examples can still be found at Knole, Belvoir Castle, and elsewhere, as well as in numerous major museums. Few carry full sets of hallmarks because they were specially commissioned. The current one is, therefore, somewhat of an anomaly, and it is the only example to our knowledge including pictorial scenes (see details). Understandably, these vases were entrusted only to the best qualified silversmiths including Jacob Bodendick (active 1662-ca. 1688), Thomas Jenkins (active ca. 1665-1707), and Anthony Nelme (ca. 1660-1723).[5]

This ginger jar carries the mark of the highly versatile Nelme, and in view of his proven ability to master foreign stylistic and technical skills, he — or at least his firm — and not an outside sub-contractor should probably be given full credit for its creation. Jars of this caliber remained fashionable only from 1660 up to about 1695, a decade after the revocation of the Edict of Nantes led to an unprecedented tide of Huguenot goldsmiths entering London. Soon they would overpower the Dutch dominance by virtue of their own artistry of design and technical methods of working plate. Amongst their ranks would emerge Paul de Lamerie (1688-1751).

auec prauillege des Œatz gehereaux des prouince Vnie

inuenté et graué par D. Marot

figure 1

Photo courtesy Cooper-Hewitt Museum

PAUL DE LAMERIE

Paul de Lamerie (1688-1751)

Paul de Lamerie, the most celebrated of all English silversmiths, was born of French Huguenot parents in Bois-le-Duc ('s Hertogenbosch), Holland on April 9, 1688. His family probably emigrated to England the following year, and by 1691 they were living in the Huguenot community on Berwick Street in Soho. He was indeed fortunate to serve his apprenticeship under Pierre Platel, one of the technically most talented and artistically most sophisticated of the early Huguenot silversmiths. After completing his seven-year apprenticeship in 1710, young de Lamerie stayed on in Platel's employ as a journeyman until he was made free of the Goldsmiths' Company and entered his first mark as an independent silversmith on February 5, 1713. He quickly established himself in business and soon developed an impressive list of clients. He was appointed a goldsmith to the King in 1716. He married Louisa Juliott the following year, and three of their six children, including their only two sons, died in infancy. It would appear that de Lamerie in the 1720s was in partnership with the silver engraver, Ellis Gamble, former master of William Hogarth. During this and the following decade, he supplied the Russian Court with a number of large and important works. He was active in the affairs of the Goldsmiths' Company throughout his career. He was admitted to the Livery in 1717 and elected to the Court of Assistants in 1731. Late in 1737 he was named with Richard Bayley and Humphrey Payne to a committee of the Company to prepare the petition and bill to Parliament for the revision of hallmarking. He was commissioned three years later, along with these two makers and Thomas Farrèn, to enlarge the Company's plate. He completed by the end of the following year three important ceremonial objects, an elaborate gilt inkstand incorporating the bell given to the Company by Sir Robert Vyner in 1667 and a large gilt sideboard dish and ewer of the most refined modelling. He was elected Fourth Warden in 1743, Third Warden in 1746, and Second Warden in 1747. Only failing health apparently prevented him from becoming Prime Warden. He died August 1, 1751 and was buried at St. Anne's, Soho. His large shop had dominated the London trade for the last three decades of his life. The advertisement for the sale of his shop stock in the January 16, 1752 issue of The Daily Advertiser *is indicative of the greater availability of ready-made goods in shops by this time. Aside from an assortment of jewelry and watches, the silver included "Tables [large salvers or waiters], Terreens and Covers, Bread-Baskets, Sauce-Boats, Tea-Kettles, Tea-Chests, Canisters, Coffee-Pots, F[i]gure and other Candlesticks, Girandoles, Cases of Knives, Forks and Spoons, Cups and Covers, Tankards, Mugs, Salts, Tea-Spoons, Sc. and enrich[e]d and finish'd in the highest Taste." Included with the tools and shop fittings in the advertisement for the second sale are "all of the Mahogany and other Presses, Counters, Drawers, Shelves, Desks, and other Fixtures" for housing these goods and conducting business. Few, then or now, would disagree with his obituary's claim in* The London Evening-Post *that he "was particularly famous in making fine ornamental Plate, and has been very instrumental in bringing that Branch of Trade to the Perfection it is now in." (Grimwade, 1976; Hare, ed., 1990; Phillips, 1968)*

Cat. No. 2

CASTER

Silver
Marks:
1. London, 2. Britannia standard, 3. 1719-20,
4. maker's mark of Paul de Lamerie (Hare, 1990,
m.m.2), fully marked under the base; London
and maker's mark only on bezel of cover,
owner's initial "G" pricked underneath the base.
Height: 9⅛ in. (23.2 cm.)
Weight: 19 oz., 3 dwt. (547 gm.)

Provenance:
Mabel Brady Garvan, New York.
Sotheby Parke Bernet, New York, 6 June 1980,
lot 107.

Published:
Bliss, 1990a, p. 8.

Description and Construction

Tall vase-shaped caster with re-entrant profiles;
cast acanthus leaf cut card work applied for
reinforcement around the bottom of the bowl
above the raised, stepped base; slightly
tapering and flaring body decorated with
molded encircling bands; central component
engraved with an armorial in a baroque
cartouche; detachable domed cover with
vertical registers pierced with fret cut panels in
alternating diaper and scale patterns; cast,
baluster finial.

Heraldry

The coat-of-arms are those of Brougham of
Brougham, Westmorland quartering Vaux of
Catterlan, Vaux of Tryermayne, and Delamore,
probably for Henry Brougham of Scales Hall,
Cumberland.

Casters — except for "blind" or unpierced ones for dry mustard — are vessels with open-worked lids used for sprinkling taste enhancements like sugar, spices, and pepper over food substances. Originating in France, they were often made in sets of three, the largest container for sugar with a pierced cover suitable to encourage the flow of lumped sweetener. The other two smaller pieces most often held Jamaica and black pepper respectively. Although they did not become common household accompaniments in England until roughly the late seventeenth century, these practical receptacles were used at Court as early as about 1600, and thereafter executed in a wide variety of sizes, forms, and designs.

Early London ones of the mid-seventeenth century were of cylindrical form. By the beginning of the eighteenth century plain or octagonal pear-shaped casters were in vogue, and these eventually gave way to vase-shaped ones. Indeed, de Lamerie's workshop was supplying this type shortly after he entered his first mark at Goldsmiths' Hall, and a caster published by Phillips can still be regarded as one of his earliest surviving pieces, if not the first, as the author claimed.[6]

The same lid pattern occurs on a number of others by this maker and it was also used liberally by de Lamerie's fellow Huguenot silversmith Isaac Liger (died 1730) as well as by Abraham Buteux (1698-1731) in 1726.[7] It seems possible then that one of these goldsmiths or an outside specialist supplied these casters to several individuals who then stamped them with their own marks and retailed them through their shops. Other vase-shaped casters by de Lamerie similar to this resplendent one, but with different perforated covers are recorded.

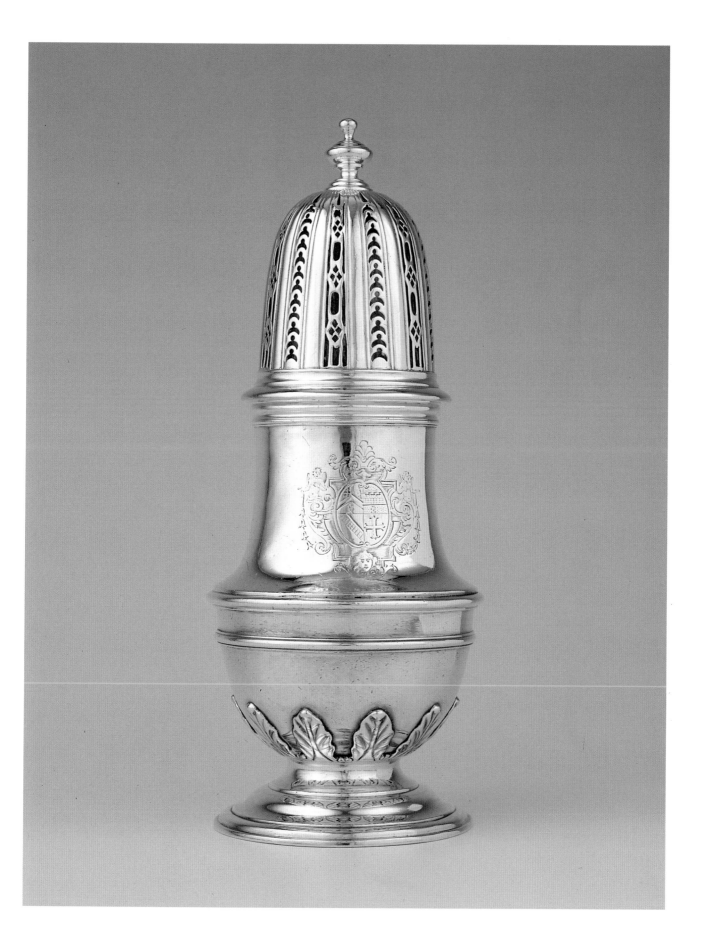

Cat No. 3

CUP AND COVER

Silver
Marks:
1. London, 2. Britannia standard, 3. 1724-25,
4. maker's mark of Paul de Lamerie (Hare, 1990,
m.m.3), marked on the bottom and body of the
cup, and the cover flange.

Height: 13⅛ in. (33.4 cm.)
Weight: 85 oz., 11 dwt. (1931 gm.)

Provenance:
Lady Islington.
Christie's, London, 19 June 1957, lot 46.
D. Black, London.
Donald S. Morrison, New Jersey.
Sotheby Parke Bernet, New York, 6 June 1980,
lot 32.

Exhibited:
Brooklyn, New York, 1958-1980, The Brooklyn
Museum.
Princeton, New Jersey, 1966
Princeton University Art Museum.

Published:
Schwartz, 1964, p. 574.
Princeton University Art Museum, 1966, cat. no.
27.
Hare, ed., 1990, p. 55, cat. no. 26 (entry by
Hare) (mentioned).

Description and Construction

Two-handled cup and cover on spreading pedestal foot flat-chased with strapwork and shell border; lower portion of the inverted bell-shaped bowl decorated with applied cut card swelling flutes ("ninepins") alternating with pierced shell or mask strapwork bands against a matted ground; similar ribs and strapwork soldered to the raised, domed cover equipped with a seam-strip flange; leaf-capped, "S"-scroll handles cast in halves and soldered to the body as is the baluster finial; nineteenth-century gilding removed at some point after its sale from the Morrison Collection.

Heraldry

A slightly rubbed area at the front indicates that an armorial has been erased.

Standing cups with covers were a fundamental type of plate refined and popularized by the Huguenot silversmiths. Their form evolved from the combination of elements found in earlier tall ceremonial cups and practical two-handled porringers.[8] The Huguenot contribution can be detected in their sturdy shape, scrolled handles capped by leaf ornament, and extensive employment of cast and applied decoration. Once established, this type of cup — exemplified by this well-proportioned and richly ornamented example — persisted throughout the century.

As London's foremost silversmith, de Lamerie naturally made these covered cups. This one relates in general terms to a variety of cups undertaken at or about the same stage in his career. Its closest point of reference is found in his silver-gilt cup at the British Museum made only one year before for George Treby (ca. 1684-1742), a most valued client. While this cup and cover has been referred to as being identical to the Treby Cup, closer examination reveals that the cast finials on the domed covers are different and there is a scale discrepancy. Also, it is no longer possible to ascertain whether the present one was likewise originally gilt, since its gilding, earlier reported as dating to the nineteenth century, was taken off.[9]

Nevertheless, their correlation poses some enticing questions about de Lamerie's production methods. It shows that although he freely re-used casting patterns, each final creation sometimes discloses minor variation. Moreover, other cups by this master employ the same decorative features yet their arrangements do not exactly replicate those found on these two.[10] Interestingly, this evidently is not the case with others of which identical versions exist.[11]

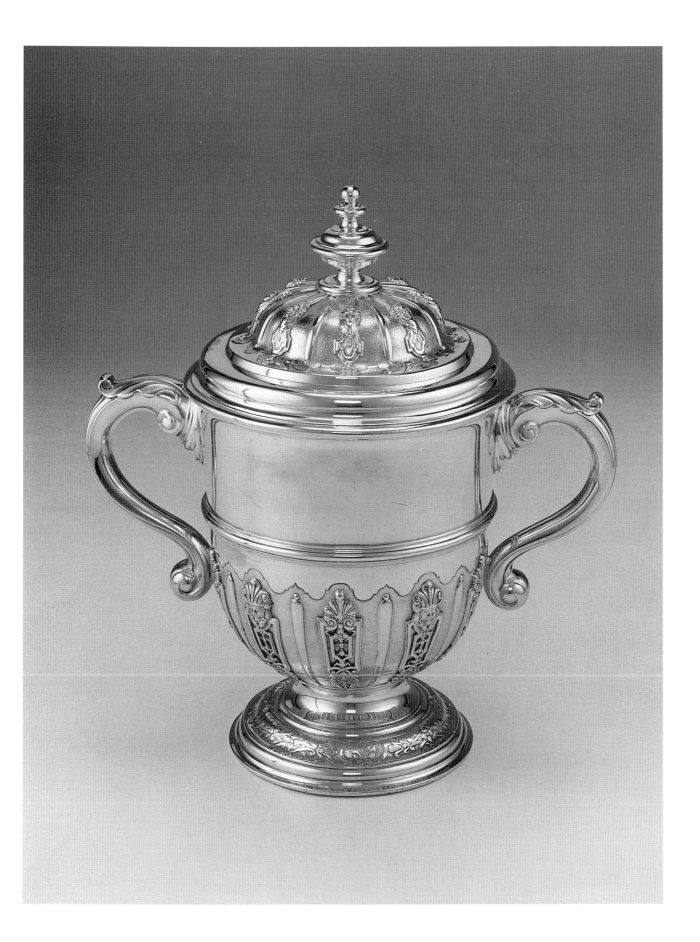

Cat. No. 4

SALVER

Silver
Marks:
1. London, 2. Britannia standard, 3. 1727-28,
4. maker's mark of Paul de Lamerie (Hare, 1990,
m.m., 3) marked on the underside.

Width: 13⅛ in. (33.3 cm.)
Weight: 66 oz., 8 dwt. (1893 gm.)
Scratch weight: 66:18

Provenance:
Tessiers, Ltd., London, 1935.

Published:
Phillips, 1968, p. 85, plate 55.

Description and Construction

Square-shaped salver hand-raised from a silver ingot into a flat surface enframed by an upturned molded brim with indented corners; four cast and soldered scroll feet echo the shape of the inturned border; center of the basin flat-chased with an armorial enclosed in an elaborate Baroque cartouche flanked by classical female herms, burning urns, a grotesque mask, and scrolling husks; inner edge flat-chased with crowned leopard crests at the corners and helmeted male and female busts at the mid-sections surrounded by interlaced diaperwork, foliated scrolls, and shells; winged female heads and palm fronds flat-chased at key intervals on the raised border of the tray.

Heraldry

The armorial is that of Reynardson of Plymouth County, Devon impaling Farnaby of Kent, for Lady Frances Reynardson née Farnaby, widow of Sir Jacob Reynardson (1652-1719).

When this salver was first published, Phillips singled out for special praise its meticulous armorial:[12]

> "The centre has a most virile, yet delicate and distinctive flat-chased surround to a coat of arms, which is full of character and shows the craftsman at his best in this class of work. There is nothing of the so-called 'Hogarthian' design in this ornament, the whole conception being purely of the Bérain school of contemporaneous French art."

This succinct analysis perfectly defines the graceful ornamentation beautifying the surfaces of this piece. To be sure, these intricate patterns are reminiscent of the complex and mildly asymmetrical cartouches filling the pattern books of French Baroque designers like Jean Bérain (1638-1711) and Daniel Marot.[13] Eventually this same tamer and clearly organized decorative vocabulary evolved steadily toward the Rococo with its more lively shells, scrolls, and foliage.

Various members of the Reynardson family regularly patronized de Lamerie's shop. A pair of similar salvers of 1730 with their arms can also be found at The Metropolitan Museum of Art, and a sole salver of 1726 with that of Swymmer impaling Reynardson resides in the private collection of Eric Shrubsole in New York.[14] Upwardly mobile members of the landed gentry, the Reynardsons represent another socio economic class who together with the nobility likewise sought de Lamerie's services.

Initially used for serving a beverage or meal or as part of a toilet service, salvers also came to be used for the formal presentation of a letter or calling card or given as wedding gifts. Ones measuring less than nine inches in diameter are usually called "waiters" today, but during the eighteenth century this was the general term for all flat serving utensils of differing shapes.

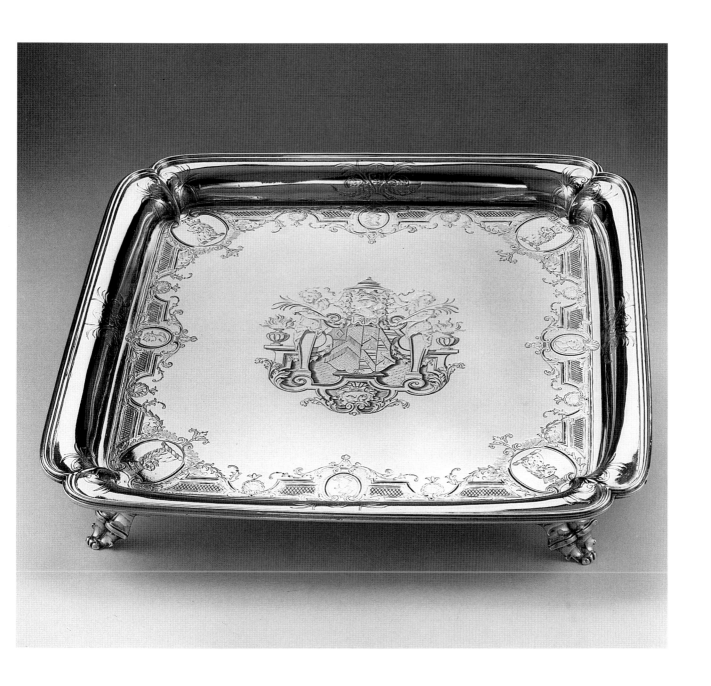

Cat. No. 5

TWO SALT CELLARS

Silver, gilt interiors
Marks:
1. London, 2. Britannia standard, 3. 1731-32,
4. maker's mark of Paul de Lamerie (Hare, m.m.
3), marked underneath.

Height: 2 in. each (5.1 cm.)
Weight: 7 oz., 2 dwt. each (204 gm.)

Description and Construction

Individual table salts with raised bulging bodies and shallow sunken bowls gilded inside to prevent pitting by the salt; cast and chased ornamentations in the form of floral festoons between turbanned and bearded faun masks applied to the main components with solder; bodies lifted on four individually cast goat hoof feet soldered to the undersides; applied knurled rims encircle the tops of the salts above plain moldings; an earl's coronet engraved beneath one of the swags at the center of each receptacle.

Heraldry

The crest is that of Howard, Dukes of Norfolk and Earls of Arundel, Surrey, Norfolk, and Norwich, probably Edward XIV, Duke of Norfolk (1686-1777).

Although the softer Britannia standard of silver imposed by law in 1697 was later repealed in 1720, de Lamerie continued to work in this higher standard until 1732, so these salts represent one of his final undertakings in the purer alloy.[15] Originally they were almost certainly part of a set of four or more, which were stock items in his shop. Executed in the 1730s, each group adheres to the same basic format, and their foliate swags have much in common with contemporary architectural decoration in plaster. Earlier trencher salts by de Lamerie exist, and other later examples often incorporate lion masks in lieu of bust reliefs. Numerous silversmiths of the following century — most notably Paul Storr (1771-1844) — copied the same basic model, but these reveal characteristically nineteenth-century chased motifs and not eighteenth-century cast decorative elements. Examples by Storr are in the Royal Collection, Goldsmiths' Hall and elsewhere.[16]

Uncovered trencher salts were common in the sixteenth century though few survive prior to the late seventeenth century. Standing salts of grand scale survive in limited quantities from the Renaissance, but without exception these served a dual ceremonial purpose or were placed before a guest of honor or other dignitary. Eighteenth century table salts such as the ones presented here destined for a wider clientele, thereby, testify to the rising social standards of individuals living at this later date. They are yet another type of dining accessory we have inherited from the well-appointed dining table of our forebears.

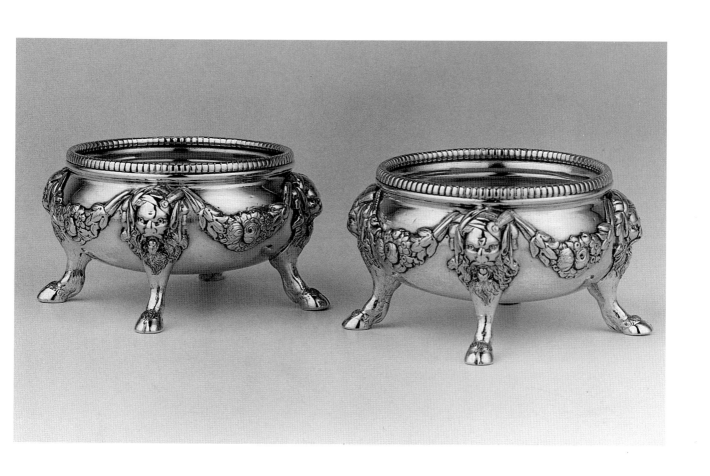

Cat. No. 6

CHAMBER CANDLESTICK, SNUFFER, AND EXTINGUISHER

Silver-gilt, steel
Marks:
1. London, 2. sterling standard, 3. 1731-32, 4. maker's mark of Paul de Lamerie (Hare, 1990, m.m. 3), 5. maker's mark of Simon Pantin II (Grimwade, no. 2607), maker's mark of de Lamerie on the bottom of the chamber candlestick; fully marked on the plate of the snuffer blade including the maker's mark of Pantin, and partly marked inside the snuff chamber; extinguisher unmarked.

Height of Chamber Candlestick: 3¾ in. (9.5 cm.)
Length of Snuffer: 4⅝ in. (11.7 cm.)
Height of Extinguisher: 3⅛ in. (8 cm.)
Gross weight: 15 oz., 9 dwt. (450 gm.)

Description and Construction

Hand candlestick with circular wax drip pan sitting on three cast scroll feet; molded rim decorated with shells and connecting scrolls and inner bands flat-chased with trelliswork; leaf-capped flying scroll handle cast and chased with trellis reserve, flower bud, and overlapping shell; domed center of tray chased with foliate flourishes from which the spool-form stem rises to the ribbed and foliate chased candle socket; pierced slot in stem for insertion of removable, scissors-type snuffer chased with trelliswork and a shell on stem and exterior of the open-sided chamber; steel blades inset into snuffer for cutting wicks; similarly chased, cone-shaped candle extinguisher with cast finial, moldings, scroll handle, and a hook for attachment into a loop at the upper side of the candle socket; earl's crest engraved on each piece.

Heraldry

The crest below an earl's coronet has yet to be identified.

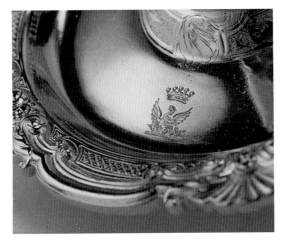

Destined for the privacy of a bedchamber, this intimate lighting accessory is important for numerous reasons. De Lamerie sometimes undertook the creation of chamber candlesticks but the exquisite beauty of this ensemble vibrantly demonstrates his capabilities in this area. It also reinterprets on his own terms the courtly sophistication of the French Régence style.[17] While the minute patterns engraved on these pieces find parallels in contemporary French plate, the shells and scrolls are nascent harbingers of the ones of utmost bravura that would become leitmotifs in his later Rococo creations.[18] As such, this is an enchanting transitional work in the master's oeuvre.

On several occasions de Lamerie was reprimanded for failing to have pieces hallmarked at Goldsmiths' Hall in order to avoid paying duty, therefore, it is not surprising that only one of his unregistered maker's marks appears here.[19] Snuffers accompanying chamber candlesticks of this date were made by independent specialist silversmiths.[20] This one carries the maker's mark of Simon Pantin II (active 1717-1733).[21] Bearing the date letter 1731, stylistic, technical, and quantitative considerations confirm that all three pieces were made *en suite* at that time.

The only other chamberstick by de Lamerie that surpasses this one in opulence belongs to the National Gallery of Victoria.[22] Also gilded, it was completed a few years later in 1734, and it is, thereby, fashioned in a more assertive early Rococo manner. Both boast coronets of unidentified nobles suggesting they were specially commissioned, unlike other chamber candlesticks by this goldsmith presumably kept in-stock for less affluent customers interested in plainer ones.

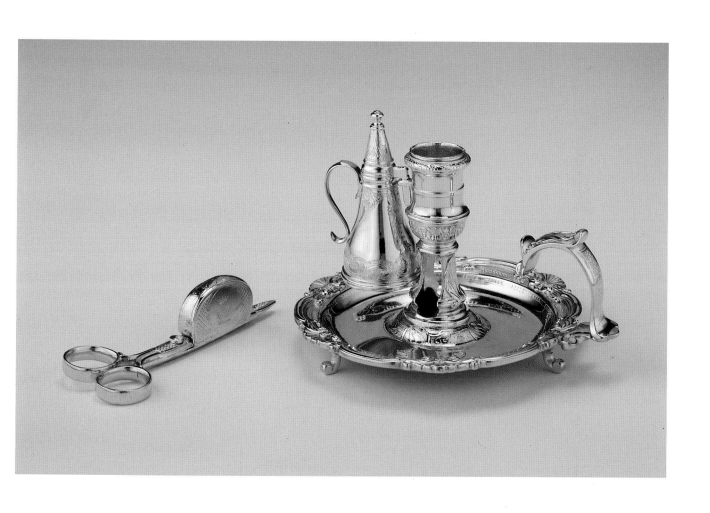

Cat. No. 7

MUG

Silver
Marks:
1. London, 2. sterling standard, 3. 1733-34, 4. maker's mark of Paul de Lamerie (Grimwade no. 2203), marked beneath the base.

Height: 6¼ in. (16 cm.)
Weight: 24 oz., 4 dwt. (691 gm.)

Provenance:
Possibly Christie's, London, 16 June 1931, lot 71.
Possibly Crichton Brothers, London.
Sotheby Parke Bernet, New York, 27 October 1982, lot 382.

Published:
Bliss, 1990a, pp. 8-9.

Description and Construction

Lidless drinking receptacle of broad baluster form with flaring sides and conspicuous brim; plain polished body raised from a silver sheet; multi-stepped, spreading foot cast and turned; wide scrolled handle cast in halves with smooth leaf-capped thumbgrasp and fluted trefoil terminals; top and bottom of the handle mounted on globular quatrefoil bosses both soldered to the body.

During the Victorian era a common custom was to present a mug of small dimension as part of a child's Christening gift. Much earlier, however, larger examples carried out either individually or in matching sets were used commonly — but not exclusively — for the consumption of alcoholic beverages. In fact, a number of contemporary sources provide evidence of alternate purposes. The Verney letters penned in the early eighteenth century disclose that it was mandatory for a boy departing for Rugby School to bring along a half-pint mug, a spoon, and a fresh pair of sheets. Additionally, an entry in the account books of Benjamin Mildmay, Earl Fitzwalter (1672-1756) records Lady Fitzwalter drank milk from a silver mug as a medicinal remedy against gout.[23]

Mugs or "canns" became popular at the outset of the Seventeenth Century according to contemporary references. The basic conception underwent only relatively minor revision for centuries, but stylistic changes in design, shape, and means and modes of decorative embellishment are discernable. Usually, mugs are cylindrical and of half or full-pint capacity, yet waisted, barrel-shaped, polygonal, or inverted bell-shaped specimens are encountered. From about 1725 a baluster-shaped type like this one emerges. Notable for both its stark and sturdy appearance, its visual impact relies solely on gently swelling contours, glistening surface effects, and the skillfully wrought handle instead of extraneous ornamentation.

Innovative Huguenot silversmiths enamored with the fashioning of far more exorbitant plate tended to shy away from producing such ordinary and artistically restrictive vessels. Indeed, less than a dozen mugs with this version apparently being the largest in scale are known from de Lamerie's extensive output. Regardless, the proportional range, the introduction of unusual decorative elements, and the masterful manipulation of the metal testify to this silversmith's strict adherence to the highest artistic and technical standards even when undertaking work on modest pieces. Another beverage container — the tankard — was evidently an even more neglected item in de Lamerie's inventory, since only about three examples have survived.

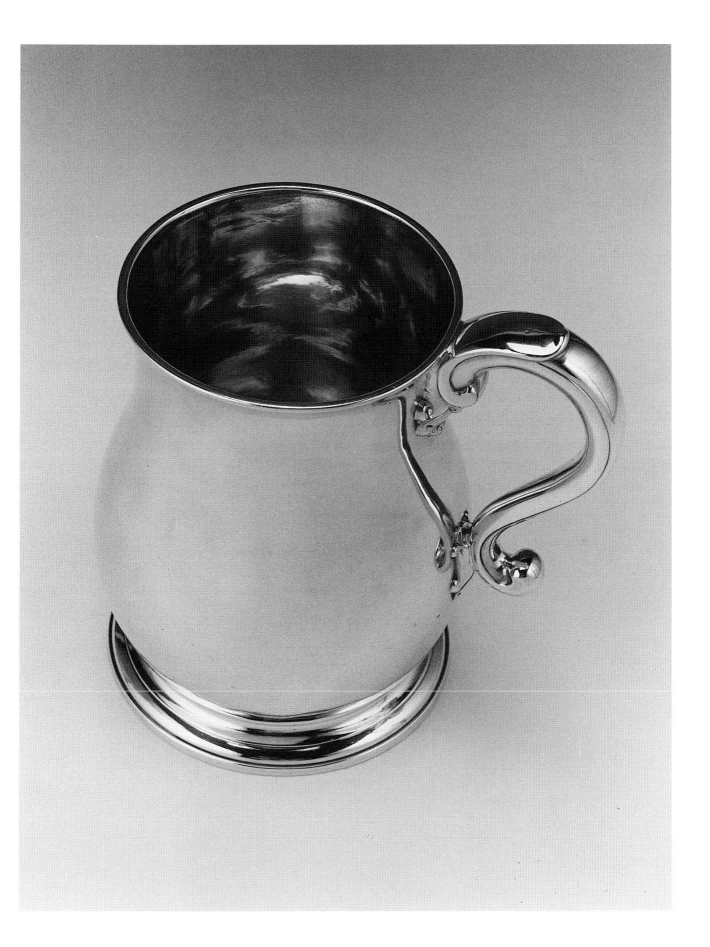

Cat. No. 8

TWO SHELL DISHES

Silver
Marks:
1. London, 2. sterling standard, 3. 1734-35,
4. maker's mark of Paul de Lamerie (Grimwade,
no. 2203), marked on the underside of each
valve.
Width: 5⅛ in. (12.9 cm.) and 5 in. (12.7 cm.)
Weight: 6 oz., 8 dwt. (192 gm.) and 7 oz., 7 dwt.
(218 gm.)

Provenance:
Reverend Alfred Duane Pell, New York, 1894.
Christie's, New York, 22-23 October 1984, lot
336.

Published:
Christie's Review of the Season, 1985, p. 317.
Müller, 1986, pp. 60-61, cat. no. 11, note 3
(mentioned). Bliss, 1990a, p. 9.

Description and Construction

Naturalistically formed escallop shell dishes;
each cast and chased underneath in the form of
a sea-shell (Pectus jacobaeus) with matted
striations and encrustations of seaweed, coral,
and tiny snail shells functioning as supporting
feet; cast and chased fronts with shell ribs
enlivened only by plain fluting; armorial crests
engraved on the simple and smooth spandrels
of the front sides.

Heraldry

The crest is probably that of Selwin or Selwyn,
County Essex and Freston, Bechington, County
Sussex.

Naturalistically modelled silver sea shells enjoyed an enduring if sporadic notoriety in Europe. Cast or actual shells encased in silver mounts were used as spice box lids from at least the seventeenth century and early documents refer to their use as individual dishes. But the oldest complete set of English escallop shells in silver to survive bears the date letter of 1675.[24] The demand for such dishes understandably increased during the eighteenth century as a positive result of the Rococo silversmith's fondness for marine motifs especially the scallop shell. In fact, de Lamerie's shop produced many of the finest wrought examples of that era. During that time and earlier, these marvelously realistic creations were normally issued in small sets of four or more. Many of these have been subsequently broken up including these two. Originally, they were made in conjunction with two others of the same date and with the identical crest which Reverend Pell bequeathed to the Metropolitan Museum of Art.[25]

Some confusion still lingers as to what purpose escallop shells served in eighteenth-century England. Although often referred to as butter dishes, butter was actually served from basins in a softened state during this period. Grimwade and others have pointed out that another use is suggested by an entry in the Wickes Ledgers housed at the Victoria and Albert Museum:[26]

> "John Trevor, Esq., 1740:
> To 5 scallops for oysters, 16 oz.
> 5 dwts. at 6/1 per oz. — 4.19.2."

True as this might be, it is difficult to imagine in view of the elaborate dining customs of the period and the large number of diners participating in the average dinner party that scallop shells — made in very limited sets of no more than ten or more and usually less — would have been used as individual oyster dishes. More plausibly, they functioned at table as strategically placed sauce dishes connected with the fish course.[27]

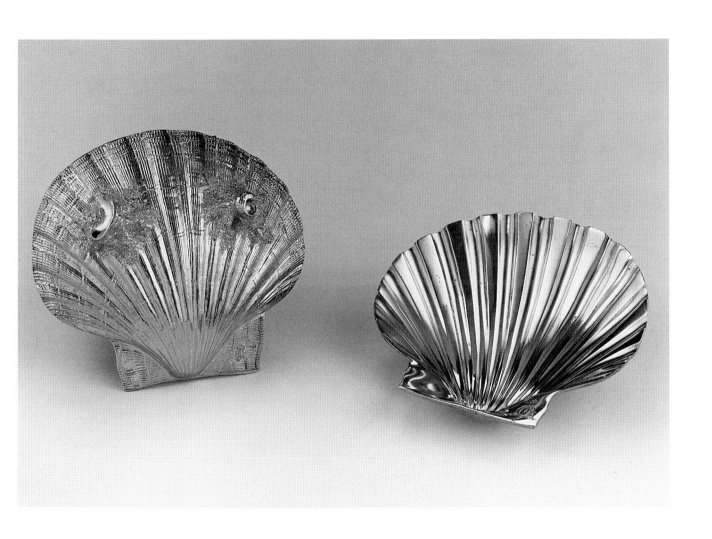

Cat. No. 9

EWER AND DISH

Silver-gilt
Marks:
1. London, 2. sterling standard, 3. 1736-27 (ewer), 4. 1737-38 (dish), 5. maker's mark of Paul de Lamerie (Grimwade, no. 2203), marked in the bottom of the ewer and underneath the basin.

Height of ewer: 15⅜ in. (39 cm.)
Diameter of dish: 25¼ in. (64 cm.)
Weight of ewer: 69 oz., 2 dwt. (1961 gm.)
Weight of dish: 175 oz., 4 dwt. (4812 gm.)
Scratch weight: 244.00

Provenance:
Christie's, London, 13 May 1920, lot 67.
Dimmer.
Sir Jeffrey Lionel Darell, London.
S.J. Phillips, Ltd., London.
J. Paul Getty, Sutton Place, 1970.
J. Paul Getty Museum, Malibu (deaccessioned).

Published:
Wenham, 1931, plate 30.
Bliss, 1990a, pp. 9-10.
The J.P. Getty Museum Journal, vol. 19, 1991, p. 163 (mentioned).

Description and Construction

Helmet-shaped ewer with a broad moulded band encircling the raised body at mid-section; Nineteenth Century arms engraved at the center enclosed by strapwork; curving scroll and leaf cut card work applied at the bottom of the bowl; resting on a compressed knop with bosses, coral, and shells above a cast bell-shaped stem with lattice work, shells, and scrolls flaring to a shaped base chased with overlapping scales, scrolls, roses and other flowers; moulded rim with ribs, bat-wing masks, and leaves with a large conch shell at the back; cast handle with a dissolving grotesque mask on the loop emerges from a voluted leaf and terminates in an inwardly facing and leaf-capped shell; raised shallow dish with an inner moulding and wide border cast and chased with flying cupids and swags emblematic of the Seasons, scalework reserves and undulating shells and scrolls; entire central ornament and coat-of-arms Nineteenth Century additions with rubbed spots on the reverse where the original coat-of-arms was screwed on; gilded later.

Heraldry

The Nineteenth Century coat-of-arms is that of Darell impaling Tierney for Reverand Sir William Lionell Darell Third Baronet (1817-1883).

When forks commenced to be used more regularly during the late seventeenth century, voluminous ewers with expansive dishes or basins in use from the Middle Ages gradually passed from table to purely display application. Until then almost everyone — even individuals from the loftiest social circles — ate with a pair of skewing knifes and a spoon requiring the employment of compulsory domestic utensils in differing materials for washing food-soiled hands with scented water between courses and after completion of the meal. Once this custom subsided, those scarcer ewers and dishes fashioned from precious metal were saved from the melting pot due to their extensive scale and the craftsmanship lavished on them. In effect, they evolved into luxurious showpieces standing on sideboards as visual testimonials to the wealth and status of their owners in English country estates, colleges, and city corporations and guilds.

continued

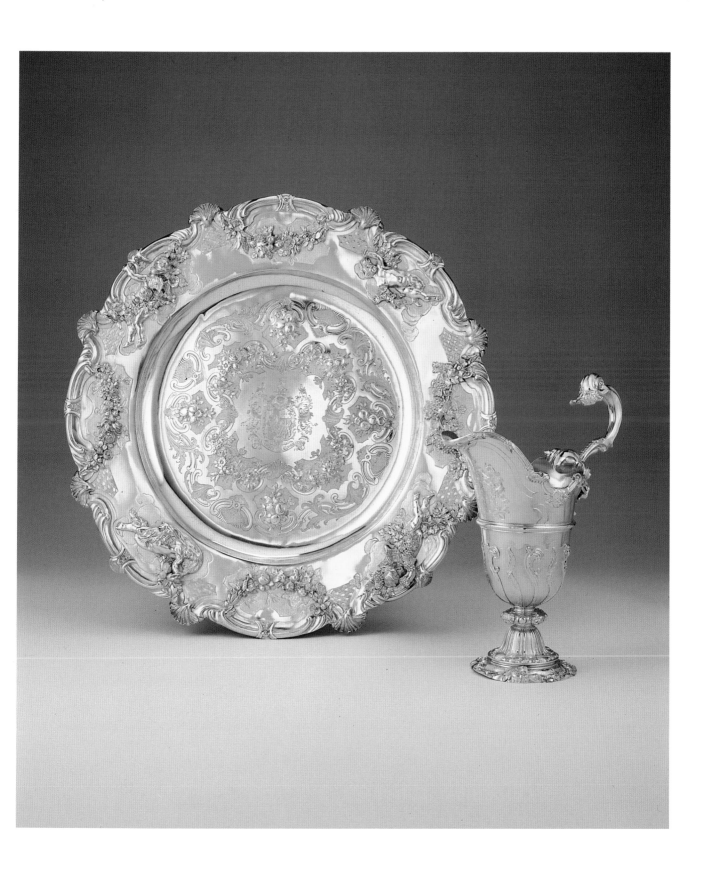

The current set is one of the earliest of a very rare group of glamorous ewers and dishes of Huguenot inspiration tempered with Auricular flourishes which this goldsmith embarked upon in 1726.[28] While a generic spirit is evident, each set is, nevertheless, conspicuously different from the others. This basin is remarkable not least for the superb quality of the airborne putti and curvaceous festoons rendered in the most pronounced sculptural terms which dominate the scalloped border (see details). The accompanying yet smaller ewer conforms closely to a standardized Huguenot type carried out by de Lamerie on several occasions. Most of the same ornamental features and the ubiquitous helmet-shaped form are discernable in works such as the Hardwicke Ewer of 1736 at the Victoria and Albert Museum or the Ely Ewer of ca. 1735.[29] All of these receptacles, as well as the present basin, validate this master's ongoing empirical fascination with the special problems posed by these showy buffet ensembles, which, would culminate for him in the more grandly conceived, densely detailed, and aesthetically resolved Rococo ewers and dishes of 1741 and 1742 executed for the Worshipful Company of Goldsmiths and Algernon Coote, 6th Earl of Mountrath (1684-1744).[30]

During the next century many different kinds of plate including ewers and basins soon appeared old-fashioned as a result of their eighteenth-century standards of comparative simplicity which subsequently gave way to the Victorian craving for heavily chased surfaces. This innocently motivated if naive viewpoint led to the acceptable practice of bringing earlier pieces up to the latest reigning fashion by means of alteration and enhancement.[31] The present basin has been "updated" only marginally by the addition of the stylish but out of place floral and vegetable clusters, shells and scrolls now filling its recessed center, and the once separately cast and original plaque with a coat-of-arms has been removed and replaced by an engraved one carried out no doubt at the same time as later chasing and engraving. Obtrusive as such intrusions might appear today, these matching pieces remain cherished and ambitious undertakings by de Lamerie.

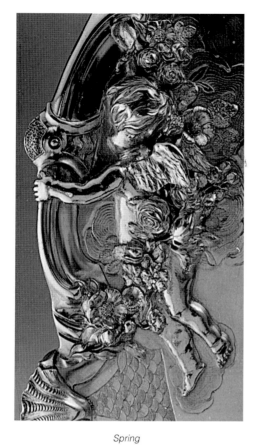

Spring

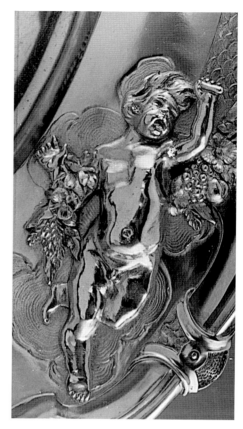

Summer

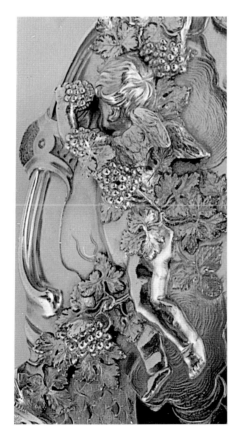

Fall

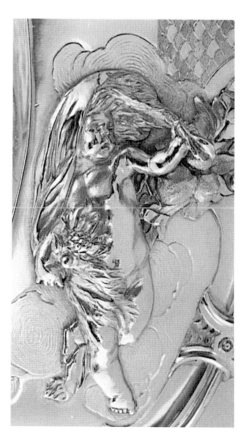

Winter

Cat. No. 10

COFFEE POT

Silver, wood
Marks:
1. London, 2. sterling standard, 3. 1738-39,
4. maker's mark of Paul de Lamerie (Grimwade,
no. 2203), fully marked underneath the base;
partly marked on the lid flange.

Height: 9½ in. (24 cm.)
Gross weight: 26 oz., 1 dwt. (739 gm.)
Scratch weight: 25:15

Provenance:
S.J. Phillips, Ltd., London, 1954.
Anonymous Collector, Europe.
Sotheby Parke Bernet, New York, 13-15 October
1981, lot 327.

Published:
Brett, 1986, p. 176, no. 717.

Description and Construction

Coffee pot of tapering cylindrical shape raised
from a single sheet of metal sitting on an
inverted, stepped and molded foot rim; upper
and lower portions of the body with shaped
bands in repoussé with undulating shells,
flowers, and scrolls on a tooled ground; raised
and hinged domed cover chased with scrolls,
flowers, and shells capped by a cast artichoke
finial; upwardly angled spout cast and chased
with batswing, flowers, shells, and scales;
double-scroll handle springs from a cast
batswing and shell at the top and a curving
scroll below; engraved at the center with a
coat-of-arms within a Rococo scroll and foliate
cartouche.

Heraldry

The modern armorial is untraced.

During the mid-seventeenth century coffee, tea, and hot chocolate began to be consumed in England emulating a practice adopted from the Orient. Indeed, as early as 1652 the first of many coffee houses, the Pasqua Rosee, was frequented by fashionable Londoners, and the drinking of these beverages at home as well was considered a civilized repose from the frenzy of daily life.[32] This necessarily prompted the need for suitable receptacles and accompaniments of all sorts in precious metals for both storage and serving. Responding quickly and eagerly, English silversmiths fashioned coffee pots of seemingly infinite design.

One goldsmith who occupied a prominent position in making vessels for the coffee and tea table was de Lamerie. Not only was he a leading practitioner throughout his long career, but the stylistic range of the resulting products is amazingly diverse, mirroring his exceptional creative impulses. While working within the confines dictated by the functional restraints of the traditional form, he continued to invent and redefine shapes and decorative modes.

Admirable for a carefully blended synthesis of ornamentation and form, this suave coffee pot was executed when de Lamerie's involvement with the Rococo just assumed maturity. The meandering floral sprays, shells, and scrolls bespeak the incipient Rococo style, but they are relegated to clearly defined zones and do not disguise the underlying shape of the pot. Even the richly articulated spout for all of its inherent movement is subdued by the simple cylindrical form of the receptacle. A large body of closely related but not identical coffee pots bear his mark. Numerous other silversmiths, for instance Eliza Godfrey (active 1720-1758), John Swift (active 1718-1758), George Wickes (1688-1761), Aymé Videau (active 1723-1773), Samuel Courtauld I (1720-1765), Robert Innes (active 1743-1758), Gabriel Sleath (1674-1756), and John Pollock (active 1734-1753), quickly followed suit in producing coffee pots recalling this same basic model in cylindrical or pear-shapes. These must have been all the rage in London from the late third up until around the middle of the fifth decade of the century.

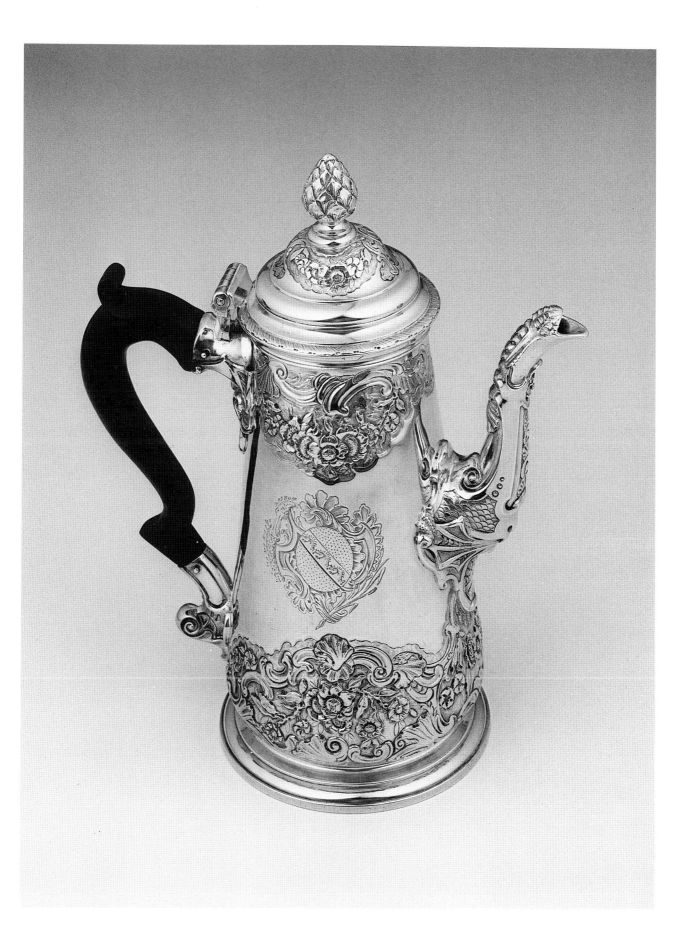

Cat. No. 11

PAIR OF TEA CADDIES AND A SUGAR BOX

Silver, mahogany case
Marks:
1. London, 2. sterling standard, 3. 1738-39,
4. maker's mark of Paul de Lamerie (Grimwade,
no. 2203), fully marked on each base; partly
marked on each lid.

Tea Caddies:
Height with handle raised:
5⅜ in. (13.8 cm.)
Weight: 10 oz., 2 dwt. (289 gm.) and 10 oz.,
4 dwt. (294 gm.)

Sugar Box:
Height with handle raised:
5⅜ in. (13.8 cm.)
Weight: 12 oz., 19 dwt. (345 gm.)

Provenance:
Sotheby's, London, 18 March 1982, lot 124.

Published:
Art and Auction, May 1982, pp. 48-49.
Art at Auction: The Year at Sotheby's 1981-1982,
p. 253. Bliss, 1990a, p. 10.

Description and Construction

Each deep and unlined cannister of oblong form
with incurved sides, shaped bases, and sliding
covers with hinged finials engraved "G," "B,"
and "S" for Green Tea, Bohea Tea, and Sugar;
sides and bottom made from sheets soldered
together at adjoining angles; lids constructed
from separate component elements soldered
together; the fronts, sides, and covers flat-
chased with cartouches of floral and shell motifs
on a matted ground; a bird featured on the
shoulder of each caddy and male jesters on the
slightly larger sugar container; armorials added
later; fitted mahogany case of subsequent
manufacture.

Heraldry

The arms appear to be those of Moore impaling
Long for Lady Catharina Maria Moore (1727-
1812), widow of Sir Henry Moore (1713-1769),
lst Baronet of Jamaica (1762) and later
Governor of New York (1765-1769).

The word "caddy" evolved from the Malay "kati" designating a unit of measure of about 1⅕ pounds, the
weight at which tea was sold, but the terms "cannister" or "tea vase" were used during the eighteenth
century to describe a container for storing tea. Appropriately, the earliest caddies of the seventeenth
century took the form of Chinese porcelain tea-jars with detachable domed covers used as a measure.
By the second decade of the next century, however, matching sets of two caddies for black (Bohea) and
green (Viridis) tea and a sugar box with an accompanying wood, ivory, or mother-of-pearl case
fitted with a lock to protect the expensive contents began to be created in a wide spectrum of shapes,
sizes, and styles.

continued

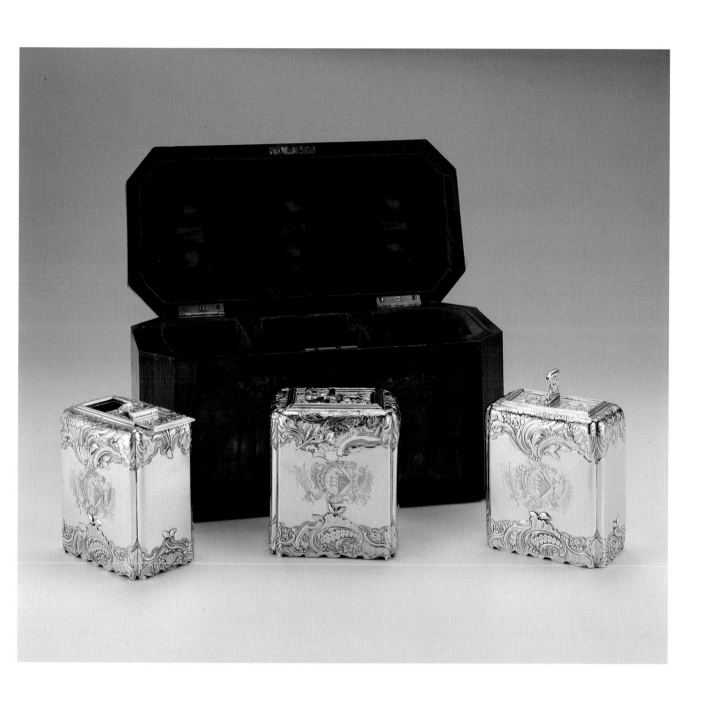

A fairly considerable number of individual tea caddies and sets by de Lamerie are present in public and private collections, indicating they issued forth in some quantity from his shop. They vary significantly from early simple pieces to later examples in the full-blown Rococo style. The current set — nobly proportioned and fluently chased with ornamentation combining figural, floral, and marine motifs — belongs to a type of tea caddy with an innovative sliding lid with hinged finial evidently first introduced by de Lamerie in the 1730s (see details). Numerous others of related shape and similar decoration exist, not least the well-published and stellar Tea Equipage of 1735 by de Lamerie at the Leeds City Art Galleries.[33] Inasmuch as this group shares some corresponding technical and decorative features, it is a testament to the multiplicity of this master's ornamental program and virtuoso craftsmanship that no individual set exactly repeats another.

Sir Henry Moore

MOORE, Sir Henry (1713-1769), colonial governor, born in Vere, Jamaica, on 7 Feb. 1713, was the son of Samuel Moore, a planter. His grandfather, John Moore, settled at Barbados in Charles II's reign, and subsequently migrated to Jamaica. Henry matriculated in Leyden University on 21 March 1731. After receiving a training in the militia and taking a part in local Jamaica politics, he was appointed lieutenant-governor of Jamaica, under a dormant Spanish Town. When the governor, Admiral Knowles, was recalled, he assumed the administration of the government, and displayed tact and firmness in attempting to remove local rivalries. He twice judiciously allayed quarrels between the two houses of the legislature; yet when martial law was proclaimed in 1759, and the council attempted to obstruct the administration, he suspended the ringleaders in that body, and procured compliance with his instructions. Thus as a pledge that the trouble over the removal of the seat of government was at an end, he actively prosecuted the erection of the government buildings which still grace Spanish Town, and form the most striking facade in Jamaica. For a few weeks in 1759 he was superseded by a full governor, Haldane, whose death again placed Moore in command, and left him to cope with the serious slave-rising which broke out at Easter 1760. This rising developed into a war which lingered on more than a year and taxed Moore's energies to the utmost. He proclaimed martial law, and placed himself at the head of the British regiments quartered in the island. The guerilla warfare adopted by the negroes was very harassing to the regular troops, and it was only through Moore's personal resource and rapidity of execution that the rising was finally suppressed; not before he had twice fallen into ambuscade and barely escaped with his life, and on another occasion, when reconnoitering alone, had only been saved by his skill as a pistol-shot. His administration came to an end in February 1762, upon which he was made baronet for his services.

In July 1765 he was appointed governor of New York, where he arrived in November 1765, just at the beginning of the troubles over the Stamp Act. His first proposal to his council was to insist on putting the act in force; but perceiving the bent of public feeling he forthwith adopted a strong popular line, suspending the execution of the act and dismantling the fort, to the great annoyance of Colden, the lieutenant-governor. In 1768 he provoked unnecessary opposition to the Billeting Act of the imperial government by attempting to establish a playhouse, and thus alienating the Presbyterians. In October 1767 he tried unsuccessfully to settle the question of the boundary with Massachusetts. his administration was terminated by his death on 11 Sept. 1769.

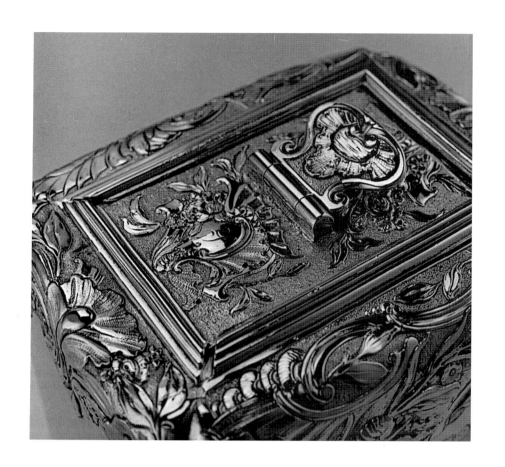

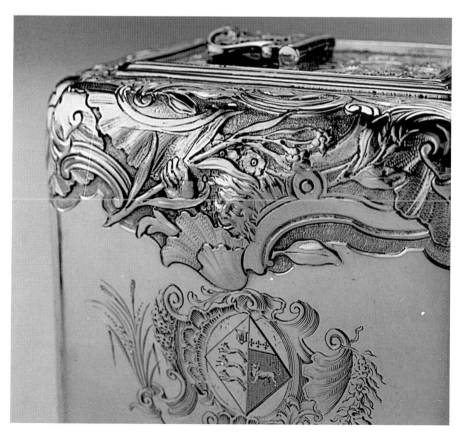

Cat. No. 12

SET OF FOUR SAUCEBOAT STANDS

Silver
Marks:
1. London, 2. sterling standard, 3. 1739-40, 4. maker's mark of Paul de Lamerie (Grimwade, no. 2204), marked on one of the flutes underneath each stand.

Length: 10⅝ in. each (27 cm.)
Weight: 22 oz., 7 dwt. (634 gm.), 22 oz., 7 dwt. (634 gm.), 22 oz., 3 dwt. (633 gm.) and 22 oz., 3 dwt. (633 gm.)

Provenance:
George, 1st Baron Anson, 1762.
Anson family by descent to George, Lord Anson.
Christie's, London, 8 June 1893, lots 15-18.
Captain Rawes (3 stands, Anson Sale, lots 15-17).
Duveen (1 stand, Anson Sale, lot 18).
M. P. Levene, Ltd., London (3 stands, Anson Sale, lots 15-17).
Mrs. R. M. Robertson, Cambridge, Ontario (1 stand, Anson Sale, lot 18).
Christie's, New York, 27 October, 1987, lot 429 (1 stand, Anson Sale, lot 18).

Exhibited:
London, Goldsmiths' Hall, 16 May–22 June 1990.

Published:
Hare, ed., 1990, pp. 81, 114, cat. no. 70 (entry by Hare).
Bliss, 1990a, p. 8.

Description and Construction

Four raised stands of shaped oblong form balanced on four individually cast and chased lion paw feet soldered to the reverses; cast and applied borders of ample proportions with reeded moldings punctuated by boldly projecting and partially matted mounts of shells, flowers, and scrolls; cherub masks against shells function as handles at the lateral ends of each tray; partially and deeply fluted sides slope gracefully down to the shallow basins left vacant except for engraved coats-of-arms.

Heraldry

The armorials are those of Anson quartering Carrier for George, Admiral Anson (1697-1762), and Isabella Carrier of Wirksworth, his mother.

Ornately cast and resplendently chased, these sauceboat stands are the earliest pieces of plate created for George Anson (1697-1762) in this collection.[34] While some contemporary stands are only minimally decorated because of their role as mere resting trays for more fancy sauceboats, no lack of attention, skill, or expense has been spared in fashioning the heavy borders with cherub head cartouches and rocaille surrounds ingratiating these four. So successful are these moulded borders in both design and execution that de Lamerie repeated the format numerous times on other sauceboat stands, as well as on even more ambitious projects such as the Brobinsky and Newdigate Centerpieces of 1734 and 1743, as observed by Hare.[35]

In a certain way the checkered history of these stands and their now disassociated sauceboats is as interesting as the objects themselves. At the famous Anson Sale of 1893 it was evidently not realized that they were sauceboat stands, and consequently they were catalogued and sold individually as "salvers". Three went to one buyer and the other to a different bidder. It was only after a separation of almost a century that the isolated fourth stand once again fortuitously surfaced in the sales room and finally rejoined its three counterparts by then already in the present collection.

Enticingly, the previous two lots offered in 1893 were the two pairs of matching sauceboats originally made for these stands They, too, were split amongst different contenders, one set formerly in the Collection of the late Countess Lazlo Szechenyi, née Gladys Vanderbilt, was eventually sold from the Breakers in Newport and from there found another home in a private collection in Toronto (figure 2).[36] As for the other two, they were acquired by Charles Davis of London and have subsequently disappeared.

continued

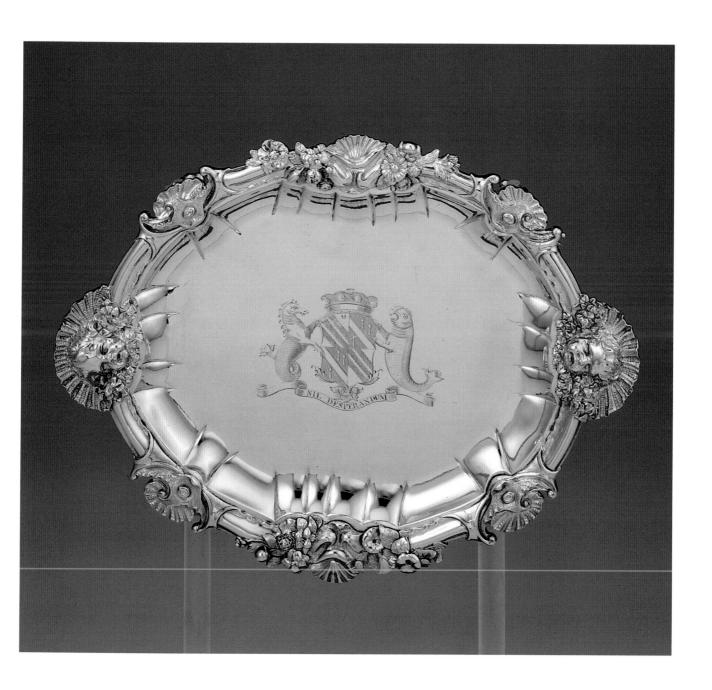

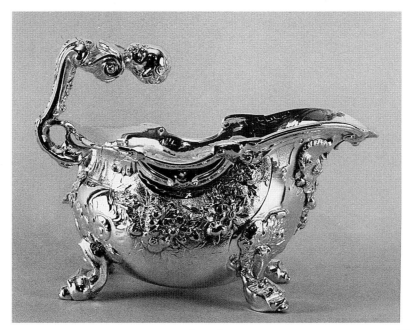

figure 2 Private Collection

Cat. No. 12 continued

Admiral George Anson

ANSON, George, Lord Anson (1697-1762), admiral of the fleet, was the second son of William Anson, of Shugborough, in the parish of Colwich, Staffordshire, and was born there on 23 April 1697; his mother Isabella, daughter of Charles Carrier, of Wirkworth in Derbyshire, sister of Thomas Parker, afterwards Lord Parker and Earl of Macclesfield, and in 1718 created lord chancellor.

In 1711(?), Anson volunteered for service on board the "Ruby", which was the beginning of his career with the Royal Navy. By the 1720s he had advanced to the rank of captain on the frigate Scarborough, which was sent to South Carolina "to protect the coast and the commerce against pirates and Spanish cruisers", which were already practising the system of annoyance which ultimately led to the war of 1739. They did not at that time, however, menace the Carolina coast,and the general nature of Anson's service was to cruise to and from the Bahamas.

Anson remained in service off the Carolinas for six or seven years, where he appears to have been popular with the Colonists, especially in Charles Town. It is alleged that Captain Anson bought the tract which would later bear his name, Ansonborough, from winnings at cards; however, another story has it that he won the entire tract in a single game. The area was part of an original grant to the emigrant Issac Mozych, which was sold to Thomas Gadsden. On March 26, 1726, Gasden conveyed this tract to Captain Anson for 300 pounds sterling. This was a very large sum of money for such a young naval officer to possess, much less pay out, so it is quite possible that Anson's winnings at cards did purchase the future Ansonborough, but the old deed in the Mesne Conveyance office in Charles Town shows that this was a regular sale, for a specific sum. (In later years, Anson had his Charles Town tract subdivided, laid out in streets and lots. In addition to George and Anson Streets, which still bear his name, he named three others for the ships that had counted most in his career: "Seaborough" and "Squirrel" had brought him to South Carolina; "Centurion" had won him fame and fortune, however these streets have since lost their distinctive names.)

In December 1737 he was appointed to the Centurion (with 60 guns) and sent to the west coast of Africa for the protection of the English trade against the encroachments of the French, after which he crossed over to the West Indies and was recalled thence in autumn of 1739.

It had been determined to give him the command of one of two squadrons that were to be sent to the Pacific to disrupt and attack Spanish positions, and when it was found necessary to curtail the plan and send only one squadron, it was put under the orders of Anson with the nominal rank of commodore. The navy, after many years of peace and decay, was at a very low ebb, and the expense of fitting out the fleet for the West Indies and the coast of Spain swallowed up all the resources of the Admiralty. There was thus great difficulty in equipping and manning the ships intended for the Pacific. To man the ships, 500 invalids were conscripted from the out-pensioners of Chelsea college. Of the 500, only 259 came on board (literally only invalids, most of them being 60 years old and some upwards of seventy). To

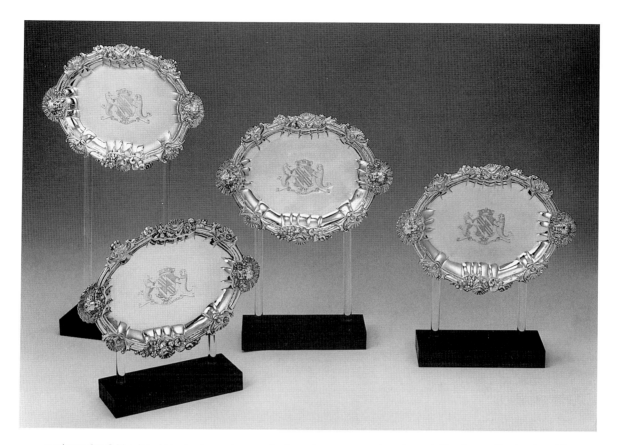

replace the 241 who deserted, newly recruited marines were put on board. Finally, on September 18, 1740, after eight months of preparations, the little squadron of six ships were put to sea. Arriving at Cape Horn in the stormy season, the ships were buffeted by adverse currents and a severe 40-day storm. Two ships were driven back and did not get round the Horn at all; one, the Wagner, was driven ashore and totally lost. The Centurion narrowly escaped a similar fate. (Of interest is that a Spanish squadron of five men-of-war tried to navigate Cape Horn four days after Anson's group and was completely decimated by the storms.)

It was not until June 1741, after being at sea for nine months, that the Centurion arrived at Juan Fernandez, with not more than 30 men (officers included) fit for duty. The Gloucester, with 50 guns, arrived some time after in still worse plight, as also the brig Trial. After refitting and resting till September, it was found that out of the 961 men who had left England in these three ships, 626 had died, leaving 335 men and boys (a number insufficient for even the Centurion alone). With hollow pretence of strength, Anson managed to destroy the Spanish commerce, blockade the ports, and sack and burn the town of Paita.Later that year he hoped to intercept the yearly treasure ship from Manila for Acapulco, even though the only remaining ship was the Centurion and now had less than 200 men left of the original 961; but some Spanish negroes and Indians, as well as some Dutchmen and Lascars, had been picked up at Macao, and the Centurion now had a total complement of 227. With this reduced crew, the Centurion met the great galleon on 20 June 1743 and captured her. In size and number of men, the Spaniard was vastly superior to the Centurion, but she was lumbered with merchandise, and of her 600 men, few were trained to arms or to act together, while during the last cruise Anson had taken great pains to exercise and train his men. The amount of treasure was enormous and Anson, deciding that nothing more was to be done, returned to England around the Cape of Good Hope. As he came into the English Channel a thick fog hid him from the French fleet which was cruising the Sound, he passed safely through it and anchored at Spithead off Portsmouth on 15 June, 1744. The treasure amounted to about 500,000 pounds sterling and was landed at Portsmouth, sent up to London and paraded in triumph through the city in a procession of 32 wagons, the ship's company marching with colours flying and a band playing.

In acknowledgment of Anson's good service, he was appointed to The Board of Admiralty, where he did much to revitalize the Royal Navy. In 1747, he was elevated to the peerage as Baron Anson of Soberton, Hampshire. On 25 April, 1748, Anson was married to Lady Elizabeth Yorke, daughter of the lord chancellor.

Since Anson's death, to this day an "HMS ANSON" has been a commissioned ship in the Royal Navy.

Cat No. 13

INKSTAND

Parcel-gilt
Marks:
1. London, 2. sterling standard, 3. 1739-40,
4. maker's mark of Paul de Lamerie (Grimwade,
no. 2204), fully marked under the tray, ink pot,
and pounce pot; partly marked on the ink pot
cover; pounce pot cover unmarked.

Length: 9⅜ in. (23.9 cm.)
Weight: 35 oz., 9 dwt. (1017 gm.)

Description and Construction

Sunken oblong-shaped stand with molded cast
border of voluted shells and scrolls, berries,
leaves, and snakes resting on separately cast
and soldered lion paw feet; raised ink and
pounce pots of baluster shape chased with
draped female busts, shells, and foliate
festoons; hemispherical wells and quill troughs
raised individually and soldered into place on
the tray; pot lids pierced with fretwork for
sanding and circular holes for dipping writing
instruments; central bell of later date with plain
moldings, trophies, shells, and figural handle in
the form of a woman carrying a basket on her
head; parcel-gilding added later.

Heraldry

The intertwined monogram "GMA" engraved on
the flat surface of the tray is unidentified.

Inkstands or standishes only became regular desk accessories in the eighteenth century. Even then
they were evidently produced less often than other kinds of plate judging from the evidence supplied
by the Parker and Wakelin Ledgers for 1766-1770.[37] Late seventeenth-century ones assume the form
of a rectangular hinged casket, a type that continued to be made later together with an open
rectangular or oblong tray variety like this fine example. The stand with a trough at either of the long
sides to hold quills is equipped with two pots for ink and pounce. These receptacles fit comfortably on
top of deep slots at the bottom of which sealing wafers would have been stored.

De Lamerie did not produce many inkstands, but at least two of them — one of 1738 in the Collection of
the Duke of Marlborough and the other of 1741 commissioned by the Goldsmiths' Company — are
certainly to be ranked among his most ambitious and ingenious undertakings.[38] Others of a more
conventional nature were repeated in part several times. For example, one of 1740 at the Victoria and
Albert Museum has similar mouldings, pots chased with masks, and paw feet, and another even closer
one of 1734 also fitted with a bell appeared on the London art market decades ago.[39] The pots and
supports on an inkstand of 1749 in the Collections of the Colonial Williamsburg Foundation are also
compatible with those on the one catalogued here.[40] However, as Davis acknowledged, the rim of that
tray was inspired by the borders of the dishes and stands on de Lamerie's Brobinsky Centerpiece of
1734 in Moscow.[41]

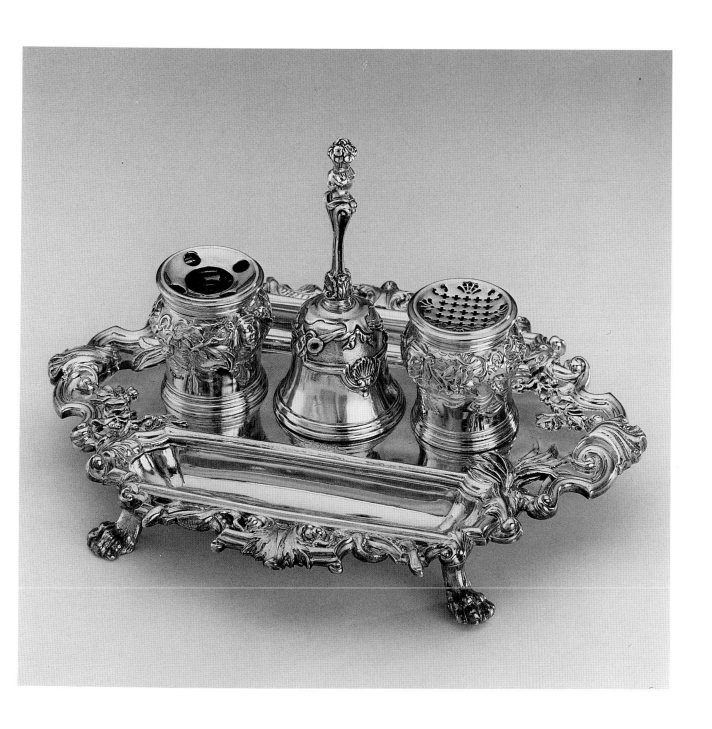

Cat.No. 14

BASKET

Silver
Marks:
1. London, 2. sterling standard, 3. 1739-40,
4. maker's mark of Paul de Lamerie (Grimwade,
no. 2204), marked on the bottom.
Height with handle raised: 10¼ in. (26 cm.)
Weight: 55 oz., 6 dwt. (1576 gm.).
Scratch weight: 55:17.

Provenance:
Possibly A. A. Hutchinson, 1929.

Exhibited:
London, March, 1929, 25 Park Lane.

Published:
London, 1929, cat. no. 53, plate 56.
Bliss, 1990a, pp.8-9.

Description and Construction

Oval basket with hinged swing handle cast in
sections with caryatids, scrolls and foliate
swags; overlay brim cast with heads of Ceres
and lasion wearing wheat and rush
headdresses encircled by alternating shell,
floral, and wheat surrounds; tapering sides
pierced with a fretsaw and chased inside with
trelliswork, scrolls, and flowers; resting on cast
and chased apron panel with open-worked
female masks, peering lions and shells
connected by leaf garlands; bottom of the basin
engraved with a later armorial in a cartouche.

Heraldry

The untraced coat-of-arms is probably of the
twentieth century.

Circular silver baskets without handles survive from Elizabethan England. In the second decade of the
eighteenth century, however, de Lamerie and others pioneered a new type of oval form with a swing
handle, tapering sides, and boldly projecting rim. Contemporary pictorial and written sources confirm
that they served a multitude of purposes. Grimwade has shown that a painting by Hogarth depicts one
piled with fruit and one of 1743 by George Wickes (1698-1761) is recorded in his intact ledgers as one
of a pair of bread baskets ordered by Frederick, Prince of Wales.[42] Schroder, too, has made reference
to the early inventory of plate belonging to the Earl of Warrington in which one of a group is cited as a
"basket for knifes, spoons, and forks."[43]

continued

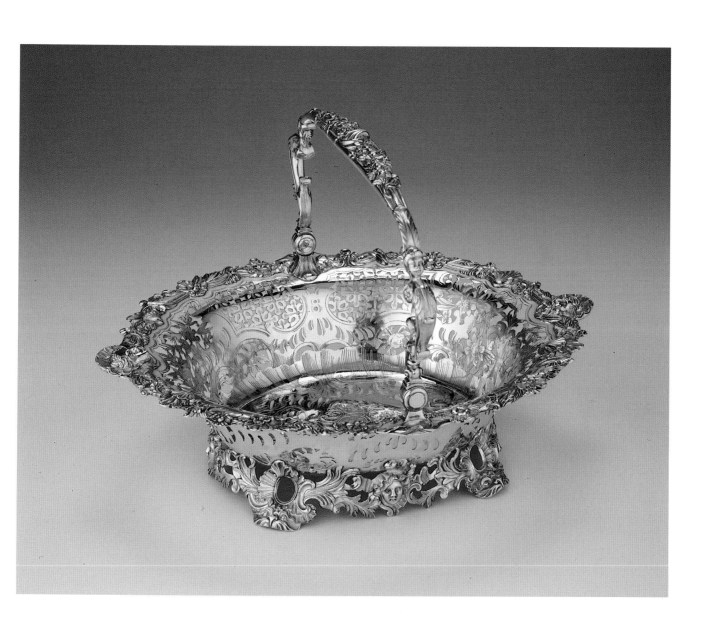

Cat. No. 14 continued

A large quantity of baskets by de Lamerie spanning the years from about 1725 through 1750 confirm that this was one of his specializations. These include examples imitating wickerwork as well as the subject basket carried out in an exuberant Rococo mode. Remarkable for its sensitive orchestration of diverse decorative components and technical treatments, it can be grouped together with a few others of the 1730s and early 1740s (see details). The handles, brims, or supporting aprons of these baskets were evidently cast from the same molds. One of a pair of 1739 at the Dallas Museum of Art is especially compatible with the current basket.[44] Other eighteenth-century silversmiths such as George Wickes, Phillips Garden (active 1730-1773), John Jacob (active 1734-1773), Louis Dupont (active 1736-1753) and Samuel Herbert (active 1747-1773) appear to have had access to the same molds, or perhaps, together with de Lamerie, they acquired the finished baskets directly from an outside specialist worker.[45] Three of 1826 at Goldsmiths' Hall reflect to a certain degree the enduring popularity of the same basic design in the next century.[46]

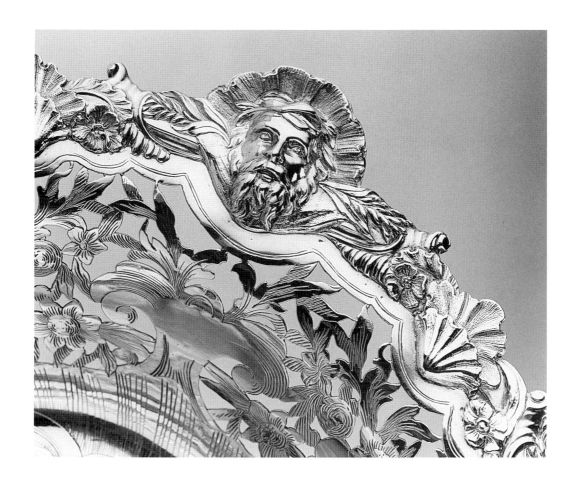

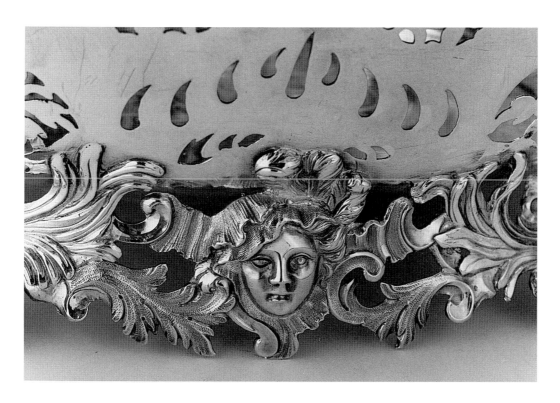

Cat. No. 15

SET OF TWELVE DINNER PLATES

Silver
Marks:
1. London, 2. sterling standard, 3. 1741-42, 4. maker's mark of Paul de Lamerie (Grimwade, no. 2204), marked on underside of each.

Diameter: 9¾ in. (24.8 cm.) each
Weight: 208 oz. (5896 gm.)

Description and Construction

Pentagonal-shaped plates hammered from sheet silver with attached gadrooned rims featuring diamond-shaped crests at the intervals; drapery mantling at outer shoulder and shallow boss at center of each; royal armorial engraved at the top of each border; pinpoint marks in the direct center of each well at the front where a compass was inserted to ensure each plate was circular.

Heraldry

The armorial consists of the royal crest, crown, garter motto, and initials of King George II (1683-1760). No physical evidence suggests that ambassadorial crests were ever engraved on the reverse sides.

Silver plates to serve the main dinner course are generally found in matching sets of a half a dozen or other higher multiples. Due to the high cost of the metal, these sets were made for wealthy households and do, or once did, bear crests or arms of the nobility or landed families. Early ones of the seventeenth century are austerely decorated with armorials only on a broad rim, whereas eighteenth-century examples display narrower borders with heavy gadrooning and reed-and-tie or beaded ornament.

These handsome plates may or may not have been part of an extensive table service. A number of similar plates, both for the entrée and soup, were produced in de Lamerie's workshop from the late 1730s up to just beyond the mid-1740s. One of these — a set of twelve hallmarked in the same year as the current group — likewise carry the royal armorials, but there are foliate in place of diamond-shaped motifs occupying their angles, confirming they were not initially part of the same service.[47] Although de Lamerie was appointed Goldsmith to the King in 1716, silver by him with royal associations is very limited, and, therefore, one can only postulate that these dinner plates were not used by the Sovereign, but instead were ordered for use by an ambassador or other emissary.[48]

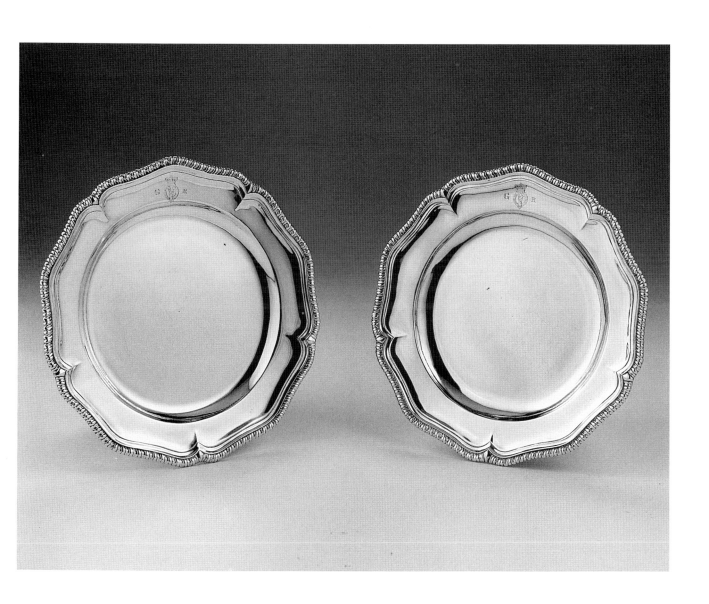

Cat. No. 16

PAIR OF SAUCEBOATS

Silver
Marks:
1. London, 2. sterling standard, 3. 1742-43, 4. maker's mark of Paul de Lamerie (Grimwade, no. 2204), marked under each belly.

Height: 5¼ in. (13.3 cm.)
Weight: 21 oz.; 4 dwt. (606 gm.) and 20 oz., 5 dwt. (581 gm.)

Description and Construction

Raised, oval-shaped sauceboats with shaped and gadrooned rims punctuated at the sides by cast shells below cresting; knuckled, double scroll handles cast in halves and soldered to the bodies with jagged leaves overlapping the brims above and flowerheads below; each boat resting on cast knuckled feet springing from scalloped bosses and terminating in padded shells; contemporary coat-of-arms in Rococo cartouche below the flaring spout of each boat.

Heraldry

The arms are those of Jodrell impaling Vanderplank.

Boat-shaped receptacles for holding sauces were introduced into England from France during the reign of George I. The earliest are double-lipped with handles at each end, but by the mid-eighteenth century more stable and functional sauceboats with a single handle and an elongated pouring spout had become the standard type. At first, they were supported on three feet and later four, as in the present case. Since silver conducts heat, sauceboats were not made to serve gravy, but rather cold sauces, and they were often included as part of a formal silver dinner service.

A sizeable number were created in this goldsmith's workshop from the 1720s up until about 1749. Usually, they adhere to established house patterns and are not profusely decorated. This gracefully balanced pair with restrained Rococo ornamentation was copied verbatim and with the substitution of lion masks and paw feet repeatedly. A nearly identical pair of the same date was once in the Morrison Collection, and others are contained in the dinner service consisting of 110 pieces that de Lamerie undertook for the politician and classical scholar Sackville Tufton, 7th Earl of Thanet (1688-1753).[49]

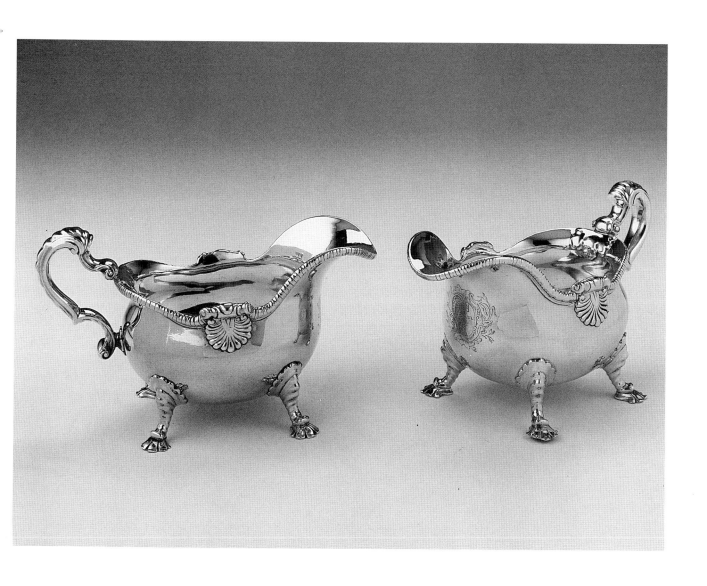

Cat. No. 17

CUP AND COVER

Silver
Marks:
1. London, 2. sterling standard, 3. 1742-3,
4. maker's mark of Paul de Lamerie (Grimwade,
no. 2204), marked inside of the base and on the
flange of the cover; engraved inside of the base:
1.

Height: 15½ in. (39.4 cm.)
Weight: 99 oz., 3 dwt. (2816 gm.)

Provenance:
Possibly Hunt and Roskell, London, 1862.
Sir Samuel Montagu, Bart. (Lord Swaythling).
Christie's, London, 6 May 1924, lot 86.
Probably Crichton Brothers, London.
William H. Green.
Sotheby's, London, 19 May 1955, lot 3.
Mr. and Mrs. Joseph S. Atha, Kansas City.

Exhibited:
London, South Kensington Museum, 1862(?).
London, Victoria and Albert Museum, Montagu
Loan, ca. 1903-1924.
Houston, Museum of Fine Arts, 10 November–
2 December 1956.

Published:
Robinson, 1863, p. 495, cat. no. 5940(?).
Phillips, 1968, p. 107, plate 138(?).
Houston, 1956, cat. no. 53.
Carver/Casey, 1978, p. 22, cat. no. 14
(mentioned).
*Virginia Museum of Fine Arts Annual Report
1987-88*, p. 6.
Virginia Museum of Fine Arts Bulletin vol. 48,
no. 4, March/April 1988, cover, p. 11.
Minneapolis, 1989, p. 64, cat. no. 47
(mentioned).
Bliss, 1990a, pp. 9-11.

Description and Construction

Double domed cover with cast and chased
scrolls, shells, and music making cherubs in
high relief surmounted by a grape finial with a
perching lizard; inverted pear-shaped body
cast and chased in sections consisting of the
youthful Bacchus within irregular shaped panels
surrounded by swirling masks, flowers, grapes,
scrolls, and shells; raised foot resting on a plain
molded base with heavily embossed lion masks,
scrolls, shells, and foliate motifs; separately cast
and soldered handles in the form of craggy
branches with trailing vines and grape clusters
topped by shells.

continued

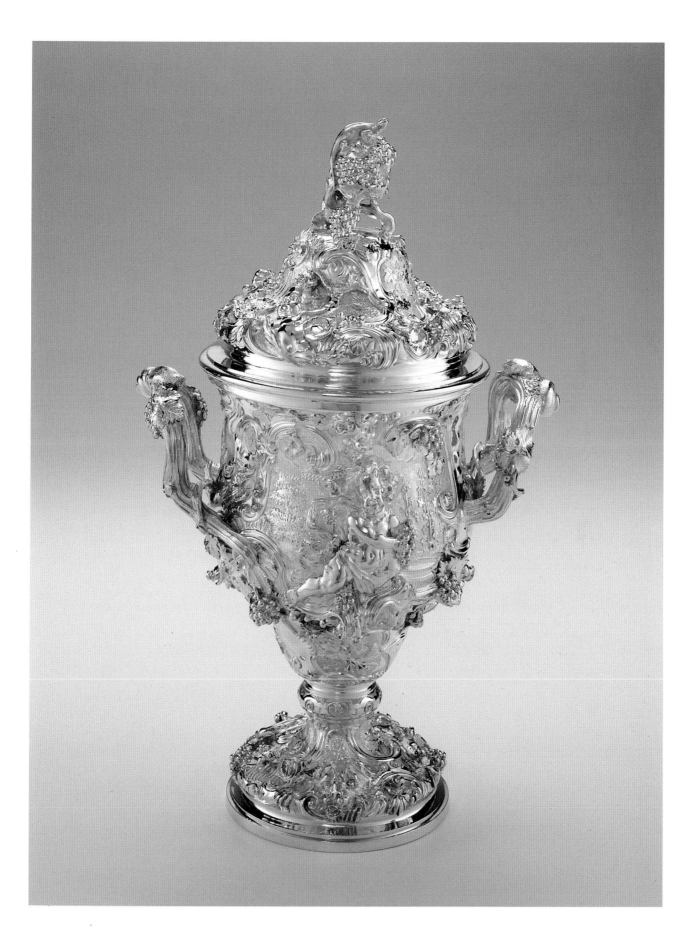

The full potential of de Lamerie's excursion into the fantasy world of the high Rococo culminates in the scintillating details that envelop every inch of this oscillating covered cup. A veritable tour de force of sculpture in precious metal that stretches the art of goldsmithing to its limits, it attests to the incomparable genius of this silversmith at the apex of his career. On both sides reigns the infant Bacchus situated within a vineyard replete with a profusion of bacchanalian motifs. Exuberantly cast and chased Rococo shells, scrolls, and intoxicated lions cram the equally sumptuous base. The cover, too, erupts with opulent ornamentation including joyous infants, swirling nautical motifs and grape leaves. Even the finial is transformed into a grape cluster atop which a small lizard appears oblivious to the riotous activity transpiring below.

Three other almost identical cups, all of 1742, are recorded. Glanville in cataloging a silver-gilt one at the Metropolitan Museum of Art noted that the handles taking the form of vine branches derive from those on a pair of ice-buckets of 1727 by the French silversmith Thomas Germain (1673-1748) at the Musèe du Louvre.[50] Another gilded version is in the Gilbert Collection at the Los Angeles County Museum of Art and one of pure silver is at the Sterling and Francine Clark Art Institute at Williamstown.[51] The continuing popularity of the model is confirmed by the fact that a later one of silver-gilt marked by Hunt and Roskell was recently on the London art market.[52]

De Lamerie also altered this basic design during his own lifetime. These other related versions date from the 1730s and are of the same form but are decorated in a more subdued manner, sometimes with auricular masks, snake handles, strapwork, and applied coats-of-arms. Examples of this type include a pair at the Dallas Museum of Art, one at the Fishmongers' Company and one at the Nelson-Atkins Museum of Art, another formerly in the Collection of Earl Cowper, and two currently untraced cups.[53] Finally, Barr discusses two comparable cups supplied by George Wickes to the Prince of Wales, but these, too, it seems were probably made in de Lamerie's workshop.[54]

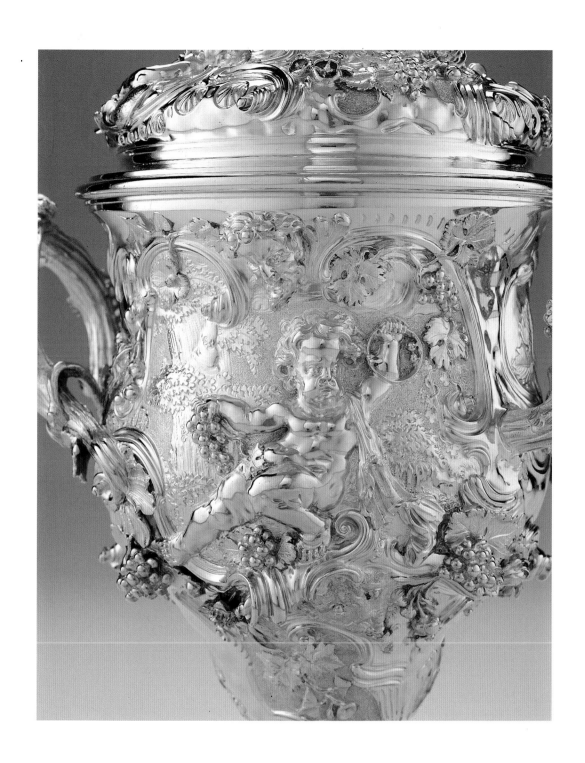

Cat. No. 18

PAIR OF CANDELABRA

Silver

Marks:

1. London, 2. sterling standard, 3. 1743-44, 4. 1746-47 (branches), 5. maker's mark of Paul de Lamerie (Grimwade, no. 2204), fully marked along the rim of each base and on the sleeve of one of the branches; partly marked on the other branch sleeve and on the bottom of each of the wax pans.

Height: 16 in. each (40.7 cm.)
Weight: 57 oz. 8 dwt. (1638 gm.) and 60 oz., 6 dwt. (1718 gm.)

Provenance:
Christie's, London, 13 April 1905, lot 70.
Letts.
Mrs. John E. Rovensky (formerly Mrs. Morton F. Plant), New York.
Sotheby Parke Bernet, New York, 19 January 1957, lot 903.

Published:
Hackenbroch, 1969, pp. 92-93 (mentioned).

Description and Construction

Each stands on a cartouche-shaped base with flutes cascading down over the edges with chased trellis panels and three cherub heads engulfed in swirling volutes; trilateral shafts with swollen and twisting upper knops chased with hanging foliate pendants and plain ovolo ornaments on the tapering stems; vase-shaped nozzles adorned with conforming foliate and scroll patterns; detachable two-light arms of voluted scroll form with foliage, flowers and buds springing from central flaming urn finials; removable branch sconces with floral and leaf motifs above detachable wax pans with foliate and shell rims; engraved crests on top of drip pans and in the panels on the bases; component elements cast independently or in sections and assembled together with solder or screws.

Heraldry

The crest is untraced.

These majestic lighting fixtures are instilled with a graceful harmony and proportional stability which distinguish them from the overcharged asymmetry characteristic of the French candelabrum designs by Juste-Aurèle Meissonnier (ca. 1693-1750) on which they are ultimately based.[55] Unlike the later candlesticks by de Lamerie in this Collection, which are a casual type produced regularly over a number of years, the model represented here is not novel, but it is far rarer. This is due, no doubt, to the costs resulting from their imposing scale, highly-wrought detailing, and substantial weight.[56] The branches of this pair are almost identical to those on two pairs of candelabra by this silversmith, one of 1742 in the Untermyer Collection at the Metropolitan Museum of Art and another of 1745 with later branches of 1747 in the Gilbert Collection at the Los Angeles County Museum of Art.[57]

In addition, the entire lower portions of the candelabra catalogued here recur nearly verbatim on a pair of candlesticks of 1749 in the Thyssen-Bornemisza Collection in Lugano.[58] Some decades ago Hackenbroch in cataloging the Untermyer Candelabra noted their similarity to a second pair of 1749 at the Metropolitan Museum from the Bache Collection, as well as to the current ones then in the Rovensky Collection.[59] Not only are the bottom sections of the Bache examples in New York compatible with those in Lugano, but their overall configuration and ornamental features — barring minor differences in the finials and branch sockets — are even more closely affiliated with the branched pair published here.

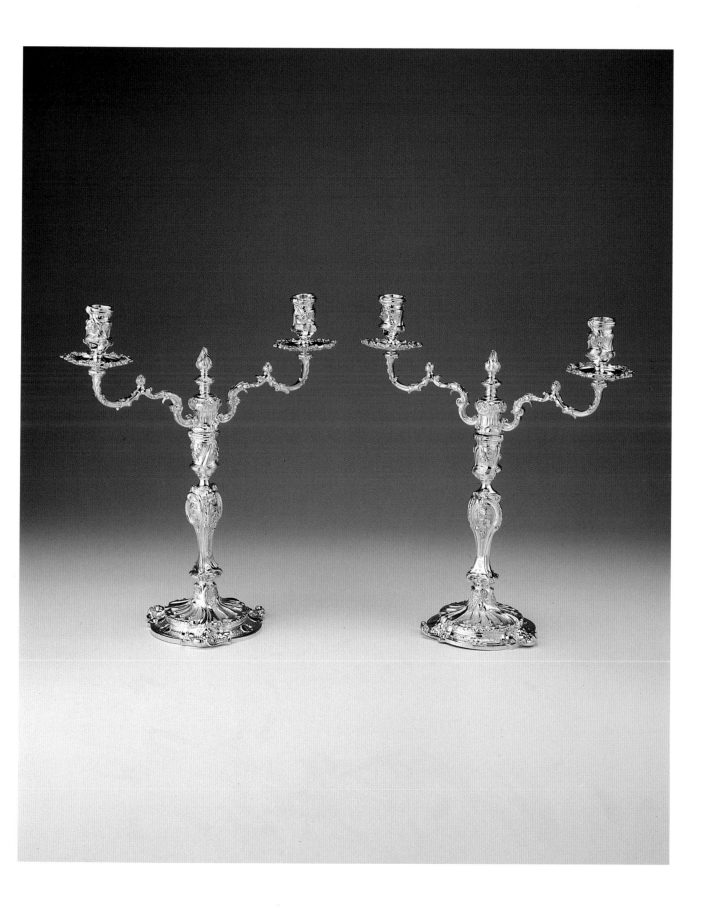

Cat. No. 19

SALVER

Silver
Marks:
1. London, 2. sterling standard, 3. 1743-44,
4. maker's mark of Paul de Lamerie (Grimwade,
no. 2204), marked on the bottom.

Diameter: 22⅜ in. (57 cm.)
Weight: 146 oz., 7 dwt. (4158 gm.)
Scratch weight: 149=12

Provenance:
Sir Timothy Waldo.
E.G.B. Meade-Waldo.
Christie's, London, 15 November 1933, lot 114.
Permain.
William Randolph Hearst.
Probably Parish-Watson and Company, New
York, 1938.
Bryan Jenks, Esq.
Christie's, London, 16 June 1965, lot 32.
Thomas Lumley, Ltd., London.
Donald S. Morrison, New Jersey.
Sotheby Parke Bernet, New York, 6 June 1980,
lot 26.

Exhibited:
Princeton, New Jersey, 1966, Princeton
University Art Museum.
Brooklyn, New York, 1966-1980, The Brooklyn
Museum.
London, Goldsmiths' Hall, 16 May–22 June
1990.

Published:
Princeton University Art Museum, 1966, cat.
no. 49.
*Art at Auction: The Year at Sotheby's, 1979-
1980*, p. 475.
Schroder, 1983, p. 18, cat. no. 13 (mentioned).
Clayton, 1988b, p. 71, no. 8.
Hare, ed., 1990a, p. 165, cat. no. 112 (entry by
Hare).
Bliss, 1990a, pp. 9, 11.

Description and Construction

Large salver or "tea table" of wavy shape
standing on four feet each with punctuated vine
tendrils, grapes, scrolls and shells;
contemporary armorial engraved in the center of
the plain basin; pierced border with
Bacchanalian masks, dressed in togas and
wearing headdresses overflowing with seasonal
attributes including wheat (Summer), flowers
(Spring), grapes (Fall), and vegetables (Winter)
alternating with shell-mounted panels; border
composed primarily of meandering grape vines
set within smooth inner and outer rims; border
assembled together with solder from a number
of cast sectional moulds and soldered into
position over the flat bottom.

Heraldry

The coat-of-arms is that of Waldo impaling
Wakefield.

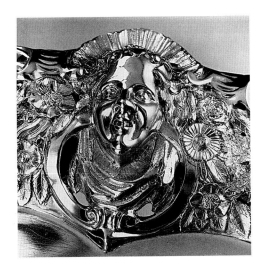

continued

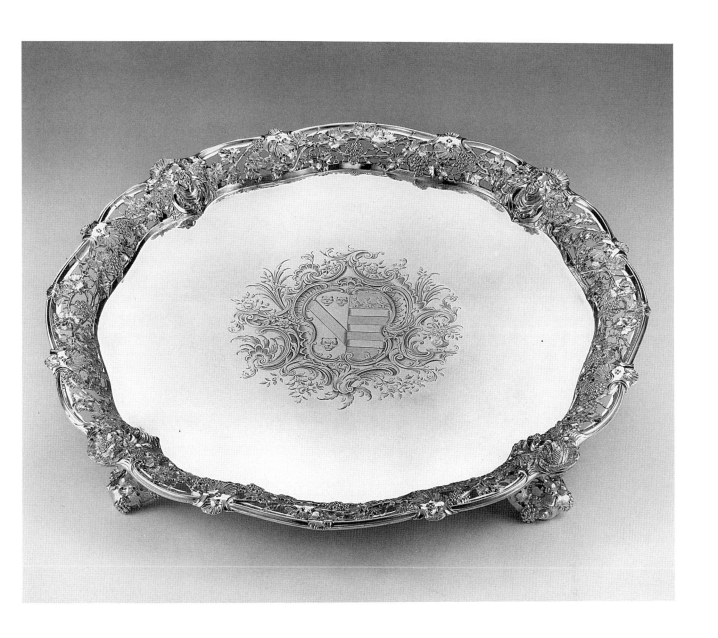

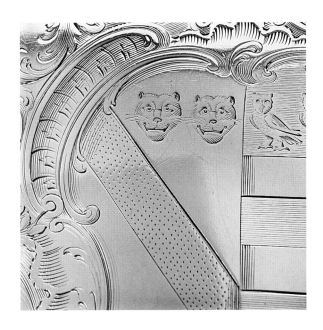

Cat. No. 19 continued

Originally salvers were employed for serving a drinking vessel to a guest but eventually they were also used for the presentation of a calling card, a newspaper, or the complete tea equipage. Made in a large number of sizes, the smallest ones are now generally referred to as "waiters." The large format of this one suggests that it was intended to stand in the drawing-room for holding a tea-kettle and other accessories associated with tea-drinking. It might have stood atop a mahogany tripod stand similar to the one still at Dunham Massey in England in which the top of the stand is shaped in order that the feet of the silver salver can slip securely into grooves (figure 3).[60] That salver and its smaller counterpart appear in an inventory of 1758 as a "tea" and "coffee" table respectively.[61] Hence, these large salvers are often called a "tea table" and appear as such in other early inventories.

This particular design with its delicately pierced border appears to have been introduced by de Lamerie himself, who repeated it in different sizes and with variations (see detail). One of the two earliest ones of 1739 is in the Al-Tajir Collection in London.[62] It is a bit smaller in width than this salver, and the related masks differ somewhat while the feet assume the form of boldly modelled eagles. The same basic pattern also became popular with other eighteenth-century goldsmiths including William Cripps (active 1731-1767), Phillips Garden (active 1730-1773), Thomas Heming (active 1738-1795/1801), Peter Archambo I (active 1710-1767), and Thomas Gilpin (active 1720-1773). It is suspected that Garden probably purchased casting patterns at the sale of de Lamerie's workshop stock and effects in 1752, and Garden and Gilpin are known to have produced other wares in designs similar or identical to de Lamerie's own.[63] Yet even a cursory examination of the major and minor differences in details and scale between these salvers implies a number of related but individual sets of casting components were in circulation at the time. The same basic type continued to be produced in the next century, albeit in a somewhat debased manner.

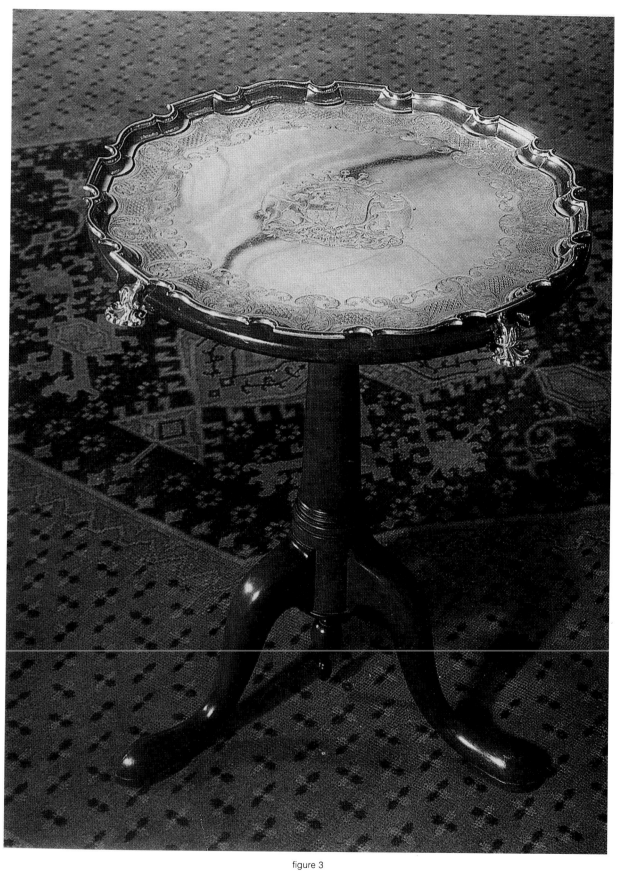

figure 3

Photo courtesy The National Trust, Dunham Massey, Cheshire

Cat. No. 20

CREAM JUG

Silver

Marks:
1. London, 2. sterling standard, 3. 1744-45, 4. maker's mark of Paul de Lamerie (Grimwade, no. 2204), marked inside of the bottom of the base.

Height: 4¾ in. (12 cm.)
Weight: 7 oz., 7 dwt. (218 gm.)

Provenance:
Hamilton-Rice Collection.
I. Freeman & Son, Ltd., London, 1965.

Published:
Bliss, 1990a, p. 11.

Description and Construction

Raised hollow body of pyriform shape with chased shells, scalework, and flutes on a partly matted ground and cast and applied floral swags beneath the undulating rim; supported on a naturalistically entwined snake forming three openwork feet which is cast and soldered to the bottom; cast and attached loop handle assumes the shape of a spiraling twig terminating in a voluted leaf and flower bud; broad pouring spout.

This delightful cream jug reflects this master's fully developed Rococo style at its very best on a diminutive scale. Although demonstrating a remarkable flight of fancy on his part, its deeply recessed interior would have been filled with cream to be taken with tea or coffee or poured over a dessert. Cream jugs only became fashionable during the reign of George I and the making of individual ones apparently declined towards the end of the century, when they began to be produced as matching components included in tea and coffee services. They are similar to milk-jugs in overall form, but they are generally smaller and have a wider lip for pouring the thick cream. In light of the considerable number of examples known, this model was undoubtedly highly favored in de Lamerie's workshop. It was, however, never duplicated exactly, but rather each one remains an individual undertaking revealing a subtle and more often a pronounced difference in decorative chasing and cast elements. The existing examples, all made in the 1740s, can be grouped into two different categories, as suggested by Wees.[64] The earlier model encompassing this one rests on a base consisting of a coiled serpent. One introduced at a slightly later date sits on a shaped support of overlapping scrolls and shells.

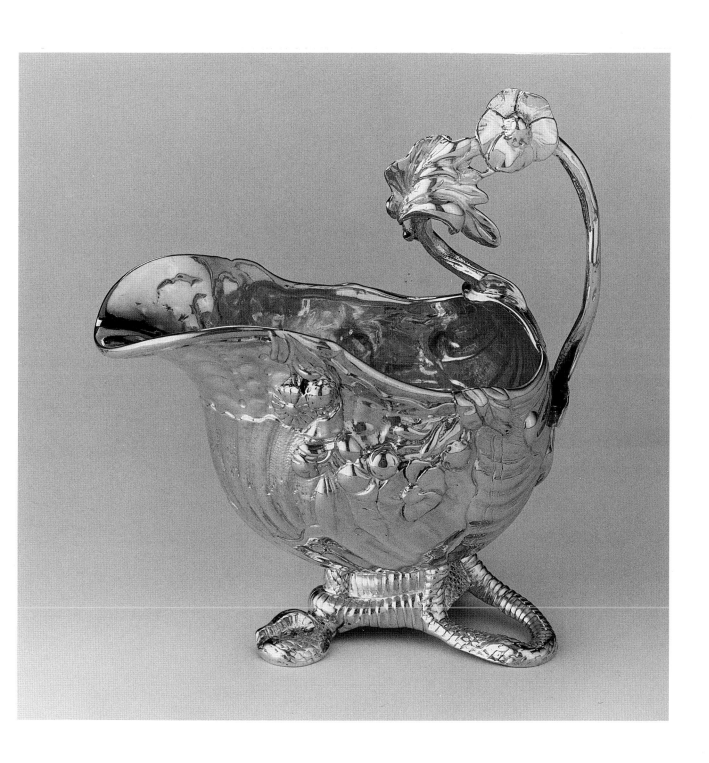

Cat. No. 21

TEA-KETTLE, STAND, AND LAMP

Silver, leather
Marks:
1. London, 2. sterling standard, 3. 1745-46,
4. 1741-42 (lamp), 5. maker's mark of Paul de
Lamerie (Grimwade, no. 2204), fully marked on
the bottom of the kettle and the bottom of the
lamp; partly marked on the inside cover of the
kettle, the flange of the lid of the lamp, and on
the bottom of the lamp ring of the stand.

Height of kettle with handle raised: 14⅞ in.
(38 cm.)
Gross weight: 95 oz., 2 dwt. (2699 gm.)
Scratch weight: 58=3 and 37=17

Provenance:
Christie's, London, 5 October 1949, lot 99.
Crouch.
William A. McMahon, New York.
Christie's, London, 28 March 1973, lot 122.
Arthur S. Leiderdorf, New York.
Sotheby Parke Bernet, New York, 4 June 1974,
lot 69.
Sotheby Parke Bernet, New York, 6 April 1989,
lot 158.

Exhibited:
London, Christie's, 1973.

Published:
Christie's, *Fanfare into Europe*, 1973.
Weltkunst, 1 June 1989, p. 1664.
Art and Auction, June 1989, pp. 192-93.
Art and Auction, September 1989, pp. 178-79.

Description and Construction

Hand-raised vessel broadly chased on one side
with a personification of the continent of America
in the form of a putto garbed as an American
Indian surrounded by flowers and scrolls; a
related putto on the other side, cradling a
cornucopia, represents one of the other
continents; cast multiple scroll handle partially
covered with a leather grip rises from swing
hinges above applied cherub masks; domed,
hinged cover with a finial assuming the form of a
hippocamp emerging from the deep; curved
and partly fluted spout springs from a matted
shell, floral swags and scrolls; removable kettle
sits on openwork tripod stand with overflowing
feather and scroll border, eagles with
outstretched wings and leaf-capped feet
terminating in voluted shell clusters; replaced
lamp rests on the stand.

Heraldry

The cartouches may originally have been
engraved with armorials.

continued

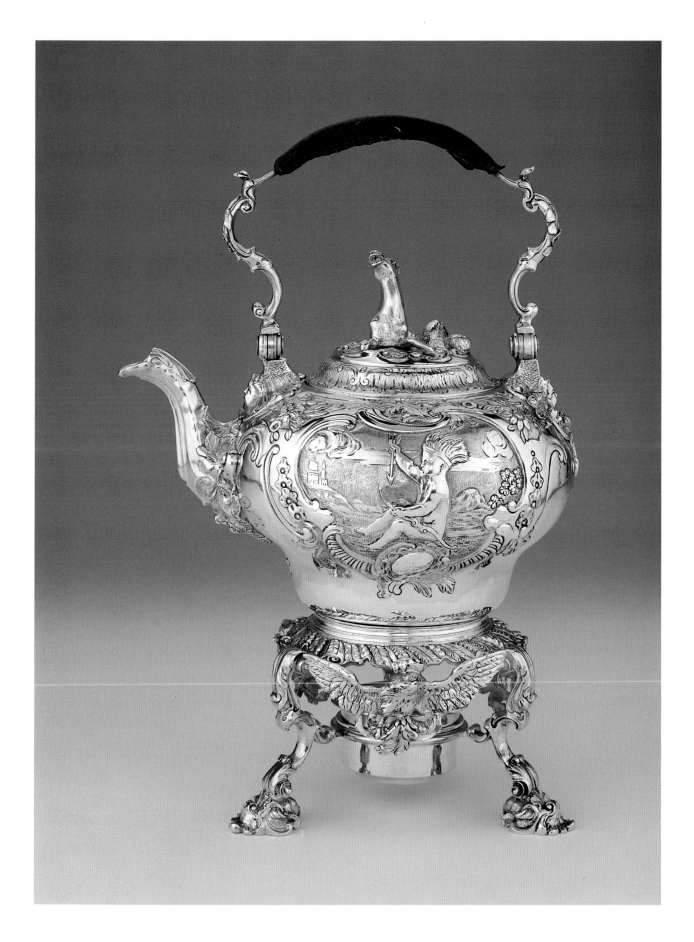

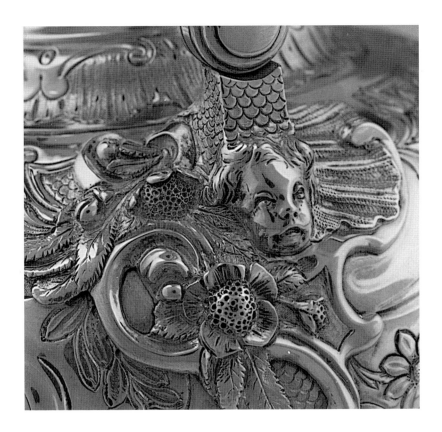

Cat. No. 21 continued

The earliest surviving English tea-kettles date from the Queen Anne period. Meant to hold a ready supply of hot water at tea time, kettles generally rest on stands equipped with lamps to heat the water from below. During the eighteenth century it was necessary to burn expensive wine spirits in the lamps, so in the 1770s tea-kettles were superseded by tea-urns.[65] The kettle returned to favor in Victorian times, however, as a result of the invention of the inexpensive fuel called camphorine.

The basic shape of the kettle evolved from bun-shaped examples to ones of globular form in the second decade of the eighteenth century. By the 1740s, however, the inverted pear-shape — as exemplified by this example — had become the preferred type. They were richly chased or embossed with ornamental scenes or motifs evolving around marine themes or Chinese inspired vignettes (see details). The current example reflects the Rococo fondness for the exotic and far away, too, as seen in the depiction of the young cherub dressed as an American Indian who personifies that Continent. Unfortunately, it is not possible to identify which part of the world his companion on the other side is intended to symbolize, because he holds a cornucopia, an attribute of prosperity associated with all of the continents since Renaissance times. (see detail opposite)[66]

Approximately forty kettles were made in de Lamerie's workshop between 1713 and 1751.[67] Most date from the 1730s, and although they often use the same cast mouldings, these are employed in differing combinations imparting to each a wide spectrum of individuality. The same or a very similar handle is found on a number of kettles, as is the short spout, which appears, for example, on another kettle of 1745 with chinoiseries at the Clark Art Institute.[68] Perhaps the kettle most closely related to this tea kettle, however, is the example of 1744 at the Metropolitan Museum of Art, on which the same spout is used and the stand is likewise embellished with spread eagles.[69] That kettle was part of a wedding present sent to David Franks (ca. 1720-1793) of Philadelphia, whose arms in conjunction with those of his wife appear. In light of the preferential treatment afforded the American Indian, it is tempting to hypothesize whether the kettle catalogued here might also have been made for a client living in one of the American colonies.

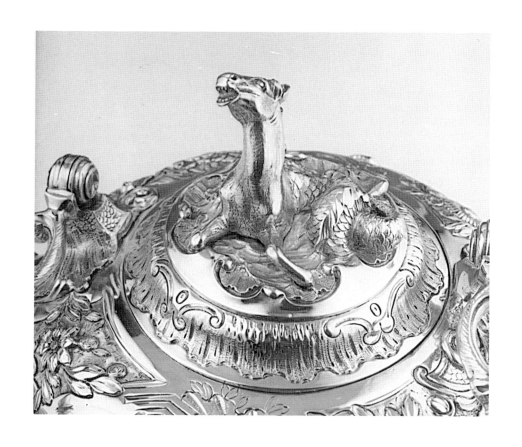

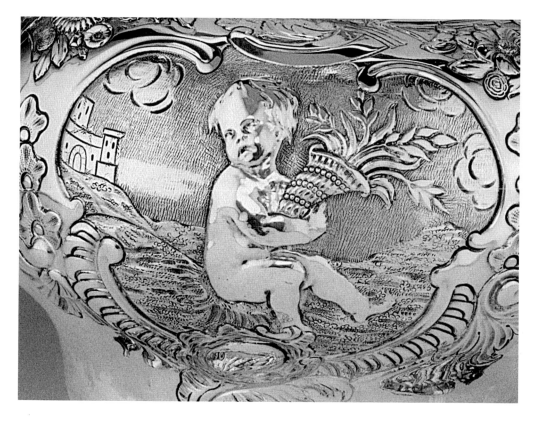

Cat. No. 22

INKSTAND

Silver
Marks:
1. London, 2. sterling standard, 3. 1745-46,
4. maker's mark of Paul de Lamerie (Grimwade,
no. 2204), fully marked underneath the tray and
one pot; partly marked on one pot and the
taperstick; pot lids unmarked.

Length: 14⅝ in. (37.4 cm.)
Weight: 77 oz., 2 dwt. (2188 gm.)

Description and Construction

Recessed tray of rectangular form with shaped
border cast in sections with gadroons, scrolls,
and shells; raised ink and pounce pots of
inverted vase-shape embossed with curving
shells and scrolls; detachable covers pierced
with circles and trelliswork; taperstick raised
with cast and fluted socket; separately cast and
applied quill rests and sunken depressions for
pots and taperstick; four paw feet cast in halves
and soldered with stylized shells to the stand.

Until the early nineteenth century inkstands were called "standishes." While these ensembles were not
made by de Lamerie in significant quantity, this is the larger of two by him in the current collection.[70]
Like that other earlier example, this one follows a conservative format consisting of a tray fitted with ink
and pounce pots flanking a central component, in this case a taperstick to facilitate writing at night. It,
too, is carried out in the restrained Rococo style reflecting a willingness on the maker's part to produce
plain objects for household use at the same time as ornate sculptural pieces in the fully developed
Rococo idiom.

An almost identical one of the same imposing scale resides in the Gilbert Collection at the Los Angeles
County Museum of Art.[71] It was made one year earlier, and, as Schroder has observed, the basic form
— and by association the present one's — is indebted to the heavily embellished inkstand of 1741
created by de Lamerie for the Goldsmiths' Company.[72] The inkstand in Los Angeles is engraved with
the arms of Admiral George Anson, the celebrated circumnavigator. Other pieces ordered by Anson
are also included in this catalogue.[73]

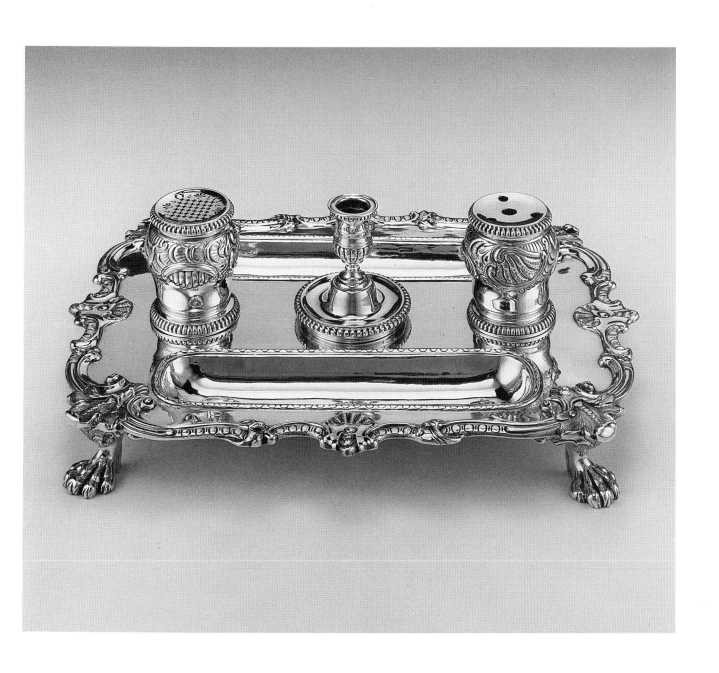

Cat. No. 23

PAIR OF WAITERS

Silver
Marks:
1. London, 2. sterling standard, 3. 1747-48,
4. maker's mark of Paul de Lamerie (Grimwade,
no. 2204), marked on the bottoms.
Diameter: 7 in. (17.8 cm.) and 7⅛ in. (18.1 cm.).
Weight: 14 oz., 1 dwt. each (391 gm.)
Scratch weight: 13=18 and 13=19

Provenance:
George, 1st Baron Anson, 1762.
Anson family by descent to George, Lord
Anson.
Christie's, London, 8 June 1893, lots 9-10 or
11-12.
Charles Davis or S. J. Phillips, Ltd., London.
Sir Samuel Montagu, Bart. (Lord Swaythling).
Christie's, London, 21 June 1910, lot 41.
Letts.
Miss M. S. Davies.
Christie's, London, 30 June 1954, lot 139.
Davidson.
Bryan Jenks.
Christie's, London, 16 June 1965, lot 30.
Garrard and Company, Ltd., London.
Trustees of the 7th Earl of Radnor's Marriage
Settlement.
Christie's, London, 24 November 1971, lot 78.

Exhibited:
London, St. James's Court, July 1902.

Published:
St. James's Court, 1902, p. 15, cat. nos. 7 and
10.
Gardner, 1903, plate 111, no. 3.
Christie's Review of the Year 1964-1965, p. 124.
Schroder, 1988a, p. 222, cat. no. 55
(mentioned).

Description and Construction

Each raised waiter of square section with
separately cast and sharply upturned border of
undulating silhouette; corners dominated by
shell lobes with interconnecting vine leaves,
grape clusters, and fish scale reserves on partly
punched grounds; flat-chased scrolling
cartouches along the inner edges with vineleaf
motifs repeating those on the outer border;
centers engraved with armorials; each elevated
on four openwork scroll feet entwined with
grapevines and shells cast and soldered into
place.

Heraldry

The coat-of-arms on each is that of Anson
quartering Carrier for George, Admiral Anson
(1697-1762), and Isabella Carrier of Wirksworth,
his mother.

continued

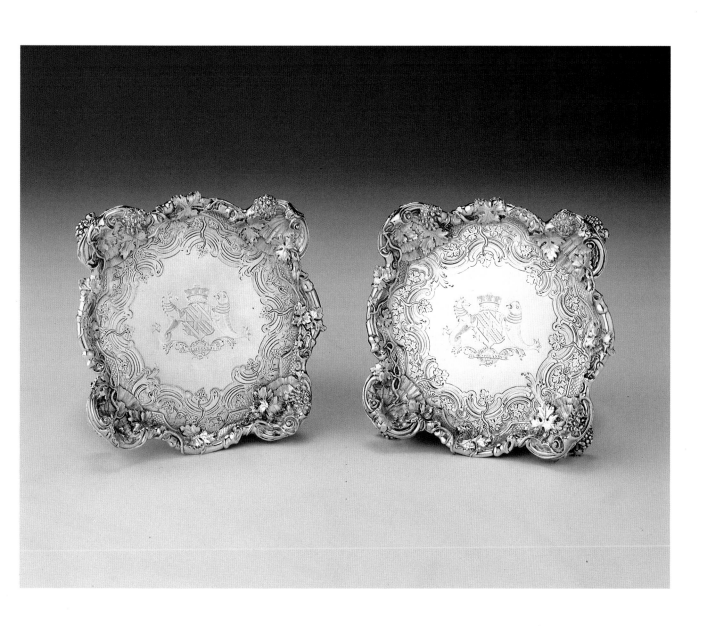

Cat. No. 23 continued

Arguably these supreme waiters together with a few others are in terms of finesse of craftsmanship this master's most accomplished creations in this realm. Fastidiously worked, their lavish borders fully exploit the fashionable Rococo motifs of lively shells, scrolls, and vine tendrils. Their extraordinary beauty suggests that de Lamerie himself played a pivotal role both in their preliminary design and subsequent execution.

The artistic quality of the examples falling within this category is matched only by their impressive pedigrees, which are amply demonstrated by the exclusivity of the family armorials appearing on them. These two bear the coat-of-arms of George, Baron Anson, Admiral of the Royal Fleet, who became a great patron of de Lamerie after amassing a huge fortune due to his interception of a Spanish galleon laden with bullion and treasures.[74] Another pair of salvers of the same design and date but of slightly larger scale is still at Shugborough, Anson's ancestral home in Staffordshire.[75] Inasmuch as salvers and waiters were often made in sets of varying sizes, it remains plausible that these two pairs were initially made as a matching ensemble of four or more service trays.

Of the same design is a sole waiter of 1736 by this goldsmith in the Gilbert Collection at the Los Angeles County Museum of Art seemingly displaying the arms of Ralph Congreve (died 1775), a leading member of Parliament (figure 4).[76] Others include a pair of waiters and salvers of 1745 presumably carried out *en suite* for the son of Algernon Coote, 6th Earl of Mountrath, another of de Lamerie's most devoted customers, and a regilded pair of 1745 can be found in the Victoria and Albert Museum.

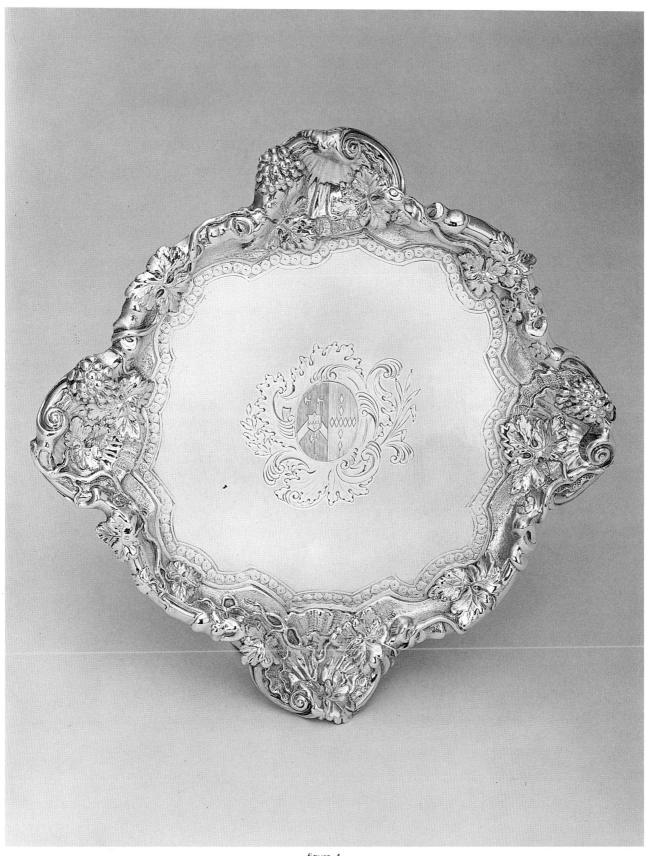

figure 4

Photo courtesy Los Angeles County Museum of Art, Waiter,
Paul de Lamerie, The Mr. and Mrs. Arthur Gilbert Collection

Cat. No. 24

PAIR OF CANDLESTICKS

Silver
Marks:
1. London, 2. sterling standard, 3. 1748-49, 4. maker's mark of Paul de Lamerie (Grimwade, no. 2204), marked underneath the bases; nozzles unmarked.

Height: 9⅞ in. each (25 cm.).
Weight: 23 oz., 2 dwt. (657 gm.) and 24 oz., 1 dwt. (751 gm.).
Scratch weight: 97 oz. the 4.

Provenance:
D. Black, London.
Sotheby's, London, 9 February 1984, lot 201.

Description and Construction

Both baluster-stemmed candlesticks rest on shaped bases cast in one piece with activated scrolls, flowers, and shells at both the straight and incurved angles; waisted domed centers chased with swirling shells, scrollwork, and acanthus leaves rising to cast baluster stems of tapering square section with guilloche knops below and shell caps and leaves revolving around the top corners; flaring sockets cast in halves with shallow flutes and rocaille below detachable nozzles chased around the upper perimeters with floral festoons and matted shell motifs; three major sections of each stick joined together with solder.

In bygone ages candlesticks, chandeliers, and sconces were the sole means of providing illumination in both domestic and civic interiors. Therefore, they were executed in an abundant variety of sizes, shapes and styles. Clayton has acknowledged that Henry VIII owned four sticks made from gold, but table candlesticks from that period rarely survived.[77] The oldest are of simple tripod design with a pricket, and by the middle of the seventeenth century a columnar shaped one with a pan to catch the dripping wax was the generally accepted type. Baluster-stemmed candlesticks, cast rather than raised, like this elegant pair, were popularized by Huguenot silversmiths working in London.

Originally, these two were from a set of four as the scratch weight engraved on them records the combined gauge for four sticks. As often noted, the candlesticks bearing de Lamerie's mark are usually consistent in design with a penchant for standardized patterns fluctuating from simple to florid. This was one of his most favored designs executed over the course of at least a decade and a half, during which there occurs an increased application of cast ornament, adjustments in chased detail and an ascent in height. Typical characteristics include the use of leaf motifs or trophies protruding from the sharply edged bases and shell surrounds encircling the shoulders of the flaring stems (see detail). Of the innumerable related examples, an earlier pair of 1741 in the Gilbert Collection at the Los Angeles County Museum of Art appears particularly close in most respects.[78]

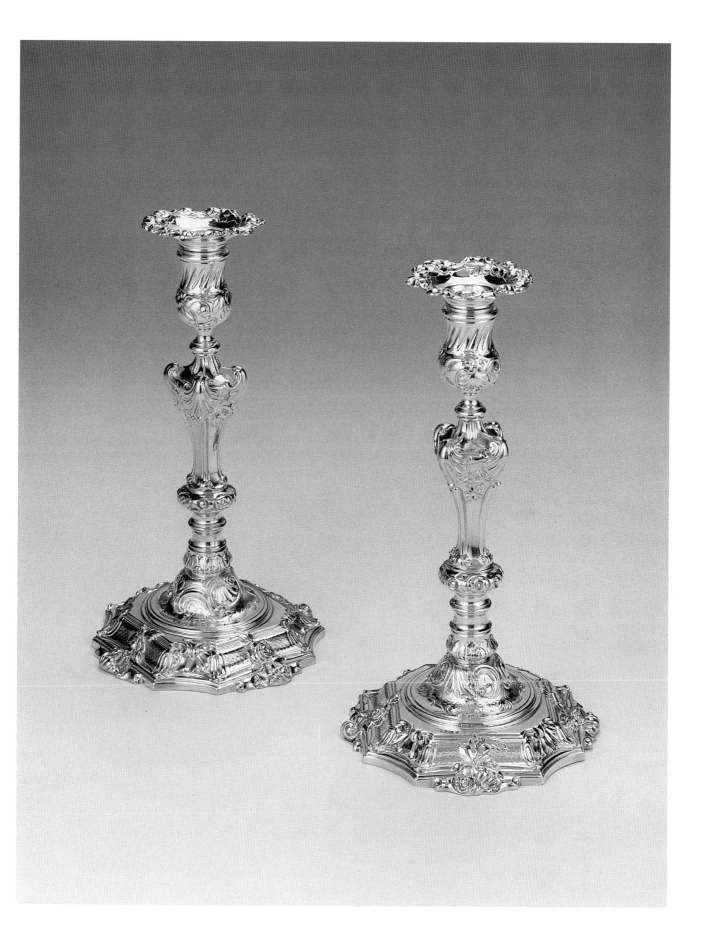

Cat. No. 25

DISH

Silver
Marks:
1. London, 2. sterling standard, 3. 1748-49, 4. maker's mark of Paul de Lamerie (Grimwade, no. 2204), marked on the underside.

Diameter: 10½ in. (26.5 cm.)
Weight: 23 oz., 2 dwt. (657 gm.)
Scratch weight: 24:15 and 28:14:75 engraved on the bottom.

Provenance:
Sotheby Parke Bernet, New York, 7 April 1987, lot 152.

Description and Construction

Shallow hand-raised dish of circular form with serrated rim divided into twenty-four concave compartments chased with alternating cartouched scalework and matted shells divided by fluted ribs; flat central boss chased with broad band of swirling scrolls, shells, flowers, and foliate clusters; four bracket feet in the form of voluted vine leaves cast and soldered to the main component.

Heraldry:

The basin discloses only minimal wear and no thinness in the metal suggesting it never bore an engraved coat-of-arms.

Distinguished for its rhythmic form and the fine quality of the chased ornamentation, this dish belongs to a large body of homogeneously shaped dishes retailed through de Lamerie's shop over a long duration.[79] In spite of an overall uniformity, their diameters, depths, and number of fluted lobes diverge, as does the character of the chased or engraved decoration. A set of eight smaller and more sparsely embellished dishes of 1736 by this master in the J. Ortiz-Patiño Collection reveal a particular affinity with this one by virtue of the similar scale and shell patterns filling the upturned flutes.[80]

Many of de Lamerie's contemporaries also undertook dishes of this sort with varying results. As a case in point, two have been identified by Barr as being from a set of eight made for Lord Montford by George Wickes in 1744. Interestingly, in the pertinent ledger they are itemized as "8 sallad dishes" at a cost of £53.15.2 excluding gilding and engraving.[81] Additional documentary evidence confirms these dishes were also used for other purposes, however. Somewhat smaller ones are termed "patty pans" in the inventory of Sarah, Duchess of Marlborough, and their ubiquitous designation as "strawberry dishes" has come to be accepted today with little concrete justification to describe all such round dishes with upcurved fluted sides and shaped borders.[82] Perchance some of them were even employed as underlying stands for tea and coffee utensils equipped with heating devices from which they were subsequently divorced and sold as solitary merchandise.

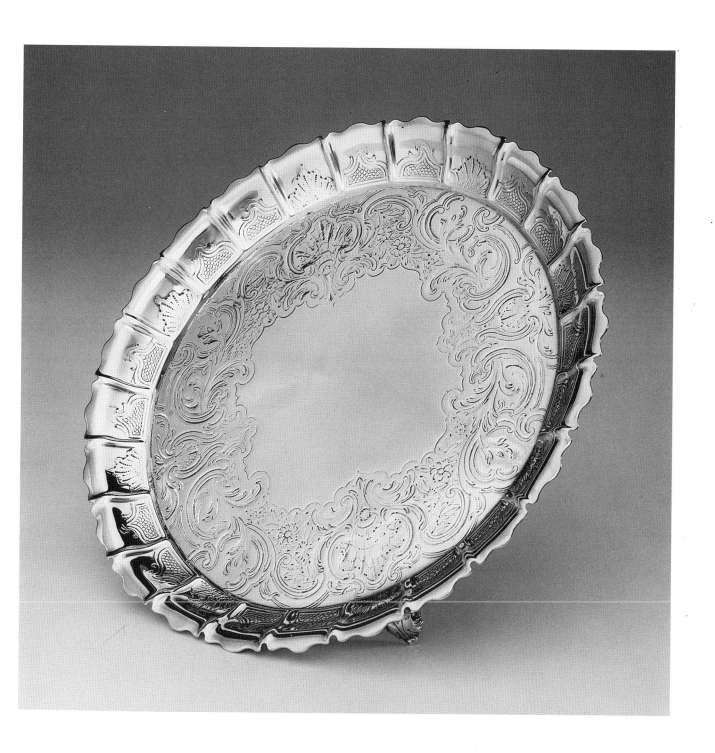

Cat. No. 26

SOUP TUREEN AND COVER

Silver
Marks:
1. London, 2. sterling standard, 3. 1749-50, 4. maker's mark of Paul de Lamerie (Grimwade, no. 2204), marked underneath the tureen, and on the lid flange.

Length: 17⅝ in. (44.8 cm.)
Weight: 126 oz., 6 dwt. (3589 gm.)

Provenance:
Sotheby's, London, 17 May 1973, lot 176.
De Mello.
Christie's, Geneva, 27 April 1976, lot 226.

Published:
Art at Auction: The Year at Sotheby's 1972-1973, pp. 288-289.

Description and Construction

Large tureen of bombé form with deeply bellied bowl and conforming removable lid; partly fluted cover with a trailing ovolo band, scallop-shaped rim, and separately cast scroll handle capped by a shell and projecting from stylized shell and scroll surrounds; shaped body resting on four curved feet affixed to cartouches of dissolving scrolls and shells; openworked side handles adorned with shells and lobate ornamentation springing from volute and shell bosses; matching armorials enframed within Rococo cartouches engraved on the body and lid.

Heraldry

The arms are those of Trinity College, Dublin.

A tureen identical in all respects including the presence of the armorials of Trinity College was sold as a pair together with it twice at auction, but they have since been separated.[83] Whether they were once part of the plate collection donated to that College or were nostalgic mementos belonging to a proud alumnus can no longer be ascertained. At least two other tureens by this goldsmith following the same format but more richly articulated are still at Eton and Brasenose Colleges in England.[84]

Several other London silversmiths of the eighteenth century made soup tureens of such forthright design, and ones by Storr were executed in a revived interpretation during the following century. As for de Lamerie, he significantly altered the pattern at numerous times, but still adhered to the same overall conception. The popularity of the design is in all probability due to the influence of the South Netherlandish goldsmith Nicholas Sprimont (1716-1771). His signed sketch for a soup tureen discloses more than a passing resemblance with varying degrees of fidelity to all of these silver tureens, not least the one catalogued here.[85] Others by de Lamerie correspond even more closely to the design, such as the example of 1750 today in the Dowty Collection.[86]

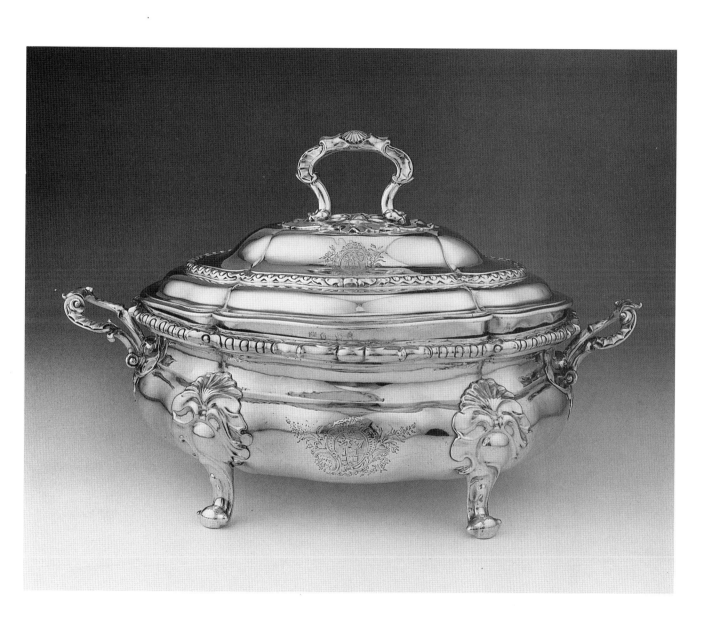

Cat. No. 27

PAIR OF DISH COVERS

Silver
Marks:
1. London, 2. sterling standard, 3. 1749-50, 4. maker's mark of Paul de Lamerie (Grimwade, no. 2204), marked within the interiors of the domes.

Length: 9 in. (22.8 cm.) and 9⅛ in. (23.2 cm.)
Weight: 20 oz. (622 gm.) each
Scratch weight: 20:14½ and 20:16½

Provenance:
George, 1st Baron Anson, 1762.
Anson family by descent to George, Lord Anson.
Christie's, London, 8 June 1893, lot 28 or 29.
C. J. Vander, Ltd., London.
Flora Whitney Miller.
Sotheby's, New York, 7 April 1987, lot 158.

Exhibited:
London, Goldsmiths' Hall, 16 May–22 June 1990.

Published:
Hare, ed., 1990, p. 116, cat. no. 72 (entry by Hare).

Description and Construction

High-domed dish covers of oval form raised by hand from silver sheet metal and enhanced by separately formed double moulded borders soldered to the bottom and a gadrooned border interspersed with leaves applied to the lower shoulder; scrolled ring handles capped by a shell spring from shell and scroll cartouches cast in halves and soldered to the lids; contemporary coat-of-arms engraved at the front of each.

Heraldry

The arms are those of Anson quartering Carrier for George, Admiral Anson (1697-1762), and Isabella Carrier of Wirksworth, his mother.

The understated attraction of these pieces is conveyed through mildly swelling outlines and broad shimmering surfaces enriched only by plain and gadroon moldings, cast scroll handles, and enblazoned coats-of-arms. They are rare and chance survivals of dish covers made to keep food on dishes warm when one or two people wished to eat in seclusion without servants in waiting. In a sense, these are the forerunners to the entrée dishes and covers introduced in about 1770. Dish covers like these would have by then appeared passé, so many were probably consigned to the melting pot. Regardless, they appear never to have been in great demand before the 1760s, at which time the introduction of Sheffield plate provided the means to manufacture them both efficiently and cheaply.

This pair is the only surviving dish covers of small oval shape by this silversmith.[87] They do have something in common, however, with a number of soup tureens which utilize the same basic format. Comparative examples are included in de Lamerie's Thanet Dinner Service, and others are in the Gilbert Collection at the Los Angeles County Museum of Art, the Al-Tajir Collection in London, the Campbell Museum, and the Huntington Collection. They are also not unrelated to the cover of the soup tureen of 1749 in the present collection.[88] At least two other prominent London silversmiths, Paul Crespin (1694-1770) and Charles Kandler (active 1727-1776), likewise made soup tureen covers resembling these.

The desirability of these covers is amplified because they were made for Admiral George Anson.[89] Hallmarked only a year after he married Elizabeth Yorke, Hare wrote provocatively about them in the catalogue accompanying the de Lamerie exhibition of 1990 by stating:[90]

> "The small size means that these were most likely intended as covers for supper dishes . . . Having married rather late in life, in 1748, Lord Anson no doubt was in favour of evening meals taken *à deux* with his new wife."

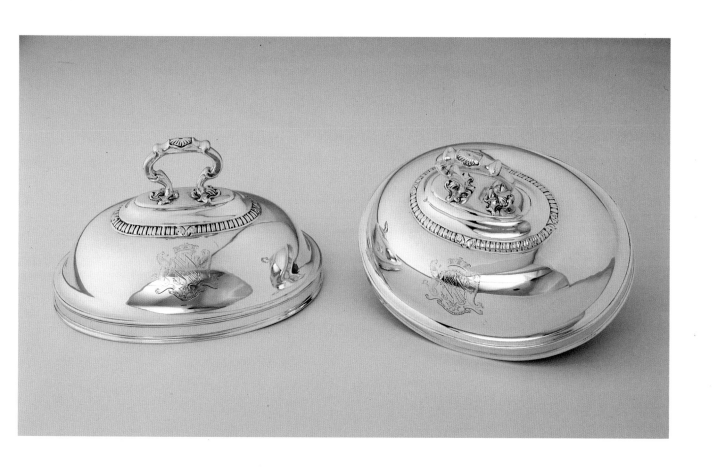

Cat. No. 28

PAIR OF TEA CADDIES

Silver
Marks: ·
1. London, 2. sterling standard, 3. 1751-52, 4. maker's mark of Paul de Lamerie (Grimwade no. 2204), marked on the bottom of each.

Height: 6¼ in. (16 cm.)
Weight: 9 oz., 11 dwt. (258 gm.) and 10 oz., 2 dwt. (289 gm.)
Scratch weight: 47:21 and 47:23

Provenance:
Sotheby's, London, 28 April, 1977, lot 184.

Published:
Brett, 1986, p. 179, no. 735.

Description and Construction

Quadrangular-shaped receptacles with volute bases and hinged lids surmounted by floral and tendril spray thumblifts; all sides of each caddy embossed and chased with male and female Oriental figures harvesting tea into a wickerwork basket or rustic, two-story thatched huts beneath palm trees all set amidst scrolls, shells, lion masks, and foliate clusters on punched grounds; bottom and sides formed from five separate panels soldered together; cast and chased covers; caddies unlined.

Chinoiserie or European ornamentation inspired by oriental sources influenced English silversmithing during various periods including the height of the Rococo when these two tea caddies were created.[91] The resulting decorative schemes are highly romanticized Western interpretations of Oriental figures and motifs and not realistic depictions of persons, places, and things actually found in the Far East. Here, the elegantly shaped sides are heavily worked with idealized scenes of pseudo-Chinese figures engaged in harvesting tea or windswept huts. Yet, these exotic vignettes are enframed within undulating Baroque cartouches surrounded by glittering shells, flowers, lion masks and other major ornamental features of the English Rococo (see detail). In passing, mention must be made of a single cannister by de Lamerie also of 1751 which appeared at auction in 1978.[92] Although the dimensions provided in the sales catalogue are smaller than the two published here, it remains questionable whether it might originally have been the matching sugar box to this set.

continued

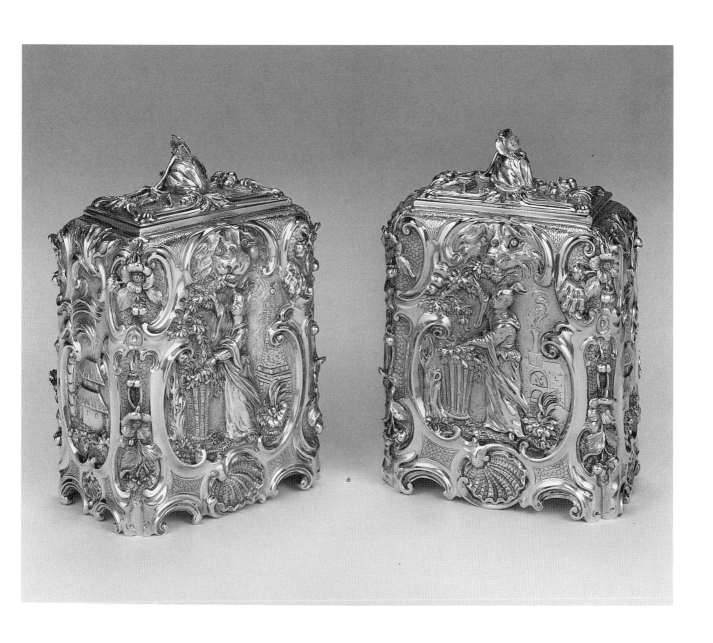

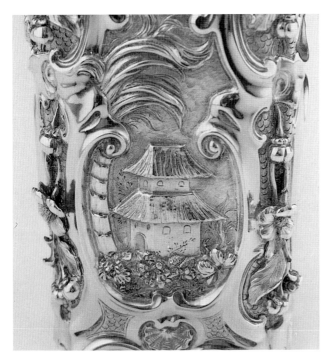

Cat. No. 28 continued

The scene on these caddies — the "Tea-picker Design" — was repeated numerous times with variations by de Lamerie, as well as being used almost continuously up until the mid-nineteenth century by other English and Irish silversmiths.[93] He is almost certainly correct in implying that although de Lamerie appears to be the first to utilize this design, it is questionable whether it was his own invention. With what is currently suspected about the organizational arrangement of his workshop, it is tempting to speculate whether this design was introduced by James Shruder (active 1737-1752), who is believed to have been employed by de Lamerie as a modeler.[94]

JAMES SHRUDER

James Shruder (active c. 1733-c. 1752)

Little is known of this intriguing maker of some of the most remarkable English silver of the rococo period. It has been suggested that he was raised and trained in Germany, for there is no record of his apprenticeship or freedom before he entered his first mark at Goldsmiths' Hall on August 1, 1737. Through Helen Clifford's research, we know that Shruder was well established four years earlier as a "chaser &c" when he took on Julian Crespin as an apprentice. She further suggests the possibility that Shruder may have served as a modeler/chaser for de Lamerie in the 1730s and 40s. She feels that several pieces marked by de Lamerie and shown in the 1990 exhibition at Goldsmiths' Hall evidence Shruder's distinctive workmanship. Shruder was also a signatory to de Lamerie's will in 1751, which may indicate a special relationship and the possibility of his being or having been in de Lamerie's employ. He was declared bankrupt in 1749, the year he produced the remarkable kettle on stand in this collection and its matching coffee pot in the Victoria and Albert Museum. Yet, he was still able to produce in 1752 the unusual kettle on stand in the Folger Coffee Company Collection. He was described as a "Modeler and Papier Mâché Manufacturer. Great Marlborough-street, Carnaby-market" in 1763 in Mortimer's Universal Director. (Grimwade, 1976; Hare, ed., 1990; Victoria and Albert Museum, 1984)

Cat. No. 29

TEA-KETTLE, STAND, AND LAMP

Silver, ivory
Marks:
1. London, 2. sterling standard, 3. 1749-50,
4. maker's mark of James Shruder (Jackson, p.
194), fully marked on the bottom of the kettle,
and on the underside of the lamp; partly marked
on the lid flange of the lamp; 5. duty stamp,
6. sterling standard, 7. indecipherable mark (5-7
marked on the replaced central portion of the
handle).

Height of kettle with handle raised: 17¼ in. (43.9
cm.)
Gross weight: 112 oz., 5 dwt. (3189 gm.)
Scratch weight: 62=2, 48=10, and 110=12.

Provenance:
Leake and Mary Nichol Okeover, 1765.
Okeover family by descent to Colonel Sir Ian
Walker-Okeover, Bt.Christie's, London, 25 June
1975, lot 108.
Garrard and Company, Ltd., London.
Simon Kaye Ltd., London.
I. Freeman and Son, Inc., New York.

Published:
Connoisseur, September 1975, p. 31 (dealer's
advertisement).
Victoria and Albert Museum, 1984, pp. 117-18,
cat. nos. G26 and G27 (entries by Barr)
(mentioned.).
Clayton, 1985b, p. 165, no. 9.
Schroder, 1988b, p. 302 (mentioned).
Bliss, 1990a, p. 11.

Description and Construction

Globular kettle raised and richly repoussé with
Neptune holding a trident drawn in a sea-chariot
by dolphins, and on the other side a ship with a
sail shaped as an armorial cartouche afloat on a
tempestuous ocean; hinged swing handle of
entwined water-reeds separated by ivory bands
springing from chased seaweed and shells with
a chain locking-pin; domed cover of sweeping
waves terminates in a cast conch shell finial;
spout in the form of a triton sounding a shell
striding a hippocamp; openwork stand of
overhanging barnacle clusters and shells
supported on three dolphin and rocaille pad
feet; shell encrusted lamp with cover; various
crests engraved on the body and the lamp;
middle section of the handle a Victorian
replacement.

Heraldry

The coats-of-arms are those of Okeover
impaling Nichol, for Leake Okeover (1701-1765)
and his wife Mary (died 1764), daughter of John
Nichol of Colney Hatch, Middlesex. The crests
are presumably those of various branches of the
Okeover family.

continued

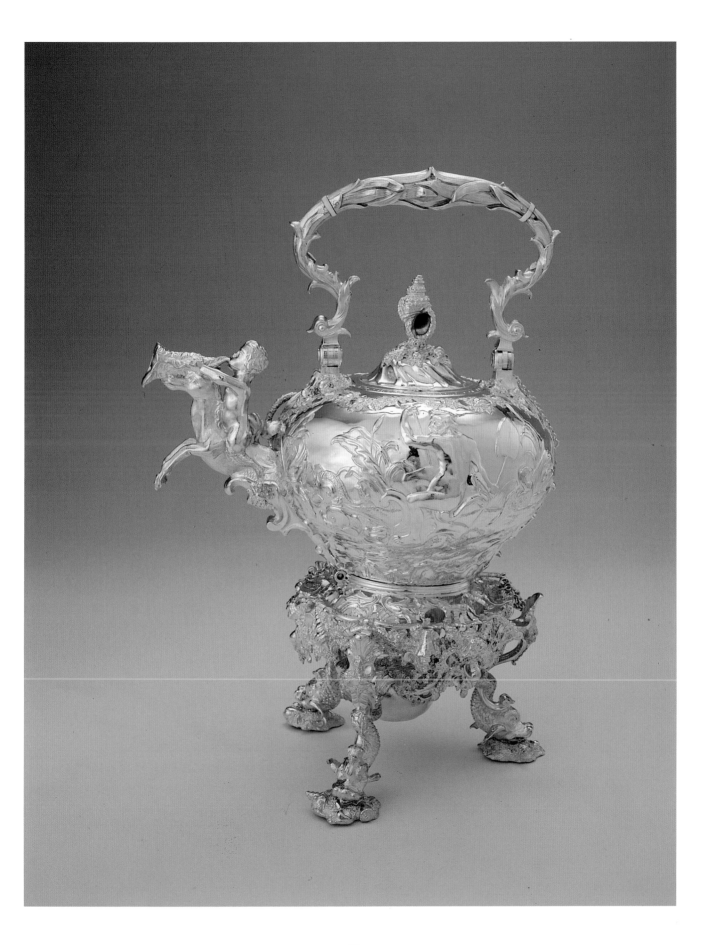

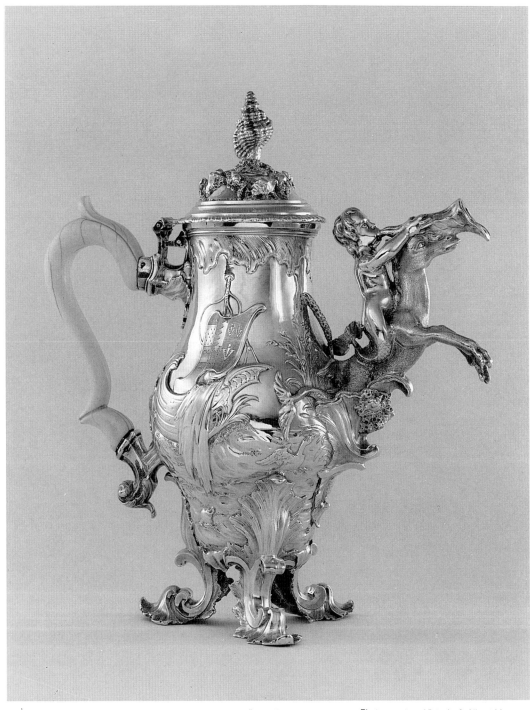

figure 5 Photo courtesy Victoria & Albert Museum

Cat. No. 29 continued

Without exaggeration de Lamerie can be considered the doyen of Rococo silver which so often displays a near obsession with nautical motifs. Other less famous but inventive goldsmiths like James Shruder (active 1737-1752), de Lamerie's probable modeller, were capable of working in this complex manner, as this magnificent tea-kettle, stand, and lamp demonstrates. Indeed, all three pieces are so heavily ornamented with oceanic elements — both natural and fantastic, animate and inanimate — that the very serviceableness of the vessel is almost disrupted. The matching and equally disquieting coffee pot was acquired by the Victoria and Albert Museum (figure 5).[95] One specialist has observed with good reason that this set is presumably Shruder's most accomplished creation.[96]

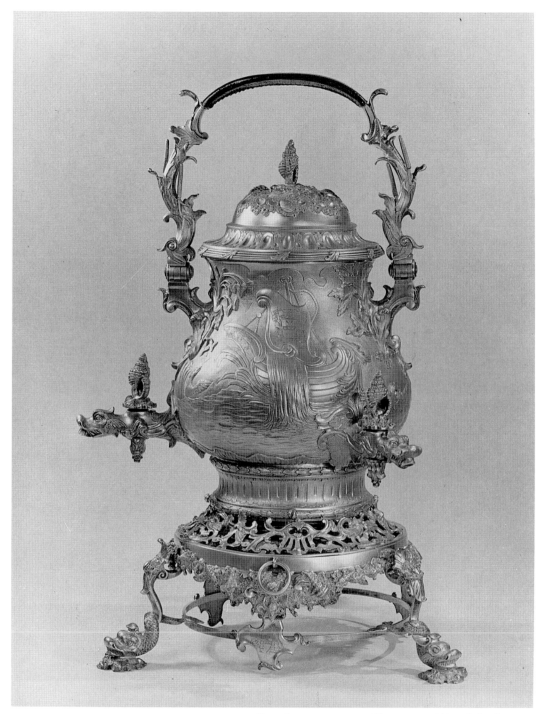

figure 6 Photo courtesy Folger Coffee Collection

In studying the coffee pot in London, Barr has traced a number of its decorative motifs — as well as through association those on this kettle — to design sources in Jacques de Lajoue's (1686-1761) *Second Livre de Cartouches* and *Recueil Nouveau De differens Cartouches*, both published in Paris in or about 1734.[97] For instance, the hippocamp spouts and the boat cartouches on the silver receptacles are borrowed from Lajou. Some of the same marine elements on the kettle also recur in identical or more developed manifestation on the hot water urn of 1752 by Shruder in the Folger Coffee Collection (figure 6).[98]

continued

Cat. No. 29 continued

A few words about the family for which these two pieces were made are in order.[99] The lineage of the Okeovers can be traced back to the twelfth century at which time their family seat was established as Okeover Hall in Staffordshire, and numerous expansion campaigns were carried out. Perhaps none was so grandiose as that initiated by Leake Okeover and his wife Mary, who employed the architects Joseph Sanderson and Simon File. The interiors contained not only fine plate, but also Old Master paintings, Flemish tapestries, English furniture, and a notable set of Chinese export porcelain with marine motifs recalling those on the two pieces of silver created by Shruder.[100]

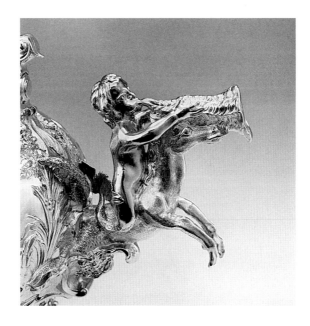

PAUL STORR

Paul Storr (1771-1844)

Paul Storr is justly remembered for his long and distinguished career that extended from 1792 until 1838. The son·of a London silver-chaser, young Storr was apprenticed about 1785 to Andrew Fogelberg. He entered his first mark with William Frisbee on May 2, 1792. This partnership soon ended, and Storr registered his first independent mark on January 12, 1793. He took up business in Fogelberg's old premises at 30 Church Street, Soho, where he worked until moving to 20 Air Street, Piccadilly, in 1796. His early work reflects the cleansed Adamesque manner of his master, but by the first years of the new century his work is evidencing new influences, such as the early historicism of his unusual candlesticks of 1800 for William Beckford. In 1801 he married Elizabeth Susanna Beyer of the pianoforte and organ building family in Compton Street, Soho, with whom he had ten children. Storr moved from his Air Street address in 1807 to head up the Dean Street manufactory of the royal goldsmiths, Rundell, Bridge & Rundell. Known· as Storr & Co., its partners included Paul Storr, Philip Rundell, John Bridge, Edmund Waller Rundell and the designer, William Theed. This productive relationship lasted until 1819. This was Rundell's great period, in which Storr played such an important part. This was the most important firm is establishing historically-derived and naturalistic styles in English silver of the early nineteenth century. Storr severed his relationship with this firm in 1819 and set up shop on Harrison Street. E. H. Bailey., Flaxman's assistant at Rundell's, became Storr's chief designer. In 1822 Storr entered into partnership with John Mortimer, and they were joined by John Hunt in 1826. Storr retired to Tooting in 1838 from what had become a very contentious relationship with Mortimer. After Mortimer's retirement in 1842, Hunt and his son took Robert Roskell of Liverpool into the firm. In these partnerships, Storr's production was prodigious and emphasized centerpieces and other display silver with lush naturalistic and rococo themes making use of extensive cast sculptural elements. Arthur Grimwade summed up his career, "In spite of small lapses, however, there is no doubt that Storr rose to the demands made upon him as the author of more fine display plate than any other English goldsmith, including Lamerie, was ever called upon to produce." (Culme, 1977; Grimwade, 1976; Honour, 1971)

Cat. No. 30

HONEY POT AND STAND

Silver-Gilt
Marks:
1. London, 2. sterling standard, 3. 1798-99,
4. 1797-98 (stand), 5. maker's mark of Paul Storr
(Grimwade, no. 2234), 6. duty stamp, fully
marked on the cover flange, the bottom of the
pot, and the underside of the tray.

Height on stand: 4½ in. (11.3 cm.)
Weight: 11 oz., 3 dwt. (321 gm.)

Provenance:
Possibly Christie's, London, 17 June 1936, lot
117.
de Havilland, Ltd., London.

Published:
Penzer, 1954, p. 261.

Description and Construction

Receptacle for the storage of honey realistically
formed as a skep bee-hive with the upper third
portion serving as a tightly fitting lid; surmounted
by a separately cast circular finial with reed-
and-tie border enframing a smooth disk
engraved on both faces with an earl's coronet;
sides of the semi-ovoid pot chased with
horizontal straw coils bound with briar strips
simulating an actual skep; flat bottom of the pot
soldered to the main component; rests on a
saucer tray with reed-and-tie outer border and
compass pinpoint on the reverse to guarantee
the · circularity of the stand; another crest
engraved on the top of the stand.

Heraldry

The disc crest is that of Ramsay, Earls of
Dalhousie.

As eye-catching as it is useful, this honey pot — ingeniously imitating a real bee-hive — is conceivably
not an original two-piece matching set. This reasoning is not conditioned by the variance in the date
letters found on each piece, since the hallmark year ran from May to May of any given year, so that
multi-component pieces carrying date letters of a one year lapse could have been assayed
together.[101] More perplexing is that the two pieces bear different armorial crests. Perhaps in this case a
previous owner owned two or more of these skeps by Storr with crests of different families, and at some
point their pots and trays were haphazardly interchanged by a servant.

Mandatory fixtures on the British breakfast table, the first known honey pots were made by Storr and
John Emes (active 1778-1808) with their subsequent production dominated by the Angells and the
Barnards. Minor differences reside in that on some the ring disk is left hollow, whereas on others one or
more naturalistically modeled bees crown the lids. On a more grandiose level the bee-hive form was
also used as the bowls of silver tea-urns and coffeepots.[102] But more akin in scale to the silver skeps
are the caneware honey pots — such as this one in the Birmingham Museum of Art (figure 7) —
manufactured by the potter-entrepreneur Josiah Wedgwood (1730-1795)[103] He, no doubt, capitalized
on the marketability of supplying inexpensive ceramic vessels of this sort for citizens unable to afford
those in costly metal.

Storr manufactured innumerable honey pots. All
seemingly date to the earliest phase in his
career from roughly 1792 to 1805 after which his
involvement with these pieces abruptly ceases.
Thanks to Grimwade, we are aware from an
entry in the Garrard Ledgers that this silversmith
supplied one or two of these hives to the firm of
Robert Garrard I (1758-1818) in 1802.[104] This
singular but documented case underscores
Storr's role as a manufacturer, whose plate was
retailed through other silversmiths' shops. In a
broader sense, it serves as a harbinger of Storr's
later affiliation as one of the chief suppliers to
Rundell, Bridge, and Rundell. As the Royal
Goldsmiths, Rundell's probably expressed no
interest in selling intriguing but rather mundane
objects of this sort.

figure 7
Photo courtesy Birmingham Museum of Art

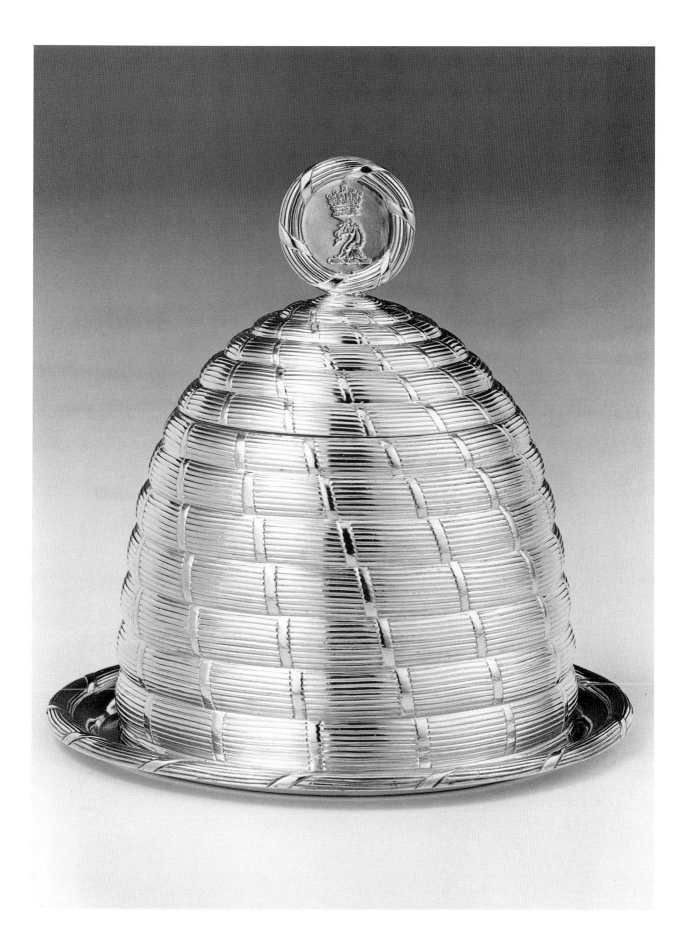

Cat. No. 31

SUGAR AND CREAMER

Silver, gilt interiors
Marks:
1. London, 2. sterling standard, 3. 1806-07,
4. maker's mark of Paul Storr (Grimwade, no.
2235), 5. duty stamp, marked on the
undersides.
Height: 3⅛ in. (8 cm.) and 3⅞ in. (10 cm.)
Weight: 9 oz., 3 dwt. (263 gm.) and 17 oz.,
8 dwt. (504 gm.)

Provenance:
Lillian and Morrie A. Moss, Memphis.

Published:
Moss, 1968, n.p.
Moss, 1972, pp. 204-205, plate 144.

Description and Construction

Circular bowls with gadrooned borders and
irregular shaped panels of fluting at the upper
sides and bottoms; each supported on three lion
paw feet cast in halves and soldered to the
bowls; cast sphinx heads wearing headdresses
in high relief and semi-circular shields with
gadrooned borders and engraved armorials
affixed to the sides above each foot; the
creamer equipped with a loop handle cast with
a beaded leaf flourish and a demi-Goddess
head in profile at the innermost edge and a
separately formed pouring spout with a sharply
angled lip; both possibly outfitted originally with
glass liners and round silver plinths.

Heraldry

The arms are those of Stracey with Brooksbank
in pretence for Edward Hardinge John Stracey
(1768-1851), who married Ann, daughter and
sole heir of William Brooksbank, The Beach,
County Chester on 17 July 1810.

figure 8

Photo courtesy Royal Collection,
Reproduced by gracious permission of Her Majesty the Queen

These eclectic pieces testify to the English silversmith's fascination with the Egyptian style, which
became popular during the early years of the nineteenth century.[105] This historicizing style received
encouragement from the publication of the works of the designer Thomas Hope (1769-1831) and
Percier and Fontaine's *Recueil de decorations intérieures*, which drew upon the archaeological
discoveries made during Napoleon's Egyptian campaign in the 1790s.[106] Equally influential were the
source books for decorative artists compiled by Charles Heathcote Tatham (1772-1842), which,
likewise, espoused interest in ancient Egyptian architectural ornament.[107]

Both fashionable and starkly ornamented, this sugar and creamer are both adorned with motifs which
appear in the designs produced by Percier and Fontaine and Tatham.[108] Their tripod design and the
sphinxes in particular are based on elements used in Egyptian art and architecture. Conversely, other
elements, for instance, the goddess's head and the lion paw feet derive from the arts of ancient Greece
and Rome, motifs employed earlier by the French goldsmith Jean-Baptiste-Claude Odiot (1763-1850).
The armorial shields simultaneously betray the influence of Medieval French enamelists. Here, these
widely diverging sources are orchestrated into a cohesive stylistic entity to form this sophisticated
tea-table ensemble.

Incalculable related pieces are known. All of them must be compared with a number of the silver items
included in the so-called "Egyptian" subsection of the "Grand Service" in the Royal Collection,
especially this salt-cellar from a set of thirty-six variously dated between 1802-1819 (figure 8).[109]
Commissioned by George III in 1803 from Rundell, Bridge and Rundell, this expansive dinner service
was manufactured in the workshops of the firm's two principal goldsmiths, Storr and Digby Scott (active
ca. 1802-1811) and Benjamin Smith II (1764-1823). It was finally purchased for use on state occasions
in 1811 by the Prince Regent, who later became George IV. All of the decorative motifs on this sugar
and creamer were first used on the pieces contributed to this major Regency service.

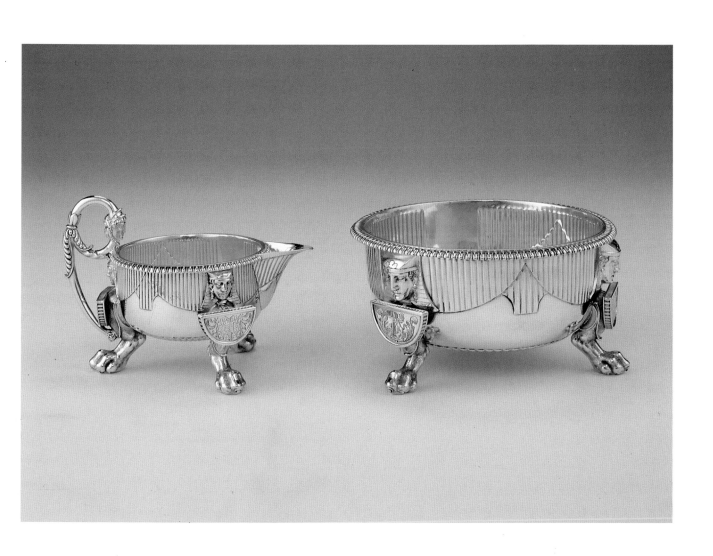

Cat. No. 32

SET OF FOUR CRUET FRAMES

Silver, parcel gilt mounts, two gilt spoons, glass
Marks:
1. London, 2. sterling standard, 3. 1806-07,
4. maker's mark of Paul Storr (Grimwade no.
2234), 5. duty stamp, fully marked on the sides
of the stands; partly marked on the handle
splats of the stands, necks and inside the lids of
the oil and vinegar ewers, sides and covers of
the mustard pots, and bottle mounts.

Length of smaller frames: 13¼ in. each (33.7
cm.)
Length of larger frames: 17¾ in. each (45 cm.)
Gross weight: 106 oz., 6 dwt. (3022 gm.), 107
oz., 5 dwt. (3047 gm.), 191 oz., 8 dwt. (5438
gm.) and 194 oz., 6 dwt. (5517 gm.)

Provenance:
Alexander, 10th Duke of Hamilton and Brandon
and by descent to His Grace the Duke of
Hamilton and Brandon.
Sotheby's, London, 20 June 1988, lot 216.

Description and Construction

Matching cruet service comprising two large
and two small frames of oval shape lifted on
couchant lion feet with pads; plain frames with
applied rims adorned with gadrooning and
shells and ovolo cartouches; looped side
handles capped with shell and acanthus grasps
spring from dual lion masks; raised central
platforms engraved with coats-of-arms and
exposed networks of foliate and shell guard
rings supported on griffon stems bolted beneath
each tray; central posts with radiating splats rise
upward with gadrooning to partly clad acanthus
and reeded ring handles; larger frames
accommodate cut-glass diamond and swirl
pattern ewers for oil and vinegar in silver mounts
with boat-shaped spouts and long thin handles,
and vase-shaped mustard pots with leaf and
ovolo edged mounts and covers encircling
crests and bud finials; smaller soy frames each
receive six mounted and tapering glass bottles
for piquant sauces with floral bud glass
stoppers, two with attached spoons;
replacements include one mustard pot mount,
two small bottles, and several stoppers.

Heraldry

The arms are those of Hamilton quartering Arran
and Douglas for Alexander, 10th Duke of
Hamilton and Brandon (1767-1854). The crests
belong to the Hamilton family.

In epochs past perishable foods — particularly meat, fowl, and fish — were not as competently
preserved as in our own day, necessitating the use of pungent or hot sauces, dressings, spices, and
liquids. By the eighteenth century it became fashionable to store these condiments in bottles set within
silver carrying frames. These two larger stands hold tall ewers for oil and vinegar along with covered
mustard pots. Their smaller associates of identical design and embellishment are generally referred to
as "soy frames" in homage to the tasty relish, which together with other exotic flavorings were imported
into England by the East India Trading Company. Some bottles on other soy frames still retain their
chained silver labels denoting they contained, for instance, soy, tarragon, kyan, chili, anchovy, catsup,
lemon, Harvey, or the Indian sauces Nepal, Mogul, and Carrache.[110]

Manufactured earlier as isolated articles, by the commencement of the nineteenth century the original
cruet frame for oil and vinegar began to be made jointly with the more recent soy frame as matching
sets. They were often of heavy weight and pronounced technical and artistic distinction. Rarely were
they issued in multiple groups of four, however, confirming that this set was destined for dining in the
grandest manner. Their armorials testify to this factor, belonging as they did to Alexander, 10th Duke of
Hamilton and Brandon, one of the most flamboyant personalities and greatest collectors of his day. His
aesthetic passions subsumed not only silver but French and Italian furniture, Old Masters, tapestries,
and Renaissance bronzes and paralleled those of his famous father-in-law William Beckford (1760-
1844), whose collections passed in part to Hamilton.[111]

The Duke was appointed Ambassador to the Court of St. Petersburg in 1806, at which time the Royal
Jewel House supplied an ambassadorial dinner service of 278 pieces of silver weighing 9513 ounces,
most but perhaps not all of which sold in 1919.[112] Each piece was engraved with the Royal armorials,
and although the present frames lack this specification, it is certainly debatable whether they were
purchased independently by Hamilton as ancillary plate for the service taken to Russia.[113] Further
support of this hypothesis is suggested in that Storr does not appear to have repeated this pattern
exactly in other frames. Several documented pieces from this service have subsequently appeared at
auction, too, including a pair of sauce tureens which share common characteristics with the present
cruets.[114]

During his Ambassadorship he is said to have fallen violently in love with Countess Polocka and to have proposed marriage. He was, however, married in 1810 to Susan Euphemia, 2nd daughter of William Beckford of Fonthill, co. Wiltshire in 1810 'one of the handsomest women of her time.' His Grace firmly believed that as a descendant of the Regent Arran, he was the true heir to the throne of Scotland, and before his death in 1852 he instructed that his embalmed body was to be buried with oriental pomp in the magnificent mausoleum which he built at Hamilton Palace.

Cat. No. 33

SET OF FOUR CANDLESTICKS

Silver, parcel-gilt
Marks:
1. London, 2. sterling standard, 3. 1808-09,
4. maker's mark of Paul Storr (Grimwade, no.
2235), 5. duty stamp, fully marked around the
ridge of each foot; partly marked on the nozzle
flanges.

Height: 14¼ in. each (36.2 cm.)
Weight: 53 oz., 3 dwt. (1511 gm.), 58 oz., 3 dwt.
(1642 gm.), 58 oz., 3 dwt. (1642 gm.) and 58 oz.,
7 dwt. (1664 gm.)

Provenance:
Sneyd Family, Keele Hall, Staffordshire.
Possibly Christie's, London, 22 or 24 June 1924.
Lillian and Morrie A. Moss, Memphis.

Published:
Moss, 1966, p. 60.
Moss, 1972, pp. 112-113, plate 52.

Description and Construction

Set of slender table candlesticks; each on a
curved, angled and lifted base cast with
triangular registers of spiralling flutes
intersected by scrolls filled with husks above
shells enframed by bands of acanthus; each
swirling trilateral stem crisply cast and chased
with scrolls engulfing three cartouches filled with
an armorial, a crest and one left vacant;
entwined cherubs sitting atop bulbous knops lift
with one hand the cylindrical nozzles fitted with
removable octagonal wax pans chased beneath
with floral and gadrooned elements; each stick
and nozzle cast in segments and assembled.

Heraldry

The coats-of-arms are those of Sneyd impaling
Bagot for Walter Sneyd (1752-1829) of Keele
Hall, Staffordshire, Sneyd, Sneyd impaling
Neville, and Neville, and the crest is that of
Sneyd.

continued

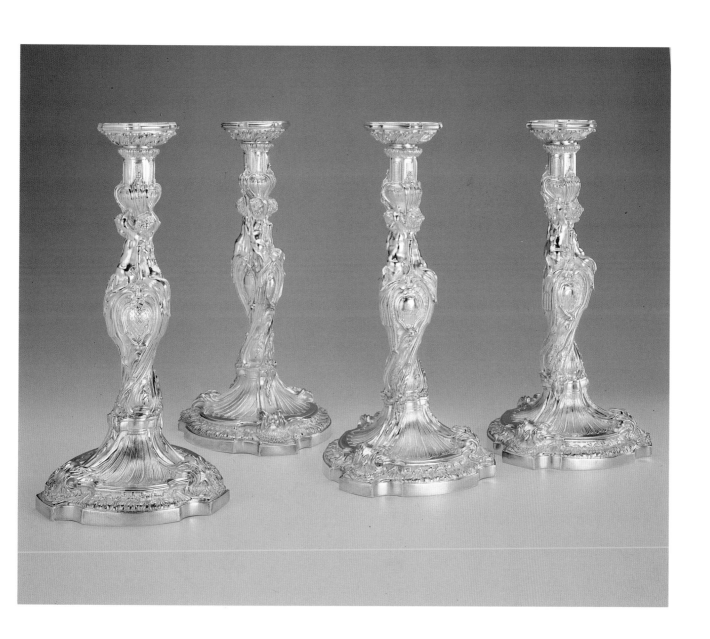

Candlesticks and candelabra with single or pairs of figures functioning as stems or supporting sockets survive from at least the seventeenth century. These apparently unique figural candlesticks were influenced by those of Juste-Auréle Meissonier (ca. 1693-1750), perhaps the most flamboyant exponent of the French Rococo style.[115] His most influential candlestick design executed from three different views was published in 1734 by Jacques-Gabriel Huquier (1694-1772) in *Oeuvre de Juste Auréle Meissonier, peintre, sculpteur, architect, et dessinateur de la Chambre et Cabinet du Roy* (figure 9).[116] This one angle alone recalls in general spirit the silver sticks under consideration here. The placid cupids upholding the sockets on the candlesticks were probably borrowed by Storr from the far more agitated ones embracing the example devised by Meissonier. Resemblances are apparent, too, in the shaped and overflowing bases, and as with the putti, the richly curving scrolls in the prints achieve a three-dimensional asymmetry absent in Storr's interpretations.

If Storr were influenced by Meissonier's designs, as seems likely, he obviously used them only for preliminary stimulation. These candlesticks are comparatively far more composed and compressed in form, instilled with a subdued frivolity, and in spite of their implied bravura and swank detailing, the overall calm results are characteristically English. In all fairness, however, it should be acknowledged that the lack of restlessness might have materialized because these candlesticks date from a still early stage in the master's oeuvre when he was only beginning to fall under the aegis of the ebullient and buoyant nature of earlier French plate.

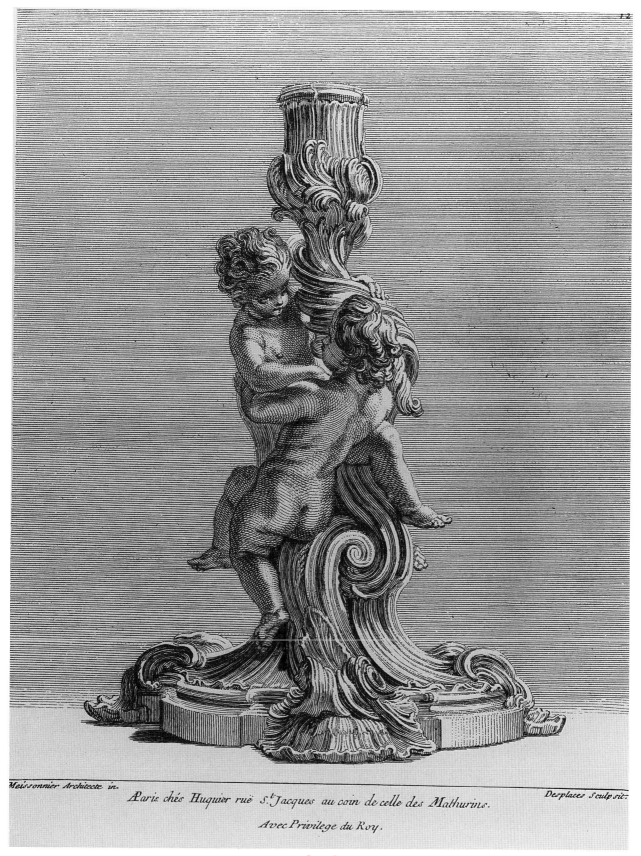

figure 9

Photo reproduced from *Pattern and Design, Designs for Decorative Arts 1480 thru 1980*, edited by S. Lambert, 1983

Cat. No. 34

EWER

Silver
Marks:
1. London, 2. sterling standard, 3. 1809-10,
4. maker's mark of Paul Storr (Grimwade, no.
2235), 5. duty stamp, marked on the bottom.

Height: 12⅞ in. (32.9 cm.)
Weight: 65 oz., 1 dwt. (1845 gm.)

Provenance:
Possibly Christie's, London, 14 July 1911, lot
157.

Published:
Penzer, 1954, p. 262.

Description and Construction

Wide bodied and curvaceous ewer; trefoil lip
with gadrooning intersected by shells and
scrolls; thick loop handle of upturned acanthus
leaves and fluting springs from the brim and
leads to a demi-goddess head wearing an eagle
head and feather headdress in full relief; raised
bulbous body with a broad repoussé band of
anthemion and lotus blossoms at the high neck
above the flaring shoulder and another register
of meandering scrolls at the bottom; main
component supported on a waisted pedestal
foot chased along the lower edge with an
encircling girdle of rope-like guilloché ornament;
parts of the handle and the bands on the body
set against matted grounds.

In order to answer the demand for silver
domestic receptacles and commemorative
trophies in the antique taste, Storr turned for
inspiration to vessels in silver, base metals, and
pottery popular in the classical world. Countless
pieces by him copy or more rarely mimic the
shape and details of the ancient askos, the
volute-krater, and the rhyton to single out just a
few. This ewer — memorable for its
complementary merger of sparse but sharp
ornament with swelling areas of plain silver — is
no exception. It is based upon the ancient
oinochoe or one-handled jug used for ladling or
pouring wine from a krater into a drinking
receptacle. One rather compelling comparison
is found in a sixth-century Greek *oinochoe*, also
of silver, at the Metropolitan Museum of Art
(figure 10).[117]

This coverless ewer was in all probability meant
for serving wine.[118] Another similar silver-gilt
one of 1815 by Storr in the Cleveland Museum of
Art is outfitted with a hinged lid.[119] In all
likelihood, it, too, was meant to function as a
wine or beer jug. The resemblance between
these two is striking, especially the handles,
both of which terminate in a female mask,
presumably cast from the same mould.

figure 10

Photo courtesy Metropolitan Museum of Art

Cat. No. 35

PAIR OF SOUP TUREENS AND COVERS

Silver
Marks:
1. London, 2. sterling standard, 3. 1810-11, 4. maker's mark of Paul Storr (Grimwade no. 2235), 5. duty stamp, fully marked on the undersides of the tureens; partly marked on the lid flanges and the finials; stamped on one of the lid flanges and on both tureen borders: 555 and 1 and 2.

Length: 17½ in. (44.7 cm.) and 17¾ in. (45 cm.)
Weight: 159 oz. (4507 gm.) and 163 oz., 6 dwt. (4638 gm.)

Provenance:
Major James Hanbury.
Christie's, London, 13 June 1967, lot 73.

Published:
Penzer, 1954, p. 273 (mentioned).

Description and Construction

Oblong and elongated pair of tureens and matching domed covers decorated with radiating areas of convex fluting offset by plain bands at the top and bottom of each vessel and at the apex of the cover; cast finial in the shape of an earl's coronet bolted into place on each lid; both receptacles supported on uplifted scroll feet springing from acanthus buttresses and ending in padded leaves; cast and reeded handles capped by acanthus foliage, stylized shells, and scrolls curving upwards from frowning twin lion-masks; matching coat-of-arms engraved twice on each tureen and crests on each cover.

Heraldry

The armorials belong to George, 9th Earl of Winchelsea and Nottingham (1752-1826).

figure 11 Photo courtesy Victoria and Albert Museum

Legend maintains that the term tureen was coined after the Vicomte de Turenne (1621-1675), Marshall of France, who reputedly used his field helmet as a tureen. In reality, the word derives from the Latin "terrenus" meaning earthen in deference to early bowls fashioned from baked clay. Silver examples were not common in England prior to the eighteenth century, the earliest maybe being one by Anthony Nelme (active 1660-1723) of 1703.[120] Once introduced, they soon became one of the most ubiquitous types of domestic tablewares throughout Britain.

Storr often reverted to this standard pattern, but he continuously reinterpreted the design in terms of the amount of fluting used and varied the number of levels on the domed lids, as well as employing other cast elements for the handles and finials. Simultaneously, he made use of the same cast handles and/or feet on several wine coolers and other vessels. Overall, the basic bodily form and especially the fluting on all of these pieces are not dissimilar to those in a drawing by Flaxman (figure 11).[121]

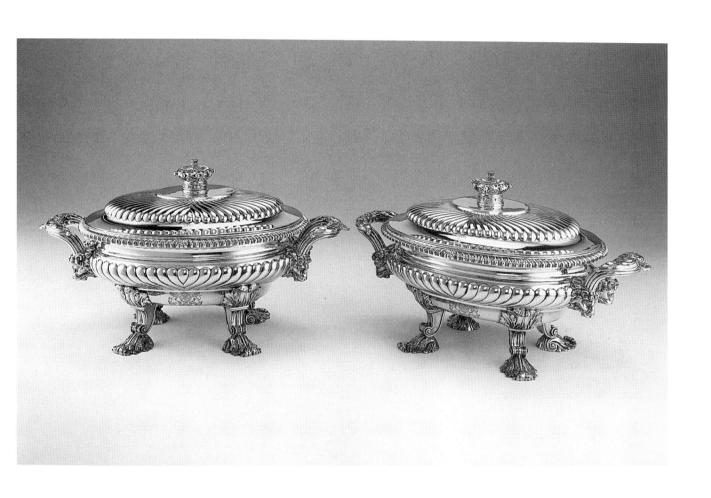

Cat. No. 36

THEOCRITUS CUP

Silver-gilt
Marks:
1. London, 2. sterling standard, 3. 1811-12,
4. 1812-13 (plinth), 5. maker's mark of Paul Storr
(Grimwade, no. 2235), 6. duty stamp, marked on
the bottom edge of the cup and the top of the
base; stamped along the bottom edge with the
Latin signature of Rundell, Bridge and Rundell:
RUNDELL BRIDGE ET RUNDELL AURIFICES
REGIS ET PRINCIPIS WALLIAE LONDINI;
engraved on the base: MADE IN LONDON A.D.
1811-12 BY PAUL STORR FOR H.R.H. PRINCE
OF WALES AND PRESENTED BY HIM TO THE
BISHOP OF WINCHESTER; stamped on the
plinth: 606(?).

Height with stand: 13 in. (33 cm.)
Weight: 143 oz., 5 dwt. (4068 gm.)
Scratch weight: 143.5

Provenance:
William Stanley Goddard, Headmaster of
Winchester College (1793-1810).
Frederick G. Morgan, 1911.
Lillian and Morrie A. Moss, Memphis.

Exhibited:
Indianapolis, Indianapolis Museum of Art, 7
February-12 March 1972. Dayton, Dayton Art
Institute, 24 March–30 April 1972.

Published:
Jones, 1911, p. 49 (mentioned).
Moss, 1968, n.p.
Wark, 1970, p. 79 (mentioned).
Moss, 1972, pp. 30, 56, 206-207, plate 145.
Indianapolis, 1972, p. 12, cat. no. 32.
Bury, 1979, p. 144 (mentioned).
Clayton, 1985a (mentioned ?).
Newman, 1987, p. 322 (mentioned).

Description and Construction

Presentation cup of Greek krater form with a
detachable square base engraved with
armorials and a later inscription; double-walled
sides of the raised bowl chased with scenes of a
maiden between two youths, and a fisherman
pulling in nets in front of a boy in a vineyard with
foxes; sides further enriched with vine branches
and grape clusters; double handles cast in the
shape of twisted, reeded, and bifurcated vine
stems springing from under the bowl and rising
to the flaring lip; rim attached with petal-boss
screws; bottom of the bowl chased with
acanthus whorls and water leaves above a short
stem merging into a spreading torus foot; vase
fits into a locating flange on top of the plinth.

Heraldry

The armorials include the feather badge and
motto of George IV as Prince of Wales, the arms
of the Bishop of Winchester, an unidentified
armorial, and a later dedicatory inscription.

The importance of the Theocritus Cup designed by John Flaxman (1755-1826) is three-fold.[122] First,
these replicated cups, together with other works, such as the Trafalgar Vases, the Shield of Achilles,
the Wellington Centerpieces, or the National Cup, rate as the most outstanding objects he designed for
the Royal Goldsmiths.[123] Secondly, they stand as significant monuments to their age, encapsulating
the loftiest aesthetic aspirations of the neo-classical movement in English silversmithing. Lastly, the
Theocritus Cup was not copied from an actual classical vase, but allowed the designer to exert his
imagination in devising the form of the cup and the layout of its lyrical scenes. Based on the Greek wine
receptacle known as a crater, the Theocritus Cup deviates from the kylix cup alluded to by the
Alexandrian poet Theocritus (ca. 300-260 B.C.). Yet Flaxman follows closely the pertinent text relating
the bucolic tale of a young goatherd who gave a cup to the shepherd Thyrsis in exchange for singing
his beloved song about Daphnis. Penzer quotes from Gow's translation:[124]

> "And I will give thee a deep cup, . . . Along the lips above trails ivy . . . And within is wrought
> a woman . . . And by her two men . . . By these is carved an old fisherman . . . [who] eagerly
> gathers up a great net . . . And a little way . . . is a vineyard . . . guarded by a little boy . . .
> About him hang two foxes, and one goes to and fro . . . plundering the ripe grapes, while
> the other brings all her wit to bear upon his wallet . . . But the boy . . . has more joy to his
> plaiting than care for wallet or for vines. And every way about the cup is spread the pliant
> acanthus."

continued

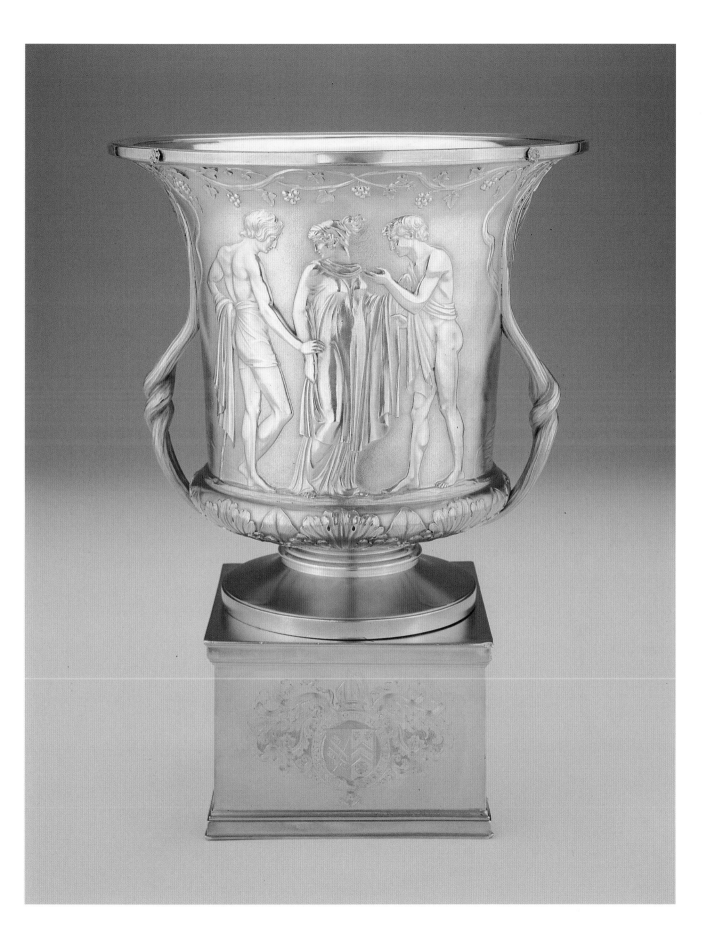

That Flaxman was responsible for the design is confirmed by a number of drawings by him, both preparatory and finished.[125] The two most complete ones include one showing the maiden flanked by suitors, and the other depicting the alternate side with the figures of the fisherman and the lad.[126]

The most famous version in silver of 1812 by Storr is in the Royal Collection.[127] It was presented by Queen Charlotte to George IV when he was Prince of Wales and her cipher and his badge appear on the cup, whereas the current one bears the badge of the Prince, the arms of the Bishop of Winchester, as well as a later inscription denoting that it was given by the Prince to the Bishop. The monarchy's centuries-long ties with Winchester are well documented. As Macquoid wrote:[128]

> "As Winchester was at one time the capital of England, many Kings made it their chief seat of residence . . . and it was no doubt from this traditional importance that reigning sovereigns . . . continually paid visits to the college."

The institution referred to is Winchester College founded in 1382. One of England's most respected public schools, it is also the repository of a small but distinguished collection of historic silver.[129] Winchester's Headmaster, William Stanley Goddard (died 1845), at some point came into possession of this cup, as Jones initially established.[130] It seems reasonable to suspect that it was acquired by him from one of the Bishop's descendents, remaining in Winchester until it passed to Frederick G. Morgan.

Storr executed two other variations on the Theocritus cup decorated with different scenes.[131] Examples in the original pattern continued to be manufactured after the dissolution of Rundell's in 1843, suggesting that the initial casting moulds or copies from them were available. Garrard's issued a number of these including a pair today in a private collection.[132] Like the other two discussed above, they, too, were made for the Crown. Queen Victoria presented them to the winner of the Royal Yacht Squadron in 1879.

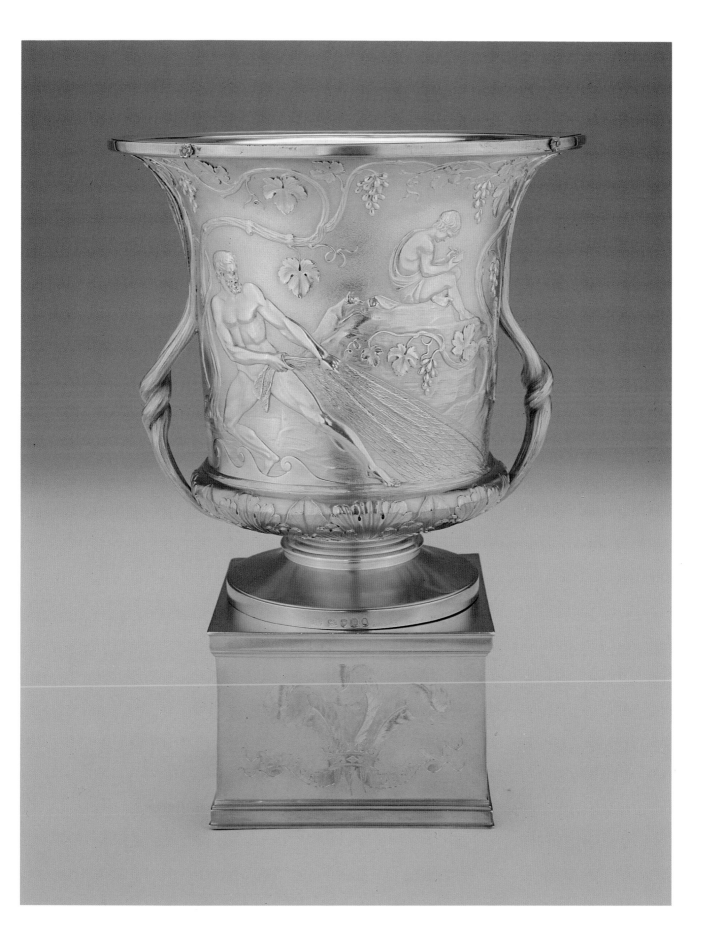

Cat. No. 37

THREE SALT CELLARS

Silver, gilt bowls
Marks:1. London, 2. sterling standard, 3. 1811-12, 4. maker's mark of Paul Storr (Grimwade, no. 2235), 4. duty stamp, fully marked on the upper sides of the shells; partly marked on the edges of the bases; stamped on the bottoms: 2, 5, 8.

Height: 4 in. each (10.1 cm.)
Weight: 20 oz., 5 dwt. (581 gm.), 20 oz., 5 dwt. (581 gm.) and 20 oz., 9 dwt. (592 gm.)

Provenance:
Possibly Sotheby's, London, 19 June, 1969, lot 175.

Description and Construction

Longitudinal figural salts assuming the form of youthful nude tritons swimming forward and floating along nautilus shells with gilded interiors; each individually cast merman grasps the edge of the shell with his hands and balances it on two tails chased with scalework; each salt uplifted on jagged-edged, oval shaped bases of cresting waves and floating algae; the figures, shells, and bases all cast in sections from separate moulds and joined together with solder; the tritons secured into position with two bolts passing through the bases.

One of the privileges enjoyed by Rundells as the holders of the Royal warrant was access to the plate held in trust in the Royal Collection. Certainly the marine pieces of the Rococo period kept there — like the Poseidon Centerpiece of 1741 probably by Nicholas Sprimont (1716-1771), and his related shell-shaped sauceboats of 1743 — would have instantly captured the fancy of all concerned. This exposure prompted the firm to embark on a campaign of creating a wide range of pieces evolving around nautical subjects.

Because these sculptural salts were manufactured solely by casting, the speedy production of multiple copies from the same patterns was possible. The general conception was, however, also altered in a model mounted on a base of rockwork with the mermen pulling a densely rippled shell.[133] Still another type by Storr is one in which two tritons, one blowing a shell and the other carrying a wreath, kneel on either side of the shell.[134] An apparently unique pair of 1840 by Storr's successors, John Mortimer and John S. Hunt (died 1865), develops the theme even further, substituting mermaids in lieu of mermen.[135]

It has been established that all of these salts are based on the large bronze sculpture *Thetis Returning from Vulcan with Arms for Achilles* of 1812 in the Royal Collection by William Theed (1764-1817), who was employed by Rundell, Bridge and Rundell as a silver designer between 1804 and 1817.[136] On this basis it is generally accepted that he was responsible for designing the salts, an attribution reinforced by a sketch contained in an album of designs executed by a number of designers retained by Rundell's.[137] The one referred to is conceivably from the hand of Edward Hodges Baily (1788-1867) after Theed (figure 12).[138]

The three presented here were possibly originally part of a set of eight as this numeral is stamped underneath one. Chronologically, they had to have been executed at the outset immediately after Theed's bronze sculpture, and many falling within this category actually pre-date the unveiling of the monumental sculpture, suggesting that the salts were already in production before or while work was underway on the bronze.

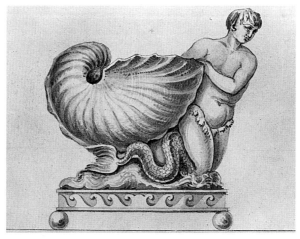

figure 12 Photo courtesy Victoria and Albert Museum

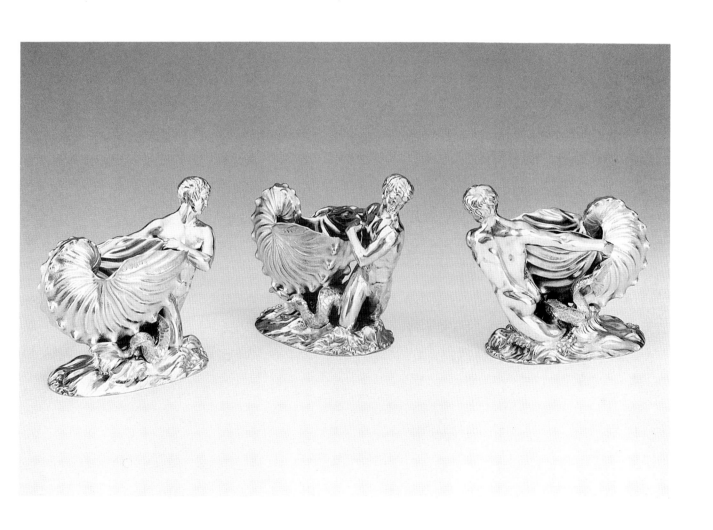

Cat. No. 38

A SET OF FOUR SALT CELLARS

Silver-gilt
Marks:
1. London, 2. sterling standard, 3. 1813-14, 4. maker's mark of Paul Storr (Grimwade, no. 2235), 5. duty stamp, fully marked at the top edges of the bowls; partly marked on the rocaille mounds, underneath the bases, on the bolts, and on the reverses of the liners; stamped on two edges of each base with the Latin signature of Rundell, Bridge and Rundell: RUNDELL BRIDGE ET RUNDELL AURIFICES REGIS ET PRINCIPIS WALLIAE REGENTIS BRITANNIAS; stamped under each base and liner: 1, 2, 3, 4.

Height: 5⅛ in. each (13.1 cm.)
Weight: 37 oz., 7 dwt. (1068 gm.), 39 oz., 1 dwt. (1108 gm.), 39 oz., 1 dwt. (1108 gm.), and 41 oz., (1162 gm.)
Scratch weight: 42-3 on two pieces.

Description and Construction

Large salt-cellars supported on rectangular plinths formed from five sheets chased in low relief with repeating wave ornament above four cast ball feet; raised liners of irregular contour freely removable from the cast scallop shell bowls enlivened with fluting and striations; stems composed of two mermen with outstretched arms and twin-tails strenuously upholding the deep wells; mermen float atop cast rocaille domed mounds chased with stylized waves, small shells, and seaweed; except for the liners and bases the other elements are cast and assembled together; salts bolted to the stands underneath; crest engraved on the bottom of each base and liner.

Heraldry

The crest is untraced.

These salt cellars represent a more vigorous and three-dimensional extrapolation on the frontally disposed salts catalogued in the previous entry. Again, a preliminary sketch of an identical salt exists on the same sheet mentioned above, and a favorable affinity with the bronze sculpture by Theed can be detected (figures 13).[139] It seems only reasonable to assume once more that the sketch in the Rundell Design Book was drawn by Baily repeating a design introduced by Theed, and that the latter was ultimately responsible for planning the salts.

continued

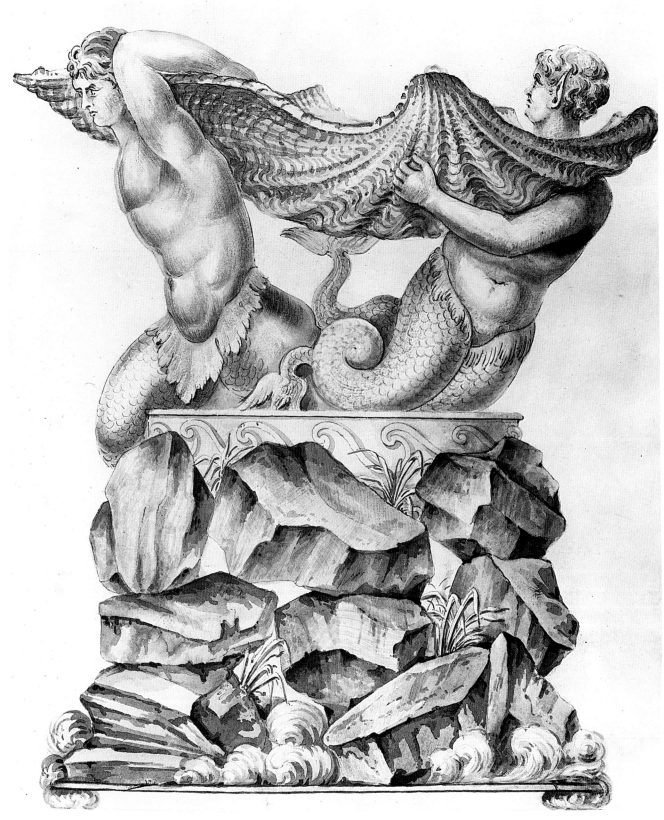

figure 13 Photo courtesy Victoria and Albert Museum

figure 14 Photo courtesy Victoria and Albert Museum

Cat No. 38 continued

Storr and others followed the design passed on to them, but occasionally the basic pattern was changed. Almost all of the examples by Storr are supported on a rocaille base, and the best of these are raised on square plinths. Simultaneously, he produced a rarer variant in which the tritons kneel on a base of piled rockwork. Indeed, Oman publishes a large dessert stand of 1812 by Storr mounted atop a base of 1820 by Philip Rundell (1743-1827) from a set in the Royal Collection alongside yet another of the sketches from the Rundell Folio (figures 14).[140]

After Storr's departure in 1819, Rundells was naturally not dissuaded from continuing to use the design, as the crowning dish of a quite curious centerpiece of 1823 bearing the mark of Rundell testifies.[141] Yet Mortimer and Hunt also prospered in producing plate with motifs recalling these earlier salt-cellars as observable in their Caviar Pail of 1841.[142]

Cat. No. 39

TEA URN

Silver, ivory
Marks:
1. London, 2. sterling silver, 3. 1814-15, 4. maker's mark of Paul Storr (Grimwade, no. 2235), 5. duty stamp, fully marked on the bottom of the bowl; partly marked underneath the base, the bolts, the cover of the burner, inside the bottom of the spirit lamp, on the arches of the tap, the lid flange, and the finial surround.

Height: 13⅝ in. (34.5 .cm.)
Gross weight: 201 oz., 4 dwt. (5709 gm.)
Scratch weight: 202

Provenance:
Lillian and Morrie A. Moss, Memphis.

Published:
Moss, 1966, p. 17.
Moss, 1972, pp. 190-91, plate 130.

Description and Construction

Hemispherical-shaped body raised in two sections; flat upper platform encircled by a wreath of myrtle leaves and berries partly overlapped by an elevated cover surmounted by a coiled snake finial resting on a bed of foliage and grapes; finial cast and bolted to the removable lid; gadrooned rim and a register of key pattern between minute beading dominates the center of the semi-circular bowl; three cast winged sphinxes on lion-paw feet support the urn on a stand raised in sections with encircling plain and egg-and-dart bands; entire structure lifted on cast winged paw feet; petal boss swing handle tap with a turned ivory grasp and short fluted pouring spout emerge from a horizontal spigot of wrapped leaves and berries soldered to the bottom; shallow lamp of vase form and sphinxes bolted to the stand.

Initially tea urns were used for dispensing boiling water and only later were they employed for discharging brewed tea. In order that the tea be kept hot, these cumbersome receptacles were outfitted with a heating device, and a tap and spigot so they need not be tilted to start the flow of the beverage. Urns took many forms including pear, globular, or vase-shaped ones, and equally diverse were their stylistic character.

continued

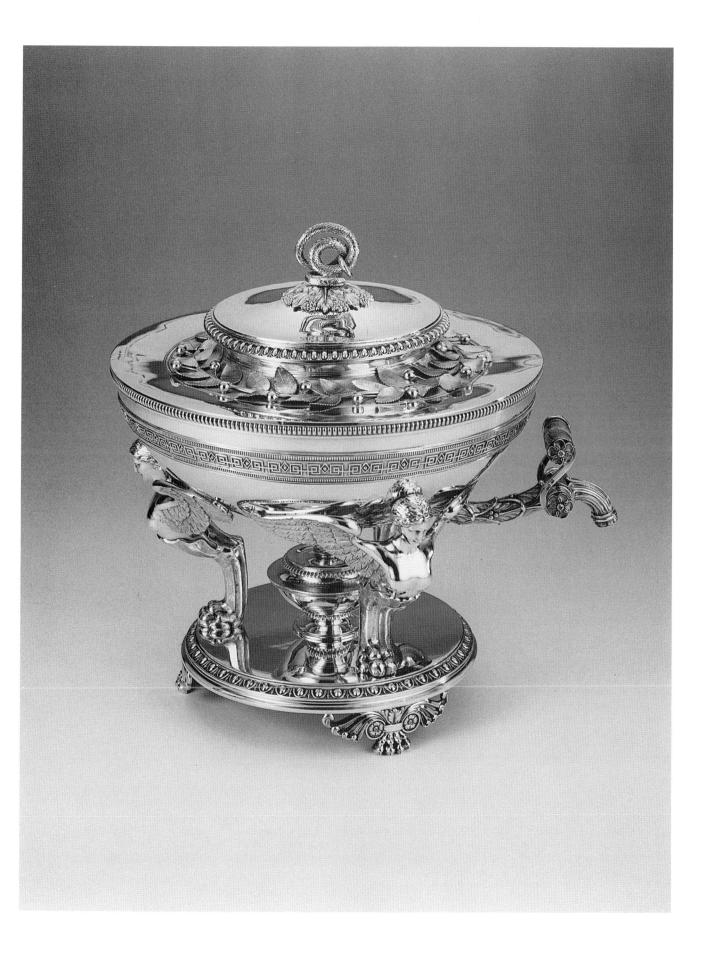

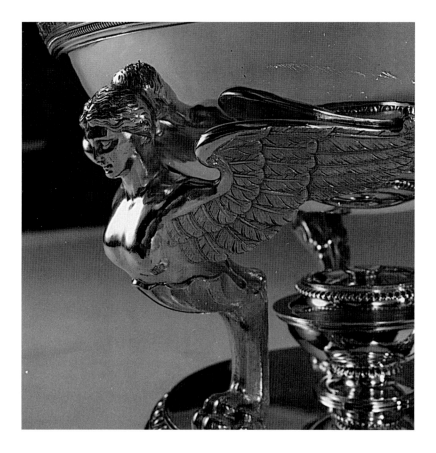

Cat. No. 39 continued

This posh example is carried out in the "Graeco-Roman" style which experienced widespread notoriety at the turn of the century. Pieces of this kind succeed in mixing a purity of form with precisely cast ornamental features of highly imaginative demeanor. Here, classical Greek motifs like key pattern and egg-and-dart bands or the encircling wreath of myrtle and berries below the cover mingle inconspicuously with sphinx supports and a coiling snake finial of ancient Egyptian inspiration.

Inasmuch as his plate is often compared to that of his co-suppliers for Rundell's, Digby Scott and Benjamin Smith II, a number of earlier urns in this style are known by them, yet Storr seldom produced tea urns in this grand and cosmopolitan manner. Whereas the series by Scott and Smith collectively reveal the reusage of the same casting components, the elements on the urn by Storr were obviously not cast from their moulds, however the basic forms and decorative embellishments share common characteristics. In addition, all of the recorded ones by Scott and Smith are gilded in opposition to the plain silver example catalogued here.

Others have acknowledged that a number of sketches by Boileau resemble the urns made by Scott and Smith with the result that the general consensus upholds that he was most likely responsible for their design.[143] This urn by Storr is no exception as two previously unpublished designs by Boileau, both for tea-urns, are generally compatible (figures 15).[144] Surprisingly, it seems to have gone unnoticed, however, that the sphinxes on these creations are of a sort which likewise appear in the designs of Percier and Fontaine, and Young has pointed out that they are also found in the work of Tatham.[145]

figure 15 Photo courtesy Victoria and Albert Museum

Cat. No. 40

ASSEMBLED SET OF TWO PAIRS OF CANDLESTICKS

Silver-gilt
Marks:
1. London, 2. sterling standard, 3. 1814-15, 4. maker's mark of Paul Storr (Grimwade, no. 2235), 5. duty stamp, fully marked along the edges of the bases; partly marked on the wax pans; inscribed on the bases of two: FROM THE DUKE OF CAMBRIDGE'S COLLECTION; stamped around the bases with the Latin signature of Rundell, Bridge and Rundell: RUNDELL BRIDGE ET RUNDELL AURIFICES REGIS ET PRINCIPIS WALLIAE REGENTIS BRITANNIAS; stamped on the wax pans: 4, 6, 7, and 11.

Height: 9⅛ in. each (23.2 cm.)
Weight: 28 oz., 2 dwt. for two (799 gm.) and 28 oz., 7 dwt. for two (813 gm.)

Provenance:
Duke of Cambridge.
Christie's, London, 6 June 1904, lot 202 (two only).
Mary S. Harkness, Waterford, Conn. and New York.
Sotheby Parke Bernet, New York, 17-20 January 1951, lot 565 (two only).
Arthur D'Espies, Short Hills, New Jersey (two only).
Sotheby Parke Bernet, New York, 12-13 April 1977, lot 234 (two only).

Published:
Penzer, 1954, p. 248 (mentions only the two from the Duke of Cambridge's Collection).

Description and Construction

Two pairs of affiliated candlesticks of baluster-shape with fluted nozzles and removable wax pans; cast tapering stems of quadrangular form with imbricated pendant husks, beads, and quatrefoils between compressed knops; upwardly fluted and spreading valance above irregularly contoured bases inundated with Rococo shells and seasonal deity masks; masks engulfed by seasonal attributes including water for Neptune (Winter), flowers for Flora (Spring), fruit for Pomona (Summer) and grapes for Bacchus (Autumn); bases cast in sections with matted grounds.

Impeccably finished and richly gilded Regency candlesticks of this sort were zealously embraced by some of this goldsmith's most notable clients. At least two of the present sticks formerly belonged to the Duke of Cambridge as their inscriptions substantiate, whereas the other pair of the same date and identical pattern must have joined them at a later time. Others of the same design were once in the possession of the Duke of Cumberland (1771-1851), the fifth son of George III, the Earl of Lonsdale (1757-1844) and Viscount Lismore. These discerning patrons would naturally have been drawn to these static candlesticks of sturdy proportions with a munificent interplay of ornament revived from styles as diverse as the Baroque, Adam, Rococo, and French Régence.

Indeed, Hayward, in discussing one example by Storr claims it "might well have been made by Paul de Lamerie."[146] Although he does not refer to a specific antecedent, the overall proportions, spherical knops, and tapering stems do bring to mind a pair of 1745 by de Lamerie at the Metropolitan Museum of Art.[147] As suggested elsewhere, too, the square bases with allegorical heads and shells find parallels in a number of other Rococo candlesticks by different silversmiths.[148] Grimwade cited the most convincing precedent as a pair of 1747 by Paul Crespin (1694-1770) in the collection of the Duke of Bedford at Woburn Abbey with good reason since Storr probably used them as the model for a pair of candelabra of 1807 also still at that location.[149]

Cat. No. 41

INKSTAND

Silver, glass
Marks:
1. London, 2. sterling standard, 3. 1814-15,
4. maker's mark of Paul Storr (Grimwade, no.
2235), 5. duty stamp, fully marked on the bottom
of the tray; partly marked on the sides of the
bottle and wafer frames, the taperstick flange,
the ink and pounce pot lids, and the mount of
one of the glass receptacles; nozzle and
extinguisher both unmarked.

Length: in. (34.8 cm.)
Gross Weight: 60 oz., 4 dwt. (1712 gm.)

Provenance:
Lillian and Morrie A. Moss, Memphis.

Published:
Moss, 1966, p. 70.
Moss, 1972, pp. 144-145, plate 83.

Description and Construction

Substantial inkstand of oval shape with raised
and fluted center and recessed pen
depressions soldered onto the tray; central bank
with two square bottle frames with applied
palmette and quatrefoil appliques flanking a
similar circular wafer tray compartment; round
taperstick with gadrooned rim, baluster socket,
removable nozzle and a chained conical
extinguisher; cut-glass inkwell and pounce pot
of diamond pattern with detachable pierced
covers and gadrooned and shell borders;
frames with grooved tongues fit into slots on the
tray secured by two locking pins running along
the bottom; raised tray applied with a cast
border of wavy gadrooned edges with
protruding clusters of shells amidst foliage;
uplifted on four winged-paw feet soldered
underneath; one glass container a later
substitute.

Heavy inkstands of this sort reflect the nineteenth-century silversmiths' fondness for massive plate,
even when such pieces were destined to serve as mere desk ornaments in a study. Contemporary
pictorial representations — be they paintings or prints — showing different kinds of plate often disclose
vital information as to how or when a particular type of piece was used or made. An almost exact one is
placed on the desk in an old sketch illustrating the interior of the library at Abbotsford, Roxburghshire,
the home of the Scottish writer Sir Walter Scott (1771-1832).[150]

This one — alluring for its ample proportions and balanced interplay of differing component elements
— is by no means unique but rather can be classified as but one example of a highly favored type
made in both sterling and Sheffield plate. A vast number of these following the same overall format but
with liberal differences in detailing were manufactured in Storr's workshop and retailed through
Rundell's. The fullsome winged paw feet on this inkstand are a recurring feature in the silver designs
carried out by Boileau.[151] While Boileau might be credited for the initial design of this element, it was
quickly absorbed as part of the common ornamental vocabulary of other silversmiths, for instance John
Angell (active ca. 1825-31) and William Elliott (active ca. 1787-1853/55), both of London, and John and
Thomas Settle of Sheffield.

Cat. No. 42

A SET OF FOUR SALT-CELLARS AND SPOONS

Silver-gilt
Marks:
1. London, 2. sterling standard, 3. 1815-16, 4. 1812-13 (spoons), 5. maker's mark of Paul Storr (Grimwade, no. 2235), 6. duty stamp, fully marked on the bottoms of the salts; partly marked on the undersides of the liners and on the bottoms of the spoons; stamped on the undersides of the salts and the liners: 390.

Height of salt-cellars: 2⅜ in. each (6 cm.)
Length of spoons: 4¼ in. each (10.8 cm.)
Weight: 53 oz., 7 dwt. (1522 gm.)

Provenance:
Christie's, London, 9 January 1946, lot 82.
Francis Stonor, Esq., Stonor Park.
Lord Camoys.
Christie's, London, 21 March 1979, lot 25.

Published:
Penzer, 1954, pp. 194-195, 264, plate 58.
Ramsey, 1960, pp. 212, 217 (mentioned).
Christie's Review of the Season, 1979, p. 282.
Clayton, 1985b, p. 272.
Virginia Museum of Fine Arts Bulletin, vol. 48, no. 4, March/April 1988, p. 1.

Description and Construction

Each semi-circular receptacle partly fluted on the bottom of the bowl; removable double flange wells headed by borders of egg-and-dart ornament; rising double handles and feet cast in the form of intertwined and realistically modeled serpents with chased coils trailing along the rims; crest engraved on the flat front surface of each bowl; four earlier spoons in the fiddle, thread and shell pattern; different crest and motto engraved on the curving spoon stems; bowls and liners raised and gadrooned with the openwork serpent supports soldered to them.

Heraldry

The crest and motto on the spoons is that of Molesworth.

Stylistically, the salts are stunning yet representative examples of the bodacious period in the history of English silversmithing today generally termed "Graeco-Roman," but one which actually employed the use of motifs of both ancient Greek and Roman and Egyptian derivation. The controlling practitioners of this historicizing mode were the Royal Goldsmiths, who offered innumerable items of contrasting type in this manner. This was never an exclusively national fashion, however, but one of international scope, finding parallels in French silver of the Empire Period, as exemplified by the work of the Parisian goldsmith Henri Auguste (1759-1816).

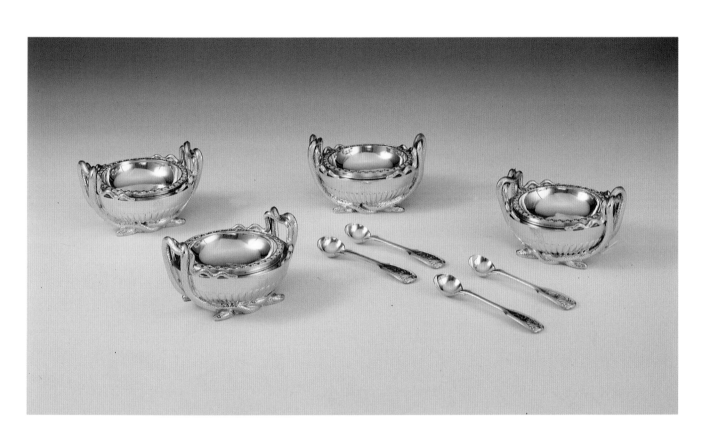

Cat. No. 43

EGG-CUP FRAME

Silver, cups gilded inside
Marks:
1. London, 2. sterling standard, 3. 1815-16, 4. maker's mark of Paul Storr (Grimwade, no. 2235), 5. duty stamp, fully marked beneath the tray and around the top of each cup; partly marked on the railing; stamped on the bottom of the frame: 432.
Length: 9½ in. (24 cm.)
Weight: 39 oz., 1 dwt. (2788 gm.)
Scratch weight: 39 oz.

Provenance:
Possibly Christie's, London, 12 November 1952, lot 142.

Published:
Penzer, 1954, p. 279 (mentioned).

Description and Construction

Oblong shaped frame with a gadroon, foliate, and shell border and a stepped and recessed upper platform with incurved sides; stand rests on four cast voluted acanthus and anthemion feet; slender pilasters at the corners with guilloche and lion masks joined to a gadrooned railing with guard-rings for suspension of six cups and slots for spoons; railing screwed to the platform; central pillar with acanthus and palm foliage surrounds a partly lobed shaft surmounted by a reeded ring handle; egg cups with cast stemmed bases and raised bowls with gadroon and shell lips; gilt interiors to prevent staining from egg-yolk; crests engraved on the tray and cups.

Heraldry

The crest and motto is that of Herbert, Llanarth, County Monmouth.

Commencing in the eighteenth century, boiled eggs were transported to the breakfast table in an egg-cup frame. The earliest known example of 1740 was created for George Booth, 2nd Earl of Warrington (1675-1758), much of whose plate still remains at Dunham Massey in Cheshire.[152] Gradually, egg-cup frames were carried out in a variety of styles and forms by an equally abundant number of goldsmiths not all of whom were centered in the capital. Rival silversmiths of Sheffield and Birmingham aggressively competed on the open market, and Hughes has calculated that one provincial firm offered sixty-four patterns between 1790 and 1825.[153]

Storr's egg-cup frames conform to related patterns and cast elements such as handles, mouldings, and feet are continuously reused. They can be classified according to their shape with most being oblong, but oval, lozenge, trefoil and triangular ones are recorded. A preliminary census of published examples suggests that aside from this one only six — either as sets of two or more commonly as individual units — bear his mark. They fall within the few years from 1810 to 1813 during which he was employed by Rundells, but three later versions of oblong or circular form from the 1820s indicate he continued their production after he left the firm.

The current example is evidently the latest surviving one this silversmith produced while employed by the Royal Goldsmiths. Comparison with an oblong version of three years earlier illustrates both the uniformity and divergency of the same type.[154] The earlier one uses a basket-weave frame of more tightly condensed proportions, so that the cups are not exposed within an openwork frame as in the later example. Egg-frames of this general format were also manufactured by the firm of Emes and Barnard (active 1808-1825) as one of 1810 demonstrates.[155]

Cat. No. 44

A SET OF FOUR WINE COASTERS

Silver, wood, baize
Marks:
1. London, 2. sterling standard, 3. 1815-16, 4. maker's mark of Paul Storr (Grimwade, no. 2235), 5. duty stamp, fully marked along the exterior lower rims; partly marked on the flat interiors; stamped with the Latin signature of Rundell, Bridge and Rundell on the outside lower edges: RUNDELL BRIDGE ET RUNDELL AURIFICES REGIS ET PRINCIPIS WALLIAE REGENTIS BRITANNIAS.

Height: 3 in. each (7.5 cm.)
Gross weight: 83 oz., 4 dwt. (2364 gm.)

Provenance:
14th Earl of Strathmore, Glamis Castle.
Catchpole and Williams, London (ca. 1921).
Henry G. Brengle, Philadelphia.
The Fly Club, Harvard University (de-accessioned).
Sold Sotheby Parke Bernet, New York, 4-5 December 1974, lot 434.

Description and Construction

Circular wine bottle coasters with acanthus leaf and reed-and-tie borders at the bottom and top; sides pierced with rotating sleeves of densely interwoven grape clusters and vine leaves and tendrils brilliantly chased on matted grounds; each supported on a turned wooden base; one retains its original baize-covered slide grip affixed to the bottom; a large coat-of-arms engraved in the deep center recess of each; the sides and borders cast and assembled together with solder.

Heraldry

The coat-of-arms is that of Bowes.

Clayton wrote perceptively about this kind of wine bottle coaster in stating:

> "The finest, and heaviest [wine coasters], often of openwork with applied vine foliage, are usually the handiwork of Digby Scott and Benjamin Smith or Paul Storr and date from the opening years of the nineteenth century."

This design was tremendously popular, a determination proven by the large quantity of surviving examples, most but not all of which are gilded. Some were part of ambassadorial services, but others were created for more general consumption and sold over the counter to casual buyers. They were issued in multiple sets of two — usually totalling six or eight — and each incorporates attributes associated with Bacchus, God of Wine, and wine consumption. The pattern was first used by Storr in about 1814, and he continuously utilized it for a number of years thereafter. On the other hand, Scott and Smith evidently first made use of the design at least as early as 1805.[156]

Variations on the general pattern are discernible. The present set belongs to the most simple group in which the pierced gallery employs only bunches of grapes and vine foliage. Others, such as one of silver-gilt of 1810 — part of the service made for the Duke of Wellington in his role as Ambassador to the Court of Louis 18th — are more complex in design due to the addition of bacchanalian putti and leopards.[157] This sort of coaster was held in such high regard that it was reproduced by George Richmond Collis of Birmingham as late as about 1842 directly from original molds he acquired after the dissolution of Rundell's.[158]

Cat. No. 45

SET OF FOUR SUGAR AND CREAM VASES, COVERS, SIFTERS, AND LADLES

Silver-gilt, glass
Marks:
1. London, 2. sterling standard, 3. 1816-17, 4. 1817-18 (sifters and ladles), 5. maker's mark of Paul Storr (Grimwade, no. 2235), 6. duty stamp, fully marked on the bodies of the vases; partly marked on the cone finials, the screws, the lid flanges, and the back of the stems of the sifters and ladles; stamped on both components of each finial: 2, 4, 5, 8.

Height of vases: 8½ in. each (21.6 cm.)
Length of sifters and ladles: 5½ in. each (14 cm.)
Weight without liners: 130 oz., 3 dwt. (3694 gm.)

Provenance:
Christie's, London, 10 July 1935, lot 68.
Lillian and Morrie A. Moss, Memphis.

Exhibited:
Indianapolis, Indianapolis Museum of Art, 7 February–12 March 1972.
Dayton, Dayton Art Institute, 24 March–30 April 1972.

Published:
Penzer, 1954, p. 26.
Moss, 1966, p. 67.
Moss, 1972, pp. 28, 192-93, plate 132.
Indianapolis, 1972, p. 15, cat. no. 49.

Description and Construction

Four covered receptacles of classical urn form each with cast and reeded loop handles; incurved necks embossed with husks and palmettes; bodies taken up with broad bands of intertwined and foliated acanthus scrolls against granulated grounds with vertical fluting below; plain stems headed by beaded collars expand to circular bases with lanceolate and anthemia leaves enclosed by a guilloché register; each rests on voluted bracket feet with grape vines centered by shells; removable domed lids with lobing enframing calyxes of floral buds, leaves, and berries surmounted by two-piece acorn finials fastened with screws; cut-glass liners slip into the hollow bowls; two perforated sifters and two hour-glass ladles of fiddle shape with shells and scrolls; crests with coronets engraved on the vases and the sifters and ladles; one liner replaced.

Heraldry

The crest is that of Howard, Dukes of Norfolk and Earls of Arundel, Surrey, Norfolk and Norwich.

Top-ranking Regency sugar and cream vases were marketed exclusively by the Royal silversmiths. Supplied with protective glass sleeves and sifters and ladles for sprinkling sugar or pouring cream over desserts, the original set of 1805 was carried out by Smith and Scott. The most well-known are a set made at a cost of £376 4s. for George IV when he was Prince of Wales in the Royal Collection, four formerly owned by the 6th Marquess of Ormonde (died 1971), and one of 1810 in the Wellington Museum, Apsley House. All are of silver-gilt in the same standard pattern, although some changes occur in the cast details, as an early example of 1805 by Smith and Scott with handles formed as cornucopias and bun feet illustrates.[159]

continued

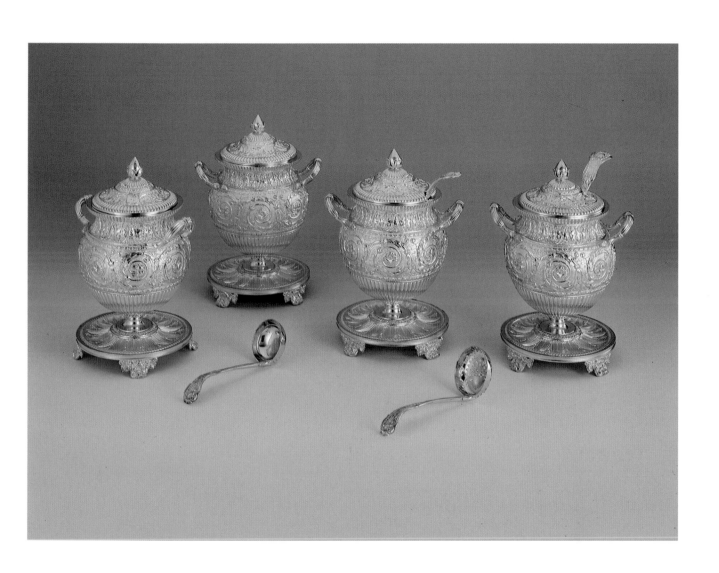

Cat. No. 45 continued

Storr began to utilize the design later because he joined the firm some five years after Smith and Scott. His are, therefore, less frequent and reveal characteristic innovations of their subsequent date of manufacture. His initial venture into this domain came about in 1814 when he included four in the silver-gilt dessert service of over fifty pieces executed between 1806 and 1816 for Edward Lascelles, 1st Earl of Harewood (1739-1820). This celebrated service was showcased at the Regency Exhibition at the Brighton Pavilion in 1951 where it was laid out on a table to emulate the banquet hosted by George IV depicted in John Nash's *Views of the Royal Pavilion*.[160] The Harewood Plate was subsequently sold, and Moss erroneously believed that the four catalogued here were part of that service.[161]

The origin of the design of these vases has been much debated. Their basic shape, silhouette, and use of complex surface ornamentation derive from an ancient Roman marble funerary urn once in the collection of William, 1st Marquess of Lansdowne and 2nd Earl of Shelbourne (1737-1805) and today in private hands (figure 16). Udy wrote of its correlation with the silver vases in proclaiming:[162]

> "It was, therefore, a very happy solution to this enigma to discover a stone urn and cover from Lord Lansdowne's Collection which is evidently the source of its design and, in addition, because it also establishes that the silversmith and his designer did see the possibilities of exploring design sources beyond those found within the covers of a folio of engravings."

Lansdowne's vase was known to Flaxman, who reproduced it with modifications on the top of the Monument to Sir Thomas Burrell of 1796 in West Grinstead Church, Sussex.

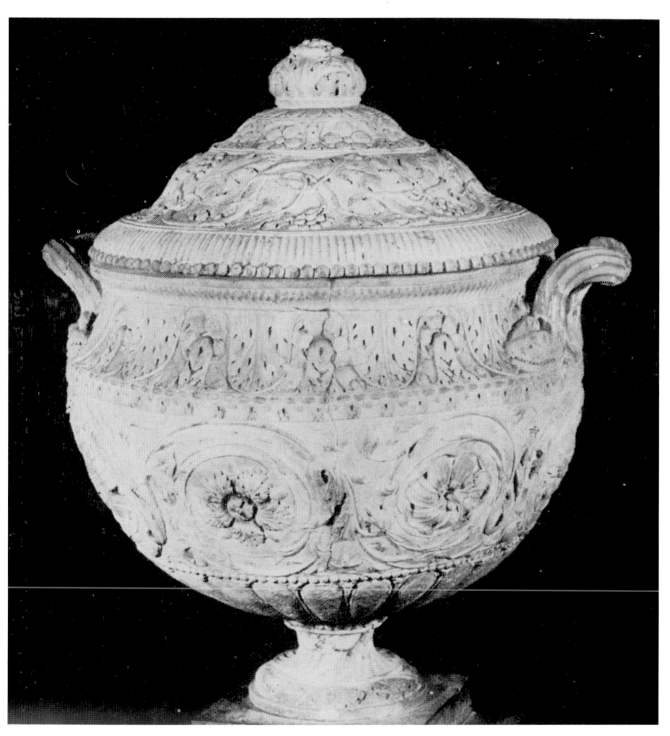

figure 16 Photo reproduced from D. Udy, "Piranesis Vasi,"
 Burlington, Volume 120, Dec. 1978

Cat. No. 46

PAIR OF CHAMBER CANDLESTICKS, SNUFFERS, AND EXTINGUISHERS

Silver-gilt, steel
Marks:
1. London, 2. sterling standard, 3. 1816-17, 4. 1815-16 (one pair of snuffers), 5. maker's mark of Paul Storr (Grimwade, no. 2235), 6. maker's mark of Rebecca Emes and Edward Barnard I (Grimwade, no. 2309) (one pair of snuffers only), 7. duty stamp, fully marked underneath the trays, and inside the chamber of one pair of snuffers; partly marked outside the chamber of one pair of snuffers, the nozzle shafts, and the sides of the extinguishers; all pieces except the nozzles and the replaced pair of snuffers engraved with the initials: "E.A. Fs." (Ernest Augustus, Fidei Commissum [to faith entrusted]); both stands stamped on the bottoms: 749.

Height of Chamber Candlesticks: 3⅞ in. each (10 cm.)
Length of Snuffers: 5⅝ in. (14.2 cm.) and 5¾ in. (14.6 cm.)
Height of Extinguishers: 3½ in. each (8.9 cm.).
Gross weight: 41 oz. (1082 gm.)

Provenance:
H.R.H. Ernest Augustus, Duke of Cumberland and King of Hanover.
Crichton Brothers, London, 1924.

Description and Construction

Recessed circular dishes with shaped borders of alternating scallop or conch shells on larger shells interspersed with leaves and scrolls on a punched ground; cast baluster stems and sockets with tiny conch shells atop scallop shells and scrolls around the tops; removable and similarly adorned nozzles act as drip pans; pierced slots in the stems into which snuffers with gadrooned ring handles and shell, scroll and fluted ornamentation fit; detachable conical extinguishers with baluster finials and double-scroll grasps slide into separately cast flying scroll handles capped by shells; box interior of one pair of snuffers equipped with a steel strip for snipping wicks; the other pair of snuffers a modern copy.

Heraldry

The full coat-of-arms engraved on the trays are those of Ernest Augustus (1771-1851), fifth son of George III, who was the Duke of Cumberland and the king of Hanover (ruled 1837-1851), and his wife's, Frederica Sophia Charlotte Alexandria, daughter of Charles Louis Frederick, Grand Duke of Mecklenburgh-Strelitz. All the other pieces except for the later pair of snuffers bear the Royal ducal crest, coronet, and Garter badge of Ernest Augustus.

Falling at about mid-point in the chronological spectrum, this luxuriant pair evokes the Rococo style of the eighteenth century. As was customary practice, the authentic pair of snuffers accompanying these chamber candlesticks was executed by another firm specializing in these accessories. In this instance, it was made by Rebecca Emes (active 1808-1858) and Edward Barnard I (active 1808-1853/55), proprietors of one of Britain's largest manufacturers, whose close working relationship with Rundell's has been well-documented.[163]

The Chamber Candlesticks are of Royal pedigree, but the historical circumstances surrounding it are less than pleasant.

On the death of his brother, William IV, Ernest Augustus succeeded in 1837 to the crown of Hanover. Of all Queen Victoria's "wicked uncles" he was perhaps the most unpopular of the six royal Dukes, largely because of his professed dislike of "liberal notions." His departure from England was the subject of considerable rejoicing. He immediately dismantled the Hanovarian Constitution and, while it might be charitable to compare his absolute rule in Germany with those of the Enlightened Despots of the previous century, his approach to kingship was more paternalistic than enlightened, and he could not be regarded in any way as a patron of the arts.

Ernest Augustus took with him to Hanover a considerable quantity of the Royal plate, some of it dating from the time of the Stuarts, to add to the plate already in Herrenhausen. A claim was made by Queen Victoria for the return of certain of the Royal plate and jewels, which had belonged to George II, George III, George IV and William IV. The King refused, and in a desperate act to demonstrate ownership, he had his initials engraved on every piece. The initials E.A.Fs. stand for "Ernest Augustus Fidekommiss," or "held in trust." After commissioned hearings, it was deemed that the silver rightfully belonged to the King.

On the death of Ernest Augustus in 1851, his son, George Frederick, succeeded to Hanover, but was deposed during the Seven Weeks War in 1866. The Prussian troops sacked Herrenhausen but failed to find the Royal plate, which had been hidden in a vault in the ground, and covered with lime and debris. Subsequently, the family used the title Duke of Brunswick. A significant portion of the Hanovian plate was dispersed by Crichton Bros. in 1924 and 1925.[164]

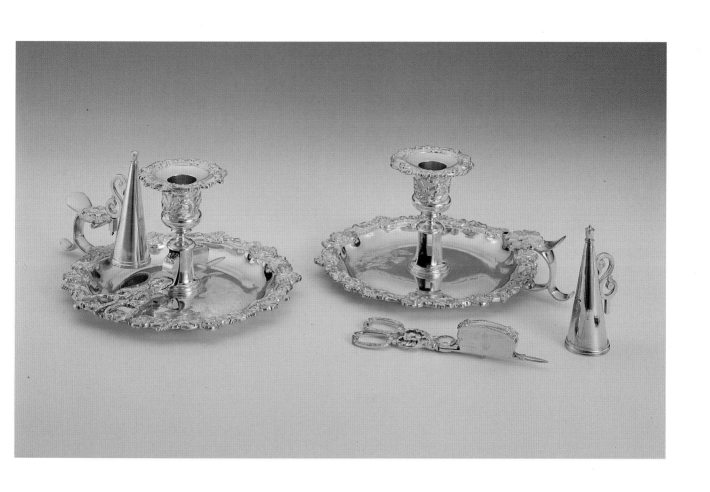

Cat. No. 47

PAIR OF SAUCEBOATS

Silver; gilt bowls
Marks:
1. London, 2. sterling standard, 3. 1817-18,
4. maker's mark of Paul Storr (Grimwade, no.
2235), 5. duty stamp, marked on the bottoms;
stamped underneath each: 16.
Height: 6 in. (15.2 cm.) each
Weight: 36 oz., 4 dwt. (1031 gm.) and 36 oz.,
9 dwt. (1046 gm.)

Provenance:
J. Pierpont Morgan.
Sotheby Parke Bernet, New York, 30-31
October–1 November 1947, lot 390.
Sotheby's, London, 22 March 1956, lot 151.
Emily van Nuys.
Robert G. Johnson.
Christie's, London, 3 November 1976, lot 175.
Mrs. M. M. Ford.
Sotheby's, London, 21 July 1977, lot 178.

Published:
Penzer, 1954, p. 265 (mentioned).
Christie's Review of the Season, 1977, p. 220.

Description and Construction

Oval sauceboats of generous dimension and
thick gauge; cast and applied flying scroll
handles wrapped in acanthus spring from
curvaceous leaf mounts; handles balanced by
boldly projecting spouts with broad pouring lips;
bowls overlapped with plunging borders of
gadrooning and intervening shells nestled in
foliage; sides abound with sharply cast festoons
of flowers and fruit bound with fluttering ribbons
against flat-chased lattice and trelliswork; hollow
bowls with gilded bellies supported on three
canted lion-claw feet headed by crisply
modeled lion masks; engraved crest on the
lower side of each boat.

Heraldry

The armorials are unknown.

In preparation for the highly publicized auction of the silver, both English and Continental, amassed by
the American industrialist J. Pierpont Morgan, Hyman concluded his introduction in the attendant sales
catalogue by writing about these two sauceboats:[165]

> "The Huguenot influence survived elsewhere the first generation of craftsmen, . . . and the
> beautiful pair of sauce boats by Paul Storr, the last of the great Georgian silversmiths, in the
> belated sunset of the Regency."

His overzealous enthusiasm was truly farsighted, however, when one considers that in 1947 the
portentous work of Regency silversmiths — even Storr — had yet to receive the recognition it deserved.
These two sauceboats hark back to a type popularized by de Lamerie, a stylistic continuity that likewise
did not elude Hyman. Numerous comparisons could be drawn, but perhaps the best is with a pair of
less heavily wrought boats of 1734 by de Lamerie in the Al-Tajir Collection in London.[166] What has
transpired, however, in these two is that Storr has transformed the controlled simplicity of the earlier
pieces into more densely packed creations of utmost grandeur augmented by sumptuously gilded
interiors.

Not only the eloquent ornamentation and spectacular execution but also their substantial proportions
and weight set them apart as two of the finest articles of this type manufactured by Storr. Others adhere
to a strikingly close but not identical format. For instance, a set of four of 1818 with different borders and
other details also resides in the Al-Tajir collection.[167] Bearing the same date letter and reiterating the
salient traits of the four in London, are another two formerly with Sotheby's which are worthy of further
exploration to determine if they might have been executed as part of the same set.[168]

Cat. No. 48

PAIR OF ENTRÉE DISHES AND COVERS

Silver

Marks:
1. London, 2. sterling standard, 3. 1817-18, 4. maker's mark of Paul Storr (Grimwade, no. 2235), 5. duty stamp, fully marked along the sides of the dishes; partly marked on the cover rims, handle base plates, and coats-of-arms; stamped inside the lids and underneath the dishes: 224; stamped on the lids: 1 and 2; engraved on the bottom of each dish: C. to E. DAVIDSON.

Length: 12¾ in. ea. (32.3 cm.)
Weight: 97 oz., 7 dwt. (2770 gm.) and 99 oz., 3 dwt. (2816 gm.)

Provenance:
George S. Heyer, Jr.

Exhibited:Indianapolis, Indianapolis Museum of Art, 7 February–12 March 1972.
Dayton, Dayton Art Institute, 24 March–30 April 1972.

Published:
Indianapolis, 1972, p. 15, cat. no. 51.
Schroder, 1988a, p. 428, cat. no. 114 (mentioned).

Description and Construction

Two oblong dishes with removable domed covers crowned by scroll handles with lion masks bolted through flowerhead base plates; each cover cast in six sections encrusted with flowers, palm fronds, shells, scrolls, quatrefoil diamond and scalework reserves; roses and swags accent the inclined corners of the lids; repeating register of quatrefoil bosses encircles the bottom edges of the covers and a gadrooned panel with shells at the angles surrounds the handles; coats-of arms on both sides of each individually cast and screwed into place; shallow, rectangular dishes raised with a cast overlapping border of gadrooning interrupted by shells encased in foliage; crests engraved on both sides of each dish.

Heraldry

The coat-of-arms are those of Davidson, Curriehill, Scotland impaling another.

The vast majority of dining table silver — be they complete services or individual pieces — from the eighteenth and nineteenth centuries are embellished only with cast details and engraved armorials. Although the basic form of these two entrée dishes was often used in Storr's oeuvre, they are remarkable for the lavishness of their decoration, and because their covers are cast and not merely raised and embossed. The separately cast and applied coats-of-arms further contribute to their special nature, and add a highly personalized dimension to an in other ways standard type of dish.

Schroder called attention to their select quality in cataloguing a portion of a dinner service of 1817 made by Storr for the 12th Duke of Norfolk (1765-1842) that is now divided between the Gilbert Collection at the Los Angeles County Museum of Art and elsewhere.[169] The two pieces from that service illustrated here convincingly show the similarities in design, ornamentation, and construction shared by these pieces and others, including the Sutton Service of 1819 in the Al-Tajir Collection in London.[170] All of the pieces falling within this tightly-woven group — these dishes notwithstanding — are unsurpassed in terms of their exceptional design and execution.

Cat. No. 49

SEAL BOX

Silver

Marks:1. London, 2. sterling standard, 3. 1818-19, 4. maker's mark of Paul Storr (Grimwade, no. 2235), 5. duty stamp, fully marked on the bottom; partly marked on the cover flange; stamped on the inside of the lid and on the interior of the box: 57.

Diameter: 6⅞ in. (17.5 cm.)
Weight: 21 oz., 4 dwt. (606 gm.)
Scratch weight: 21:5

Provenance:
Possibly King George III by Royal descent to King Edward VII.
Sir Arthur Lyttelton-Annesley, A.D.C., K.C.V.O., 1903.
Mrs. Annesley Vachell.
Sotheby's, London, 12 December 1974, lot 20.

Published:
Banister, 1981, p. 1609.
Waldron, 1982, p. 29, no. 52.

Description and Construction

Circular Royal seal box constructed from single sheets of metal joined together by solder; slightly raised cover with thumb lift hinged to the side of the shallow receptacle intended for the storage of a wax impression or the original metal matrix of the Great Seal of the Realm; double key-hole shaped depressions at the sides for threading suspension cords to which a treaty or other document bound in a leather cover would have hung alongside the box; lid with moulded borders enframing a continuous bezel of oak leaves and acorns; smooth surfaced center deeply embossed and meticulously chased in facsimile of the Royal armorials and motto of George III, St. George and the Dragon, and the Order of the Garter.

Heraldry

The Royal armorials belong to George III.

This gloriously emblazoned seal box reflects the ability of powerful English rulers to amass costly objects associated with the administration of daily affairs, while the visual imagery reaffirms the temporal authority of their sovereignty. They could be used to preserve a wax impression of the Great Seals of former rulers, which after their deaths could be used to authenticate earlier documents. Naturally, seals were also issued to living sovereigns so they could impress the Great Seal of the Realm on Royal documents and charters. But most were probably presented to ambassadors and other dignitaries in order that they, too, might conduct the business affairs of the British Empire. Such useful boxes also held the seals of British universities, corporations, mayors, and others. When one still retains its wax seal and affixed documents intact, it is called a "skippet," of which a handful of American examples likewise survive.[171]

It is impossible to determine what document might have been attached by tasseled cording to a specific example, or whether it was provided as ambassadorial plate or actually belonged to the monarch whose armorials it conspicuously proclaims. In this case there exists a family history which appears more factual than apocryphal because the box remained in their possession for nearly a century.

Banister has recounted the alleged provenance of this receptacle:[172]

> "The earlier examples bear the mark of Rundell, Bridge & Rundell's chief silversmith, Paul Storr; among them is a box hallmarked in 1818, 6¾ in. in diameter and weighing a good 21 oz., which was presented in 1903 by King Edward VII to Sir Arthur Lyttelton-Annesley on his retirement as A.D.C. [Aide-de-Camp] to the King and his investiture as K.C.V.O. [Knight Commander of Royal Victorian Order]."

Another source relates that Sir Arthur presented the box to his great niece, Mrs. Vachell, from whom it entered this collection by way of the international art market.[173] The earliest by Storr appears to date to 1815, and another one of 1817 was lent by Viscount Esher to the Loan Exhibition held at 25 Park Lane in London in 1929.[174] Storr stopped making them after he left Rundell's, but these standard seal boxes continued to be produced by others until at least the close of the century. One of 1826 by John Bridge (1755-1834), Storr's former business partner at Rundell's, was carried out less than a decade after this one.[175]

Cat. No. 50

VASE AND COVER ON PLINTH

Silver-gilt
Marks:
1. London, 2. sterling standard, 3. 1819-20, 4. maker's mark of Paul Storr (Grimwade, no. 2235), 5. duty stamp, fully marked on the body of the vessel; partly marked on the lid flange; engraved along the cover flange: MAKEPEACE SON & HARKER. FECER[T].; engraved on the front of the plinth: BURDEROP RACES 1821. IOHN BENETT ESQ[R]. STEWARD.

Height: 12⅞ in. (32.7 cm.)
Weight: 136 oz., 2 dwt. (3861 gm.)

Description and Construction

Grand presentation trophy of classical kantharos form with slightly ogee body capped by an egg-and-dart protruding border; cast calyx of vineyard leaves, grape clusters and intwined tendrils trail from the body into the cast and tightly bifurcated vine stalk handles; lower circumference of the belly with wide fluting above a partially gadrooned collar and spreading circular foot stem mounted on a plain square base; round cover with wide smooth ledge ascends in a banded stage to a fluted central dome endowed with a cast seedpod finial engulfed in upturned matted leaves.

An impressive example of Regency silver of massive form and weight, this covered vase replete with a square plinth is marginally reminiscent of the eminent Warwick Vase. That ancient marble of A.D. 120-135 was discovered in fragments in the late eighteenth century and eventually sold to the Earl of Warwick.[176] A veritable milestone of inspiration for Regency silversmiths, Rundell's was commissioned by Lord Lonsdale (1757-1844) to execute a full-scale version of it in silver which never came to fruition, but two bronze copies from molds by Theed together with Storr were made in France in 1821, one of which stands today on the terrace steps at Windsor Castle.

continued

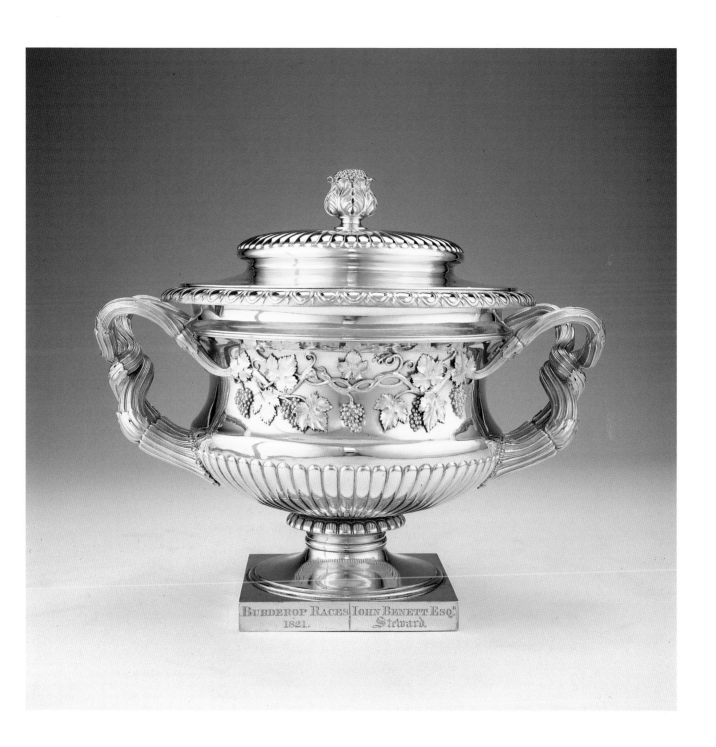

figure 17 Photo courtesy Victoria and Albert Museum

Cat. No. 50 continued

Reduced copies in silver were made by Storr from about 1810 onwards often with modifications so severe in their transmutation that only the underlying shape and a selection of the cast details resemble the prototype. This is particularly true of the vase discussed here, which owes greater allegiance to another classical marble vase on a tall pedestal published in Giovanni Battista Piranesi's (1720-1778) *Vasi, candelabri, cippi, sarcofagi, tripodi, lucerne ed ornamenti antichi* of 1778.[177] The only dramatic differences concern the substitution of gadrooning and a shorter foot on our piece. To compound the issue, it is highly plausible that the silver designer was also exposed to several as of yet unpublished drawings contained in the Flaxman Sketchbook (figures 17-18).[178] What these comparisons intimate is that a variety of antiquities as well as contemporary patterns might have jointly influenced the final creation.

figure 18 Photo courtesy Victoria and Albert Museum

Cat. No. 51

SET OF FOUR SAUCEBOATS

Silver
Marks:
1. London, 2. sterling standard, 3. 1819-20, 4. maker's mark of Paul Storr (Grimwade, no. 2235), 5. duty stamp, marked on the bodies beneath each lip.

Height: 6⅛ in. each (15.5 cm.)
Weight: 34 oz., and 35 oz.

Provenance:
Violet, Lady Beaumont.
Christie's, London, 16 November 1949, lot 129.
Collection of the San Antonio Museum Association, San Antonio (deaccessioned).
Christie's, New York, 18 October 1989, lot 163 and 28 April 1992, lot 166.

Published:
Penzer, 1954, p. 265 (mentioned).

Description and Construction

Pair of shell-form sauceboats with deep spiral fluting ending broad pouring spouts; bodies further garnished with sinuously fashioned rims of leaf and scroll flourishes and bands; mellifluous clusters of flat-chased scrolls, shells, leaves, curlicues, and scalework along the upper bowls; separately cast coiling serpents joined to the crinkle-edged rocaille bases of foam and shells; each multi-scroll handle in the shape of a winding lamprey with open mouth feeding on swirling shells projecting over the interior; engraved with a crest and Earl's coronet under each lip.

Heraldry

The crest belongs to Browne, Earls of Kenmare.

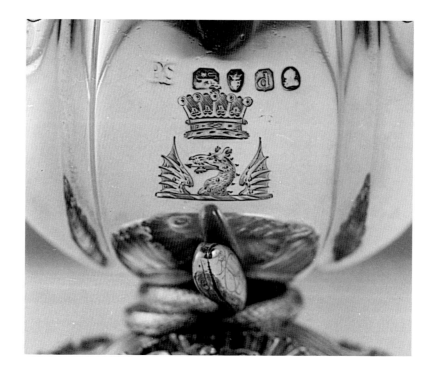

With little hesitation, these sauceboats might be accepted as four of the most premiere examples of this model from Storr's hand. The textural precision and manual dexterity of their chasing alone are seldom equalled or surpassed in their identically designed counterparts. Widely scattered, the examples hencefar located were carried out by Storr roughly between the mid-teens to the mid-twenties of the nineteenth century.

continued

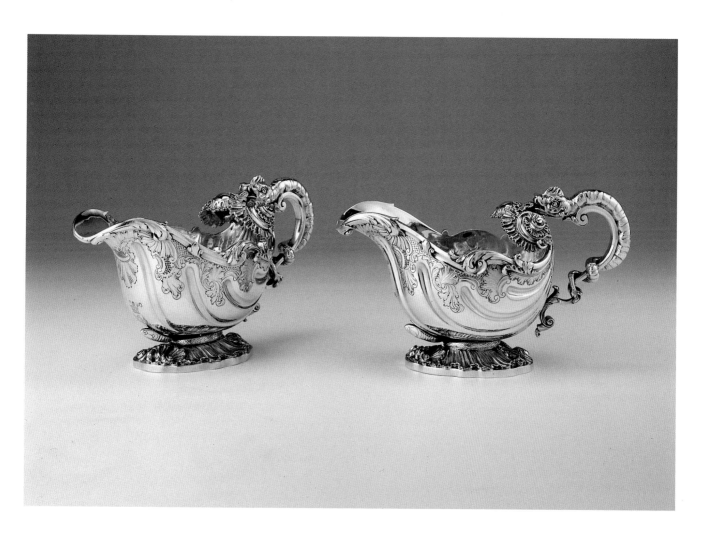

Cat. No. 51 continued

They are revivals of shell-bodied Rococo sauceboats or cream jugs with imaginative handles in the form of griffins, storks, eagles or monsters together with rocaille work. Models of this caliber were undertaken by de Lamerie, William Cripps (active 1738-1767), Charles Kandler (active 1727–ca. 1776), Paul Crespin (1694-1770), and David Willaume I (1658-1741), who as early as 1720 applied a handle in the form of a serpent on a creamer.

Still, the sauceboats that ultimately inspired this model were not those of a native born Englishman, but rather the Liegeois silversmith Nicholas Sprimont (1716-1771). A sauceboat of ca. 1746 by him at the Museum of Fine Arts, Boston agrees in overall form and employment of marine motifs.

The firm of Garrard issued at least one set in this pattern of 1825, as well as one of the same year to match one of 1812 by Storr.[179] Finally, metal sauceboats transmit heat so they were used for cold sauces, and the nautical motifs on them underscore their association with the fish portion of a meal. Handles akin to those on our pair are identified repeatedly as serpents. Pragmatically, they are actually lampreys — vertebrates native to both salt and freshwater, including the Thames, which resemble eels with suctional mouths they fasten to shells and other oceanic food sources — just as we encounter them on these sauceboats.

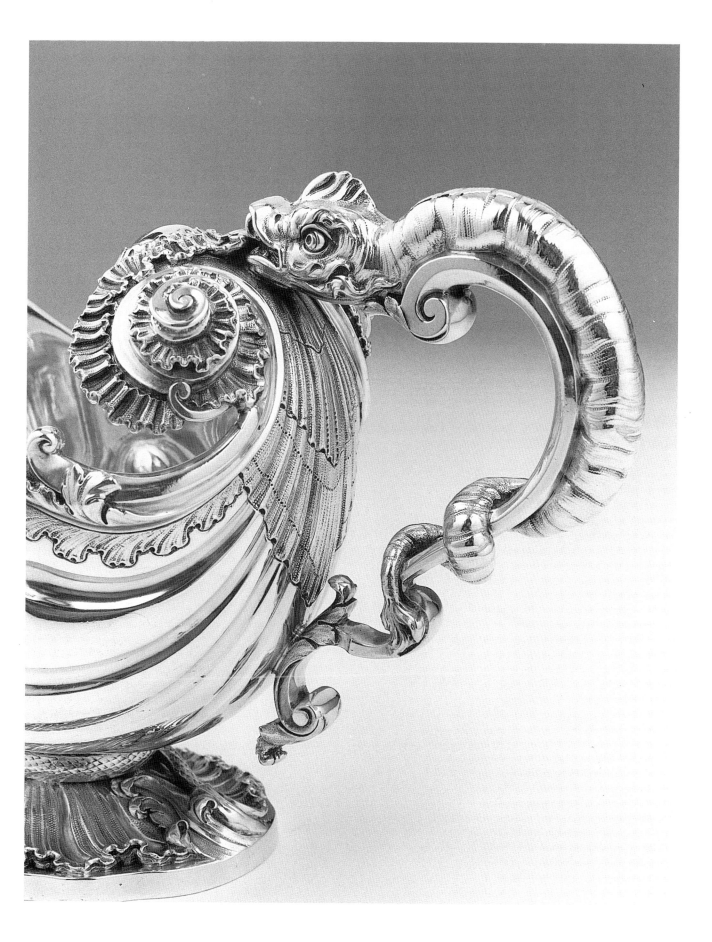

Cat. No. 52

PAIR OF SAUCE TUREENS AND COVERS

Silver
Marks:
1. London, 2. sterling standard, 3. 1820-21,
4. maker's mark of Paul Storr (Grimwade, no.
2235), 5. duty stamp, fully marked on the
undersides; partly marked inside the lids and on
the foliate surrounds of the handles.

Height: 6½ in. (16.4 cm.) each
Weight: 47 oz., 3 dwt. (1260 gm.) and 47 oz.,
8 dwt. (1355 gm.)

Provenance:
Lillian and Morrie A. Moss, Memphis.

Published:
Moss, 1966, p. 32.
Moss, 1972, pp. 88-89, plate 29.

Description and Construction

Double-handled and bombé shaped tureens
with matching lids; hollow bodies spaciously
ribbed and overlapped with applied oak and
acanthus leafage and shells cast and chased in
high relief; each rests on four short and curving
shell and leaf feet separately cast; curving,
ribbed, and cast looped handles project widely
from acanthus leaf clusters; tureens with boldly
cast and projecting borders overflowing with
leaves and shells; removable covers with
jagged edges lead up to stepped and broadly
fluted low domes surmounted by cast and
detachable twig looped lifts rising from oak
foliage surrounds secured with screws.

figure 19 Photo courtesy Victoria and Albert Museum

One of the most momentous discoveries over the last several decades to advance the study of English silver was the chance uncovering of the previously mentioned album of drawings for silverplate — known as the Rundell Design Book — executed between 1815 and 1833.[180] Acquired for the Victoria and Albert Museum, Oman was the first to address the unique problems posed by these forty-eight designs which cover the complete gamut of plate retailed by a leading goldsmith firm flourishing in nineteenth-century London. Individually, they divulge idiosyncratic stylistic and technical characteristics, and while he cautiously concluded that all the patterns should be attributed to Baily, he recognized some disclose a connection with another leading Rundell designer, Thomas Stothard (1755-1834).

One of the sheets ascribed to Baily is this pen and wash sketch that Oman identified as the precise source for the model represented in this entry (figure 19).[181] Some variation is apparent, most noticeable in the handles, but this fails to negate the overwhelming affinity in both form and decoration. Actually, the sketch bears an even closer relationship to some of the numerous other tureens, both for sauce and soup, carried out by Storr during the final years of his tenure at Rundell's and less often after he set out on his own in 1819. Because this pair carries the date letter of 1820, it is one of the earliest in this pattern which he produced in his new premises at Harrison Street, Clerkenwell. Naturally, this well-favored type was manufactured by other firms as well.

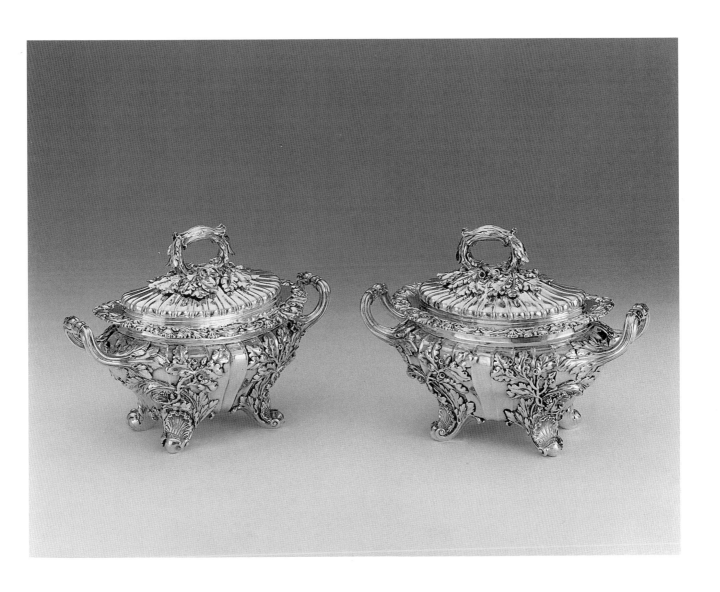

Cat. No. 53

CUP

Silver-gilt
Marks:
1. London, 2. sterling standard, 3. 1821-22, 4. maker's mark of Paul Storr (Grimwade, no. 2235), 5. duty stamp, marked on the upper side of the body.

Height: 7½ in. (19 cm.)
Weight: 29 oz., 6 dwt. (839 gm.)

Provenance:
Lillian and Morrie A. Moss, Memphis.

Published:
Moss, 1966, p. 22.
Moss, 1972, pp. 148-149, plate 86.

Description and Construction

Calyx-krater cup of relatively small dimensions with deep hollow interior garnished with a floral boss soldered to the bottom; plain rim above the broad, tapering, and smooth surfaced upper body embossed with a scene of two greyhounds chasing a hare against a matted landscape with finely detailed shrubbery; bulbous lower portion of the body taken up with crisply cast and applied leaves, hops, and roving branches; gadrooned collar divides the bowl from the individually formed, waisted, and spreading base; cast and tooled double loop vine branch handles project from beneath the bowl and curve widely upwards to merge with the soldered festoon encircling the bowl; engraved crest on back side.

Heraldry

The crest is that of France of Bostock, County Chester or of Ystym Colwyn, Oswestry, County Salop.

Patterns from Antiquity were held in highest regard during the Regency Period even though this comely cup was produced a year after George, Prince of Wales ceased to rule as Regent for his father, George III. Well balanced, symmetrical, and successfully combining plain and rich surfaces, it follows the form of the broad-bellied and wide-mouthed *calyx-krater* used for mixing wine and water in the classical world. They were then called by that name because their upper portions evoke the calyx of a flower. In this particular example the antique correlation is further emphasized by the updated addition of a boss of blossoming petals applied to the bottom interior. Certain other details, particularly the foot with its gadrooned collar, were likely borrowed from elements occurring on ancient vases in Piranesi's Vasi and other contemporary sources.[182]

When this piece was created the *krater* design served as the starting point for an assortment of silver vessels including wine coolers and racing trophies. Sometimes, the somewhat stale antiquarian appearances of the latter were infused with fresh vitality by intermingling contemporary hunt or chase vignettes. Here, two greyhounds actively pursue a fleeing hare within a lush country setting. Portrayed at the height of the action, the sporting competition is known as coursing for hares, which together with deer were the prime prey for the English gentry before their attention turned to the fox chase.

This cup appears to be the only published one by Storr decorated with a rabbit chase scene. A Jug of 1834 by Benjamin Smith III (1790-1858) in the Gilbert Collection at the Los Angeles County Museum of Art affords an interesting comparison, however, as the shape also vaguely resembles a Greek vessel, an Olpe, besides the lower body contains horse-racing scenes.[183] Neither of these pieces bears a dedicatory inscription, however, suggesting that although they were meant as trophy cups, they were never officially presented as such.

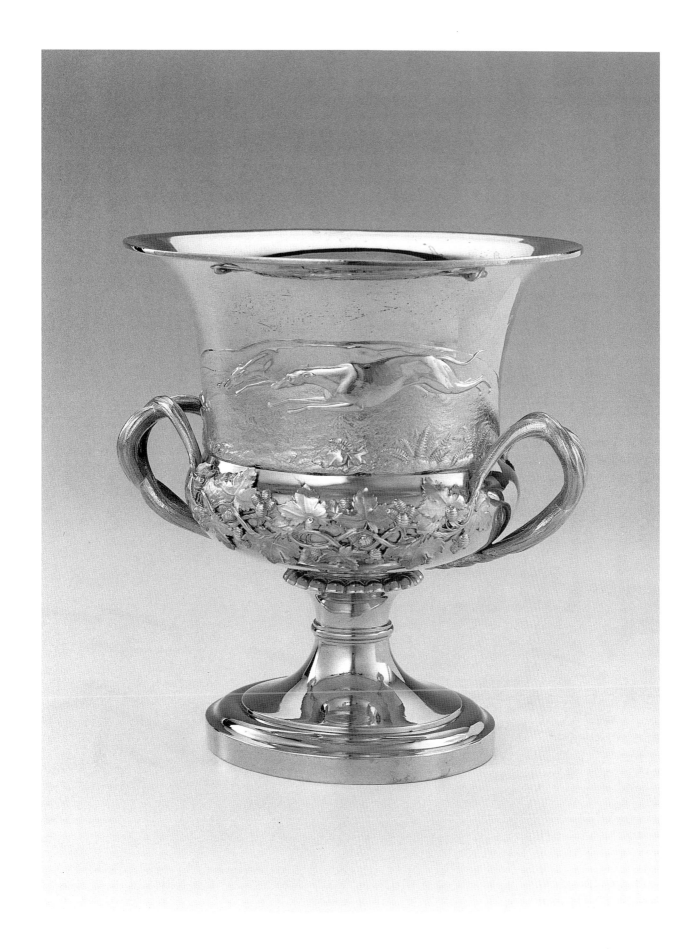

Cat. No. 54

SALVER

Silver
Marks:
1. London, 2. sterling standard, 3. 1823-24,
4. maker's mark of Paul Storr (Grimwade, no.
2235), 5. duty stamp, fully marked underneath
the basin; partly marked on the border.

Diameter: 26½ in. (67.4 cm.)
Weight: 249 oz., 2 dwt. (7064 gm.)

Provenance:
Eastern Art Museum (deaccessioned).
Sotheby Parke Bernet, New York, 2-3 February
1962, lot 229.
Thomas Lumley, Ltd., London.
Sotheby's, London, 13 December 1962, lot 91.
W. Comyns and Sons, Ltd., London.
Lillian and Morrie A. Moss, Memphis.

Exhibited:
Indianapolis, Indianapolis Museum of Art,
7 February–12 March 1972.
Dayton, Dayton Art Institute, 24 March–30 April
1972.

Published:
Moss, 1966, p. 38.
Moss, 1972, pp. 26-27, 160-61, plate 103.
Indianapolis, 1972, p. 17, cat. no. 63.
Skerry, 1980, p. 25 (mentioned).

Description and Construction

Huge Zodiac tray with moulded border features
female masks wearing headdresses
representing Summer (wheat), Autumn
(grapes), Winter (vegetables) and Spring
(flowers); other intervals with animals including
birds (Summer), hare (Autumn), fox (Winter),
and lamb (Spring) surrounded by a whirlpool of
scrolls, shells, flowers, trellis and scalework, and
a ewer against matted grounds; tray cast in
lower relief and enclosed within a wandering
network of scroll, shell, and foliate strapwork
with Zodiac signs; clockwise from the top
appear: Capricorn (goat); Aquarius (water-
bearer); Pisces (fish); Aries (ram); Taurus (bull);
Gemini (twins); Cancer (crab); Leo (lion); Virgo
(virgin); Libra (balance); Scorpio (scorpion); and
Sagittarius (archer); smooth center engraved
with a coat-of-arms; raised on four cast voluted
scroll supports.

Heraldry

The arms are those of Ffarington quartering
Benson, Rufine, Bradshaw, Bradshaw (ancient),
Aspull, Fitton, Carden, Malvoisin, Brereton,
Nowell, Merely, Fitton, Hargreaves, and
Ffarington for Lieut. Col. Willian Ffarington
(1766-1837), High Sheriff of Lancashire (1813).

Together with its matching companion at the Museum of Fine Arts, Boston, these two enormous salvers were not designed for table use as their excessive surface ornamentation and pristine condition render them impractical as "tea trays" like the one by de Lamerie in this collection.[184] Instead, they were meant as sideboard plate to adorn the interior of a stately English home. Both bear the multi-charged arms of William Ffarington.[185] The emphasis given to the representation of the Zodiac cycle and its obvious implications of the passage of time suggest that they were commissioned as a pair in celebration of a paramount event in Ffarington's life. Possibly, they marked his twentieth-wedding anniversary to his second wife, Hannah, daughter of John Matthews of Tynemouth, whom he had wed on the 5th of July 1803.

continued

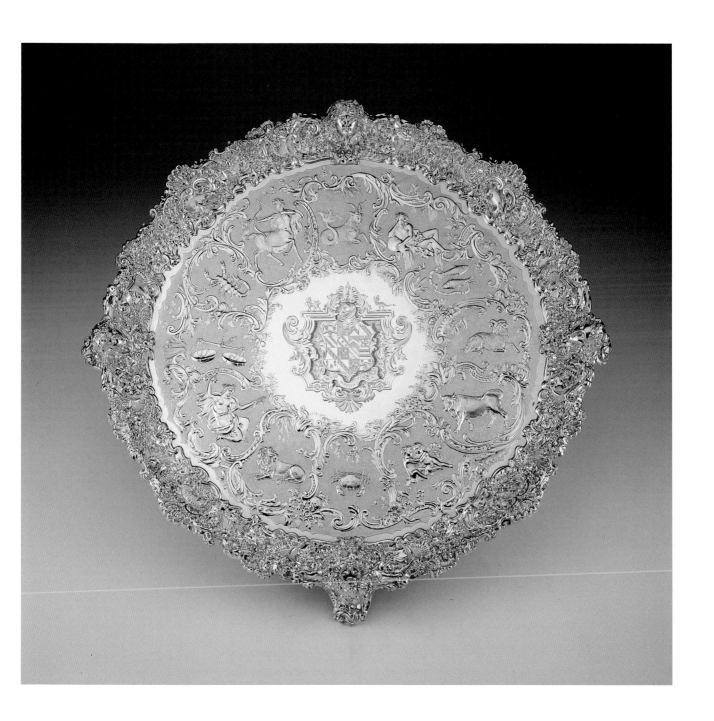

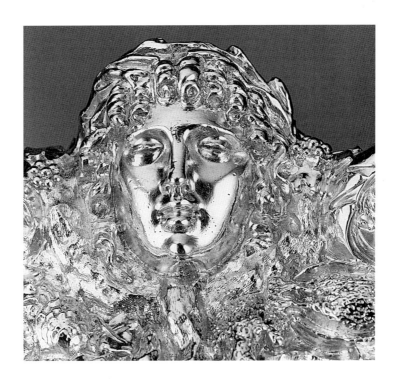

Cat. No. 54 continued

Only two other Zodiac salvers are known by Storr, and they, too, are also no longer together. One was given to the Yale University Art Gallery in 1948, and its companion was once in the possession of J. Pierpont Morgan.[186] While their inner basins are identically decorated as the other two, they are outfitted with equally heavy but differing borders of knuckled volutes which otherwise incorporate the seasonal busts and animals. Both were hallmarked in 1827, and the fact that they were also conceived as a matching pair cannot be seriously questioned. In point of fact, the one at Yale carries an unidentified coat-of-arms and the later inscription "the gift of N. Philips, Esqr., Made in London, 1827," whereas its counterpart bears an intwined monogram as well as the dates "1837-1887," indicating that they were a fiftieth-wedding anniversary gift presented by Mr. Philips to a presently unknown couple sixty years after they were made.

While she was unaware of the matching tray in the Morgan Collection or the probable reasons for which both pairs were undertaken, Skerry, nevertheless, encapsulated the broader issues at hand concerning Zodiac salvers in writing about the example at Yale:[187]

> "With its cyclical representation of time and its unfailingly perfect workmanship, the zodiac tray by Paul Storr represents a parting salute to the ethos of a changing period, on the verge of the industrial revolution, and the modern conception of time as a linear rather than cyclical progression, yet its existence reaffirms the traditional practice and belief of an era soon to pass."

Cat. No. 55

STIRRUP CUP

Silver, gilt interior
Marks:
1. London, 2. sterling standard, 3. 1826-27,
4. maker's mark of Paul Storr (Grimwade, no.
2235), 5. duty stamp, marked on the outside of
the collar; engraved around the lip: MOSTYN
HUNT, CUP WON IN 1826. BY MR. STEVENS'S
GR. G. BY GRIMALDI.

Height: 5⅞ in. (15 cm.)
Weight: 12 oz., 3 dwt. (348 gm.)

Provenance:
Ormond Arthur Blyth, Esq.
Sotheby's, London, 16 March 1978, lot 171.

Description and Construction

Trophy cup rendered in the form of a wily fox head with integrally cast broad collar functioning as both a drinking lip and flat surface support; rim with acanthus, palm and leaf border with narrower molding; naturalistically modeled sly-faced features; extensively chased and tooled with a coat imitating thick fur; sunken eyes, projecting snout, raised and alert ears, and clenched mouth all evoke the cunning instincts of the actual creature.

figure 20

Photo courtesy Paul Mellon Collection Upperville, Virginia

Finding antecedents in ancient Greek rhytons or drinking vessels in the shape of animal heads, cups such as this one were revived in England in both silver and ceramics to serve a utilitarian purpose, as well as being tangible tributes to a nationalistic love of sports. The term "stirrup cup" derives its name from the act of a mounted individual with his feet firmly in the stirrups who drinks a spirit beverage, commonly mulled wine, as a bracer from one of these receptacles just prior to the outset of a sporting event. As on this intriguing example, inscriptions denote that they were given as trophies to victors in fox hunts, horse races, and the like.

The inscription on this version discloses it was awarded to Mr. Stevens in 1826 in recognition of his triumph in one of the numerous fox chases sponsored by various branches of the Mostyn family of England and Wales, many of whom were themselves avid collectors of earlier English and Welsh plate.[188] This cup must have been presented to Stevens by Sir Thomas Mostyn — an eccentric fellow according to contemporary accounts — who was Master of the Bicester Hunt between 1800 to 1829.[189] Far from your average thoroughbred, too, Grimaldi, the noble beast whose name is also engraved on the cup, is depicted in numerous sporting prints of the period including this aquatint by James Pollard, (1792-1867) in the private collection of Paul Mellon (figure 20).[190] Unfortunately, Grimaldi, then owned by Squire Osbaldeston, is depicted in the sheet as he falls during the Northampton Grand Steeple Chase of 1833.

Appearing around 1765, fox heads were the first animals depicted on stirrup cups. As time progressed, there was a mounting tendency towards verisimilitude of genuine physical attributes as this one avows. Another example predating this cup by a year and also descending from the well-known collection of fox head stirrup cups gathered together by Ormond Blyth is reputedly cast from the same exact mold.[191]

Cat. No. 56

JUG

Silver
Marks:
1. London, 2. sterling standard, 3. 1827-28, 4. maker's mark of Paul Storr (Grimwade, no. 2235), 5. duty stamp, marked on the bottom; engraved on the underside: "F."

Height: 5 in. (12.8 cm.)
Weight: 11 oz., 3 dwt. (320 gm.)

Description and Construction

Coverless jug of pear-form hand-raised with multi-ribbed moulded base soldered to the bottom of the deep belly; gently sloping sides laboriously embossed and chased with a frieze of meandering hops and foliage on a densely punched ground enframed by simple bands at the top and bottom; leaf-capped handle of triple scroll silhouette cast in halves and soldered to the sides by means of stylized shell clusters; slightly protruding brim of plain silver attached to the top of the receptacle.

Most small uncovered English jugs were for milk or cream, but the larger scale of this example clearly indicates that it did not function in that capacity. The intricately worked but amply spaced frieze of hop and foliate decoration revolving around the body confirms that it was originally constructed as a beer or ale jug. Other specimens exist, but they are larger and usually of baluster shape, sometimes inscribed with the letter "A" or "B" indicating whether they were meant to hold ale or beer. Since this one lacks the presence of a letter, and because both ale and beer are made from hops, it is not possible to more precisely determine which beverage the current one accommodated.

Evidently, this is one of the few hop jugs bearing Storr's mark recorded in the literature thus far. It is, however, not the only instance in which a continuous band of hops is employed as the primary means of ornamentation on cups and mugs by him intended to hold malted liquors. The dates on these vessels apparently reveal that they were carried out in Storr's workshop only after he broke away from Rundell, Bridge and Rundell in 1819. The same decorative repertoire continued to be of use after Storr's retirement in 1838, as seen in a considerably later beaker of 1874 by Hunt and Roskell, the name eventually adopted by the firm begun by Storr.[192]

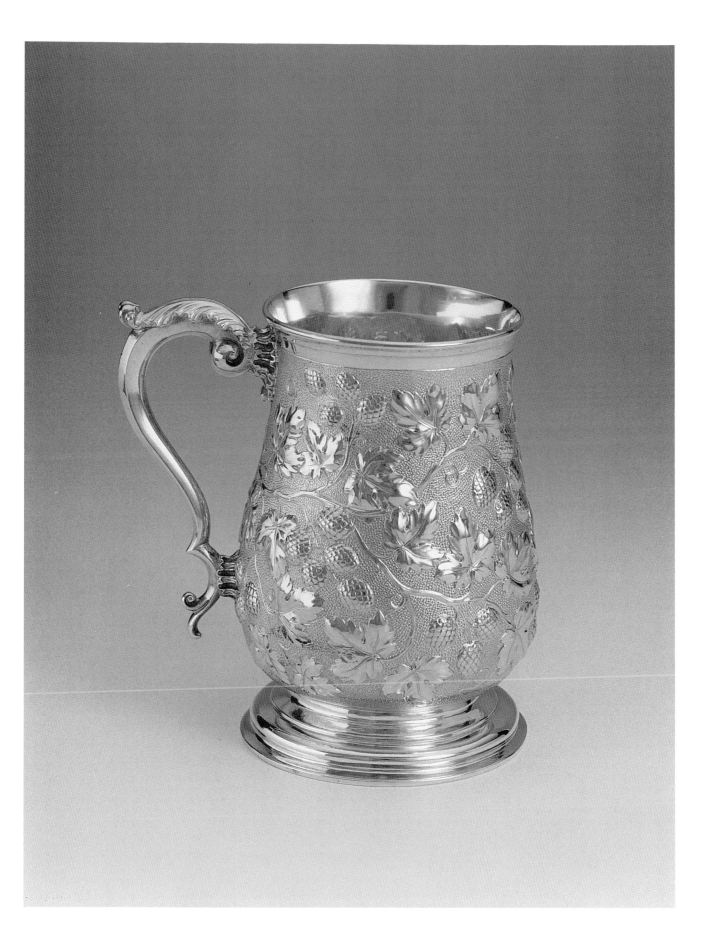

Cat. No. 57

VASE AND COVER

Silver-gilt
Marks:
1. London, 2. sterling standard, 3. 1827-28,
4. maker's mark of Paul Storr (Grimwade, no.
2235), 5. duty stamp, fully marked inside the
base; partly marked inside the cover.

Height: 16 in. (40.6 cm.)
Weight: 121 oz., 2 dwt. (3436 gm.)
Scratch weight: 121 05

Provenance:
Lillian and Morrie A. Moss, Memphis.

Published:
Moss, 1966, p. 58.
Moss, 1972, pp. 108-09, plate 48.

Description and Construction

Campana-shaped vase and cover of large
dimensions rests on a stem in the form of a
tree-trunk growing from a base of finely
pounced earth strewn with floral buds,
branches, tufts of grass, and pebbles; majority
of the hollow and swollen bowl covered with
sprightly foliage and berries interrupted by two
blank cartouches; looped handles in the form of
tied foliate stems emerge from surrounds of
leaves and berries cast and applied to the belly;
multi-domed cover chased and embossed with
registers of swirling branches, berries, and a
seed-pod finial cast in two parts; stylized scallop
shells hang free over the rim; plain register at the
bottom of the base repeated on the lid.

Countless cups and covers in the classical taste
were mass produced in the nineteenth century
as display pieces. The fundamental shape of
this organic vase and cover is reminiscent of
ancient urns like the Warwick Vase. Conversely,
the dominant ornamentation of leaf and berry
motifs on this cup pays passing homage to
affiliated elements on other ancient vases, such
as the Buckingham Vase or the Hellenistic
Krater discovered in 1680 in the Via Albani.[193]
This practice of conflating structural form with
decoration influenced by two or more different
sources to create a new variation was
widespread in the silversmiths' trade.

Equally accessible to the silversmiths employed
by this firm were the sketches contained in the
album of sketches attributed to Flaxman.[194] Two
sheets from that folio for two trophy cups make
use of related berry or acorn patterns as on the
piece presented here, and one of them even
shows vine stem handles similarly issuing forth
from acorn leaf clusters (figures 21).[195] The
purpose of these comparisons is not to declare
that any of these designs by Piranesi or Flaxman
directly inspired the current cup, but to call
attention to the plentitude of patterns of
comparable spirit then within reach of the
designers.

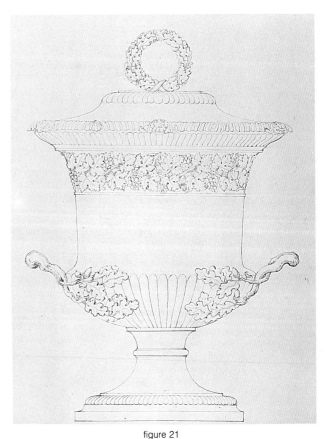

figure 21

Photo courtesy Victoria and Albert Museum

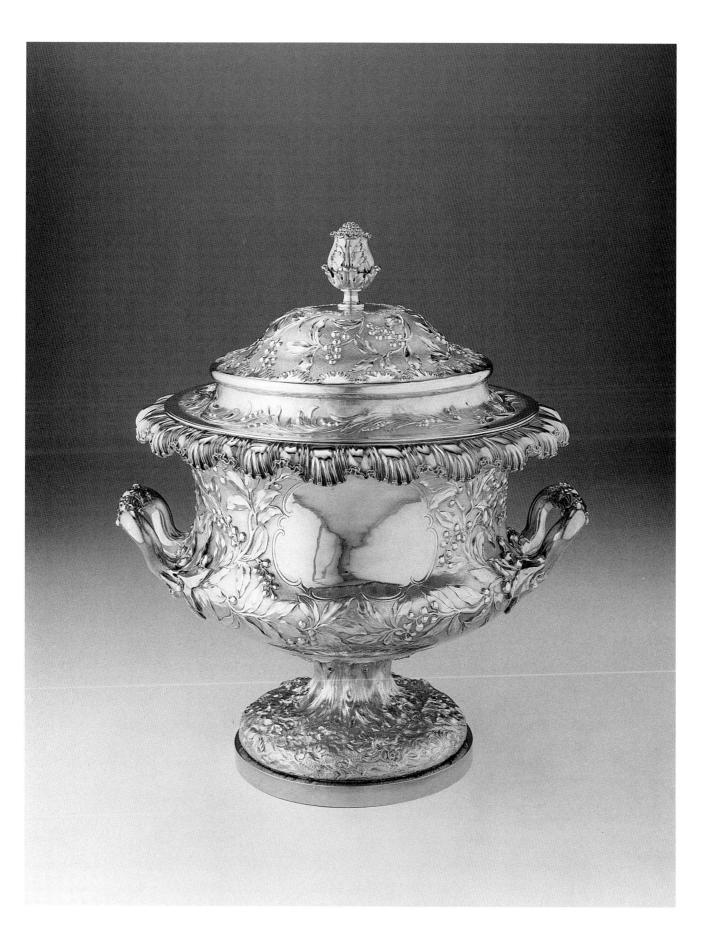

Cat. No. 58

VASE AND COVER

Parcel-gilt
Marks:
1. London, 2. sterling standard, 3. 1829-30, 4. maker's mark of Paul Storr (Grimwade, no. 2235), 5. duty stamp, fully marked on the body of the vase; partly marked inside the lid and on the bolt.

Height: 14½ in. (36.8 cm.)
Weight: 66 oz., 9 dwt. (1896 gm.)

Provenance:
Lillian and Morrie A. Moss, Memphis.

Published:
Moss, 1966, p. 57.
Moss, 1972, pp. 146-147, plate 85.

Description and Construction

Cup and lid of slender urn shape; reeded and foliated handles set high on the rim travel up in a loop and down to the sides of the body; egg-and-dart border above a plain tapered neck; embossed and matted water leaves at the shoulder repeated on the bottom of the bowl with alternating lotus blossoms; fillet travels around the stem and a band of acanthus leaves chased around the dome of the pedestal foot; bowed smooth lid with an acanthus bud and pod finial cast integrally with a leaf mound bolted underneath; different coat-of-arms engraved on each side at the center with two other crests on the cover; gilding added later.

Heraldry

One of the arms is that of Granville of Wellesbourne, County Warwick, with Onslow in pretence for Bernard Granville (born 1804), who married Mathewana Sarah, daughter of Captain Matthew Richard Onslow, on 28 June 1828.

Certain features of the ornamentation and form of this vertically oriented vase recall the prominent Gainsborough Cup of 1791 at the Royal Academy of Arts designed by the American Benjamin West (1738-1820), painter to George III.[196] West entrusted the transferral of his design into silver to Storr, and the ensuing result was a superb cup of cool and sleek early neo-classical character. However, there are significant differences between the two vases reproduced here, indicating that the much later example relies only tangentially on the one in London which owes much to the style fostered by Robert Adam (1728-1792).

A fairly limited edition of these vases contingent upon the general format of the Gainsborough Cup but with major alterations and adjustments were produced sporadically in Storr's workshop.

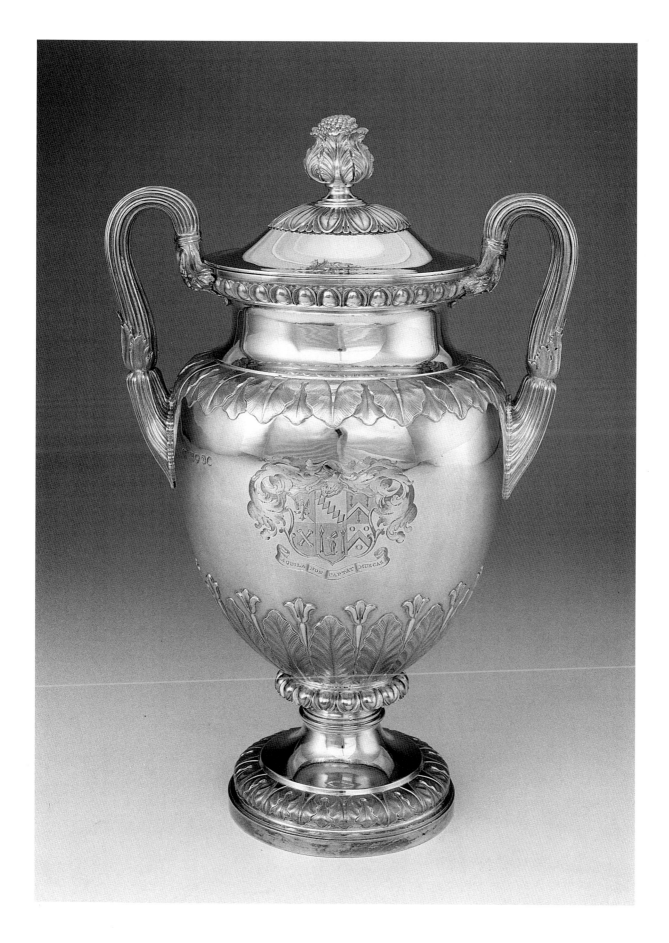

Cat. No. 59

STATUE OF HEBE

Silver
Marks:
1. London, 2. sterling standard, 3. 1829-30, 4. 1837-38 (base), 5. maker's mark of Paul Storr (Grimwade, no. 2235), 6. duty stamp, fully marked on the reverse bottom edge of the figure and on the top of the pedestal; partly marked on three bolted screws; inscribed along the edge of the statuette: No. 8 PUBLISHED AS THE [ACT] DIRECTS BY STORR & MORTIMER 13 NEW BOND STREET LONDON July 1 (?) 1830; stamped beneath the marks on the figure: STORR & MORTIMER.

Height of statuette: 23¼ in. (59 cm.)
Height of pedestal: 13¾ in. (35 cm.)
Weight: 303 oz., 5 dwt. (8604 gm.)

Provenance:
Sir Francis Burdett.
Duchesss of St. Albans, née Harriet Mellon.
William Aubrey de Vere, 9th Duke of St. Albans.
Possibly Baroness Angela Burdett-Coutts.
Sotheby's, London, 5 February 1970, lot 92.
Lillian and Morrie A. Moss, Memphis.

Published:
Barron-Wilson, 1886, vol. 2, p. 298.
Moss, 1972, pp. 39, 244-245, plate 181.
Culme, 1977, p. 120.
Brett, 1986, pp. 276-77, no. 1280.

Description and Construction

Hollow-cast sculpture of Hebe, cup bearer to the gods, depicted as she momentarily alights on a cloud bank; tall circular plinth with fluting above stepped mouldings; her wavy hair bound up in classical fashion and fastened with a fillet beneath which ringlets enframe the idealized face with serene eyes, unpierced pupils, narrow nose, and parted lips; standing nobly with the weight resting on her extended right foot, the goddess tilts a wine ewer in her upraised right hand and balances a goblet in her left; both vessels individually cast with beaded and lanceolate leaves; exposed flesh brushed to create supple surface effects; long pleated skirt caught about the waist in an unbelted overflow; implied motion blows the garment back from her forward leg clearly discernable beneath the fabric; drapery at the back is more turbulent with fluttering curved concavities and sharp ridges.

A penchant for statuary silver arose during the unveiling of the nineteenth century.[197] This phenomenon came about as the consequence of the employment of skilled sculptors as designers by goldsmithing firms, as well as the favorable public reaction to the gigantic figural pieces included in international trade exhibitions. However, the taste for exorbitant sculpture in silver gained notoriety several decades before such exhibitions became regular events. The possible repertoire was as potentially limitless as the resulting creations were enormously complicated and sternly realistic. Most popular were large-scale racing trophies and testimonial extravagances of energetic animal groups or victorious scenes instilled with a propagandist bent.

Free-standing silver statues of individual personalities were less frequently undertaken. When fashioned, they were usually portrayals of members of the Royal family especially Queen Victoria. Storr seldom undertook such commissions, his best known is the portrait sculpture of George III.[198] It is not generally known, however, that an imposing figure of a mythological Bacchanal playing cymbals and jubilantly dancing carries his mark.[199]

By comparison, that figure pales in relation to this sublime full-length sculpture of Hebe. She is a small-scale reduction in silver of a monumental marble sculpture existing in several versions by Antonio Canova (1757-1822), the foremost Italian neo-classical sculptor, whose work dominated European statuary from the end of the eighteenth century up through the Victorian period.[200] A patron of the Bonaparte family, Canova excelled in tomb sculpture, busts of the Emperor and his family, which poignantly extol the imperial grandeur of the Napoleonic regime, and many works of classical subjects.

This Hebe closely follows Canova's gesso maquette preserved at the Gipsoteca Canoviana in his native village of Possagno, Italy.[201] This working model was used for at least two of the marble replicas, one of 1808-1814 at Chatsworth and another of 1816-1817 in the Pinacoteca Civico in Forli, which has been judged to be the most beautiful (figure 22).[202] Credibly, it is this later marble which, both optically and psychologically, most felicitously resembles the more diminutive metal example by Storr. True, some adjustments are detectable, but the silver figure does succeed in capturing the dignified lyricism and fresh radiance of this prototype, as well as its somewhat chilly Roman classicism tempered by elegiac naturalism.

continued

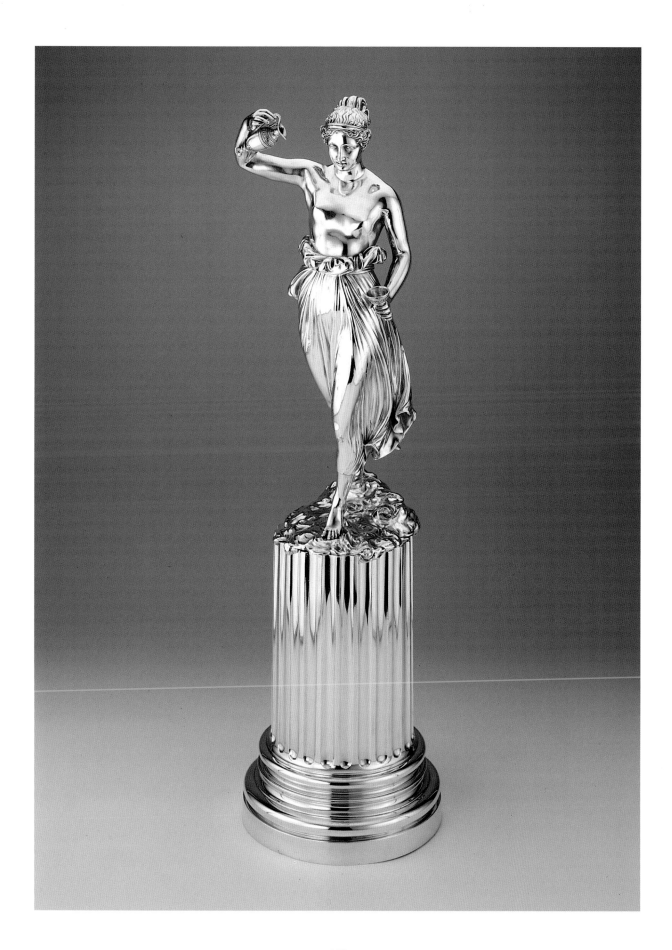

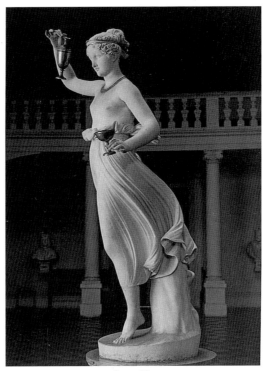

Cat. No. 59 continued

The history of this silver statue is nearly as well-established as the marble on which it is based is famous. Culme called attention to a codicil in the will drafted by its previous owner, the former stage actress Harriet Mellon (ca. 1777-1837), who became the Duchess of St. Albans upon her marriage to William, 9th Duke of St. Albans (1801-1849).[203] It reads in part:[204]

> "I give to the said Duke [William] . . . the silver-gilt service of plate in my mansion-house or residence in Piccadilly, and the silver Hebe and stand presented to me by Sir Francis Burdett"

This invaluable excerpt proves that it was a treasured gift from Sir Francis Burdett (1770-1844), a controversial English politician.[205] Possibly the Duchess's silver dessert flatware might have been in the "Canova" pattern, too, in which works by Canova — including Hebe, Sappho, and Dancing Girl Reposing — decorate the stems and backs, as shown in several sets.[206] In summation, Culme pontificates on the seminal role Hebe played in nineteenth-century English silver design:[207]

"It appears that Hebe was a favorite subject with silversmiths' designers; apart from forming the handle on various table bells . . . James Dudley, a London silversmith . . . was responsible for a silver-gilt mounted green glass spirit bottle for Scotch whisky, the stopper for which was a miniature version of Canova's Hebe. It was appropriate that Hebe, the goddess of youth who possessed powers of rejuvenation, should adorn the bottle: the name "whisky," an abbreviation of whiskybae," from the Gaelic "uisgebeatha," means "water of life."

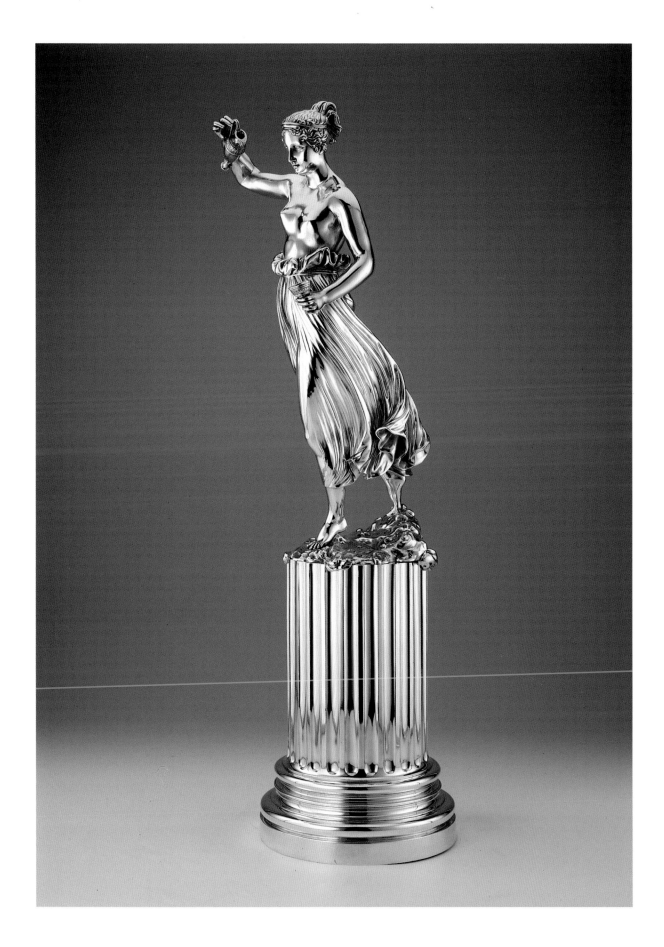

Cat. No. 60

DRESSING SERVICE

Silver-gilt, glass, steel, brass, ivory, enamel, rosewood, velvet
Marks:
1. London, 2. sterling standard, 3. 1829-30, 4. maker's mark of Paul Storr (Grimwade, no. 2235), 5. duty stamp, fully marked on a number of pieces; partly marked on others.

Length of case: 16¾ in. (42.5 cm.)
Gross weight: 437 oz., 5 dwt. (12403 gm.)

Published:
Armstrong, *Architectural Digest*, February 1982, p. 72.

Description and Construction

Gentleman's toilet service fitted within a hinged, silver mounted and velvet lined rosewood travelling case; deep inner chamber holds four cut-glass toilet water bottles, a shaving jug with a detachable ivory mounted handle, a cylindrical shaving beaker, two long glass boxes with pierced covers and seven smaller silver lidded containers with glass or silver compartments; sliding lower drawer accommodates an assortment of writing and manicure implements including propelling pencil, enamel and apostle capped dip pen, two pairs of scissors, nail file, tooth pick/probe, cork screw, thimble, buttonhook, shoelace threader, bodkin, and tongue scraper; box covers and bottle lids with scrolls, shells, flowers, and quatrefoil reserves surrounding a central coat-of-arms; brass plaque engraved with a crest screwed to the top of the case; pull-out carrying handles at the sides emerge from silver appliques in the form of shells set within the carcass of the case.

Heraldry

The slightly later arms are those of Bruce impaling Clifton for Sir Henry Hervey Bruce (1820-1907), High Sheriff of Londonderry, who married Marianne Margaret, daughter of Sir J. G. Jukes Clifton in 1842.

Concern for one's physical appearance — an interest of both sexes — has been addressed by individuals of all cultures with the aid of cosmetics and other sundry vanity articles for time immemorial. One of the more personal and costly of the silver particulars carried out during this period was the multi-component toilet service with mirrors, combs, cosmetic containers and boxes of all sorts and sizes, scent bottles, pomade jars and other dressing utensils and baubles. The earliest of these were made for a lady's boudoir, a precious and rare example being a Charles II toilet service of 1679 at the Virginia Museum of Fine Arts.[208]

Extensive dressing cases of the sort catalogued here were a natural offshoot of earlier toilet services like the one just mentioned except that the later ensemble was meant to pamper and accompany a gentleman traveller. Both wonderfully self indulgent and efficient, these fitted cases were almost always equipped with a "secret" drawer, as on this one, and a number of English goldsmiths were concerned with their manufacture, although in restricted quantity due to their expense. Within reach of only the well-to-do, these ponderous carryalls eventually became obsolete when the aristocracy found it necessary to significantly reduce their hired help.

This dressing service is one of four masculine grooming services by Storr hencefar identified. Another of 1834 and 1835 also contains silver-gilt boxes and bottles decorated with scrolls and flowers in a Rococo-revival manner.[209] Stored in an amboyne box, that one boasts coronets and cyphers and the initials "MA" possibly for Archibald, 1st Marquess of Ailsa. Seemingly, the earliest of 1819 and the latest of 1837, both — like ours — in rosewood case were known to Penzer.[210]

Cat. No. 61

COFFEE POT

Silver-gilt
Marks:
1. London, 2. sterling standard, 3. 1830-31, 4. maker's mark of Paul Storr (Grimwade, no. 2235), 5. duty stamp, fully marked on the underside of the pot; partly marked on the lid flange.

Height: 10⅝ in. (27 cm.)
Weight: 31 oz., 9 dwt. (904 gm.)

Provenance:
Lillian and Morrie A. Moss, Memphis.

Exhibited:
Indianapolis, Indianapolis Museum of Art, 7 February–12 March 1972.
Dayton Art Institute, 24 March–30 April 1972.

Published:
Moss, 1966, p. 13.
Moss, 1972, pp. 104-05, plate 44.
Indianapolis, 1972, p. 18, cat. no. 68.

Description and Construction

Pear-shaped coffee pot of irregular contour supported on four cast and openwork scroll feet with pierced and unpierced lozenges; unhinged, removable, and regilded cover in the form of concave and convex lobes and cockscrews interspersed with punctuated and solid lozenges; raised cover outfitted with a seam strip flange and securing bracket fits tautly into the top of the pot above a scrolled rim; repoussé clusters of birds, insects, butterflies, flowers, grapes, pears and other fruit set within broken scroll cartouches constitute the sole ornamentation on both sides of the body; short spout cast with strainer inside for stopping the flow of sediment from Turkish coffee; spout adorned with voluted scrolls and leaves springs upwards ending in a tightly-pinched lip; double scroll handle cast and chased with whirling foliage; crest crowned with the monogram "T.H.S." engraved on the bottom.

Heraldry

The crest is unknown.

The arrival of Huguenot artisans during the late seventeenth century is but one of a long succession of cross-channel migrations that altered the future course of British silversmithing. Other foreign goldsmiths relocated not out of fear of religious persecution, but of their own free choice. One was Christiaen van Vianen (1598-1667), nephew of the more famous Dutch silversmith, Paulus van Vianen (ca. 1565/70-1613).[211] In 1632, the younger was in London in the service of Charles I, returning to his native Utrecht in 1643, but he was back at the English court around 1660, dying there in royal service.

continued

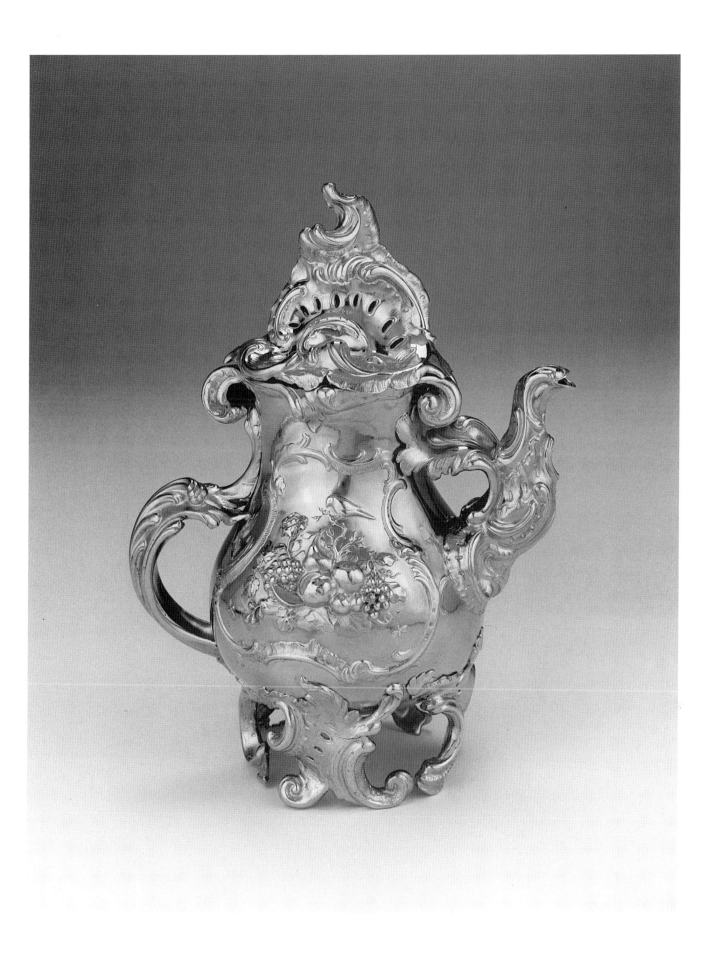

figure 23 Photo courtesy Victoria and Albert Museum

Cat. No. 61 continued

Christiaen was content to rely primarily on the designs of his father, Adam van Vianen (ca. 1565-1627), going so far as to publish a volume of both their works called *Modelles artificiels de divers vaisseaux d'argent* in 1650. The son, however, introduced into England the Auricular style to which this fairly amusing coffee pot is partly indebted. When compared with a design by the elder van Vianen, both the similarities and differences conspicuously emerge (figure 23).[212] The affinities rest mainly on the capriciously distorted silhouettes enshrouding fanciful surface details of curving and slithering lobes. Yet the silver pot declines to convey the dissolving liquidity of mass, and the structural elements do not metamorphorsize into figural representations. Simultaneously, the limited adornment on the central body allows the underlying mode of construction to remain less obscured.

Mart. Engelbrecht excud. A.V.

figure 24 Photo courtesy Germanisches Nationalmuseum Nürnberg

This piece also owes allegiance to South German silversmiths' work of a century later. One printmaker responsible for the dissemination of his country's interpretation of the Rococo style was Caspar Gottlieb Eisler of Nuremberg, whose work has been compared by Snodin with de Lamerie's.[213] In publishing a pattern for a coffee pot of ca. 1750 by Eisler at the Germanisches Nationalmuseum in Nuremberg, Snodin notes that this combination of auricular shapes with corkscrew decorations recalls de Lamerie's manner, although the late date of the print makes it improbable that de Lamerie — but possibly not Storr, we might suggest — could have been inspired by engravings of this character (figure 24).[214] Particularly significant is that the lobed ornament in this print and Storr's object is less molten than van Vianen's, and absent, too, is such an intense interest in figurative depiction.

Cat. No. 62

COFFEE JUG

Silver, ivory
Marks:
1. London, 2. sterling standard, 3. 1833-34,
4. maker's mark of Paul Storr (Grimwade, no.
2235), 6. duty stamp; fully marked on the bottom
of the base; partly marked on the cover flange
and along the bottom of the handle; stamped
underneath the base: STORR AND MORTIMER
and 273.

Height: 11 in. (28 cm.)Gross weight: 30 oz.,
9 dwt. (876 gm.)

Description and Construction

Covered jug with twisting body flat-chased with
swirling zones of shells, scrolls, and trellis work
alternating with single and triple diagonal flutes
some terminating in leaves; armorial and crest
engraved on the body; balanced on circular and
indented foot chased with scroll and trelliswork;
partly bifurcated handle of tendril form and
texture capped with leaves and subdivided by
ivory insulating rings; handle ferrules attached
at the top by longitudinal sockets and pins and
the bottom springs upwards from coffee plant
sprays and beans; short pouring beak with a
stationary curving lid projects up from the rim;
hinged lid with similarly chased motifs rises to a
small and plain round lift accentuated by a
wrythen finial; strainer coarsely excised from the
beak; jug probably originally stood atop a stand
with a heating device.

Heraldry

The arms are those of Quin impaling Spencer for
George Quin (1792-1888), 2nd son of Thomas,
1st Marquess of Headfort, who in 1813 assumed
the name of Quin. On 14 April 1814 he married
Georginia Charlotte, 2nd daughter of George
John, 2nd Earl Spencer.

Vessels of such pleasant and rhythmic form are often misleadingly termed as hot water jugs in modern
parlance. However, there are specific structural considerations that unite as well as differentiate hot
water from coffee jugs. True, both have a pouring lip or beak with a sealed flap attached close to the lid
as opposed to a tubular spout located mid-way down the length of the receptacle as on a coffee pot.
Yet the major variance is that the inside beak of the coffee jug is inset with a strainer since they were
usually made for heavily sedimented Turkish coffee. Were it not for the presence of such a partial
obstacle, the unsavory residue would pass uninterruptedly through the lip during pouring.

Close physical scrutiny of this coffee pot reveals
that the original strainer has been crudely cut
out of the interior of the hollow chamber. The
appearance of the cast coffee plant spray
replete with beans located below the
imaginatively concocted handle reaffirms its
intended function. It is instructive, too, that the
other two known jugs of this model by Storr were
likewise planned for serving coffee. An
apparently identical one was part of a large
silver-gilt Breakfast Service made for Robert
Henry Herbert, 12th Earl of Pembroke and 9th
Earl of Montgomery (1791-1862), whose plate
collection is coincidentally represented in this
collection by a sole basket of 1836 from another
service.[215] Less accomplished in design and
chasing, but, nevertheless, related is an earlier
coffee jug of 1829 retaining its original stand
and burner.[216] Storr must have been somewhat
enamored of several of the ornamental and
technical elements decorating these pieces. As
random examples only, a handle of not
unrelated facture occurs on a small cream jug of
1820 and allied fluting is found on a number of
works, not least one of the more ambitious
mustard pots in the Colman Collection.

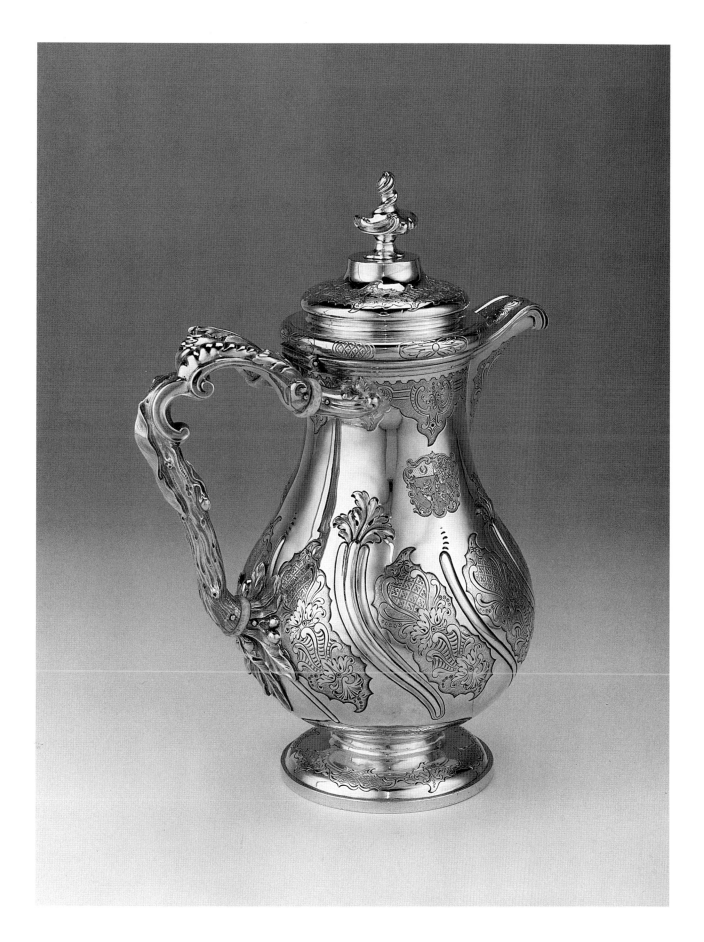

Cat. No. 63

STIRRUP CUP

Silver, parcel-gilt interior
Marks:
1. London, 2. sterling standard, 3. 1834-35, 4. maker's mark of Paul Storr (Grimwade, no. 2235), 5. duty stamp, marked along the exterior of the neckband.

Height: 6½ in. (16.4 cm.)
Weight: 17 oz., 3 dwt. (490 gm.)

Clayton, 1985a, p. 389 (mentioned).
Newman, 1987, p. 302 (mentioned).

Description and Construction

Presentation drinking cup taking the shape of an assuredly modeled stag head; features consist of prominent antlers terminating in seven points, perched ears, keen eyes, broad snout, and parted mouth; head and exterior of flaring back support stippled and punched to create frosted textural effects; angled lip adorned with encircling band of alternating egg-and-dart elements inside of a thin molding; piece cast in halves and soldered together; hollow interior partially gilded.

One of two cups of this sort by Storr in this collection, this visually realistic creation was planned as a trophy prize, yet it lacks a congratulatory inscription. Stirrup cups assumed the form of the heads of a number of animals, and their representations fluctuated from highly stylized to more exacting portrayals. Greyhounds, boars, hares, and stags were deemed appropriate subjects, and Newman even refers to a rare set of stag hoof cups by the London silversmith John Robins (active 1764-1831) of 1802.[217]

To our understanding, Storr manufactured only two other stag head cups. Differing significantly in details and facture, they were not cast from an identical mould as was apparently the situation with others. One cognate example was also made in 1834 for Prince George of Cambridge (1819-1904), a grandson of George III, who conferred it upon Charles Davis according to its inscription.[218] Sterner and more foreboding in facial countenance, the silky softness of the textured coat is felicitously transmitted through careful chasing. Dated 1835, the third cup like this one discloses a calmer disposition and terser handling of surfaces, yet the antlers here are inventively configured as a handle for grasping ease.[218]

Cat. No. 64

BASKET

Silver
Marks:
1. London, 2. sterling standard, 3. 1836-37, 4. maker's mark of Paul Storr (Grimwade, no. 2235), 5. duty stamp, marked on the side of the bowl; engraved on the underside of the base: NO. 2 and MP.

Length: 16 1/4 in. (41.3 cm.)
Weight: 43 oz., 7 dwt. (1238 gm.)

Scratch weight: 43:16

Description and Construction

Shaped oval basket of deep depth almost entirely cast; scalloped-edge border abounds with minutely burnished, partly matted, and asymmetrical Rococo cartouches of scrolls, leaves, shells, and quatrefoil scalework reserves with a monogram and coronet at the recessed central top and bottom; smoothly dipping sides of the well decorated with diaperwork and scalework clusters and eight convex and curvaceous flutes initiate from leaves; flat central cavity is plain aside from an engraved monogram cypher crowned with a coronet; sloping exterior sides with concave impressions resulting from the inside repoussé ornament; stands on a separately wrought pedestal foot base affixed with solder to the bottom.

Heraldry

The entwined monograms, both engraved and cast, are those of Robert Henry Herbert, 12th Earl of Pembroke and 9th Earl of Montgomery (1791-1862).

Robert Henry Herbert, 12th Earl of Pembroke and 9th Earl of Montgomery acquired at least two table services from Storr. A renegade by Victorian standards of proper conduct, his problems arose from his tempestuous love affair with Princess Ottavia Spinelli (died 1857), daughter of the Duke of Laurino, who he wed in 1814. The nuptials were considered clandestine by Sicilian Law, and his father intervened with the result that the authorities imprisoned Lord Herbert and placed his wife in a convent and the couple never reunited. After escaping, Pembroke succeeded to the Earldom on his father's death, took his seat in the House of Lords in 1833, and succumbed without issue decades later in Paris.

Touched upon above in connection with another silver article in this collection, Pembroke's silver-gilt Breakfast Service of 1829-1836 was dispersed as a single unit awhile ago.[220] Alternatively, this exquisite basket was part of an expansive dinner set commissioned between 1828-1836 which was ostensibly vended piecemeal with the result that the whereabouts of some components are known, while others have disappeared to uncertified locations. This basket is not of unique design as another of 1837 without the entwined monogram and coronet of the Duke was in the Christner Collection, and one of 1835 is also recorded.[221] Having their formal origins in eighteenth-century spoon trays of conforming shape with spiralling flutes, these baskets are ubiquitously termed as "fruit dishes," but they might just as well have once held desserts or sweetbreads.

On the basis of the inclusion of the heraldic devices of either the monogram or the wyvern of the Pembroke family, it is possible to single out individual pieces initially included in this service. In shape and ornamentation the Pembroke Basket has much in common with a pair of platters of 1834 from the same set which eventually entered the Moss Collection.[222] A piece of vastly differing type but one in which the wyvern functions as the handle is a sauce boat of 1835, no doubt also meant to be used together with these other items at Lord Pembroke's dinner table.[223]

Another creation from the set, of pronounced disparity, is the massive eight-light candelabrum of 1835 surmounted by the wyvern which found its way to the Metropolitan Museum of Art as early as 1959.[224] The most recent and equally impressive piece in scale to emerge from this group is the sideboard dish of 1828, which was offered at auction as late as 1991.[225] Indubitably, other objects from this treasured set are bound to come onto the market in the future, which will eventually enable a fairer and more comprehensive assessment of what is now a hodgepodge assortment of exceptionally diverse objects from a long neglected service.

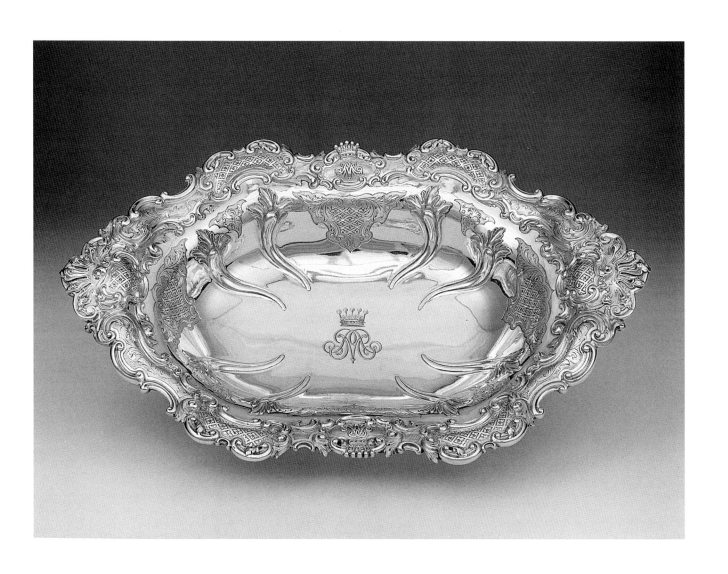

Cat. No. 65

WRITING SET

Silver-gilt
Marks:
1. London, 2. sterling standard, 3. 1837-38,
4. 1838-39 (hand taperstick), 5. maker's mark of
Paul Storr (Grimwade, no. 2235), 6. duty stamp,
fully marked on top of the inkstand, underneath
the pen rest, and the bottom of the taperstick;
partly marked on the inkstand cover,
underneath the pot, and the extinguisher;
stamped on the bottom of the stand: STORR &
MORTIMER 219; stamped underneath the
taperstick: STORR & MORTIMER 178; stamped
on top of the stand: 1.

Height of Inkstand: 7½ in. (19 cm.)
Height of Hand Taperstick: 2½ in. (6.4 cm.)
Length of Pen Tray: 12½ in. (31.7 cm.)
Gross Weight: 102 oz. (2891 gm.)

Provenance:
Christie's, London, 24 February 1971, lot 166.
I. Freeman, London.
Lillian and Morrie A. Moss, Memphis.

Published:
Moss, 1972, pp. 44, 262-63, plate 194.
Clayton, 1985b, p. 292.

Description and Construction

Desk service of three matching items; triangular
inkstand cast in three sections with a cast and
applied rim lifted on voluted scroll and shell feet;
stand accommodates three cut-glass bottles at
the angles and a circular pot on claw feet with
female masks, scrollwork, and a gadrooned lid
capped by an amorino; pot bolted to the stand
from the bottom; oblong pen tray of scroll outline
with partial interior fluting rests on cast shaped
feet; hand taperstick of curvaceous silhouette
with a long cast handle and floral-headed
socket; plain extinguisher with a baluster finial
slides into a ring on the socket; cypher with a
coronet engraved on each piece; one glass
bottle replaced.

Heraldry

The monogram surmounted by an earl's coronet
is that of Charles, 4th Earl of Hardwicke.

Chronologically, this desk set made *en suite* is the latest work in this collection marked by Storr, who
retired in 1838. Just prior to that, in about 1830, the earlier French Rococo manner of the eighteenth
century emphasizing energetic scrollwork and shell motifs was resurrected once again. Dubbed
erroneously as "Louis XIV," this urbane style was stimulated by the flamboyantly conceived and
meticulously modeled pieces created by Parisian goldsmiths such as Germain and Meissonnier. The
asymmetrical shapes of these writing accoutrements resemble in general form a couple of the silver
masterworks by Germain, but their malleability can be best compared with the fanciful designs of
Meissonnier.[226] While by no means as highly charged, their sinuously curving and swelling outlines
resemble the patterns popularized by him as this sheet from the *Oeuvre de Juste-Auréle Meissonnier*
demonstrates (figure 25).[227]

continued

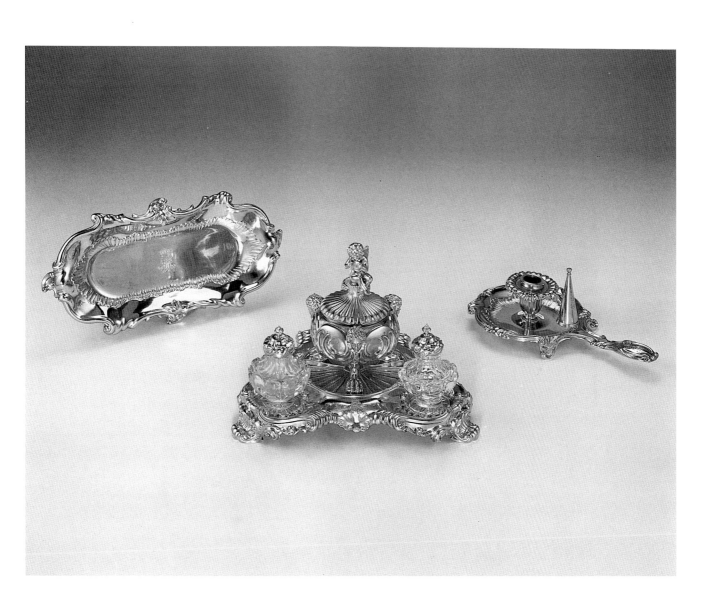

Cat. No. 65 continued

A couple of similar pieces by Storr's successors exist, most especially this identical but sole inkstand of 1840-1844 by both Mortimer and Hunt and Hunt and Roskell.[228] It should be mentioned that these cherub finials are recurring features in Storr's oeuvre. A relationship might be drawn with the boy sitting on the platform of the Portland Font of 1797, but it is within his later works that this identical figure — probably cast from the same mould — is repeatedly encountered. Comparable figures were carried out by other London silversmiths as well. Two adorn the apex of a silver-gilt inkstand of 1843 by Charles Thomas (born 1801) and George Fox (born 1816) at Brodick Castle, which in other salient respects also resembles the service published here.[229]

The arms are those of the Fourth Earl of Hardwick.

Yorke, Charles Philip (1799-1873), born at Sidney Lodge at Southampton on April 2, 1799. After three years at Harrow he entered the Royal Naval College at Portsmoth in February 1813. In May 1815 he was appointed as Mid Shipman on the "Prince" flagship at Spithead. Then to the "Leviathan" and then to the "Queen Charlotte," in which he was involved at the bombardment of Algiers.

After several promotions, he was made commander of the "Alacrity," which was actively engaged in the suppression of piracy in the Mediterranean. In June 1825, he was promoted to the rank of Captain and from 1820 to 1831, he commanded the "Alligator" in Greek waters.

He was M.P. for Reigate 1831-2 and for Cambridgeshire 1832-4. On the death of his uncle, Philip Yorke, 3rd Earl of Hardwicke, on November 18, 1834, without male issue, Charles Philip, succeeded to the title.

In 1844-5 he commanded the "Black Eagle" yacht, and carried back to the continents the Emperor of Russia, who presented him with a valuable diamond snuff box.

On January 12, 1854 he was put on the retired list with the rank of Rear Admiral. He died on September 17, 1873 at Sidney Lodge.

figure 25 Photo reproduced from *Oeuvres of J. A. Meissonnier,*
edited by D. Nyberg, 1969

Cat. No. 66

TWO WINE COOLERS

Silver
Marks:
1. London, 2. sterling standard, 3. 1845-46 (one vase), 4. 1855-56 (one vase and one collar and liner), 5. 1837-38 (one liner), 6. maker's mark of John S. Hunt (Jackson, 231), 7. maker's mark of Paul Storr (Grimwade, no. 2235) (one collar and liner), 8. duty stamp, fully marked on the bodies of the vases and on one collar and liner; partly marked on the other collar and liner; stamped on one vase: No. 2295 PUBLISHED AS THE ACT DIRECTS BY HUNT & ROSKELL 156 NEW BOND STREET LONDON DECR. 9 1846; stamped on the other vase: HUNT & ROSKELL LATE STORR & MORTIMER 7054; stamped on one liner: 4.

Height: 12½ in. each (31.8 cm.)
Weight: 120 oz., 3 dwt. (3410 gm.) and 122 oz., 1 dwt. (3461 gm.)

Provenance:
P. J. Dearden, Esq.
Sotheby's, London, 12 November 1970, lot 139.
N. Bloom and Son, Ltd., London.

Published:
Culme, 1977, p. 105 (mentioned).

Description and Construction

Wine coolers of heavy gauge in the form of ancient krater vases; deep hollow basins with plain removable collars and detachable cylindrical liners with locating shafts; each with a beaded and ovolo brim connected to soaring double scroll handles with laurel, guilloche, and rosette motifs springing from cranes; deeply fluted necks lead to frosted bodies cast in low relief; one depicts Ariadne crowned with the Corona Borealis and Dionysus in a quadriga being led through clouds to Jove by Eros, Maenads, and Bacchantes above masks of Hercules and Silenus joined by vineyard festoons; second shows Ceres reclining in a serpent-drawn chariot amongst wheat rushes with attendants bearing gifts of the harvest, worshippers, a philosopher, and a river god above Plutus heads connected by wheat swags; both rest on lobed, semi-circular and cube-shaped bases; stag crest engraved on each plinth and collar.

Heraldry

The crest is untraced.

English neo-classical silversmiths favored classical vase forms in designing wine coolers usually made in pairs of two or four. Often these were glamorously retailed in a contemporary carrying case as the two to be discussed here were when they appeared at auction in 1970.[230] These are equipped with liners so that the bottles can be isolated from the iced water and chunks deposited in the pails for easy replacement of empty bottles with fresh ones.

It has been demonstrated that a closely compatible wine cooler with an encircling Bacchanalian procession by several goldsmiths including Storr is based in part upon a second-century Roman marble relief in the Vatican Museum in Rome.[231] Similarly, the narrative friezes of the two current coolers might also be copied from presently unidentified reliefs on ancient Dionysian and Eleusinian sarcophagi.[232] The cranes following the curvature of their necks and shoulders are a common ancient motif often found in the work of Piranesi, Tatham, Pencer and Fontaine, and one which appears, for instance, in somewhat differing form on the Standing Cup by Garrard catalogued below.[233]

Storr and his successors carried out a considerable number of coolers in these specific designs. By far the most famous is the Lumley Cup by Storr of 1837 which depicts Dionysus conducting Ariadne to Jove. Mounted on a later base dated 1845, it resides at the Victoria and Albert Museum (figure 26).[234] The cup was presented to the operatic impresario Benjamin Lumley (ca. 1811-1875) in recognition of his first successful season as proprietor of Her Majesty's Theatre in London. Lumley speaks most affectionately about it in his memoirs:[235]

> "Above all I would mention a magnificent testimonial from the artists of the establishment
> . . . The presentation of this testimonial was, perhaps, the most gratifying incident of the
> year. It was spontaneously 'got up' by the co-operation of all the artists, in both the operatic
> and the choreographic departments of the theatre . . . and was presented to me on the
> 18th of July, with the following inscription:–'Hommage à Monsieur B. Lumley, par les
> artistes du Théâtre de Sa Majesté, en commemoration de l'heureux événement qui assure
> ce Théâtre la continuation de sa bienveillante et juste administration.'"

continued

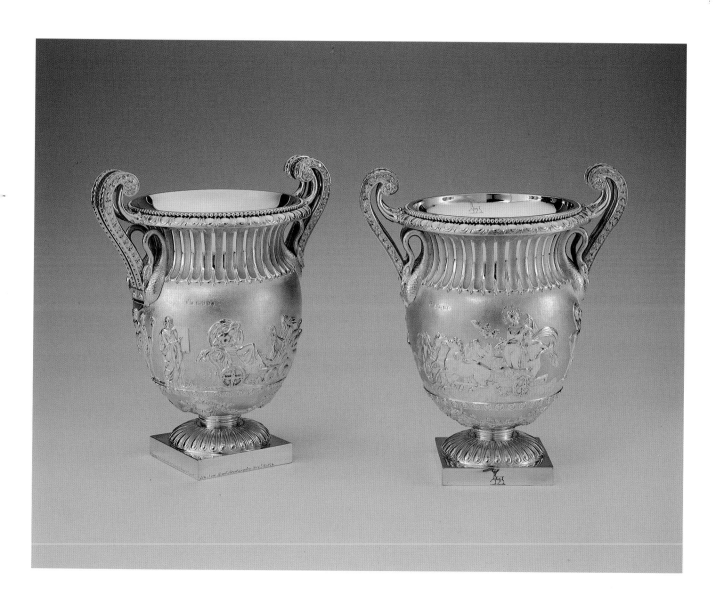

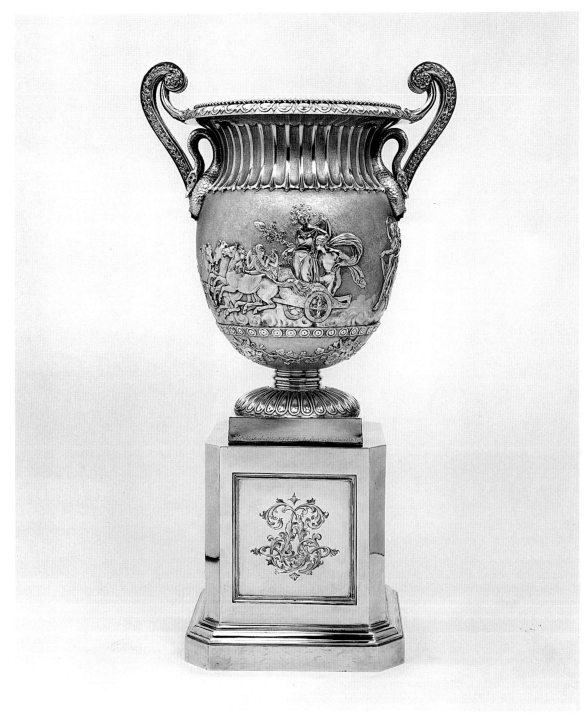

figure 26 Photo courtesy Victoria and Albert Museum

Cat. No. 66 continued

Such coolers remained popular continuously throughout the century as attested not only by the actuality of widely dated specimens, but also because a vintage photograph taken at the International Exhibition of 1862 shows a pair of this sort included amidst the silver displayed in the booth manned by the firm of Hunt and Roskell. And at the Crystal Palace Exhibition of 1851, it is, furthermore, reported that "the compartment of Messrs. Hunt and Roskell, Late Storr and Mortimer, alone contained no less than three tons' weight of silver."[236]

ROBERT GARRARD I AND ROBERT GARRARD II AND BROTHERS

Robert Garrard I (1758-1818) and Robert Garrard II (1793-1881)

The elder Robert Garrard was born on November 15, 1758, the second son of a Cheapside linen draper. He was not trained as a working silversmith but rather served his apprenticeship under a London "hardwareman" and member of the Grocers' Company. When made free of that Company in 1780, Garrard described himself as the "late apprentice to Stephen Unwin now with Messrs. Wakelin & Co. Goldsmiths, Panton Street, Haymarket." He probably dealt mainly with the business side of this prestigious firm that George Wickes had established in 1722. He married in 1789 Sarah, presumably the daughter of Sebastian Crespel, who with James Crespel were the primary outworkers for Wakelin & Co. after 1769. John Wakelin took on Garrard as a partner in 1792, at which time they entered their joint mark at Goldsmiths' Hall. From John Wakelin's death in 1802, Garrard was the sole owner of the business until his own death sixteen years later. He was succeeded by his three eldest sons: Robert II (1793-1881), James (1795-1870), and Sebastian (1798-1870). The firm was known as R.J. & S. Garrard or Robert Garrard & Brothers. Robert maintained his position as the controlling member in a succession of partnerships for over sixty years until his death in 1881. He had served his apprenticeship with his father and was made free by patrimony of the Grocers' Company in 1816. He was elected its Master in 1853, while his brother James was active in the Goldsmiths' Company, eventually appointed its Prime Warden in 1847 and again in 1850. The firm rapidly expanded and prospered under Robert's direction to become the leading retail concern in the London silver trade during the middle decades of the century. They were appointed Goldsmiths and Jewellers to the King in 1830 and Crown Jewellers in 1843, supplanting Rundell, Bridge & Rundell both in position and influence. Like Rundell's, they had by this time developed a strong design department that the sculptor Edmund Cotterill headed from 1833 until 1860. He was responsible for a large number of well designed and modelled sculptural groups, centerpieces, vases, and sporting cups, including the famous America's Cup of 1848. Family control of the firm ended after one hundred and fifty-four years with the death of Sebastian Henry Garrard in 1946. This collection brilliantly represents this firm's special ability in elegantly handling sculptural forms not only for presentation and display pieces but also for dining plate in historically revived and naturalistic styles. (Culme, 1977 and 1987; Garrard & Co. Ltd., 1991; Grimwade, 1976; Lever, 1974)

PAIR OF SOUP TUREENS, COVERS, AND STANDS

Silver, baize
Marks:
1. London, 2. sterling standard, 3. 1810-11, 4. maker's mark of Robert Garrard I (Grimwade, no. 2320), 5. duty stamp, fully marked on the bottoms of the tureens and stands; partly marked on the lid flanges; stamped inside of the covers and tureens: 1, 2.

Length: 21¼ in. each (54 cm.)
Gross Weight: 158 oz., 1 dwt. (4482 gm.) and 160 oz. (4536 gm.)
Scratch weight: 158=8 and 160=18

Provenance:
Sneyd Family, Keele Hall, Staffordshire.
Christie's, London, 22 or 24 June 1924.
William Randolph Hearst.
Parish-Watson & Co., New York, 1938.
Sotheby Parke Bernet, New York, 10-11 June 1975, lot 499.
Sotheby's, New York, 27 April 1990, lot 382.

Published:
Art at Auction: The Year at Sotheby's 1974-1975, p. 270.Garrard and Company, Ltd., 1991, p. 68, cat. no. 29 (entry by Clifford) (mentioned).

Description and Construction

Raised pair of bombé-shaped tureens supported on baize padded upturned shell and scroll feet issuing forth from realistically cast and chased boar and ram heads; broad shallow bodies engulfed with applied festoons of vegetables including turnips, artichokes, asparagus, cabbages, and mushrooms modelled in full relief; two foliate scroll and shell-capped handles spring from each side; detachable covers above reeded collars with flowerheads and shells lead to guilloche and ovolo stepped bands and plain domes surmounted by cast eagles with mantled wings hovering over strewn prey of fowls, pigeons, pheasants, and rabbits; conforming and elongated boat-shaped stands chased with raised fluted centers highlighted by acanthus sprays and bolted berries enframed by tied laurel and repeating ovolo registers and outer reeded and leafed rims ending in star-studded stylized shells and voluted hand-lifts; each elevated on scrolled and pierced cast supports; one baize pad missing.

Heraldry

The arms belong to Walter Sneyd, Esq. of Keele and Commander of the Staffordshire Regiment at Windsor and Lieutenant Colonel of the King's bodyguard (1752-1829) impaling those of the Hon. Louisa Bagot, daughter of William, 1st Lord Bagot. They wed on 9 May 1786. The crests are those of Sneyd.

continued

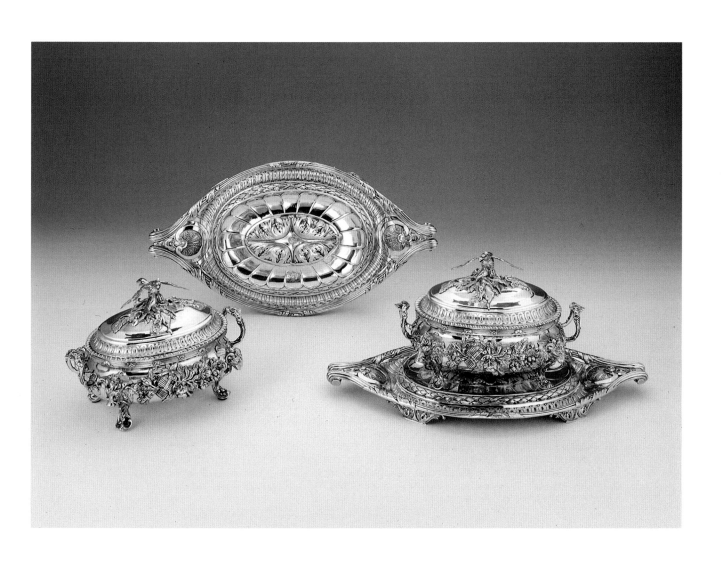

Cat. No. 67 continued

Garrards has long been esteemed for presentation silver in the form of trophies, racing cups, and table centerpieces in addition to useful wares such as these fascinating soup tureens made for the illustrious Sneyd family. Maintaining their family seat, Keele Hall, in Staffordshire, the Sneyds were dedicated collectors of plate, both antique and contemporary.[237] When in 1808 George III sold selected items from the Royal Collection to Rundells, the firm instead of melting down the trove insightfully sold the pieces to favored clients including Walter Sneyd. As a result, he procured a rare Huguenot chandelier of 1691-1697 by Daniel Garnier (active ca. 1687-1710), and ten of the earliest surviving English sconces, eight of ca. 1670 and two of 1700 by Philip Rollos (active 1675-1721).[238]

Adhering to a form popular during the mid-eighteenth century, these two are, nevertheless, distinguishable as later creations due to their elaborate surface ornamentation unlike that of their more restrained precursors.

Recently it has been shown that the identical design was utilized as early as 1757 by William Cripps (active 1738-1767) in addition to one of 1770 by John Parker (1734-1796) and Edward Wakelin (1717-1784), two earlier members of the concern today called Garrard & Company, Ltd.[239] Those tureens exist without their stands, yet a different kind of tureen known in at least one pair of 1772 by Thomas Pitts (ca. 1723-1793) — a documented supplier to Parker and Wakelin — rests upon stands of the exact pattern but with slightly different feet as those in the current collection.[240] Another heavier and more densely decorated example also missing its stand made two decades after ours carries the mark of Robert Garrard's son, and a further pair of 1809 by the elder Garrard is also recorded.[241] The intriguing merger of animal and vegetable motifs on these tureens confirms their original intent as serving receptacles for game soup.

195

Cat. No. 68

PAIR OF SAUCEBOATS

Silver
Marks:
1. London, 2. sterling standard, 3. 1824-25,
4. maker's mark of Robert Garrard II (Grimwade,
no. 2322), 5. duty stamp, fully marked inside the
bases; partly marked on the undersides of the
liners; stamped on the bottom of the bases:
GARRARDS, PANTON STREET, LONDON;
stamped on the liners: 3 and 5.

Height: 9½ in. (24.1 cm.) and 9¼ in. (23.5 cm.)
Weight: 56 oz., 5 dwt. (1601 gm.) and 55 oz.,
6 dwt. (1576 gm.)
Scratch weight: 3/01/13587 on each.

Provenance:
Mabel Grace Camelinat.
Sotheby's, London, 30 November 1972, lot 92.
Spink and Son, Ltd., London.
Sotheby's, London, 18 July 1974, lot 84.

Exhibited:
London, Garrard and Company, Ltd., 14 May–
8 June 1991.

Published:
Art at Auction: The Year at Sotheby's 1972-1973,
p. 292.
Waldron, 1982, p. 146, no. 450.
Garrard and Company, Ltd., 1991, pp. 64, 66,
cat. no. 27. (entry by Bliss).
North, 1991, p. 353 (mentioned).

Description and Construction

Boat-shaped sauceboats with partly fluted
bodies resembling ship hulls rest on rocaille
bases realistically cast in sections with waves,
shells, coral, and twin dolphins; tails of dolphins
rise to the pouring spouts or support the feet of
the figural handles; separately cast and chased
handles in the form of loosely draped and
seated mythological figures soldered to the
sterns; one probably represents Hebe holding a
cup and ewer, and the other Jupiter balancing a
cup on his head; raised detachable liners;
crests engraved beneath the spouts and on one
side of the liners.

Heraldry

The crest surmounted by a baron's coronet is
unidentified.

continued

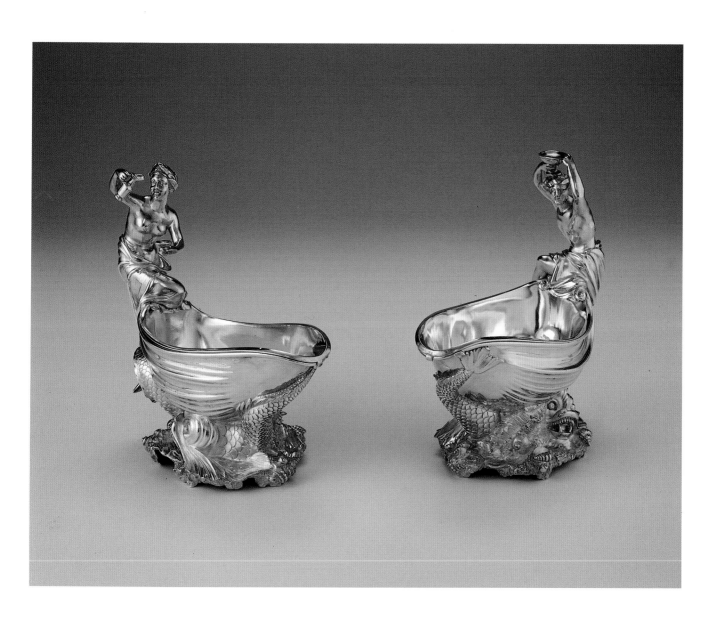

Cat. No. 68 continued

These superbly wrought sauceboats dramatically illustrate Garrard's leading role in manufacturing silver domestic objects with marine themes inspired by pieces created during the Rococo period. Indeed, the overall design and the dolphins in particular are directly related to a set of four sauceboats made in 1743 for Frederick, Prince of Wales by the Liegeois goldsmith Nicholas Sprimont in the Royal Collection.[242] Comparison of Sprimont's sauceboats with these clearly shows major differences in the figures forming the handles.

More faithful copies of Sprimont's pieces were made in 1780, including one set for the 4th Duke of Rutland by Robert Hennell (1741-1811), and later in 1819 by Robert Garrard II (1793-1881).[243] Garrards also drastically altered the design later in the century as shown on a pair of salt cellars of 1857 of decidedly Victorian taste in which small cupids serve as the handles.[244] A large set complete with ladles is itemized in the Garrard Ledgers against the account of the Earl of Harborough for 13 February 1819:[245]

> "8 finely chased sauceboats with figure handles supported by dolphins and rock work . . . 456 oz. 10 dwts. . . . £519 5s."

The numerals 3 and 5 engraved on the liners of the current sauceboats indicate that they, too, were initially part of a larger set.

Not surprisingly in view of the fact that Sprimont gave up goldsmithing in 1747 to assume the position as manager and later owner of the then fledgling Chelsea porcelain manufactory, partially related counterparts are also found in English ceramics of the period.[246]

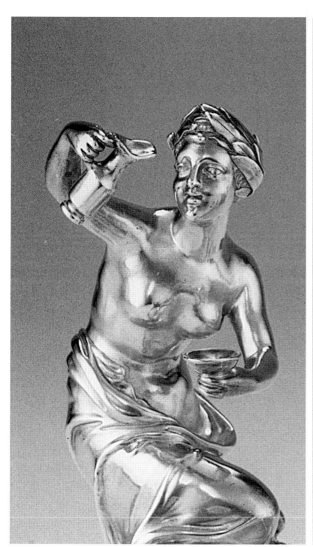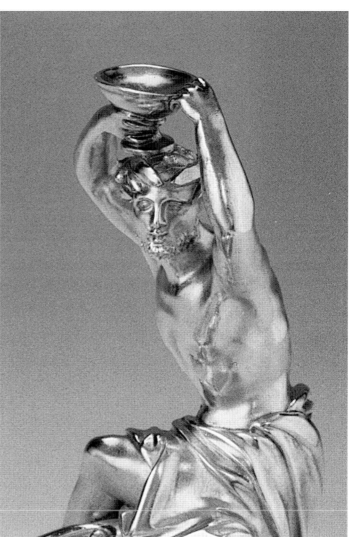

Cat. No. 69

PAIR OF CANDELABRA

Silver
Marks:
1. London, 2. sterling standard, 3. 1825-26,
4. 1826-27 (branch sleeves and nozzles), 5.
maker's mark of Robert Garrard II (Grimwade,
no. 2322), 6. duty stamp, fully marked along the
base edges and on the branch sleeves; partly
marked on the sockets, nozzles, and the wax-
pans; stamped on the branch sleeves: 1, 2;
stamped on the sockets, nozzles, and drip-
pans: 1, 2, 3, 4, 5, 6; stamped inside each base:
GARRARDS, PANTON STREET, LONDON.

Height: 23 in. each (58.5 cm.)
Weight: 160 oz., 4 dwt. (4547 gm.) and 161 oz.,
3 dwt. (4572 gm.)

Description and Construction

Pair of three-light candelabra each on a domed
cast base chased with basketweaving,
anthemion, and scrolls above circular platforms
uplifted on three shell and scroll cartouches;
marginally clad mythological characters
probably representing Bacchus and Ariadne or
Liber and Libera seated precariously atop vase-
shaped stems with fluted necks and vertically
ridged knops; adults support with uplifted arms
male infants wearing a plain or grape leaf
drapery swag; putti balance knurled and
campana-formed sockets chased with
quatrefoil, ovolo, and wave flourishes;
detachable reeded branches cast in halves
slide into the tops of the candlesticks by tubular
sleeves; branches interspersed with leaves and
floral buds spiral up to three removable drip-
pans each with smooth and matted leaves
beneath detachable lanceolate leaf sockets and
removable overlapping petal nozzles; spindly
finials cast with scrolls, leaves, and flowers
including carnations, peonies, and roses.

Magnificent partly on account of their sheer scale, skillful interplay of vertical and horizontal elements,
and the exploitation of textural effects extending from dry basketweave, to sensuous flesh, or
diaphanous leafage, these candelabra are carried out in the Louis XV taste. So attractive is the overall
design that it was repeated in both direct copies and free variations well into the nineteenth century. It
was initially introduced by the eminent French goldsmith Thomas Germain as early as 1732, who
proudly points to it in a portrait of himself and his wife by Nicholas de Largilliére (1656-1746) in the
Calouste Gulbenkian Foundation in Lisbon (figure 27).[247]

continued

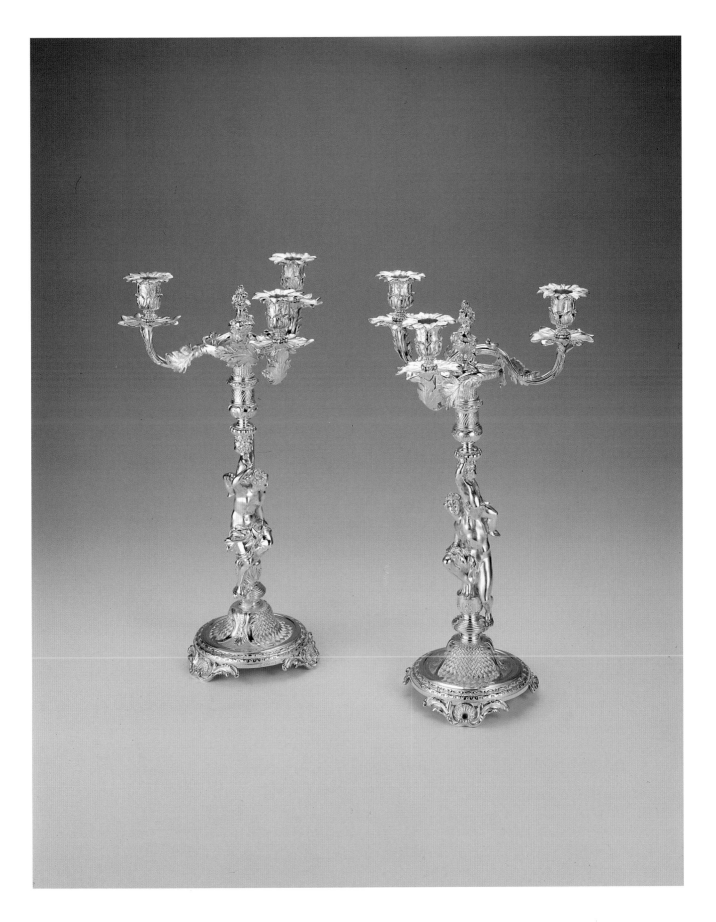

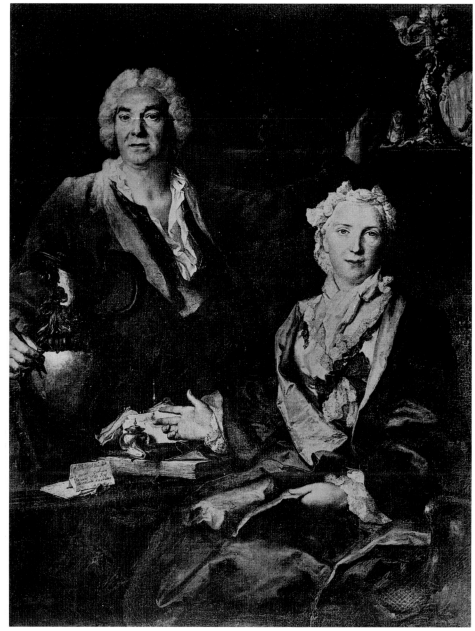

Cat No. 69 continued

As early as 1744 exact replicas were made in London by both John Le Sage (active ca. 1718-1750) and George Wickes (1698-1761), and later in 1770 Parker and Wakelin, Wicke's successors, also utilized the design for a pair in the Fairhaven Collection at Anglesey Abbey, Cambridgeshire.[248] How the pattern reached England is not fully certain, but a pair by Germain was at Ham House, Richmond in the eighteenth century and is now at the Detroit Institute of Arts.[249] Another pair of nearly the same model in the Espirito Santo Collection in Portugal was carried out in 1757 by Francois-Thomas Germain (1726-1791).[250] The last English examples to closely follow the originals are a pair of 1816 by Storr in the Al-Tajir Collection in London.[251]

Somewhat perplexing is that the first pair of British manufacture to be based on Germain's archetypes are not precise copies at all. In 1738 Kandler made use of the basic concept in a pair as of this date on the London art market.[252] Here, he incorporated major changes including the substitution of the domed basketweave bases and intertwined satyr couples on the originals for more fluidly shaped and heavily detailed supports above which the figures of Heracles and Iole hug the stems, the precise iconography of which has been explored by Schroder.[253]

Though not in the same way, the pair catalogued here also deviates from Germain's scheme, and the figures are certainly intended to depict specific deities from the ancient pantheon. The Bacchanalian implications of the motif of the grape vine swag draped around one of the boys are obvious, and leads to the speculation that the couple are Bacchus, god of Wine, and his wife Ariadne, or Liber Pater, the Italian god of wine, and his partner Libera.[254] The presence of the infants is perhaps best explained in that both of these Arcadian couples were associated with fertility cults rather than the children are meant to represent their own offspring.

Cat. No. 70

SOUP TUREEN, COVER, AND STAND

Silver
Marks:
1. London, 2. sterling standard, 3. 1827-28 (base and liner), 4. 1829-30 (cover and bowl), 5. maker's mark of Robert Garrard II (Grimwade, no. 2322), 6. duty stamp, fully marked underneath the stand and on the body; partly marked on the finial, inside the lid, the dolphin gills and all bolts and screws; base stamped: GARRARDS, PANTON STREET, LONDON; base and stem stamped: 1; dolphins stamped: 1, 2, 3, 4.

Length: 21½ in. (54.6 cm.)
Weight: 510 oz. (14469 gm.)
Scratch weight: 512 17

Provenance:
Sotheby's, London, 20 June 1988, lot 222.

Description and Construction

Formal tureen of campana form and great weight; removable domed lid with rippling flutes rising to a mound of overlapping water leaves and a finial simulating a crayfish wobbling over a pile of mussel shells and vegetables bolted into position; armorial engraved on the center of the raised and smooth bowl with a cast rim of overhanging lippets and shells above and a lower border of cresting waves; interior outfitted with a raised plain liner engraved with a crest and two cast scroll lift handles; stem assumes the form of quadruple dolphins each cast in half and secured to an inner waisted support by two bolts; entire structure supported by four additional screws to a bursting stand of swirling waves and shell-encrusted handles; twin-tailed triton holding a rudder while blowing a conch shell and a mermaid clenching a scallop and adjusting her luxurious hair serve as handles.

Heraldry

The arms are those of Higginson of Saltmarshe Castle, County Hereford quartering Barneby-Lutley of Brockhampton, County Hereford, for Edmund Barneby (1802-1871), son of John Barneby of Brockhampton. Inheriting Saltmarshe from his great-uncle, William Higginson, he took the surname and arms of Higginson.

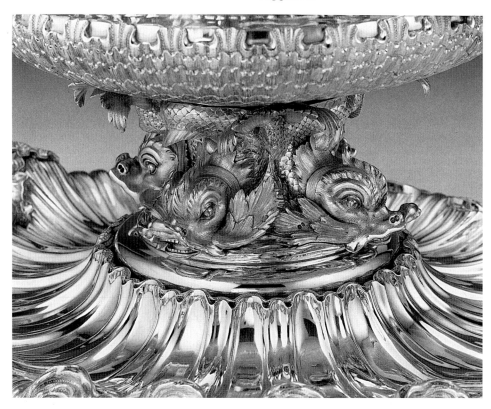

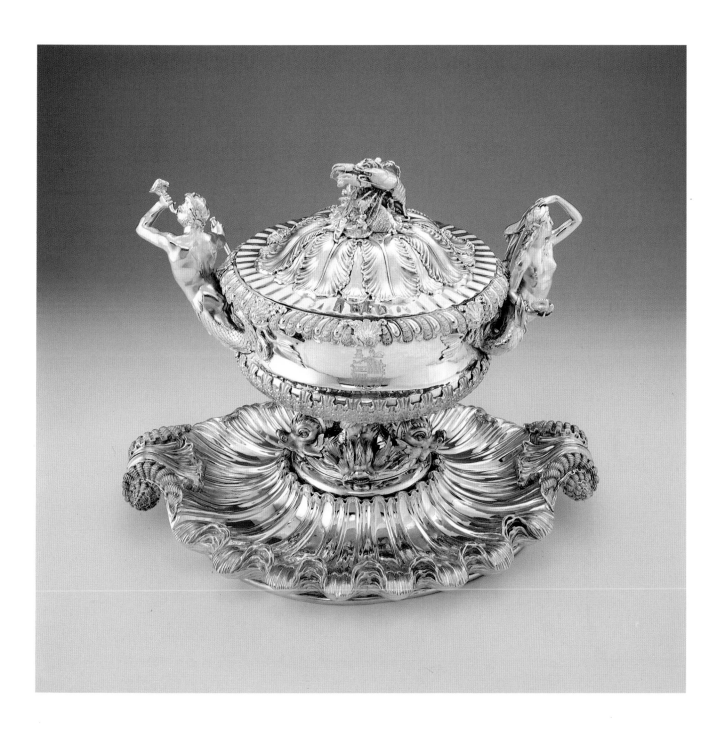

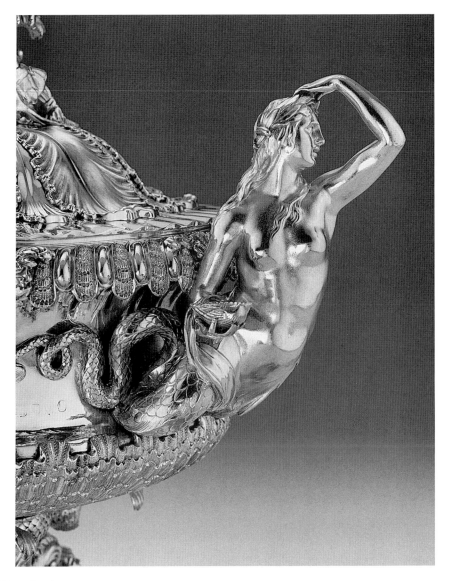

Cat. No. 70 continued

A tour de force of the English goldsmith's art both in terms of its monumental scale and flawless execution, this particular model — but not this specific tureen — belonged to the Earl of Harborough as set forth in his account in the Garrard Ledgers. Dated 12 June 1819, the citation enumerates:[255]

> "2 finely chased terrines, stands, with marine figures supported by dolphins, with linings . . . 1058 oz. 13 dwts . . . 1128."

A number of other nobles and the gentry were also willing to allocate vast sums on these exorbitant creations. While the Earl's set might tragically have been sent to the melting pot, others survive in addition to the single example published here. Another identical tureen of 1824 also by Robert Garrard II in the Campbell Museum has long been known in the literature.[256] The abundant decorative repertoire of nautical motifs enhancing its form suggests that it, too, was intended as a tureen for dispensing fish soup. Moreover, the affinities confirm that both were made from the same stock casting patterns.

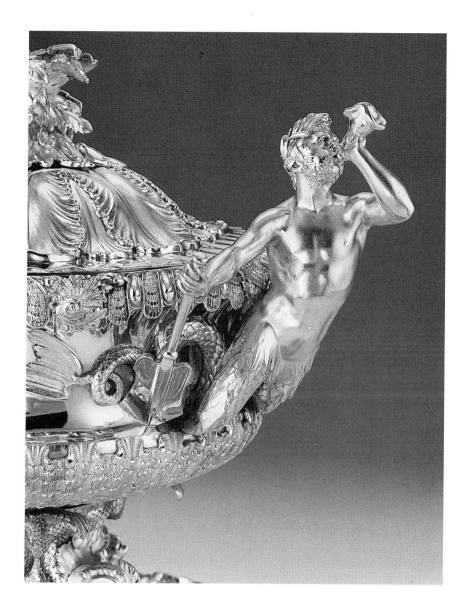

In reality the casting components had to have been lent to — or more probably were borrowed from Storr and Company — as two pairs marked by him are recorded. One set of 1820 and 1821 by Storr with the armorials of William, 6th Duke of Devonshire (died 1858) was sold from the Chatsworth Collection, and yet another pair of 1822 with the arms of the Portuguese barons Sampaio emerged at the von Bulow auction.[257] Collaboration of this sort between competing firms in the London silversmiths' community was almost certainly not as uncommon as it might initially seem. Culme has shown that the mermaid and the merman forming the handles on these tureens appear as base figures on a mirrored centerpiece by Storr and Mortimer of 1838, and Penzer published four dessert dishes of 1838 again by Storr on which nearly duplicate tritons occur.[258] Other instances demonstrating the mutual exchange of casting patterns by these firms have been noted elsewhere.

Not only was there a reciprocal interchange of production materials, but the parties involved even entered into negotiations concerning the allocation of workshop spaces. Penzer first called attention to this phenomenon, which Culme later recapitulated as:[259]

> "he [Storr] had come to an arrangement with the brothers Robert, James and Sebastian Garrard, working and retail silversmiths of Panton Street, Haymarket, whereby the latter leased a range of workshops from Storr in Francis Street adjoining Harrison Street. This probably occurred just prior to an insurance policy dated 18th November 1822 . . ."

Cat. No. 71

STANDING CUP AND COVER

Silver-gilt
Marks:
1. London, 2. sterling standard, 3. 1843-44, 4. maker's mark of Robert Garrard II (Grimwade, no. 2322), 5 duty stamp, fully marked on the lid and on the bowl; partly marked on the finial.

Height: 16¾ in. (42.5 cm.)
Weight: 53 oz., 7 dwt. (1522 gm.)

Description and Construction

Tall standing cup constructed from multiple segments fitted permanently together; removable cover with a border of lanceolate leaves and beading below a dome of strapwork, husks, and a voluted knop surmounted by a Royal crown; overhanging brim combines shells with plain bosses above a moulding of anthemion and lotus design; cylindrical-shaped upper body displays three empty cartouches of pure silver; lower bowl with heart-shaped lobes above a running leaf calyx from which bands jut upwards to accommodate three seated music-making boys; vertical tripod stem with three wolf heads and architectural turrets descends to addorsed cranes; domed spreading base with anthemion and leaf bands above a shaped and pierced apron panel of alternating medallions and wolf masks.

By the second decade of the nineteenth century revivals of the Rococo, Chinoiserie and the Gothic ushered in an unprecedented wave of eclecticism in English silversmithing. The historical conception of the Gothic style was not then limited to Medieval times but extended up to the seventeenth century. The popularity of Renaissance silver gained momentum as the century unfolded, because it captured the romantic admiration of private collectors on both sides of the Atlantic. Sir Augustus Wollaston Franks (1826-1897), Baron Ferdinand de Rothschild (1839-1898), and J. Pierpont Morgan (1837-1913) eagerly sought early continental treasures in precious metals.[260]

The major firms such as Rundell, Bridge and Rundell made pieces in a revived Renaissance style and smaller retailers like Kensington Lewis (ca. 1780-1854) eked out a living by selling plate of an antiquarian flavor.[261] Garrard's energies were primarily spent on silver simulating the marine Rococo style, but the Renaissance Revival was not left unaddressed. Perhaps, their most ambitious exercise involved translating a drawing by the German mannerist goldsmith Erasmus Hornick (ca. 1520-1585) into an organic silver-gilt ewer of extraordinary merit.[262] Executed in 1885, it was presented to the Worshipful Company of Goldsmiths in 1900.

continued

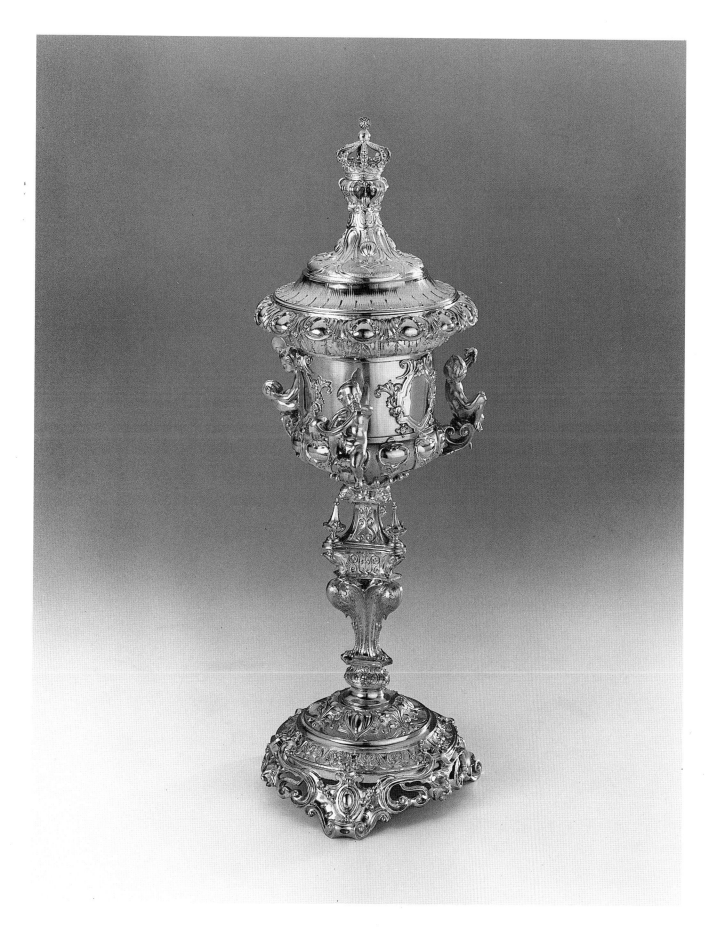

figure 28 Photo courtesy Victoria and Albert Museum

Soli deo honor, et ... gloria semper

QVIDQVID AGIS, PRV-
DENTER AGIS, ET QVOD
TIBI FIERI NON VIS, AL
TRI, NE FECERIS.

ANNO. M. D. LXII.

Cu gratia et priui. ...legio

Erasmus ... Nurm- ... berge. Hornnick F.

figure 29 Photo courtesy Kunsthistorisches Museum, Vienna

Cat. No. 71 continued

This glittering cup does not copy any existing Renaissance design to our knowledge. Rather, it is an eccentric creation composed of a hodge-podge of disparate elements gleaned from a variety of sources which manage to hold together visually in spite of the odd way in which they are piled up. Yet the basic form does vaguely resemble a drawing of a covered cup of ca. 1550 by Hornick at the Victoria and Albert Museum (figure 28).[263] The bosses enwrapped in scrolls on the base and the pointed architectural turetts on its stem are likewise motifs reminiscent of those appearing at the bottom and top of an engraving dated 1562 by Hornick which served as the title-page for ornamental albums entitled collectively *Grodesche et Arabesche* (figure 29).[264] It should also be noted that the foot of this cup has much in common with the swelling scrolls populating the designs in the Hornick Codices, as well as those by his contemporaries and followers, albeit it is as equally akin to those supporting a number of Rococo silver pieces.[265]

Inasmuch as this cup is influenced by ones of Renaissance date, the overriding character is absolutely Victorian. For example, the waterbirds on the stem are used by designers like Tatham, Piranesi, Percier and Fontaine.[266] It is, however, the presence of Rococo motifs such as the shells and scrolls or the neo-classical anthemion, lotus blossoms, leaf calyxes, and lanceolate leaves which establish the cup as a Victorian concoction. A stylistically not dissimilar modern cup resides at Goldsmiths' Hall, but it more closely adheres to the dictates of a sixteenth-century German precursor.[267]

Cat. No. 72

TABLE BELL

Parcel-gilt
Marks:
1. London, 2, sterling standard, 3. 1849-50,
4. maker's mark of Robert Garrard II (Grimwade,
no. 2322), 5. duty mark, marked in one of the
cartouches; dedicatory inscription engraved
consecutively from cartouche to cartouche: LR
FROM HER MAJESTY VR XMAS 1855.

Height: 5⅛ in. (13 cm.)
Weight: 10 oz., 9 dwt. (309 gm.)

Exhibited:
London, The Great Exhibition, 1851.

Published:
Wyatt, 1851-53, plate 46(?).
Culme Strang, 1973, p. 70.

Description and Construction

Small hand bell with a sound-bow in the shape
of an inverted cup; lower beaded lip encircles
the flaring mouth; surface decoration consists of
three inscribed cartouches immersed within
swirling scrolls, stylized shells, foliate and fruit
clusters, and four female masks; upper portion
of the bow enlivened with precisely cast lizards,
a bee, a beetle and convoluted leaves; handle
with straight stem of octagonal section with
girdles below convex scrolled knop enriched
with hanging swags crowned by a finial in the
form of a seated putto holding a blank shield;
ungilded interior with a clapper suspended from
a ring loop.

The Victorian era coinciding with the lengthy reign of Queen Victoria (1837-1911) has been
appropriately termed as the century of the international exhibitions. These high-minded expositions —
particularly the Great Exhibition of 1851 held at the Crystal Palace in London — led to the establishment
of the Victoria and Albert Museum in London, as well as through emulation the development of
America's oldest museums in Boston and New York City.[268] Furthermore, these public spectacles
provided the stage for the new mechanical processes of mass production brought about by the
Industrial Revolution.

Manufacturers throughout Britain including the firm of Garrard's, which had succeeded
Rundell's as Royal Goldsmiths in 1830, were
anxious to participate in industrial exhibitions as
a viable means of financial gain and self-
proclamation. In keeping with the implied aims
of these endeavors, they chose to show not only
gigantic silver candelabra, statuary, cups and
flagons but also jewelry and small novelties.
Indeed, Clifford has established that the firm
stocked its booths at the Great Exhibition with
no fewer than eighty-three objects.[269] A
representative selection of these occurs in one
of the plates in the commemorative catalogues
of the exhibition published by Matthew Digby
Wyatt (1820-1877) (figure 30).[270] What is so
engaging about this specific lithograph is that
the bell tucked away at the far right side is
obviously the same model or possibly even the
exact bell as the one catalogued here.

The naturalistic details of these bells were
certainly influenced by those on the bell of ca.
1558 at the British Museum carried out in the
style rustique or nature casting technique
popularized by the German Mannerist goldsmith
Wenzel Jamnitzer (1508-1585).[271] Garrard
issued at least one other closely related bell of
1845, but this bell alone sustains the eminence
of having been presented as a Christmas gift by
Queen Victoria as its inscription proves.[272] This
company made other bells of more conventional
form, one such example of 1830 in the Royal
Collection might infer that Victoria's
predecessor, William IV, preferred a more
traditional type instead of the Renaissance
inspired one she thought worthy as a royal
present.[273]

figure 30 Photo reproduced from
Industrial Arts of the Nineteenth Century at the Great Exhibition,
M. Digby Wyatt, 1851-1852

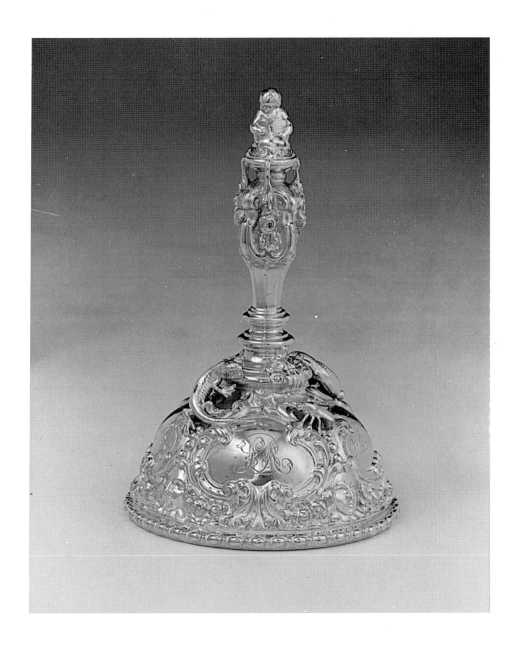

Cat. No. 73

INKSTAND

Silver, glass
Marks:
1. London, 2. sterling standard, 3. 1849-50, 4. maker's mark of Robert Garrard II (Grimwade, no. 2322), 5. duty stamp, fully marked on the bottom of the tray and each lid flange; partly marked on both mounts; stamped underneath the tray: R. & S. GARRARD, PANTON ST., LONDON.

Length: 13¾ in. (35 cm.)
Gross weight: 77 oz., 4 dwt. (2194 gm.)

Description and Construction

Three-bottle inkstand of oblong shape; upturned applied border with sprawling branches, scrolls, and gadrooning; floral blossoms at the short sides act as thumb lifts; pen depressions surround a raised bank supporting pear-shaped and faceted cut-glass bottles; side bottles fit into cast mounts enveloped by wide bands of twisting leafage and scrolls repeated on the spiralling cover of the central pot; octagonal covers with patterns resembling ice crystals capped by baluster finials; mounts are secured under the bottom of the tray with screws and the middle bottle slides into a depression soldered into the raised stand; supported on openwork cartouche brackets; a crest engraved within the well on both long sides of the tray.

Heraldry

The crests are untraced.

Over the duration of its long history Garrard's can be credited with an unbroken chain of involvement in creating numerous types of plate including inkstands. Equally praiseworthy also is that the stylistic range and rank of their writing utensils have continued to vary significantly yet consistently. At the apex of the Rococo, George Wickes, then the firm's proprietor, carried out a number of these pieces in the taste of the period. Later his successors, Parker and Wakelin, continued the tradition producing more subdued but pleasing inkstands, for instance, the plain example of 1769 which Sir Joshua Reynolds (1723-1792) presented to the Royal Academy to commemorate his appointment as its first President.[274]

Thereafter, Robert Garrard I (1758-1818) and then Robert Garrard and Brothers persisted in manufacturing inkstands in escalating quantities. Not only simple ones, but also more ornate examples in a revived Rococo manner were undertaken. The current one falls within this latter category as the leafage and scrolls trailing along the borders or the pierced bracket feet with undulating scrollwork clearly attest. Regardless of its use of eighteenth-century motifs, the symmetrical juxtapostioning of these now more broadly handled elements coupled with the sheer weight of the piece are positive indicators of its later date.

Its overall vivacity and the cast covers and the glass mounts in particular immediately bring to mind a more flamboyant inkstand with a malachite tray of 1843 in the Gilbert Collection at the Los Angeles County Museum of Art.[275] That one bears the joint mark of the firm controlled by the Barnards, who enjoyed an enduring working relationship with both Rundell's and Garrard's. The correspondence between these two inkstands is thus easily explainable because the Barnards were supplying Garrards with plate, as sometimes noted.[276] Garrard's use of the same leaf and scroll ornamentation on this inkstand was not limited to other standishes but is also detectable in mustard pots sold by them in a corresponding stylistic vein.

Cat. No. 74

TWO SALT CELLARS

Silver, baskets gilded inside
Marks:
1. London, 2. sterling standard, 3. 1859-60,
4. maker's mark of Robert Garrard II (Grimwade,
no. 2322), 5. duty stamp, marked on the rocks at
the back of the bases; stamped along the base
rims: R. & S. GARRARD, PANTON ST.,
LONDON.

Height of boy: 7⅜ in. (18.8 cm.)
Height of girl: 7½ in. (19 cm.)
Weight of boy: 15 oz., 4 dwt. (436 gm.)
Weight of girl: 15 oz. (425 gm.)
Scratch weight: 31 oz.

Provenance:
Christie's, London, 23 July 1975, lot 79.

Description and Construction

A pair of standing figural salts of flower sellers
cast piece-mould; each on a shaped rocaille
base inundated with widely curving lobes,
leaves, shells, rock piles, and grass patches;
the boy with disheveled hair reaches up to
adjust the straw hat while holding the basket
against his thigh; he wears a sleeveless jacket
over an open-collared shirt, breeches and
pointed shoes; his companion in a delicate
cross-legged stance arranges a floral garland in
her hair, repeating in reverse the bodily
movement of her fellow vendor; she is clothed in
a laced corselet, rumpled apron, long pleated
skirt and slippers; one venting hole beneath
each figure.

In unison with others catalogued in the following two entries, these sentimental depictions of
adolescents meant to act as salt-cellars are dexterously captured in arrested motion. These two are but
part of an extensive series of small-scale statuary of children from different parts of the world dressed in
national, regional, or folk customs which were avidly collected in England during the nineteenth
century.

Garrard's specialized in the making of these statuettes, and other firms, especially Edward Barnard
and Sons and to a lesser extent C. T. and G. Fox, were also concerned with their production.[277] The
original sketch patterns for most of the ones retailed by Garrard's have survived at the firm to the
present day, affording the opportunity of identifying the models by name and ascertaining that they
then sold for twenty pounds apiece.[278] The current pair appears under the name "English." Only one
other identical pair of three years earlier is published to-date, but on the premise of prevailing
nationalistic pride, this native couple was probably one of the more favored groups available for
purchase.[279]

The initial conception of such figurines finds its roots in eighteenth-century France where comparable
ceramic and silver statuettes in the Louis Quatorze style were then all the rage. For their general
character, they rely on the equally affable and sweet looking youngsters found in the decorative
paintings of the French master Jean Antoine Watteau (1684-1721) after whom one of the pairs by
Garrards is named.[280] Watteau's adolescents served not only as models in tapestry design but also for
porcelain and silver statuettes made not only in France but also in Germany and England. It is certainly
fair to concede that silver statuary representing foreign peoples would no doubt have held a special
appeal for nineteenth-century Britons during their great age of world colonization.

Cat. No. 75

TWO SALT CELLARS

Silver, basket interiors gilded
Marks:
1. London, 2. sterling standard, 3. 1863-64 (lad), 4. 1865-66 (miss), 5. maker's mark of Robert Garrard II (Grimwade, no. 2322), 6. duty stamp, marked on the reverse edges of the bases; stamped around the foot rims: R. & S. GARRARD, PANTON ST. LONDON.

Height of lad: 7¾ in. (18.7 cm.)
Height of miss: 6 in. (15.2 cm.)
Weight of lad: 15 oz., 9 dwt. (450 gm.)
Weight of miss: 18 oz., 6 dwt. (527 gm.)

Provenance:
Christie's, London, 19 October 1983, lot 188.

Published:
Clayton, 1985b, p. 301.

Description and Construction

Two associated salt cellars formed as an Irish peasant girl and a Spanish youth holding wicker baskets; maiden of shy demeanor with braided hair outfitted in a short-sleeved tunic and a long dress; self-confident dandy raises a smoke to his face; he is dressed in a folk costume consisting of a bonnet, kerchief, an earring, a plaid shawl draped over an inner jacket, breeches, greaves, and boots; casting vent beneath each figure; both mounted atop separately cast and chased rocaille bases.

Unlike the pair of salts just catalogued these two examples were not conceived as a matching couple. They do belong, however, to the large series of figural salts of this type retailed by Garrards from around the mid-1850's up to the present day. In the still intact sketch patterns for these salts the Spanish boy is matched with a female of the same nationality draped in a mantilla, while the Irish lass is seen in the company of a rustic Irish boy. Regardless of their diverging costumes and ethnic identities, the timidity of the Irish girl does serve as a successful foil to the implied brazenness of her Spanish companion.

continued

Another copy of the young Spaniard is reproduced in the following entry, and one as late as 1905 exists together with his female counterpart.[281] The Irish maiden likewise recurs again in this collection in conjunction with her Celtic partner, both of a decade later, as well as in another set of eight of 1855 and 1856.[282] The model of the Irish couple is of immense importance, too, in the study and understanding of these silver figurines. They definitely derive from nearly identical models which were shown together with two other salt cellars at the Great Exhibition of 1851.[283] Executed by the French goldsmith and jeweller Jean-Valentin Morel (1794-1860), the sets were well-received by the public and critics. Culme quotes from the comments about them set forth in *The Crystal Palace and Its Contents:*[284]

> ". . . quite of the Watteau order. Each of these figures has been individually modelled, and finished with great care in the repoussé method . . . every feature and lineament is the result of the inspiration and accurate handling of the artist at the moment of execution; and exact repetitions are impossible. This is conducive to the culture of art; though of course contrary to the economic principles of mere manufacture."

The actual salts of 1850 by Morel discussed above surfaced at auction over a century later (figure 31).[285] Although they are mounted on domed bases and at least two lean rather precariously to one side, the correlation with the Garrard examples is undeniable and further hints that these models were introduced by Morel into England. Copies commenced to be carried out by Garrards about a half decade after Morel's examples made their debut at the Crystal Palace. Little is known about the Parisian Morel who remained in London for only a brief duration from 1848-1852, yet long enough for him to leave a lasting imprint as these tender creations vouch.[286]

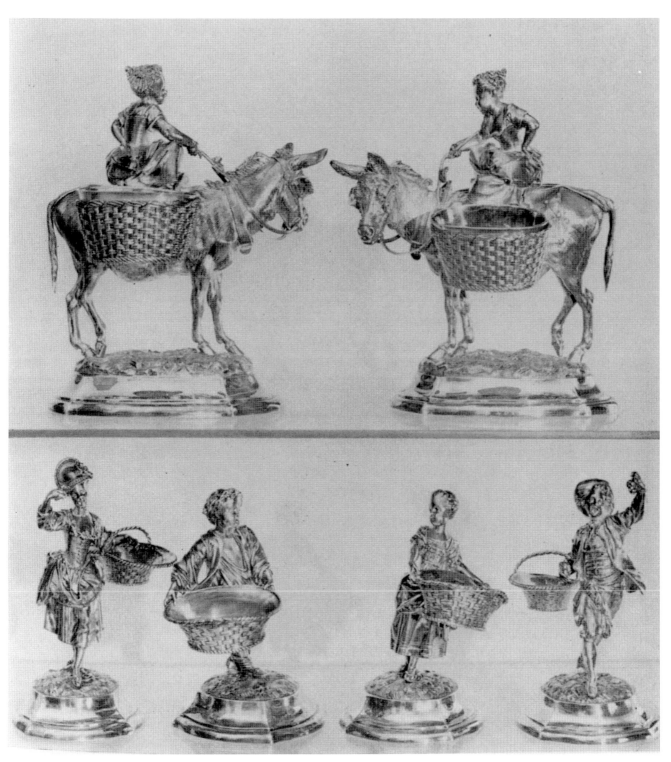

figure 31 Photo courtesy Sotheby's

Cat. No. 76

SIX SALT CELLARS

Silver, four with gilt basket interiors
Marks:
1. London, 2. sterling standard, 3. 1863-64,
4. 1861-62 (Greek girl), 5. 1855-56 (Irish lad and
miss), 6. maker's mark of Robert Garrard II
(Grimwade, no. 2322), 7. duty stamp, fully
marked on the base edges beneath the rock
piles; four stamped near the bottom edge of the
stands: R. & S. GARRARD, PANTON ST.,
LONDON.

Height of Irish lad: 6 in. (15.2 cm.)
Height of Spanish dandy: 7 in. (17.8 cm.)
Height of Irish miss: 6⅛ in. (15.5 cm.)
Height of Greek girl: 7 in. (17.8 cm.)
Height of French (Normandy) girl: 7⅜ in.
(18.7 cm.)
Height of Hungarian lass: 7 in. (17.9 cm.)
Weight of Irish lad: 15 oz., 4 dwt. (481 gm.)
Weight of Spanish dandy: 15 oz., 9 dwt.
(496 gm.)
Weight of Irish miss: 15 oz., (435 gm.)
Weight of Greek girl: 18 oz., 2 dwt. (567 gm.)
Weight of French (Normandy) girl: 19 oz., 4 dwt.
(541 gm.)
Weight of Hungarian lass: 16 oz., 1 dwt.
(464 gm.)

Provenance:
Ward, Earls of Dudley, Himley Hall, Dudley
County (four only).
Sotheby's, London, 6/ 11/ 20 February 1986, lot
149 (four only).

Description and Construction

Six assembled sculptural salts all atop rocaille
bases with one or two casting vents; each
carries a wickerwork basket gilded inside
except for the Irish couple; figures include a
youthful Spaniard in a native outfit; females
entail a long-haired Grecian girl admiring a
grape cluster in her uplifted right arm and
wearing a beaded cap, top-coat, a sash,
pantaloons and sabots; casually posed French
lass attired in a tall Norman laced headdress,
low-cut blouse with lace sleeves, bracelet, and
crucifix; she demurely pulls her skirt to the side
revealing stockings and bow shoes; statuesque
Hungarian maiden in an upturned brim hat,
collared tunic, scarf, sashed skirt, and laced
boots seemingly communes with a falcon
perched on her left wrist.

Gathered together as if in the process of a private conclave are figures consisting of two matching
groups of three and one of two from larger sets hallmarked in the same year, as well as a sole statuette
of a Grecian maiden. Some of them — namely the Irish partners and the Spanish youth — are models
already discussed in the two preceding entries, but the three young women are single representatives
in this collection. Taken in totality, they provide a fairly representative review of the differing types of
diminutive sculptural salts in this picturesque genre sold by the Royal Goldsmiths. Each is easily
identifiable by name with the pertinent pattern in the firm's sketch designs.

However, a silver-gilt set of eight of 1855 and 1856 in a private collection includes several not present
in this collection.[287] Also, as stated above, not all of the designs for the statuettes apparently survived.
Fifteen individual couples are sketched on the two known sheets, but a set of four statuettes by
Garrards of 1871 contain three not recorded in the designs.[288] Of these, a Persian boy carrying a bowl
occurs in the sketches and is known in at least one silver figurine, but the other three including a
Turkish lad lifting the cover from a tureen, as well as two females, one wearing a pointed coronet and an
Indian squaw are absent from the intact sketches. Moreover, several appearing in the sketches are not
accountable for in silver versions.

As Clifford has validated, Garrards expounded on these general types in creating salt cellar
adaptations of them riding donkeys.[289] She illustrated one such set of 1864, of which yet another set of
two of 1853 appeared on the art market in 1982.[290] Once again, it is possible to speculate with some
conviction that they, too, were inspired by two almost indistinguishable models of 1850 by Morel, who
created them during his short stay in London.[291]

Four of the salts reproduced here were once the property of William Ward, the 1st Earl of Dudley
(1818-1885) and the seventh wealthiest man in England. Residing in a splendid rebuilt mansion in the
French style, Witley Court, the Earl furnished it with French paintings, furniture, porcelaine, and bronzes
much of which he acquired at the 1867 exhibition. These French-inspired figures are thereby entirely
characteristic of his known taste.

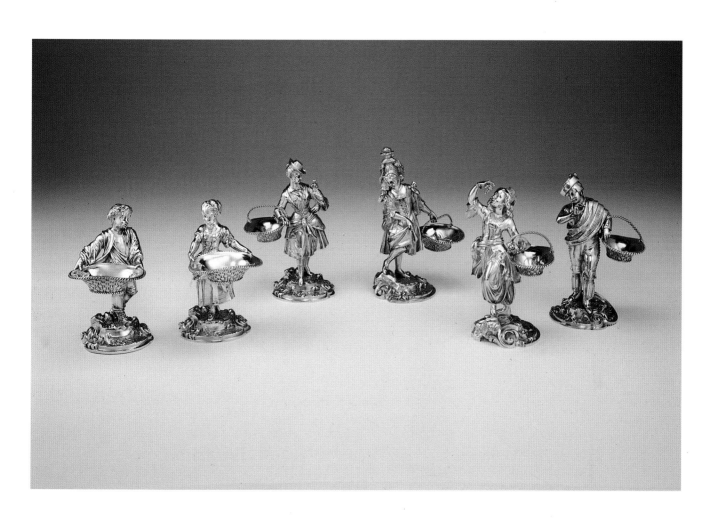

Cat. No. 77

TEAPOT

Gold, wicker
Marks:
1. London, 2. 18-karat gold standard, 3. 1867-68, 4. maker's mark of Robert Garrard II (Grimwade, no. 2322), 5. duty stamp, fully marked on the body; partly marked inside the cover and on the finial; engraved around the rim of the foot: R. & S. GARRARD, LONDON.; engraved underneath the base: 03.01.1827.

Height: 8 in. (20.3 cm.)
Weight: 22 oz., 7 dwt. (643 gm.)

Exhibited:
London, Garrard and Company, Ltd., 14 May–8 June 1991.

Published:
Garrard and Company, Ltd., 1991, p. 87, cat. no. 44. (entry by Bliss).
North, 1991, p. 353 (mentioned).

Description and Construction

Egg-shaped teapot on a waisted and spreading foot with a chased guilloche band and applied beading; raised and burnished body with cast and applied oval medallions of Cupid warming his hands at a brazier and Cupid holding a bird and a nest after Tassie on punched grounds; embossed trailing band of bud and leaf motifs with a plain molding below and beading above at the juncture of cover and body; hinged lid surmounted by a fluted knop finial separately cast and attached by a screw; fluted spout with a plain lip cast in halves and soldered to the body; plain loop handle enwrapped in woven wicker springs from cast voluted shells.

Towards the close of the nineteenth century much domestic silver recalled the earlier style of Flaxman, who together with his equally distinguished compatriot Robert Adam (1728-1792), were the leading champions of the neo-classical style.[292] Silver in this manner drew upon the decorative repertoire of classical antiquity, and several of its characteristic elements are present in this teapot, for instance, the registers of foliate and guilloche ornamentation, and even its shape is traceable to precursors in the Adam style.[293] The most classicizing traits are, however, the medallions of putti — probably emblematic of love — which are based on the molded copies after antique intaglios popularized by James Tassie (1735-1799). These were freely borrowed by English silversmiths particularly Andrew Fogelberg (active 1732-1815) and Stephen Gilbert (active 1750-1793).[294] Indeed, a Tassie medallion of the same subject as one of the two on this teapot appears on a differently shaped teapot of 1778 by Fogelberg at the Victoria and Albert Museum.[295]

continued

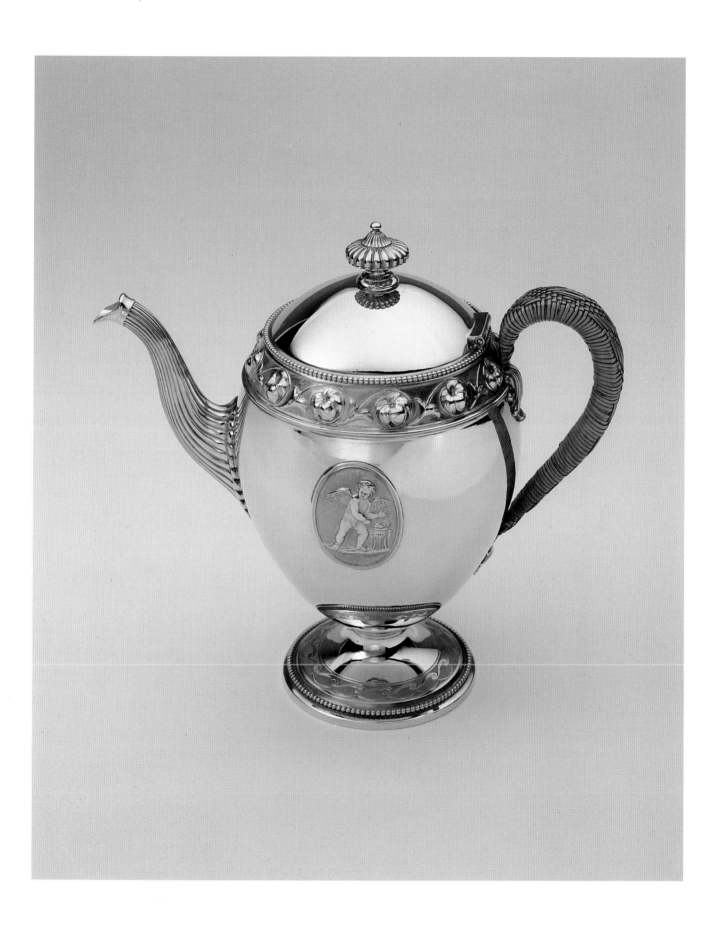

Flaxman. 252

A Flaxman pattern Coffee Pot to match with silver handle and button — oz 32·8 — £12·12·0
A Dᵒ Embossed — oz 26· — £10·10·0
A Stand for above — oz 22· — £8·0·0

A Flaxman pattern Tea Pot to match with silver handle and button — oz 27·3 — £11·11
A Dᵒ Embossed — oz 21·18 — £10·0

A Flaxman pattern Sugar Basin to match gilt inside — oz 20 — £9·9·0
A Dᵒ Embossed — oz 18·5 — £7·0·0

figure 32 Photo courtesy Garrard & Co.

Cat. No. 77 continued

It would be foolish to dismiss the teapot catalogued here as but one more servicable receptacle, however. Aside from the splendid design and meticulous craftsmanship, it is made from 18-karat gold, hardly a stock item in any nineteenth-century shop inventory. In fact, this is one of only four English gold teapots of the period recorded in the literature to date.[296] The others — all from the eighteenth century — include two of 1736 and 1737 by James Kerr, both intended as Royal race prizes, as Grimwade surmises, and one of 1785 by Daniel Smith (active 1740-1796) and Robert Sharp (active 1747-1803).[297] Due to the pristine condition of the teapot presented here, it is doubtful that it was ever used at the tea table. Instead, a luxury object of this status was indubitably a special commission meant to commemorate an important event, such as a wedding or a fortieth birthday, a hypothesis reinforced by the precise date "03.01.1827" engraved on the bottom. Interestingly, a design for a closely comparable neo-classical teapot — fittingly named "Flaxman" — appears in the still intact Pattern Book of Robert Garrard II (figure 32).[298]

EDWARD CORNELIUS FARRELL

Edward Cornelius Farrell (c. 1780-1850)

Little is known of Edward Farrell's early life. Born in Middlesex about 1780, he was living in London by 1801 at 18 King's Head Court, Fetter Lane, Holborn. He moved in 1818 to 24 Bridge Street, Covent Garden, next door to the Drury Lane Theatre, where he lived until his death in 1850. He did not enter his first mark until April 27, 1813, though he may have been working as early as 1801, for he was described as a "silversmith" in Holden's Triennial Directory *of 1805-1807. He probably served in this early period as a journeyman or an outworker for another shop. Considering the pronounced character of his later work and that he is described in the* London Post Office Directory *for 1828 and 1829 as a "working silversmith and chaser," he may have worked early on in his career, like James Shruder, as a chaser/modeler. We know from John Culme's research that his rise to prominence is attributable to his association from roughly 1816 to 1834 with Kensington Lewis, a flamboyant retail silversmith, and their response to the lively interest then for silver, both old and new, in earlier styles. Lewis's commerce in decorative antique silver dates from the sale of the Duke of Norfolk's silver in 1816, when he acquired a cup and stand and a tankard, all presumably of seventeenth-century date and chased with scenes of classical deities. This set a pattern for the goods he handled or had Farrell make or refurbish for their clients. Important to their success was the patronage during the mid-1820s of Frederick, Duke of York and the younger brother of George IV. For the five years before his death in 1827 Lewis provided him and their other important clients with an amazing group of Farrell's work, often elaborately ornamented in seventeenth-century taste. His massive figural candelabrum of Hercules Attacking the Hydra that he fashioned for the Duke of York in 1824-26, stands thirty-five inches in height and weighs more than eleven hundred ounces. Farrell also refurbished antique silver for Lewis and provided him with skillful replacements of elements, reconstructions from fragments, and copies to make sets. He also densely chased plain pieces of eighteenth-century silver. Farrell's work for Lewis declined in quantity, ambition and interest after the death of the Duke of York in 1827. He increasingly relied for the rest of his career on the production, in particular, of heavily decorated tea and coffee services featuring scenes inspired by seventeenth-century Dutch genre painting. A teapot of this type by Farrell with London hallmarks for 1733-34 and stamped with Lewis's customary retailer's signature ("LEWIS SILVERSMITH LONDON") is the last document of Farrell's business relationship with Lewis. Surviving pieces indicate that Farrell worked at least until 1847. He may have been assisted late in his career by the silversmith William Thomas Weatherhead, who married his daughter in 1838 and was listed with her at Farrell's address in the 1841 census. Farrell died on March 16, 1850. (Culme, 1975, 1977, 1987; Grimwade, 1976 [1982 and 1990 editions])*

Cat. No. 78

CHRISTENING CUP WITH COVER

Silver-gilt
Marks:
1. London, 2 sterling standard, 3. 1840-41, 4. maker's mark of Edward Cornelius Farrell (Grimwade, no. 585), 5. duty stamp, fully marked on the lip of the bowl; partly marked inside the cover, and on the cover flange; engraved around the top of the cup: TO THE HON: VICTOR ALEXANDER YORKE, FROM HIS GODMOTHER VICTORIA. R. 2: JUNE 1842.

Height: 19¾ in. (50.1 cm.)
Weight: 66 oz., (1871 gm.)

Description and Construction

Standing covered goblet with a multi-level bowl tapers to a vase stem supported on a hexagonal foot; detachable cover surmounted by a cast statuette of S. John the Baptist bolted underneath; leaf and foliate strapwork borders between a wider register of smooth bosses and Virtues after a plaquette probably from the Jamnitzer workshop decorate the lid; flaring drum of matted and plain lobes with a dedicatory inscription; cylindrical mid-section of the bowl cast in low relief with scenes of the Shame of Noah and Moses Striking the Rock after plaquettes by Peter Flötner above a flaring moulding with bosses and masks; cast stem centered by a knop with masks and herms leading to a multi-domed foot with floral and foliate mouldings; cup and cover constructed from raised and cast components held together with solder.

This Royal Christening cup was presented by Queen Victoria to Victor Alexander Yorke in celebration of his baptism on 2 June 1842. The basic design adheres to the standard type of ornamental goblet with cover much used for presentation purposes in South Germany during the Renaissance. It is a replica but not an exact copy of the famous standing cup by the Nuremberg goldsmith Jacob Frölich (active 1555-1578) presented to the Worshipful Company of Broderers in London in 1606 by John Parr (figure 33).[299] Together with the Edmund Harrison Cup of 1611, these two are the finest pieces of plate in the collection of that livery company, and they were continuously used by its members as "loving cups" during festive occasions until 1924.[300]

Replicas and copies of all sorts with minor and major differences in the cast components, surface treatments, ornamental details, and manufacturing methods were made in the nineteenth century.[301] In addition to this one, at least two others of about the same exact date are known. One of these bears the mark of Storr and the date letter 1832 in conjunction with the mark of Mortimer and Hunt, and the other of 1841 is punched by Mortimer and Hunt.[302] Both were also presented as baptismal gifts by Victoria and the Prince Consort in 1840 and 1842, confirming that a number of these soaring goblets by various firms were kept ready by the Royal Couple, who served as godparents to a number of infants of privileged birth.[303]

continued

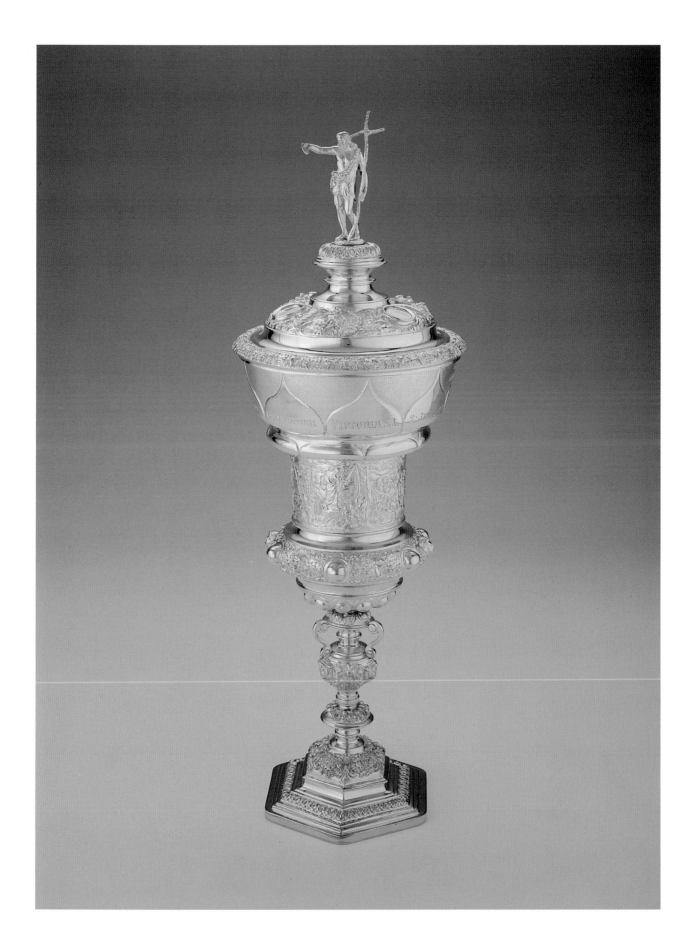

Stylistically, they disclose the nineteenth-century interest for plate carried out in a Renaissance revival mode, but their quirky additions and intended purpose clearly betray their Victorian origins. Not only their form but some of the details, as well, are modeled directly after those appearing on sixteenth-century prototypes that were a specialty of the Renaissance goldsmiths active at Augsburg and Nuremberg. The low-relief scenes of the Shame of Noah and Moses Striking the Rock found on the John Parr cup, as well as on most of the later copies and replicas including ours, are modeled after Renaissance plaquettes by Peter Flötner (active ca. 1485-1546), while the Virtue repeated on the lids is taken from one of about the mid-sixteenth century tentatively attributed to the workshop of Albrecht and Wenzel Jamnitzer.[304]

Although this cup is evidently the only replica of the Parr Cup by Farrell (1775/81-1850), it is certainly not unusual to find his mark on a piece of plate in this historicizing style, as he was profoundly influenced by antique plate as his collective oeuvre demonstrates.[305] Farrell was the principal supplier to the retailer Kensington Lewis (ca. 1790-1854), whose shop specialized in antique wares and "modern" interpretations such as this one. Lewis's chief patron was Frederick, Duke of York (1763-1827), the second son of George III.

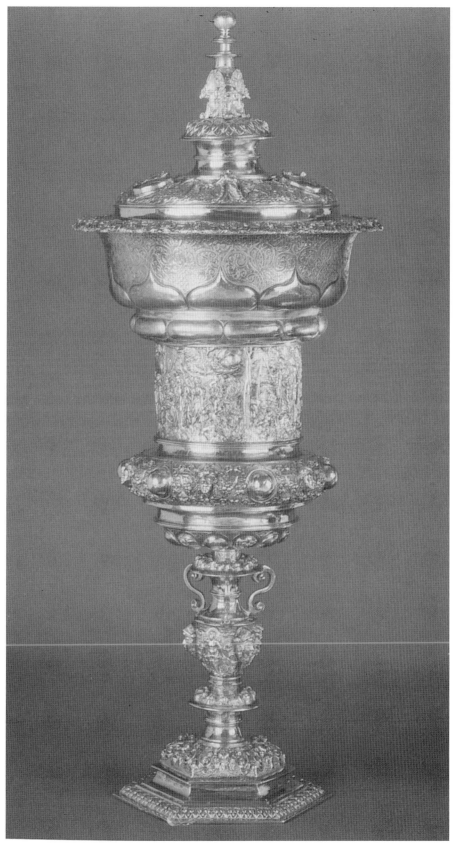

figure 33 Photo courtesy Worshipful Company of Broderers

NOTES

1. Shulsky, 1990, passim, explores in depth the Queen's collection. The importation statistics reappear in Shulsky, p. 47 from Jrg, 1982, p. 149.
2. Published by Cooper-Hewitt Museum, 1988, pp. 202-03, cat. no. 171; Thornton, 1978, figure 73; Shulsky, 1990, pp. 51, 54, figure 8. Concerning Marot's views on interior decoration see Cooper-Hewitt Museum, 1988, pp. 15-24 (essay by Baarsen).
3. The reliefs are not to be found in Weber, 1975. The one of the escape from Troy is similar to but not identical to one on a Restoration silver dish at the Victoria and Albert Museum (Inv. No. M.1647-1944) as well as to a French gantière published by Hernmarck, 1977, vol. 1, p. 252, vol. 2, plate 703.
4. Compare these figures and other motifs on the jar with those in Zancarli's designs reproduced by Oman, 1970, p. 17, plate 94. Concerning Zancarli see also Oman, 1965, p. 7; Turner, 1985, p. 7; Schroder, 1988b, p. 122.
5. Grimwade, 1971, pp. 185-86; Banister, 1971, pp. 187-93, 228; and Banister, 1976-1977, pp. 28-31 have identified and reconstructed the oeuvre of Jenkins.
6. See Phillips, 1968, p. 75, plate 1. On his misreading of the date-letter as 1711 instead of 1713 consult Hare, ed., 1990, p. 31, cat. no. 2 (entry by Taylor).
7. Hughes, 1954, p. 66, fig. 11 and Clayton, 1985b, p. 117, no. 11. Concerning a likely professional connection between Buteux and de Lamerie see Hare, ed., 1990, p. 27 (essay by Clifford).
8. Tait, 1982, pp. 202-07 traces the emergence of the two-handled cup in English silversmithing. Other sources include: Waldron, 1982, pp. 67-79; Clayton, 1985a, pp. 133-39; Newman, 1987, pp. 337-38.
9. Schwartz, 1964, p. 574 stated that the cup was gilded in the nineteenth century.
10. Contrast the cups of 1723 and 1726 in the Farrer Collection published by Jones, 1924, p. 71, plate 35; Phillips, 1968, p. 80, plate 30; Fletcher, 1973, figure 49; Goldsmiths' Hall, 1953, cat. no. 135 and the one of 1720 in Phillips, 1968, p. 76, plates 11, 12. Hare, ed., 1990, p. 28 (essay by Clifford) mentions one of 1723 with handles identical to those on the Treby Cup.
11. See the cup of 1720 in the Royal Collection also supplied for Treby published by Hare, ed., 1990, p. 50, cat. no. 21 (entry by Hare).
12. Phillips, 1968, p. 85.
13. The influence of Bèrain and Marot on de Lamerie is examined by Hare, ed., 1990, pp. 16-19 (essay by Snodin). Characteristic designs by Marot include, for example, the three reproduced by Schroder, 1988a, p.196, fig. 53a, b, c.
14. See Hackenbroch, 1969, p. 90, cat. no. 174, and McNab Dennis, 1970, fig. 50 for the salvers at the Metropolitan vand in the Shrubsole Collection respectively. Ms. Jessie McNab of the Metropolitan Museum of Art jointly assisted in the heraldic identification of these salvers.
15. On the meaning and repercussions of the Britannia standard see, for example Clayton, 1985a, pp. 46-47, 239.
16. Consult Jones, 1911, p. 168, plate 85, no. 1 and Carrington, 1926, p. 140, plate 83 for ones by Storr of 1814 and later copies of 1913.
17. The impact of the Règence style on English silversmiths is touched upon by Phillips, 1968, pp. 50-52; Hare, 1990, ed., pp. 15-16, 18-20 (essays by Hare and Snodin); Hayward, 1959, pp.1-12.
18. The cast and engraved details on these pieces resemble the waiters on the centerpiece published by Hare, ed., 1990, p. 134, cat. no. 87 (entry by Hare) and the dessert dishes illustrated by Phillips, 1968, pp. 95-96, plates 91-92.
19. Concerning his scuffles with the authorities consult Hare, ed., 1990, pp. 9-13, 29 (essay by Hare). On duty-dodging in general see particularly Banister, 1961, pp. 104-07.
20. Clayton, 1985a, p. 360; Waldron; 1982, p. 75.
21. A possible working relationship between Pantin and de Lamerie is hinted at by the fact that Pantin's daughter Eliza married the silversmith Benjamin Godfrey, whose will was witnessed by de Lamerie. See Hare, ed., 1990, p. 27 (essay by Clifford) and Grimwade, 1976, pp. 455-56, 524, 613.
22. Illustrated by Lawrence, 1968, p. 16, plate 10; National Gallery of Victoria, 1980, p. 40 (entry by Brody); Galbally, 1987, pp. 154, 159, plate 6.28.
23. Both references are referred to by Hare, ed., 1990, p. 100, cat. no. 56 (entry by Hare). For the Account Books of Mildmay, today in the Essex County Record Office, see Edwards, 1977.
24. This group of ten by Samuel Hood (active 1675-1705) is in the Al-Tajir Collection, London, for which consult Christie's, 1989, p. 56, cat. no. 36 with reference to other examples by the same maker.
25. Published by Avery, 1925, pp. 70-71.
26. Grimwade, 1961, pp. 9-10; Hughes, 1969, p. 1180.
27. See Hare, ed., 1990, p. 120, cat. no. 75 (entry by Kendall and Hare).
28. De Lamerie's involvement with this type of plate is touched upon by Clayton, 1985a, p. 184; Hernmarck, 1977, vol 1, p. 249; Hare, ed., 1990, pp. 19-20 (essay by Snodin). The earliest set of 1726 made for George, Baron Anson in the Fowler Museum is published by Hayward, 1972, pp. 47-49, figures 1, 2 and referred to by Schroder, 1988a, p. 194.
29. Hare, ed., 1990, pp. 13-14, figure 5 (essay by Hare) reproduces the Hardwicke Ewer, and the currently unlocated Ely Ewer was exhibited at the University of Texas at Austin, 1969, cat. no. 73 and reproduced by Brett, 1986, p. 174, no. 711 as having sold at Sotheby Parke Bernet, New York, 4 June 1974, lot 80. Compare also the example appearing in Phillips, 1968, p. 101, plate 115 and Brett, 1986, p. 174, no. 712. It sold in London at Sotheby's on 17 November 1960, lot 173.
30. Regarding these masterworks of Rococo goldsmithing, see particularly Phillips, 1968, p. 106, plates 134, 135; Jones, 1977, pp. 46-49, cat. no. 17; Schroder, 1988a, pp. 249-55, cat. no. 65; and Hare, ed., 1990, pp. 138-43, cat. nos. 91, 92 (entries by Hare and Schroder).
31. Useful sources dealing with this subject include Culme, 1977, passim; Culme, 1989, pp. 114-118; Culme, May, 1985, n.p.
32. Lillywhite, 1963, passim, remains the most indispensable handbook about coffee houses. For coffee in general consult Ukers, 1935, passim.
33. The set at Leeds is believed to be the earliest surviving complete tea equipage. See Victoria and Albert Museum, 1984, pp. 106-07, cat. no. G1 (entry by Glanville); Glanville, 1987, p. 92, fig. 36; Hare, ed., 1990, pp. 102-03, cat. no. 59 (entry by Hare); Clayton, 1985a, p. 406, no. 618; Museum of London, 1985, pp. 240-41, cat. no. 348.
34. See cat. nos. 23 and 27 in this publication for other pieces once belonging to Anson.
35. Consult Hare, ed., 1990, pp. 80-81, cat. no. 40, p. 108, cat. no. 64, p. 114, cat. no. 70, and p. 126, cat. no. 81 (entries by Hare, Schroder, and Glanville).
36. The set once at the Breakers was dispersed at Sotheby Parke Bernet, New York, 16 September 1972, lot 499.
37. Clifford, 1990, p. 19 through computer analysis of the firm's ledgers has determined that no more than ten orders per year were placed for writing equipment, mostly inkstands.
38. For these two see especially Hare, ed., 1990, pp. 145, 148-49, cat. nos. 94, 97 (entries by Hare). Others include pp. 30, 96, 98, 105, cat. nos. 1, 51, 53, 61 (entries by Wees, Kendall, Hare, and Glanville).
39. The example at the Victoria and Albert Museum is mentioned in Hare, ed., 1990, p. 105, cat. no. 61 (entry by Glanville) in reference to another more simple but related inkstand. The other sold at Sotheby's, London, 22 November 1951, and is published in Connoisseur, June 1952, p. 131 and June 1958, p. XIX.
40. Davis, 1976, pp. 203-04, cat. no. 223 with earlier bibliography. More recently it was illustrated by Brett, 1986, p. 179, no. 734.

41. Davis, 1976, p. 204.
42. See Grimwade, 1974, p. 46, plate 41B.
43. Schroder, 1988b, p. 198.
44. Published by Kennedy, 1957, p. 46, plate 58.
45. Identical basket handles by Wickes and Garden are referred to in Hare, ed., 1990, p. 28 (essay by Clifford). For those by the other makers see Banister, 1972, p. 33; De Castres, 1977, figure 33; Victoria and Albert Museum, 1952, plate 20; Oman, 1965, no. 138; Hughes, 1968, plate 22. These include handles, rims, and apron panels.
46. Consult Carrington/Hughes, 1926, p. 136, plate 81.
47. Sold at Christie's, Geneva, 27 April 1976, lot 231 and later at Christie's, London, 6 July 1988, lot 168.
48. On de Lamerie's appointment as Royal Goldsmith, his ewer and basin presented by George II, and the cup honoring the Prince of Wales which he evidently supplied to George Wickes consult Phillips, 1968, pp. 34-36 and Hare, ed., 1990, p. 11, 25 (essays by Hare and Clifford) and p.153, cat. no. 100 (entry by Hare). Concerning ambassadorial plate see Waldron, 1982, p. 18; Clayton, 1985a, p. 15; Hayward, 1963, pp. 3-7.
49. See Sotheby Parke Bernet, New York, 25-26 April 1978, lot 801 and Sotheby Parke Bernet, New York, 6 June 1980, lot 25 for the Morrison pair. The Thanet Service of 1742-1746 sold at Sotheby's, London, 22 November 1984, and a portion of it is reproduced in *Art at Auction: The Year at Sotheby's 1984-1985*, p. 270. Also, consider the comments offered in Hare, ed., 1990, pp. 27-28 (essay by Clifford) and p. 125, cat. no. 80 (entry by Kendall and Hare).
50. Victoria and Albert Museum, 1984, p. 112, cat. no. G12 (entry by Glanville). It is also published by Avery, 1925, p. 71, cover illustration, and McNab Dennis, 1970, p. 53, color plate I.
51. Regarding the Cup in Los Angeles see Jones, 1977, pp. 50-51, cat. no. 18 and Schroder, 1988a, pp. 260-64, cat. no. 67. It is unlikely that this cup was the one exhibited in 1862, since the catalogue entry does not state that the piece was gilded. Nor does the one published by Phillips, 1968, p. 107, plate 138 state that it is silver-gilt, suggesting that it is either the ungilded cup catalogued here or the one at Williamstown and not the one in the Gilbert Collection as Schroder maintains. For the cup in Williamstown see Carver/Casey, pp. 20-22, cat. no. 14.
52. With Asprey and Company, Ltd. in June of 1990.
53. For these cups consult Schroder, 1988a, pp. 260-64; Hare, ed., 1990, p. 137, cat. no. 90, p. 152, cat. no. 99, p. 153, cat. no. 100 (entries by Hare). See also Christie's, London, 27 May 1953, lot 169, Christie's, London, 24 November 1971, lot 53, and Victoria and Albert Museum, 1984, pp. 107-08, cat. no. G3 (entry by Glanville).
54. See Barr, 1980, p. 161, and Hare, ed., 1990, p. 153, cat. no. 100 (entry by Hare.)
55. Reference to bibliographical materials relating to Meissonnier appears in cat. no. 33, note 2.
56. Consult cat. no. 24 for these candlesticks.
57. See Hackenbroch, 1969, pp. XXXVIII-XXXIX, 92-93, cat. no. 180 and Victoria and Albert Museum, 1984, p. 112, cat. no. G14 (entry by Glanville) for the pair in New York. Schroder, 1988a, pp. 278-80, cat. no. 72 publishes the two in Los Angeles.
58. Initially published by Müller, 1986, cat. no. 12.
59. Hackenbroch, 1969, pp. 180-81.
60. Published by Hayward, 1978, p. 36, figure 8; Schroder, 1988b, pp. 173-74; Washington, 1985, pp. 190-91, cat. no. 122 (entry by Banister).
61. See Washington, 1985, p. 190, cat. no. 122 (entry by Banister).
62. Published by Hawkins, 1980, vol. I, pp. 21-23, cat. no. 5, Banister, 1965, pp. 94-95, and Christie's, 1989, pp. 112-13, cat. no. 80.
63. Concerning Garden and Gilpin and their relationship to de Lamerie, see the comments in Hare, ed., 1990, pp. 15, 28 (essays by Hare and Clifford) and Brett, 1986, p. 10.
64. Hare, ed., 1990, p. 164, cat. no. 111 (entry by Wees).
65. For tea-urns consult Hughes, 1962, pp. 1026-?.
66. Le Corbeiller, 1961, pp. 209-23 provides an insightful summary of the representation of the continents in art. For the use of the cornucopia see particularly pp. 217-18.
67. Schroder, 1988a, p. 197, cat. no. 48.
68. Related handles are found on kettles published by Schroder, 1988a, cat. nos. 56, 58, pp. 224-25, 229-33; Christie's, New York City, 10 December 1986, lot 101. For the one in Williamstown see Carver/Casey, 1978, cat. no. 35, pp. 48-49.
69. Published by Dauterman, 1958, pp. 200-01; McNab Dennis, 1967, pp. 174-79; McNab Dennis, 1981, pp. 66-67, fig. 50; Hare, ed., 1990, pp. 162-63, cat. nos. 109-110 (entries by Hare).
70. See cat. no. 13.
71. Schroder, 1988a, pp. 274-77, cat. no. 71.
72. Schroder, 1988a, p. 277. For the inkstand at Goldsmiths' Hall consult Phillips, 1968, pp. 105-06, plate 133 and Hare, ed., 1990, pp. 148-49, cat. no. 97 (entry by Hare).
73. See cat. nos. 12, 23, and 27.
74. Other Anson plate fashioned in this collection includes cat. nos. 12 and 27.
 It should be acknowledged that in the Anson Sale of 1893 another pair of waiters of the same date was dispersed as separate lots.
75. Reference to these salvers is made by Hare, ed., 1990, p. 113 and one is illustrated by Schroder, 1988b, p. 206.
76. See Schroder, 1988a, pp. 222-23, cat. no. 55.
77. Clayton, 1985a, p. 54.
78. Consult Jones, 1977, pp. 40-41, cat. no. 14 and Schroder, 1988a, pp. 244-45, cat. no. 63.
79. A selection of the most similar ones includes Miles, 1976, cat. no. 98 (1737); Phillips, 1968, p. 111, plate 162 (1750); Christie's, London, 23 June 1976, lot 104 (1739); Carver/Casey, 1978, p. 37, cat. no. 27 (1739).
80. Hare, ed., 1990, pp. 122-23, cat. no. 77 (entry by Kendall and Hare).
81. Consult Barr, 1980, p. 201.
82. For reference to the Duchess's inventory and to "salad" and "strawberry dishes" in general see Hughes, 1965, pp. 1375, 1377; Clayton 1985a, pp. 305-07, 390-91; Newman, 1987, pp. 272, 304-05; Wadron, 1982, pp. 160-62.
83. Sotheby's, London, 17 May 1973, lot 176, and Christie's, Geneva, 27 April 1976, lot 226.
84. See Jones, *et al*, 1938, plate 17, Museum of London, 1985, p. 240, cat. no. 349, and Watts, 1928, p. 52, cat. no. 275.
85. Sprimont's sketch at the Victoria and Albert Museum is illustrated by Oman, 1965, no. 141 and Fletcher, 1973, p. 13.
86. Published by Hare, ed., 1990, pp. 116-17, cat. no. 73 (entry by Hare).
87. The Anson sale catalogue of 1893 includes two lots for dish covers each consiting of a pair of 1749, so it is possible that another two covers made *en suite* with the ones catalogued here exist.
88. Consult cat. no. 26.
89. See cat. nos.12 and 23 for other Anson plate in this collection.
90. Hare, ed., 1990, p. 116. Reviews of the exhibition were prepared by Cooper, 1990, pp. 426-27; Murdoch, 1990, pp. 506-07; Schroder, 1990, pp. 1368-79; Bliss, 1991, pp. 6-7.

91. On chinoiseries and their application to English silver consult for instance Dauterman, 1964, pp. 11-25; Honour, 1962, pp. 90-93, 306-310; Glanville, 1987, pp. 15-22; Newman, 1987, p. 73; Clayton, 1985a, pp. 89-90.
92. Christie's London, 22 November 1978, lot 132.
93. Kaellgren, 1982, pp. 484-89.
94. Concerning the elusive Shruder and his probable association with de Lamerie, see particularly Hare, ed., 1990, pp. 13, 15, 24-28 (essays by Hare and Clifford).
95. Published by Victoria and Albert Museum, 1984, pp. 117-18, cat. no. G26 (entry by Barr); Turner, 1985, p. 17, plate 14; Glanville, 1987, p. 97, Schroder, 1988b, p. 302; Hare, ed., 1990, p. 25 (essay by Clifford).
96. Schroder, 1988b, p. 302.
97. See Victoria and Albert Museum, 1984, pp. 117-18, cat. nos. G26 and G27 (entries by Barr). For an overview of other pieces by Shruder influenced by Lajoue consult Hare, ed., 1990, p. 25 (essay by Clifford). The print of a boat by Francois Jouillain (born 1697) after Lajoue is reproduced in Victoria and Albert Museum, 1984, p. 118, cat. no. G28 (entry by Snodin). The basic source on Lajoue's designs is Roland Michel, 1984.
98. See Dauterman, 1959, p. 63; Grimwade, 1974, p. 50; Victoria and Albert Museum, 1984, p. 118, cat. no. G27 (entry by Barr); Glanville, 1987, p. 97; Newman, 1987, p. 171.
99. Regarding the Okeover family see the articles by Oswald, 1964, pp. 172-76, 224-28, 568-72, 645-49 with reference to additional literature.
100. Published by Victoria and Albert Museum, 1984, p. 243, cat. nos. 01 and 02 (entries by Snodin and Kerr); Oswald, 1964, p. 228; Howard, 1974, p. 398; and Howard/Ayers, 1978, vol. II, pp. 413-15. Portions of the service were dispersed at Christie's, London, 21 March 1966, lot 22 and Christies, London, 3 March 1975, lots 165-184.
101. Clayton, 1985a, pp. 204-06 offers a concise analysis of the hallmarking system in England and Newman, 1987, p. 101 provides details about date letter cycles.
102. See Hughes, 1973, p. 529, and Newman, 1987, p. 37.
103. For another example consult Reilly, 1989, vol. II, pp. 477, 479, plate 789, no. 2.
104. Grimwade, April 1961, p. 6.
105. On the Egyptian Revival see Hayward, 1971, p. 865; Snoden, 1978, pp. 124-33.
106. Regarding the influence of Hope and Percier and Fontaine's publications consult Hayward, 1971, p. 865.
107. Concerning Tatham see Udy, 1971, pp. 269-76; Udy, 1975, pp. 104-05; Hayward, 1971, p. 865.
108. See Percier and Fontaine, 1812, plate 18, no. 2, and Tatham, 1806, plate 39.
109. The salts in the Royal Collection have been published by Jones, 1911, p. 168, plate 85; Oman/Hayward, 1954, p. 28, cat. no. 68; Queen's Gallery, Buckingham Palace, 1991, p. 131, cat. no. 92. Regarding the "Grand Service" consult Snodin, 1978, pp. 128-31; Udy, 1978, p. 827, note 16; and Queen's Gallery, Buckingham Palace, 1991, pp. 126-27, 130-31, cat. nos. 85, 91, 92, color plate 24.
110. On their contents, consult particularly Hughes, 1968, p. 296.
111. Regarding Hamilton's diverse collections centering around an English clock cabinet see Freyberger, 1991, pp. 10-13 and Freyberger, 1981, pp. 401-09 for his French furniture. On the Hamilton and Beckford silver see Snodin/Baker, 1980, pp. 735-48, 820-34 and Baker/Schroder/Clowes, 1980, passim.
112. An itemized list of its contents appears in Penzer, 1954, pp. 254-55. The service sold at Christie's, London, 4 November 1919.
113. This idea is suggested in Sotheby's, London, 20 June 1988, lot 216.
114. Christie's, New York, 30 October 1990, lot 174.
115. Useful publications relating to Meissonier entail Nyberg, ed., 1969, passim; Hayward, 1973, pp. 70-75; Lambert, ed., 1983, pp. 60, 62-63, cat. no. 2.3.i (entry by Snodin); Honour, 1971, pp. 173-79.
116. Published initially by Huquier, 1734, n.p. and much later by Lambert, ed., 1983, pp. 60, 62-63, cat. no. 2.3.i (entry by Snodin) and Honour, 1971, pp. 176-77.
117. Published by von Bothmer, 1984, p. 29, cat. no. 35, frontispiece. Compare also the Hellenistic pitcher on pp. 56-57, cat. no. 96. Another quasi-related oinochoe in bronze is discussed by Kent, 1976, cat. no. 32. On Greek and Roman gold and silver in general consult Strong, 1966, passim, and Oliver/Luckner, 1977, passim.
118. Wine jugs and flagons are surveyed by Waldron, 1982, pp. 338-47 and Clayton, 1985a, pp. 226-31.
119. Hitherto unpublished, the ewer (Acc. No. 43.181) is part of the Thomas S. Grasselli Memorial Collection.
120. Jackson, 1911, vol. II, p. 816. But see the comment of Clayton, 1985a, p. 363.
121. Victoria and Albert Museum, Inv. No. E.79-1964. See cat. no. 36, note 1 for reference to publications about Flaxman.
122. The literature dealing with Flaxman as a designer of silver entails: Bury, 1979, pp. 140-48, cat. nos. 182-189; Snodin, 1979, pp. 149-51, cat. nos 190-197; Wark, 1970, passim; Bury, 1966, pp. 152-58; Hayward, 1971, pp. 865, 110-11, 115; Oman, 1966, pp. 174-83; Udy, 1978, pp. 828-29, 836-37; Culme, 1977, passim.
123. On the Trafalgar Vases see Berkowitz, 1981, pp. 104-05; Bury, 1979; pp. 142-43, cat. no. 182; Hayward, 1971, p. 865; Ivon-Jones, 1975, p. 447; Snodin, Art at Auction: The Year at Sotheby's, 1983-1984, pp. 274-83; Culme, 1977, pp. 61-62, 135; Bury, 1979, pp. 145-47, cat. no. 187; Snodin, 1979, p. 150, cat. nos. 194a and 194b. Concerning the Wellington Plate see the references cited in cat. no. 44, note 3. For the National Cup see Hayward, 1971, p. 115; Bury, 1966, pp. 153, 155-157; Jones, 1911, pp ?, plate 87; Bury, 1979, p. 147, cat. no. 188; Snodin, 1979, p. 151, cat. no. 195; Bury/Wedgwood/Snodin, 1979, pp. 344-53.
124. Consult Penzer, 1954, p. 158 for the complete excerpt.
125. For these sketches see Wark, 1970, pp. 77-79, cat. no. 59; Snodin, 1979, p. 150, cat. no. 193; Queen's Gallery, Buckingham Palace, 1991, p. 127, cat. no. 86.
126. The first at the Victoria and Albert Museum is published by Snodin, 1979 p. 150, cat. no. 193 and the second in the British Museum is mentioned by Wark, 1970, p. 77 and Snodin, 1979, p. 150.
127. Published by Jones, 1911, p. 120, plate 61; Penzer, 1954, pp. 158-59, plate 40; Hayward, 1971, p. 110, figure 1; Hernmarck, 1977, vol. II, pp. 206-07, plate 545; Honour, 1971, p. 241; Lever, 1975, plate 24; Wilding, 1951, plate 62; Queen's Gallery, Buckingham Palace, 1991, p. 127, cat. no. 86.
128. Macquoid, 1903, p. 149.
129. Hawkes, 1933, pp. 23-24, Macquoid, 1903, pp. 149-66, and Oman, 1962, pp. 2-11 examine the silver belonging to Winchester College.
130. Jones, 1911, p. 49. Goddard's tenure as Headmaster is touched upon by Hawkes, 1933, p. 36 and dealt with at greater length by Kirby, 1892, pp. XII, 132, 403-04, 419.
131. A listing of many of the replicas of the Theocritus Cup by Storr, as well as his variations is offered by Newman, 1987, pp. 322-23. To that census might be added a pair of 1814 and 1822 by Philip Rundell which sold at Christie's, Geneva, 15 May 1985, lot 73.
132. Published by Garrard and Company, Ltd., 1991, pp. 88-89, cat. no. 45 (entry by Clifford) with reference to one of 1868. Another of 1864 also by Garrard's sold as lot 109 at Christie's, Geneva, 13 May 1986.
133. See Christie's, 1989, p. 198, cat. no. 151 (1822). It was also used by John Hunt, for which see Sotheby's, London, 11 November 1982, lot 90 and Brett, 1986, pp. 278-79, no. 1293 (1855).

134. Examples are published by Moss, 1968, n.p. and Moss, 1972, pp. 216-17, plate 153 (1835); Sotheby's, London, 10 February 1977, lot 220 (1828 and 1832); Christie's, London, 13 May 1953, lot 45 (1838); Sotheby's, New York, 28-29 October 1988, lot 209 (1828 and 1832).
135. Sotheby's, New York, 19 April 1991, lot 308.
136. The sculpture was exhibited and published in *Royal Academy of Arts Bicentenary Exhibition*, 1969, p. 50, cat. no. 171. For Theed and his work consult Bury, 1966, p. 80; Bury, 1979, p. 141; Hayward, 1971, pp. 865, 110-11; Oman, 1966, p. 176.
137. Oman, 1966, pp. 174-183.
138. Victoria and Albert Museum, Inv. No. E.114-1964.
139. Victoria and Albert Museum, Inv. No. E.114-1964.
140. Oman, 1966, pp. 181-82, figures 12, 13. The stands are also published by Jones, 1911, p. 180, plate 91, no. 1.
141. See Sotheby's, London, 19 October 1978, lot 175.
142. Untraced, it was sold as part of the Recksten Collection at Christie's, London, 22 May 1991, lot 9.
143. See Christie's, 1989, pp. 158-59, cat. no. 121; Schroder, 1988a, pp. 338-41, cat. no. 90; Snowdin, 1978, pp. 124, 131, color plate A.
144. Victoria and Albert Museum, Inv. Nos. 8431.3 and 8390.12.
145. See Percier/Fontaine, 1812, plates 14, 18, 20, 21, 22, 23, 29, 34, 39, 52, 62. Young, 1986, p. 336 with reference to Udy, 1966, no. 7.
146. Hayward, 1971, p. 111, figure 2.
147. Published in Houston, 1956, cat. no. 60.
148. Schroder, 1988a, p. 416, cat. no. 111 refers to several comparable sticks, and see Foster/Atkinson, 1896, p. 96, cat. no. 175 for a related pair by Elizabeth Godfrey (active 1731-1758).
149. Consult Grimwade, 1965, p. 504; Grimwade, 1974, plate 79a; Jones, 1977, pp. 7-8, and Schroder, 1988a, pp. 416, 418. The Storr candelabra are illustrated by Penzer, 1954, pp. 126-27, plate 24.
150. Both illustrations appear in Wainwright, 1989, figures 154, 156, together with a discussion of Abbotsford on pp. 147-207.
151. On its use by Boileau's see Snowdin, 1978, pp. 128-29, 131, figure 8; Young, 1986, p. 336, figure 5; and Schroder, 1988a, pp. 363, 375, figures 82, 84.
152. Concerning the 2nd Earl of Warrington and his plate consult especially Hayward, 1978, pp. 32-39.
153. Hughes, 1968, p. 1335.
154. Sold at Sotheby's, London, 1 November 1990, lot 385.
155. Illustrated by Holland, 1978, p. 118 and Waldron, 1982, p. 205, no. 653.
156. See Schroder, 1990, cat. no. 26.
157. Published by Penzer, 1954, pp. 180-81, plate 51; Hughes, 1957, figure 195; Banister, 1987, p. 151, figure 58; Hernmarck, 1977, vol. II, plate 497; Goldsmiths' Hall, 1966, cat. no. 70; Oman, 1965, no.199a; Taylor, 1963, plate 63b. For other plate at Apsley House see Oman, 1954 *passim*; Oman, 1973, pp. 197-205; Jervis/Tomlin, 1990, pp. 16-27.
158. As pointed out by Bury, 1966, p. 218, figure 17.
159. Sold at Sotheby Parke Bernet, New York, 25 February 1969, lot 73, Sotheby's, London, 16 December 1971, lot 40, and reproduced by Brett, 1986, p. 249, no. 1121.
160. Regarding the Harewood Plate and the Regency Exhibition consult Penzer, 1954, pp. 27, 154-55, 166-67, 180-83, 186-87, 192-93, plates 38, 44, 51, 52, 54, 57; Brighton, Royal Pavilion, *Souvenir Programme and Catalogue of the Regency Exhibition in the Royal Pavilion, Brighton*, 1951, *passim*; Smith, 1951, pp. 41-44; Musgrave, 1951, pp. 90-95.
161. The service was dispersed at Christie's, London, 30 June 1965 and 6 July 1966. Ours bear later date letters, do not carry the Lascelles family armorial, and have plain rather than fluted stems unlike the Harewood examples. Moss's error is repeated in both Moss, 1966, p. 67 and Moss, 1972, pp. 192-93, plate 132. For the Harewood family see *Burke's Peerage*, pp. 1065-68.
162. Udy, 1978, p. 837. On the Lansdowne family consult *Burke's Peerage*, pp. 1309-11.
163. Consult Banister, 1980, pp. 165-69; Banister, 1983, pp. 38-39; Bury, 1966, pp. 157, 219. For Emes see also Glanville/Goldsborough, 1990, pp. 15-16, 20, 36-38, 43, 93, 100, 104, 136, 165-66.
164. Concerning the famous Cumberland plate and its checkered history see Jones, 1924, pp. 41-42; Jones, 1920, pp. 679-86.
165. Sotheby Parke Bernet, New York, 30-31 October–1 November 1947, p. iii. On the collecting activities of the Morgan family and their bequest of European decorative arts to the Wadsworth Atheneum and elsewhere, consult Roth, ed., 1986, *passim*.
166. See Christie's, 1989, pp. 98-99, cat. no. 69.
167. See Christies, 1989, p. 187, cat. no. 144 with reference to prior literature.
168. Consult Sotheby's, London, 22 June 1972, lot 171; *Art at Auction: The Year at Sotheby's 1971-1972*, p. 334, no. 7; Waldron, 1982, p. 146, no. 449.
169. Schroder, 1988a, pp. 425-29, cat. no. 114. Other segments of the service are owned by the present Duke of Norfolk, the Detroit Institute of Arts, and others were in the Moss Collection. See Schroder, 1988a, pp. 425-29, cat. no. 114 for additional bibliography and an illustration of one piece in Detroit, which is also discussed by Winokur, 1973, p. 93.
170. For the Sutton Service see Hawkins, vol. I, 1983, pp. 141-49, cat. no. 42, and Christie's, 1989, pp. 190-91, cat. no. 146.
171. For a few American "skippets" see Brown, 1978, pp. 140-41.
172. Banister, 1981, p. 1609.
173. This information is recorded in the auction sales catalogue issued by Sotheby's, London, 12 December 1974, lot 20. Presumably, it was relayed to the auction house authorities by Mrs. Vachell.
174. Penzer, 1954, p. 265. It was dispersed at Christie's, London, 17 April 1940, lot 5. See London, 1929, cat. no. 840, plate 63, for the one once belonging to Viscount Esher. Another example was sold from the Collection of the Duke of Hamilton at Sotheby's, Lennoxlove, 24 June 1980, lot 272.
175. See Christie's, London, 22 May 1991, lot 164. Yet another of 1825 by Bridge is illustrated by Banister, 1981, pp. 1608-09, figure 3.
176. Penzer, 1955/1956, pp. 183-88, 1956, pp. 18-22, 71-75 remains the seminal study about the Warwick Vase. See also Marks/Blench, 1979, *passim* and Udy, 1978, pp. 829-30.
177. Consult Piranesi, 1905, p. 3, plate 17.
178. Victoria and Albert Museum, Inv. Nos. E.76-1964 and E.92-1964.
179. Sotheby's, London, 18 November 1965, lot 69 and Sotheby's New York, 12 June 1986, lot 59 respectively.
180. Oman, 1966, pp. 174-83.
181. See Oman, 1966, pp. 182-83 figures 13-14, who related the sketch to a pair of sauce tureens of 1819-20 at The Victoria and Albert Museum.
182. Compare the designs for bases or the actual pieces by or attributed to Stothard and Theed reproduced in Oman, 1966, pp. 175, 178, 179, figures 2, 3, 8, 9. Collate also those in the engravings by Piranesi discussed by Udy, 1978, pp. 822, 825, 831, 832, figures 35, 36, 37, 41, 42, 47, 50, 52, 54, as well as Piranesi, 1905, pp. 3, 4, 5, plates 17, 36, 45, 47.
183. Jones, 1977, pp. 98-99, cat. no. 39; Schroder, 1988a, pp. 468-71, cat. no. 126.

184. The Boston salver has been published in Frick Collection, 1978, exhibition checklist, no. 19 and mentioned by Moss, 1966, p. 38, Moss, 1972, p. 160, and Skerry, 1980, p. 25.
185. These arms were identified by Mrs. Gale Glynn of Devon, England in relation to the salver in Boston. Her report is on deposit in the Department of European Decorative Arts and Sculpture at that museum.
186. Skerry, 1980, pp. 16-25 publishes the salver and other silver by Storr at the Yale University Art Gallery. The example formerly in the Morgan Collection sold at Sotheby Parke Bernet, New York, 30/31 October–1 November 1947, lot 166.
187. Skerry, p. 25.
188. Their holdings probably included The Mostyn Great Salt (1586-87) and the Mostyn Tompion (ca. 1695-1700) published by Glanville, 1990, pp. 113, 163, 166, 452, 453, 454, 456, cat. nos. 83-86, and Garnier, 1982, pp. 228-30. The collection at Mostyn Hall, North Wales is surveyed by Jones, 1907, pp. 68-77.
189. Concerning this family see Burke's Peerage.
190. The print, one of a set of six, is catalogued by Snelgrove, vol. 3, 1981, pp. 135-36. Regarding Pollard, consult Egerton, vol. 2, 1978, p. 267, and especially Selway, 1965, passim.
191. This information is provided in the entry for an unillustrated cup sold as the succeeding lot to the one now in this collection at Sotheby's, London, 16 March 1978, lot 172.
192. See Waldron, 1982, p. 165, figure 514. It sold at Sotheby's, Belgravia, 7 July 1977, lot 499.
193. On these pieces, consult Udy, 1978, pp. 833-34.
194. Concerning Flaxman and the sketch book, see the literature appearing in cat. no. 36, note 1.
195. Victoria and Albert Museum, Inv. Nos. E.92-1964 and E.97-1964.
196. For the Gainsborough Cup, consult Oman, 1969, p. 43; Belsey, 1988, p. 110, cat. no. 48.
197. Wardle, 1970, pp. 79-94 and Bury, 1966, pp. 219-22 provide overviews of Victorian silver statuary and exhibition plate.
198. Published by Penzer, 1954, pp. 226-27, plate 74, and Grimwade, 1953, pp. 48, 104, plate 48.
199. Christie's, London, 25 June 1969, lot 59.
200. Fundamental texts dealing with Canova's life and work entail: Bassi, 1943, passim; Bassi, 1957, passim; Clark, 1957 passim; Bassi, 1972, passim; Praz/Pavanello, 1976, passim.
201. For the gypsum model and fragments consult Praz/Pavanello, 1976, p. 119, cat. no. 214; Bassi, 1957, pp. 106-07, cat. nos. 83-86; Bassi, 1972, pp. 46-49, cat. nos. 83-86.
202. In Thieme-Becker, 1911, vol. 5, p. 518, Paoletti cites the example at Forlì as "die schnste von allen." It and the Chatsworth example are published by Praz/Pavanello, 1976, p. 119, cat. nos. 213, 215, color plates 48-49; Bassi, 1943, pp. 21, 44, plates 46, 47.
 Two other marble versions of Canova's Hebe are in Berlin and Leningrad. Praz/Pavanello, 1976, p. 102, cat. nos. 98-100 reproduce them in addition to the gesso model in the Galleria Communale d'Arte Moderna in Milan on which they are based. See also Bassi, 1943, pp. 21, 44, plate 45.
203. Barron-Wilson, 1887, vols. 1-2, passim, offers a fascinating biography of the Duchess of St. Albans. Regarding the lineage of the Dukes of St. Albans consult Debrett's Peerage, pp. 1020-21, Burke's Peerage, pp. 1970-72. Other silver once belonging to the Duke or Duchess includes: Christie's, 1989, pp. 179, 196, cat. nos. 138, 149, Art at Auction: The Year at Sotheby's, 1983-1984, p. 284, and Hawkins, 1983, vol. 1, pp. 150-51; Moss, 1966, pp. 26 , 29 and Moss, 1972, pp. 132-33, plates 68, 69; Hartop, 1991, pp. 184-85, 189.
204. Culme, 1977, p. 120 extracts this quotation from Barron-Wilson, 1887, vol. 2, pp. 290-91.
205. Information about Burdett can be gleaned from Barnhart, ed., 1954, vol. 1, p. 716; The New Encyclopaedia Britannica, 1990, vol. 2, p. 642.
206. See Sotheby's, Belgravia, 10 October 1974, lot 61 and Culme, 1977, p. 120. Other flatware services in this pattern by Chawner and Company are illustrated by: Sotheby's, Belgravia, 22 January 1976, lot 271 and Brett, 1986, p. 283, no. 1314; Pickford, 1983, p. 143, figure 220.
207. Culme, 1977, p. 120. The bottle referred to was dispersed at Sotheby's, Belgravia, 24 February 1972, lot 177.
208. Published by Glanville, 1987, pp. 53-54, figure 18; Bliss, 1990b, p. 273, and Brown, ed., 1991, p. 115 (entry by Estes).
209. Sold at Christie's, London, 15 December 1965, lot 147 and again at Christie's, London, 18 October 1967, lot 58.
210. Penzer, 1954, pp. 206-07, 260, plate 64.
211. Regarding the van Vianen family and their artistic output consult Lightbown, 1968, pp. 426-39; Honour, 1971, pp. 97-103; ter Molen, 1986, pp. 22-31; Citroen, 1987, pp.8-14.
212. Reproduced by Fletcher, 1973, p. 9. Another somewhat related design by Christiaen appears in Wills, 1983, p. 43, and compare the silver ewer and basin published by Frederiks, 1952, plates 170a and 170b.
213. For the work of Eisler see, for instance Thieme-Becker, 1914, vol. 10, pp. 438-39; and the sources listed in cat. no. 51, note 3.
214. Discussed and illustrated in Hare, ed., 1990, p. 23, figure 12 (essay by Snodin).
215. This service was offered en total as lot 201 at Sotheby's, London, 10 March 1977. In addition to pieces of 1829-36 by Storr, it also contained a lampstand by Hunt, and a few nineteenth-century Parisian items.
216. Formerly the property of Mrs. V. M. Hutton, this jug was dispersed at Sotheby's, London, 4 May 1972, lot 118.
217. Newman, p. 302.
218. This Royal cup sold at Sotheby's, Belgravia, 12 September 1974, lot 241, and is illustrated in Art at Auction: The Year at Sotheby's 1974-1975, p. 275 and Brett, 1986, p. 276, no. 1278.
219. Published by Waldron, 1982, p. 194, no. 614, and Asprey Antiques, October 1985, p. 31, no. 2.
220. Consult cat. no. 62.
221. The Christner example appeared at Christie's, New York, 7 June 1979, lot 56, and the other at Sotheby Parke Bernet, New York, 13 December 1984, lot 85 and earlier at Sotheby Parke Bernet, New York, 25 February 1969, lot 103.
222. Illustrated in both Moss, 1966, p. 41 and Moss, 1972, pp. 17, 62-63, plate 3. On p. 17 of the latter publication, Moss stated he purchased this pair in 1958.
223. Sotheby Parke Bernet, New York, 13 May 1970, lot 28.
224. Published in Indianapolis, 1972, p. 19, cat. no. 74 and McNab Dennis, 1981, p. 86, color plate 18.
225. Christie's, New York 30 October 1991, lot 277.
226. See Germain's "Surtout de table" of 1763 and tureen stand of 1757 published by Hermarck, 1977, vol. I, pp. 186-87, vol. 2, plates 403, 414.
227. Published by Nyberg, ed., 1969, folio 10, plate 35. For other references relating to this silversmith consult cat. no. 33, note 2. Compare also the centerpiece design reproduced by Schroder, 1988a, p. 19, figure 4.
228. Examples in a comparable stylistic vernacular are published by Waldron, 1982, p. 108, figure 323 and Wills, 1983, p. 57. The one reproduced was offered at Sotheby's, London, 12 November 1991, lot 247.
229. See Baker/Schroder/Clowes, 1980, and Connoisseur, November 1980, p. 100.
230. As noted in Sotheby's, London, 12 November 1970, lot 139.
231. See Udy, 1978, pp. 826, 828-29. Oman, 1966, pp. 178-79, 181-82, figure 8 reproduces a design for a wine cooler probably by Baily after Theed at the Victoria and Albert Museum based on the ancient relief. That sketch and not the marble itself was most likely the source from which the designers worked.

232. A search through the corpus of Dionysian sarcophagi compiled by Matz, 1968-69, 1975, vols. 1-4 failed to locate the exact source for one of our coolers.
233. For a full discussion of this device see cat. no. 71 with pertinent literature cited in note 8.
234. Brief synopses of the Lumley Cup are provided by Culme, 1977, p. 105 and Newman, 1987, p. 200. Regarding relations between the silversmiths' trade and the theatrical profession, see Culme, 1975, pp. 293-301.
235. Lumley, 1976 ed., pp. 128-29.
236. The photograph of the booth maintained by Hunt and Roskell in 1862 is illustrated by Wardle, 1970, p. 109, plate 29. For the quotation consult Tallis, 1851, vol. I, part 2, p. 139.
237. For the Sneyd family and their collections consult Kolbert, 1976, passim; Tipping, 1924, pp. 1023-24; and the Sneyd Family Papers of 1849 (facsimile copy on deposit in the Department of Collections, The Colonial Williamsburg Foundation). See also cat. no. 33 for a set of candlesticks made for the Sneyds.
238. Davis, 1976, pp. 13-19, cat. nos. 1-3 discusses these pieces and their provenances.
239. Consult Garrard and Company, Ltd., 1991, p. 68, cat. no. 29 (entry by Clifford).
240. Published in Christie's, London, 25 October 1989, lot 167 and Christie's Review of the Season 1990, p. 359. Pitts as a specialist sub-contractor of èpergnes and tureens for Parker and Wakelin as disclosed in that firm's account books is touched upon by Grimwade, 1961, p. 6; Barr, 1980; Schroder, 1988b, pp. 181, 193-94; Clifford, 1990, pp. 20-21; Garrard and Company, Ltd., 1991, p. 25 (essay by Clifford).
241. The example reproduced of 1831 is published by Garrard and Company, Ltd., 1991, p. 68, cat. no. 29 (entry by Clifford), which also mentions the pair of 1809.
242. Sprimont's sauceboats are published by Grimwade, 1974, plate 33A; Victoria and Albert Museum, 1984 pp. 113-14, cat. no. G17 (entry by Barr); Queen's Gallery, Buckingham Palace, 1988, p. 120, cat. no. 115; Toronto, 1958, p. 48, cat. no. G.26, figure 1; Museum of London, 1985 pp. 270-71, cat. no. 402.
243. See Clayton, 1985a, p. 326, plate 485; Sotheby's, New York, 7 April 1987, lot 113; Victoria and Albert Museum, 1984, p. 114; Queen's Gallery, Buckingham Palace, 1988, p. 120. Regarding the work of Hennell consult Hennell, 1955, pp. 260-66.
244. Sold at Sotheby's, Belgravia, 17 December 1981, lot 326 and illustrated in Art at Auction: The Year at Sotheby's 1981-1982, p. 255.
245. VAM, GL2, p. 101.
246. See Victoria and Albert Museum, 1984, p. 244, cat. nos. 04-05 (entries by Mallet); Museum of London, 1985, pp. 270-71, cat. no. 403; Ormond, 1968, pp. 224-26; Sheppard, 1953, p. 44. On the subject in general see also du Boulay, 1965, pp. 18-19, and La Marche, 1991, passim.
247. Concerning Germain and the painting in question consult Honour, 1971, pp. 154-63; T. and A. Crombie, 1954, pp. 259-65; Barr, 1980, pp. 84-86; Davis, 1970, plate 164; Schroder, 1991a, p. 12. Monographic studies on de Largillière entail Pascal, 1928, passim and Petit Palais, 1928, passim.
248. The most concise discussion of the replicas remains Barr, 1980, pp. 84-86. The ones by Le Sage sold at Christie's, London, 24 October 1990, lot 247.
249. Published by Davis, 1970, figure 164. Purportedly, according to a letter on file at the Detroit Institute of Arts thoughtfully brought to my attention by Bonita La Marche, yet another pair of the same date, 1732, also by Germain with the arms of Louis Phillipe were with S. J. Phillips, Ltd., London in 1989.
250. The pair in Portugal are mentioned by Barr, 1980, p.92, note 6 and in Christie's, 1989, p. 186, cat. no. 143.
251. See Christie's, 1989, p. 186, cat. no. 143 and Newman, 1987, color plate 8.
252. Published by Clayton, 1985a, pp. 51, 53, figure 63; Art at Auction: the Year at Sotheby's, 1989-1990, pp. 364-65; Schroder, 1991a, pp. 11-13, 21.
253. Schroder, 1991a, pp. 12, 21.
254. For information about these deities see: Avery, ed., 1962, pp. 152, 209-10, 404-08, 640-41, 852-53; Peck, ed., 1965, pp. 123-24, 524-25, 952; Hammond/Scullard, eds., 1970, pp. 106-07, 223-24, 352-53, 607; Radice, 1971, pp. 15, 22, 45-46.
255. VAM, GL2, p. 123.
256. Selected publications entail: Dauterman, 1969, cat. no. 13; Dauterman, 1983, cat. no. 59; Buhler, 1970, p. 906, figure 5; Honour, 1971, p. 245; Lever, 1975, p. 152, figure 35; Culme, 1977, pp. 80, 138; Hayward, 1971, p. 115.
257. The Chatsworth Tureens were dispersed at Christie's, London, 25 June 1958, lot 24 and are published or referred to by Hayward, 1971, p. 115; Clayton, 1985a, p. 366, figure 543. The others sold at Sotheby's, New York, 28-29 October 1988, lot 218 and earlier at Christie's, Geneva, 27 April 1976, lot 196.
258. See Culme, 1977, pp. 80, 138, 146, and Penzer, 1954, pp. 236-37, plate 79.
259. Culme, 1977, p. 80, and Penzer, 1954, p. 63.
260. For these collectors see respectively Read/Tonnochy, 1928, passim; Read, 1902, passim and Tait, 1988, vol. II, passim, and Roth, ed., 1987, passim.
261. Regarding Lewis, consult cat. no. 78, note 7.
262. The drawing is illustrated in Hayward, 1976, plate 152. Concerning Hornick see Hayward, 1976, pp. 243-51; Hayward, 1964-1965, pp. 92-96, 164-70, 250-54, 1965, pp. 144-49; Hayward, 1967-1968, pp. 216-22, 162-67; 161-66; Hackenbroch, 1967, pp. 54-63; Hayward, 1968, pp. 201-07.
263. Published by Hayward, 1964, pp. 168-69, figure 9 and Hayward, 1976, pp. 205, 357, plate 205.
264. Kunsthistorisches Museum, Vienna, Inv. No. 6640, folio 56, no. 163. Selected publications include: Berliner, 1926, vol. I, plate 199, no. 2, vol. 2, p. 56; Berliner, 1981, rev. ed. by Egger, vol. I, p. 64, vol. 2, plate 566; Parshall, 1982, especially pp. 144-46, 171-72; Scheicher, 1975, p. 86.
265. On this matter, see Hayward, 1968, pp. 161-63, figure 2-5.
266. Young, 1986, pp. 334-35, figures 1, 2, 3 traces the origin of this motif as it appears on a candelabrum by Scott and Smith, as well as reproducing designs in which it is used by Piranesi and Tatham. This same device was also utilized by Percier and Fontaine, for which see Lambert, ed., 1983, pp. 76-77, cat. no. 2.7 (entry by Lambert).
267. This later cup appears in Carrington/Hughes, 1926, p. 127, plate 77.
268. On the Great Exhibition of 1851 and earlier and later expositions consult: Culme, 1977, pp. 113-216; Wardle, 1970, pp. 67-78, 114-24; Sparling/Rowe, 1982, passim; Gibbs-Smith, 1964, passim; Freeman, 1967, pp. 374-75; The Crystal Palace Exhibition, Illustrated Catalogue, London 1851, 1970, unabridged re-publication, passim; Pevsner, 1951, passim.
269. Garrard and Company, Ltd., 1991, pp. 29-31, 73, cat. no. 34 (essay and entry by Clifford). See also Wardle, 1970, p. 70.
270. Wyatt, 1851-53, plate 46. The illustration has also been published by Culme/Strang, 1973, p. 70, plate 144.
271. The bell reproduced here has been published by Tait, 1988, vol. 2, pp. 12-14, 96-105, figures 1, 84-89, color plate 5; Hayward, 1976, pp. 208, 209, 377, 378, plate 423; Pechstein, 1967, passim; Hernmarck, 1977, vol. II, plate 831. On the work of the Jamnitzer family consult Rosenberg, 1920, passim; Hayward, 1976, pp. 208-15; Kris/von Falke, 1926, pp. 185-207; Germanisches National Museum, 1985, passim. The seminal study on "Der Stil 'Rustique'," as Kris termed it, remains his article of 1926, pp. 137-208.

272. Sold at Sotheby's, London, 24 November 1983, lot 213.
273. See Grimwade, 1953, p. 47, 108, cat. no. 52 for the example in the Royal Collection. Another example of different form by the Garrard Brothers appeared at Sotheby's, London, 27 April 1989, lot 166.
274. Reynold's inkstand is published by Jones, 1939, p. 53, figure 1; Oman, 1969, p. 41, figure 1; Garrard and Company, Ltd., 1991, p. 62, cat. no. 23 (entry by Clifford).
275. Published by Schroder, 1988a, pp. 474-76, cat. no. 128.
276. Comparative analogies are provided in Garrard and Company, Ltd., 1991, pp. 84-86, cat. nos. 42-43 (entries by Clifford). Regarding their business transactions see also Banister, 1980, p. 166.
277. The most useful analysis of these salt-cellars is provided by Garrard and Company, Ltd., 1991, pp. 84-86, cat. nos. 42, 43 (entries by Clifford).
278. As pointed out in Garrard and Company, Ltd., 1991, p. 84, cat. no. 42 (entry by Clifford).
279. Published in *Art at Auction: The Year at Sotheby's, 1973-1974,* p. 290, Brett, 1986, p. 284, no. 1321, and sold at Sotheby's, Belgravia, 21 February 1974, as lot 132.
280. Two in the "Watteau" pattern are included as part a group of 1855 published by Garrard and Company, Ltd., 1991, pp. 84-85, cat. no. 42 (entry by Clifford).
281. See Garrard and Company, Ltd., 1991, p. 86, cat. no. 43 (entry by Clifford).
282. Regarding the pair of 1855 amd 1856 consult Garrard and Company, Ltd., 1991, pp. 84-85, cat. no. 42 (entry by Clifford). Two further copies of the boy alone from the 1860's sold at Christie's, London, 22 October 1986, as part of lot 150.
283. The Morel salts are reproduced in *The Crystal Palace and Its Contents: An illustrated Cyclopedia of the Great Exhibition of 1851,* 11 October 1851, p. 21.
284. Culme, 1977, p. 202.
285. Sotheby Parke Bernet, Newport, Chateau-sur Mer, 16-18 September 1969, lots 864-865.
286. For Morel see Thiéme-Becker, 1931, vol. 25, p. 134; Mantz, 1863, pp. 534-50; Culme, 1977, pp. 51, 53, 156-57, 201-02, 205; Wardle, 1970, pp. 76, 150-51. Examples of some of his other works are reproduced in *The Crystal Palace Exhibition, Illustrated Catalogue, London, 1851,* 1970, unabridged re-publication, pp. 112-13; Wyatt, 1851-52, vol. 2, plates 107, 145; Brett, 1986, pp. 380-81, no. 1809.
287. Published by Garrard and Company, Ltd., 1991, pp. 84-85, cat. no. 42 (entry by Clifford).
288. Dispersed as lot 299 at Sotheby Parke Bernet, Urshel at San Antonio, 28-29 April 1977. Another example of the Persian servant is reproduced in Garrard and Company, Ltd., 1991, pp. 84-85, cat. no. 42 (1855) (entry by Clifford).
289. See Garrard and Company, Ltd., 1991, p. 86, cat. no. 43 (entry by Clifford).
290. Sotheby Parke Bernet, New York, 16-17 December 1982, lot 532.
291. This pair sold with the four Morel salts exhibited at the Great Exhibition at Sotheby Parke Bernet, Newport, Chateau-sur Mer, 16-18 September 1969, lot 866.
292. Rowe, 1962, pp. 1-13; Rowe, 1965, *passim*; Royal Academy, 1979, *passim* are but a few of the sources dealing with English neo-classical silver.
293. See, for example the one of 1774 from the tea and coffee service supplied to the actor David Garrick published by Glanville, 1987, p. 104, fig. 38.
294. For Tassie see Clayton, 1985a, pp. 403-04; Newman, 1987, p. 316; and Hawkins, 1983, vol. I, pp. 74-77. Regarding Fogelberg consult Oman, 1947, pp. 158-60.
295. Published by Hernmarck, 1977, vol. 2, plate 324 and Rowe, 1965, plate 76B.
296. The standard studies on English gold plate encompass Jones, 1907; Grimwade, 1951, pp. 76-82, 128, 10-16, 83-89, 127; Schroder, 1986, pp. 8-15.
297. See Jones, 1907, pp. VII, XX, 20, plate 22; Grimwade, 1951, pp. 15-16, 83-87, 89; Schroder, 1986, pp. 14-15.
298. Consult Barr, 1980, for additional information about this sketch book. The wicker handle was made by an outside specialist worker. Concerning silversmiths and basketmakers who made wicker handles for silver vessels, see Banister, 1967, pp. 21-24.
299. The John Parr Cup is published by Kris, 1928, pp. 28-30; Holford, 1910, pp. 148-50, 153-55, 161-63, 204, plate 6; Levy, 1986, pp. 18, 33, 35, 39, 46, 87, 89; Hayward, 1976, p. 384, plate 483.
300. Levy, 1986, p. 33.
301. Consult Levy, 1986, pp. 39, 89; Cripps, 1881, p. 91. One at the Metropolitan Museum of Art mentioned by Hayward, 1976, p. 384 is actually a modern electrotype as first identified orally by Klaus Pechstein. See also the replica perhaps by John Beauchamp in Christie's, London, 22 October 1986, lot 165.
302. For discussion of the first, see *The Proceedings of the Society of Silver Collectors, 1970-1972*, 1975, p. 109. The second sold at Sotheby's, Belgravia, 13 October 1973, lot 170, and is reproduced by Brett, 1986, p. 278, no. 1289.
303. Others of differing designs given by Victoria include one of 1842 by Mortimer and Hunt at the Victoria and Albert Museum published by Bury, 1966, pp. 156-57, figure 15.
304. See Weber, 1975, pp. 56-57, 157, cat. nos. 33.1, 33.3, 248, plates 6, 7, 73.
305. For Farrell and Lewis, consult Culme, 1975, pp. 26-41; Culme, 1977, *passim*; Oman, 1978, pp. 126-27; Glanville, 1987, p. 121; Culme, 1985, n.p.

BIBLIOGRAPHY

Allan, Will, "Garrard, The Crown Jewellers," *Connoisseur*, vol. 204, June 1980, pp. 77-81.

Alvear Review, no. 3, 1990 ("Famous English Silverware," with summary in English), pp. 40-49, 86.

Antique Collector, "The Cumberland Plate," August and September 1966.

Armstrong, Nancy, "Antiques. For the Dressing Table," *Architectural Digest*, vol. 39, February 1982, pp. 72-77.

Ash, Douglas, *How to Identify English Silver Drinking Vessels 600-1830* (London: G. Bell and Sons, 1964).

Ashmolean Museum, *Report of the Visitors 1959* (Oxford: Oxford University Press, 1959).

Asprey Antiques PLC, *Silver* (London: Asprey Antiques PLC, October 1985).

Avery, Catherine B., *The New Century Classical Handbook* (New York: Appleton-Century-Crofts, 1962).

Avery, C. Louise, "European Silver, The Alfred Duane Pell Bequest," *Bulletin of The Metropolitan Museum of Art*, vol. 20, March 1925, pp. 69-72.

Baker, Malcolm/Schroder, Timothy/Clowes, E. Laird, *Beckford and Hamilton Silver from Brodick Castle* (London: Spink and Son, Ltd., 1980).

Banister, Judith, "Forgers, Furbishers and Duty-Dodgers," *Apollo*, vol. 75, October 1961, pp. 104-07.

————, *An Introduction to Old English Silver* (London: Evans Brothers, Ltd., 1965).

————, "A Century of Tureens," *Antique Dealer and Collector's Guide*, December 1966, p. 68.

————, "A Basketmaker's Accounts with Some 18th Century Silversmiths," *The Society of Silver Collectors, The Proceedings 1963-1964*, Spring 1967, pp. 21-24.

————, "Sixty Glorious Years of Silver Tea Caddies," *Antique Dealer and Collector's Guide*, April 1967, p. 44.

————, "Scallop Shells in English Silver," *Antique Dealer and Collector's Guide*, June 1967, p. 68.

————, "Thomas Jenkins, The Master Craftsman," *Proceedings of the Society of Silver Collectors*, vol. 2, 1971, pp. 187-93, 228.

————, *Mid-Georgian Silver* (London: Hamlyn, 1972).

————, "Three Centuries of Silver Coffee Pots," *Antique Dealer and Collector's Guide*, vol. 25, July 1972, p. 70.

————, "Pots for a Pungent Spice: Two Centuries of Silver Mustard Pots," *Antique Dealer and Collector's Guide*, vol. 38, August 1973, pp. 62-64.

————, "Thomas Jenkins, 17th Century Master Craftsman," *Goldsmiths Company Review 1976-1977*, pp. 28-31.

————, "Cups of the Chase," *Country Life*, 1 December 1977, pp. 1613-1614.

————, "Identity Parade: The Barnard Ledgers," *The Society of Silver Collectors, The Proceedings 1974-1976*, Autumn 1980, pp. 165-69.

————, "Rewards of High Office, Silver Seal Cups and Salvers-I," and "Pomp from Circumstance, Silver Seal Cups and Salvers-II, *Country Life*, 5 February 1981, pp. 334-35 and 29 January 1981, pp. 278-79.

————, "Preserving A Good Impression, Some Silver Seal Boxes," *Country Life*, 4 June 1981, p. 1609.

————, "A Postscript to the Barnard Ledgers," *The Silver Society, The Proceedings 1979-1981*, Spring 1983, pp. 38-39.

————, *English Silver* (London: Cassell, 1987).

Barnhart, Clarence L., *The New Century Cyclopedia of Names*, vol. 1 (New York: Appleton-Century-Crofts, 1954).

Barr, Elaine, *George Wickes, 1698-1761, Royal Goldsmith* (New York, Rizzoli, 1980).

————, "The Bristol Ewer and Basin" in: *Art at Auction: The Year at Sotheby's 1982-1983*, pp. 284-88.

Barron-Wilson, Mrs. Cornwall, *Memoirs of Miss Mellon Afterwards Duchess of St. Albans*, 2 vols. (London: Remington and Co., 1886).

Bassi, Elena, *Canova* (Bergamo: Istituto Italiano d'arti Grafiche, 1943).

————, *La Gipsoteca di Possago, sculture e dipinti di Antonio Canova*, (Venice: Neri Pozza, 1957).

————, *Antonio Canova a Possagno: Catalogo delle Opere* (Treviso: Canova, 1972).

Belsey, Hugh, *Gainsborough's Family* (Sudbury: Gainsborough's House Society, 1988).

Berkowitz, Roger M., "The Patriotic Fund Vases," *Apollo*, vol. 113, February 1981, pp. 104-05.

Berliner, Rudolf, *Ornamentale Vorlageblttter des 15. bis 19. Jahrhunderts*, 2 vols. (Leipzig: Klinkhardt and Bierman, 1926).

————, Rudolf, *Ornamentale Vorlageblttter des 15. bis 19. Jahrhunderts*, 2 vols. (Munich: Klinkhardt and Bierman, rev. ed. by G. Egger 1981).

Bliss, Joseph R., "Decorative Arts from Byzantium to Edwardian Europe at the Virginia Museum, *Antiques*, vol. 138, August 1990b, pp. 270-77.

————, "Highlights by Paul de Lamerie from the Gans Collection of English Silver at the Virginia Museum," 2 parts, *Silver*, vol. 23, September/October 1990a, pp. 8-10, vol. 23, November/December 1990a, pp. 8-11.

————, "Paul de Lamerie: At the Sign of the Golden Ball, An Exhibition of The Work of England's Master Silversmith," *The Decorative Arts Society Newsletter*, vol. 16, 1990-1991, pp. 6-7.

Brett, Vanessa, *The Sotheby's Directory of Silver, 1600-1940* (London: Sotheby's, 1986).

Brighton, Royal Pavillion, *Souvenir Programme and Catalogue of the Regency Exhibition in the Royal Pavillion, Brighton* (Brighton: Royal Pavillion, Art Gallery and Museums, 1951).

Brown, Joan Sayers, "Skippets," *Antiques*, vol. 114, July 1978, pp. 140-41.

Brown, Walter R. ed., *The Stuart Legacy, English Art 1603-1714* (Birmingham: Birmingham Museum of Art, 1991 (contributions by E. Adams, S. Estes, D. Hyland and F. Sommers).

Buhler, Kathryn C., "Silver Tureens in the Campbell Museum Collection," *Antiques*, vol. 97, June 1970, pp. 904-09.

Bursche, S., *Tafelzier des Barock* (Munich: Schneider, 1974).

Bury, Shirley, "Flaxman as a Designer of Silverwork" in: *John Flaxman, R.A.*, ed. David Bindman (London: Royal Academy, 1979), pp. 140-51.

————, "The Lengthening Shadow of Rundell's," 3 parts, *Connoisseur*, vol. 161, February, March, and April 1966, pp. 79-85, 152-58, 218-22.

Bury, S./Wedwood, A./Snodin, M., "The Antiquarian Plate of George IV: A Gloss on E. A. Jones," *Burlington*, June 1974, pp. 344-53.

Carrington, John Bodman/Hughes, George Ravensworth, *The Plate of the Worshipful Company of Goldsmiths* (Oxford: Oxford University Press, 1926).

Carver, Beth S./Casey, Eileen M., *Silver by Paul de Lamerie at the Sterling and Francine Clark Art Institute* (Williamstown: Sterling and Francine Clark Art Institute, 1978).

Chilton, Meredith/Palmer, J. P., *A Taste of Elegance. Eighteenth Century English Porcelain from Private Collectors in Ontario* (Ontario: George R. Gardiner Museum of Ceramic Art, 1986).

Christie's, *Fanfare into Europe* (London: Christie's, 1973).

————, *The Glory of the Goldsmith, Magnificent Gold and Silver from the Al-Tajir Collection*, intro by Charles Truman (London: Christie's, 1989).

Citroen, Karel, "Copy, Manner or Creation? Influences and Confluences in European Silver," *The International Silver and Jewellery Fair and Seminar Handbook*, London, 1987, pp. 8-14.

City of Manchester Art Gallery, *Catalogue of Silver from the Assheton Bennett Collection* (Manchester: City of Manchester Art Gallery, 1965).

Clark, Anthony M., *The Age of Canova: An Exhibition of the Neo-Classical* (Providence: Rhode Island School of Design, 1957).

Clayton, Michael, *The Collector's Dictionary of the Silver and Gold of Great Britain and North America*, (London: Antique Collectors' Club, 2nd ed. 1985a).

————, *Christie's Pictorial History of English and American Silver* (Oxford: Phaidon, 1985b).

Clifford, Helen, "The Organization of An Eighteenth Century Goldsmith's Business," *The International Silver and Jewellery Fair and Seminar Handbook*, 1990, pp. 16-22.

Colman Collection of Silver Mustard Pots (Norwich: Colman Foods, 1979 (researched by H. Godfrey).

Comstock, Helen, "18th-Century English Salvers," *Antiques*, November 1959, pp. 450-53.

————, "English Silver Coffee Pots," *Antiques*, December 1959, pp. 548-51.

Cooper-Hewitt Museum, *Courts and Colonies: The William and Mary Style in Holland, England, and America* (New York: Cooper-Hewitt Museum, 1988) (contributions by Reiner Baarsen, Gervase Jackston-Stops, Phillip M. Johnston and Elaine Evans Dean).

Cooper, John K., "Exhibition Reviews: Britain's Greatest Goldsmith," *Apollo*, vol. 131, June 1990, pp. 426-27.

Crighton, R.A., *Cambridge Plate: An Exhibition of Silver, Silver-gilt, and gold Plate Arranged as part of the Cambridge Festival 1975* (Cambridge: Fitzwilliam Museum, 1975).

Cripps, Wilfred-Joseph, *South Kensington Museum Art Handbooks, College and Corporation Plate* (London: Chapman and Hall, Ltd., 1881).

Croft-Murray, Edward, "An Account of John Flaxman," *Walpole Society*, vol. 28, 1938.

Crombie, Theodore and Elsie, "The Apotheosis of the Rococo Silversmith's Art," *Connoisseur*, vol. 134, 1954, pp. 259-65.

Culme, John, "Kensington Lewis: A Nineteenth-Century Businessman," *Connoisseur*, vol. 190, September 1975, pp. 26-41.

————, "Thou Sheer, Immaculate and Silver fountain!" in: *Art at Auction: The Year at Sotheby Parke Bernet 1975-1976*, pp. 292-301.

————, *Nineteenth-Century Silver* (London: *Country Life* Books, 1977).

————, *Attitudes to Old Plate 1750-1900* (London: Sotheby's, May 1985) (pamphlet based on a paper read at the International Silver and Jewellery Fair and Seminar).

————, "Chasing Silversmiths" in: *Sotheby's Great Sales* (London: Sotheby's , 1989), pp. 114-116.

————, *The Directory of Gold and Silversmiths, Jewellers and Allied Traders, 1838-1914* (Woodbridge: Antique Collectors' Club, 1987).

Culme, John/Strang, John G., *Antique Silver and Silver Collecting* (London: Hamlyn, 1973).

Dauterman, Carl C., "A Magnificent Gift of Lamerie Silver," *The Metropolitan Museum Art Bulletin*, vol. 16, March 1958, pp. 193-203.

————, *Antique English Silver Coffee Pots* (Cincinatti: Procter and Gamble Company, Folger Coffee Collection, 1959).

————, "Dream-Pictures of Cathay: Chinoiserie on Restoration Silver," *The Metropolitan Museum of Art Bulletin*, vol. 23, Summer 1964, pp. 11-25.

————, "English Silver in an American Company Museum," *Connoisseur*, vol. 159, 1965, pp. 206-11, 274-79.

————, *The Campbell Museum Collection* (Camden: Campbell Museum, 1st ed. 1969).

————, *Selections from the Campbell Museum Collection* (Camden: Campbell Museum, 5th ed. 1983).

Davis, Frank, *French Silver, 1450-1825* (New York: Praeger, 1970).

Davis, John D., *English Silver at Williamsburg* (Williamsburg: The Colonial Williamsburg Foundation, 1976).

De Castres, Elizabeth, *A Collector's Guide to Tea Silver 1670-1900* (London: Frederick Muller, 1977).

Derwis, Paul, "Some English Plate at the Hermitage," *Burlington*, vol. 67, July 1935, pp. 35-37.

du Boulay, "Some Parallels in Silver and Ceramic Forms," *The Society of Silver Collectors, The Proceedings 1961-1962*, Spring 1965, pp. 18-19.

Edwards, Arthur C. *The Account Books of Benjamin Mildmay, Earl of Fitzwalter* (London: Regency Press, 1977).

Egerton, Judy, *Sport in Art and Books, The Paul Mellon Collection, British Sporting and Animal Paintings 1655-1867*, vol. 2 (London: Tate Gallery for the Yale Center for British Art, 1978).

————, *British Sporting Paintings, The Paul Mellon Collection in the Virginia Museum of Fine Arts* (Richmond: Virginia Museum of Fine Arts, 1985).

Ensko, Stephen G. C./Wenham, Edward, *English Silver 1675-1825* (New York: Arcadia, 1937).

Fletcher, Lucinda, *Silver* (London: Orbis, 1973).

Foster, J. E./Atkinson, T.D., *An Illustrated Catalogue of the Loan Collection of Plate Exhibited in the Fitzwilliam Museum* (Cambridge: Deighton Bell and Macmillan and Bowes, 1896).

Frederiks, J. W., *Dutch Silver*, 4 vols. (The Hague: M. Nijhoff, 1952-1961).

Freeman, Larry, *Victorian Silver, Plated and Sterling, Hollow and Flatware* (Watkins Glen: Century House, 1967).

Freyberger, Ronald, "Eighteenth-Century French Furniture from Hamilton Palace," *Apollo*, vol. 114, December 1981, pp. 401-09.

————, "The Duke of Hamilton's Clock Cabinet" in: *Christie's International Magazine*, vol. 8, June 1991, pp. 10-13.

Frick Collection, *English Silver: Exhibition Checklist*, New York, 1978.

Galbally, *The Collections of the National Gallery of Victoria* (Melbourne: Oxford University Press, 1987).

Gardner, J. Starkie, *Old Silver-Work Chiefly English, from the XVth to the XVIIIth Centuries: A Catalogue of the Unique Loan Collection Exhibited in 1902 at St. James's Court, London, in Aid of the Children's Hospital, Gt. Ormond Street* (London: B. T. Batsford, 1903).

————, "Silver Toilet Services," *Connoisseur*, vol. 12, May-August 1905, pp. 95-100.

Garnier, Richard, "The Mostyn Tompion: Links with the Court Team of Craftsmen" in: *Christie's Review of the Season 1982*, pp. 228-30.

Garrard and Company, Ltd., *Catalogue of the Exhibition of Choice Old English Plate from Private Collections* (London: Garrard and Company, Ltd., 1915).

————, *Royal Goldsmiths, The Garrard Heritage* (London: Garrard and Company, Ltd., 1991) (essays by H. Clifford and A. Weston and entries by H. Clifford and J. Bliss.

Germanisches National Museum, *Wenzel Jamnitzer und die Nürnberger Goldschmiede kunst 1500-1700* (Nuremberg: Germanisches National Museum, 1985).

Getty Museum Handbook of the Collections (Malibu: J. Paul Getty Museum, 1986).

Gibbs-Smith, C. H., *The Great Exhibition of 1851* (London: Victoria and Albert Museum, revised ed. 1964).

Glanville, Philippa, *Silver in England* (London: Unwin Hyman, 1987).

————, "Chinese Influences on English Silver 1550-1720,:" *The International Silver and Jewellery Fair and Seminar Handbook*, London, 1987, pp. 15-22.

————, *Silver in Tudor and Early Stuart England, A Social History and Catalogue of the National Collection 1480-1660* (London: Victoria and Albert Museum, 1990).

————, "The Chesterfield Wine Coolers," *NACF Review*, 1990, pp. 103-08.

Glanville, Philippa/Goldsborough, Jennifer Faulds, *Women Silversmiths 1685-1845, Works from the Collection of the National Museum of Women in the Arts* (New York: Thames and Hudson, 1990).

Godfrey, Honour, "Stuffed Udder, Boiled Boar and Silver Mustard Pots, The Colman Collection at the Cooper-Hewitt," *Connoisseur*, vol. 205, October 1980, pp. 140-45.

Goldsmiths' Hall, *Treasures of Oxford, Catalogue of the Exhibits* (London: Goldsmiths' Hall, 1953).

————, *The Sterling Craft: Five Centuries of Treasures from the Worshipful Company of Goldsmiths, London* (London: Goldsmiths' Hall, 1966).

————, *The Goldsmith and the Grape: Silver in the Service of Wine* (London: Goldsmiths' Hall, 1983).

Great Exhibition, Official Descriptive and Illustrated Catalogue, 3 vols. (London, 1851).

Grimwade, Arthur G., "A New List of Old English Gold Plate," 3 parts, *Connoisseur*, vol. 127, June 1951, pp. 76-82, vol. 128, September, 1951, pp. 10-16, vol. 128, November 1951, pp. 83-89, 127.

————, *The Queen's Silver, A Survey of Her Majesty's Personal Collection* (London: *Connoisseur*, 1953).

————, "Royal Toilet Services in Scandinavia," *Connoisseur*, vol. 137, April 1956, pp. 175-78.

————, "Mr. Francis Stonor's Collection of Silvergilt-I.," *Connoisseur*, June 1960, pp. 38-43.

————, "The Garrard Ledgers," *The Proceedings of the Society of Silver Collectors*, 10 April 1961, pp. 1-12

————, "Silver at Althorp: IV. The Rococo and Regency Periods," *Connoisseur*, vol. 154, December 1963, pp. 226-31.

————, "Silver at Althorp, II, The Candlesticks and Candelabra," *Connoisseur*, vol. 152, March 1963, pp. 159-65.

————, "Family Silver of Three Centuries," *Apollo*, vol. 82, December 1965, pp. 498-506.

————, "Crespin or Sprimont? An Unresolved Problem of Rococo Silver," *Apollo*, vol. 90, August 1969, pp. 126-28.

————, "A Case of Mistaken Identity, Thomas Jenkins,: The Man," *Proceedings of the Society of Silver Collectors*, vol. 2, 1971, pp. 185-86.

————, *Rococo Silver, 1727-1765* (London: Faber and Faber, 1974).

————, *London Goldsmiths, 1697-1837: Their Marks and Lives* (London: Faber and Faber, 1976).

Gruber, Alain, *Silverware* (New York: Rizzoli, 1982).

Hackenbrock, Yvonne, *English and Other Silver in the Irwin Untermyer Collection* (New York: Metropolitan Museum of Art, 1963).

—————, *English and Other Silver in the Irwin Untermyer Collection* (New York: Metropolitan Museum of Art, rev. ed. 1969).

—————, "Chelsea Porcelain, Some Recent Additions to the Irwin Untermyer Collection," *Metropolitan Museum of Art Bulletin*, vol. 29, June 1971, pp. 405-17.

Hammond, N. G. L./Scullard, H. H., eds., *The Oxford Classical Dictionary* (Oxford: Clarendon Press, 2nd ed., 1970).

Hare, Susan, ed., *Paul de Lamerie, At the Sign of the Golden Ball: An Exhibition of the Work of England's Master Silversmith (1688-1751)* (London: Goldsmiths' Company, 1990).

Hartop, Christopher, "Silver: An Exceptional Year," in: *Christie's Review of the Season 1991*, pp. 182-99.

Hawkes, Charles F. C., *Winchester College; An Essay in Description and Appreciation* (London: Country Life Limited, 1933).

Hawkins, J. B., *The Al Tajir Collection of Silver and Gold*, vol. 1 (London: E. and C. T. Koopman, 1983).

Hawley, Henry, *Neo-Classicism, Style and Motif* (Cleveland: Cleveland Museum of Art, 1964).

Hayden, Arthur, *Chats on Old Silver* (London: Dover, 1969).

Hayward, Helena, "English Rococo Designs for Silver," *The Society of Silver Collectors, the Proceedings 1968-1970*, Autumn 1973, pp. 70-75.

Hayward, J. F., *Huguenot Silver in England, 1688-1727* (London: Faber and Faber, 1959).

—————, "Ambassadors' Plate," *The Society of Silver Collectors, The Proceedings 1960-1961*, 1963, pp. 3-7.

—————, "Candlesticks with Figure Stems, Some Important English and Continental Examples," *Connoisseur*, vol. 152, January 1963, pp. 16-21.

—————, "The Mannerist Goldsmiths, III Antwerp," *Connoisseur*, vol. 156, June, July, and August 1964, pp. 92-96, 165-70, 250-54, vol. 158, March 1965, pp. 144-49.

—————, "The Mannerist Goldsmiths, V, Germany," *Connoisseur*, vol. 164, April and July 1967, pp. 216-22, 162-67, vol. 168, July 1968, pp. 161-66.

—————, "The Goldsmith's Designs of the Bayerische Staatsbibliothek Reattributed to Erasmus Hornick," *Burlington*, vol. 110, 1968, pp. 201-07.

—————, "Rundell, Bridge and Rundell, 'Aurifices Regis'," *Antiques*, 2 parts, vol. 99, June 1971, pp. 860-65, vol. 100, July 1971, pp. 110-15.

—————, "English and Irish Silver in the Francis E. Fowler Jr. Museum in Beverly Hills, California: Part 2," *Connoisseur*, vol. 179, 1972, pp. 47-55.

—————, *Virtuoso Goldsmiths and the Triumph of Humanism, 1520-1620* (London: Sotheby's, 1976).

—————, "The Earl of Warrington's Plate," *Apollo*, vol. 107, July 1978, pp. 32-39.

Hennell, Percy, "The Hennells Identified, *Connoisseur*, December 1955, pp. 260-66.

Hernmarck, Carl, *The Art of the European Silversmiths, 1430-1830*, 2 vols. (London: Sotheby's, 1977).

Hickl-Szabo, H., "Silver at the Royal Ontario Museum," *Canadian Collector*, April 1966.

Holford, Christopher, *A Chat About the Broderers' Company by An Old Boy and Past Master* (London: George Allen and Sons, 1970).

Holland, Margaret, *Phaidon Guide to Silver* (Oxford: Phaidon, 1978).

Honour, Hugh, "Silver Reflections of Cathay," 2 parts, *Antiques*, vol. 81, January and March 1962, pp. 90-93, 306-10.

—————, *Goldsmiths and Silversmiths* (New York: G. P. Putnam's Sons, 1971).

Houston, *Silver by Paul de Lamerie in America* (Houston: Museum of Fine Arts, Houston, 1956).

Howard, D. S., *Chinese Armorial Porcelain* (London: Faber and Faber, 1974).

Howard, D. S./Ayers, J., *China for the West*, vol. 2 (London: Philip Wilson for Sotheby's, 1978).

Hughes, G. Bernard, "Pierced Silver Table Baskets," *Country Life*, 10 November 1950, pp. 1603-04.

—————, "Silver Salvers, Waiters, and Trays," *Country Life*, 29 September 1950, p. 99

—————, "Silver Standishes and Inkstands," *Country Life Annual*, 1951.

—————, "Old English Silver Tea-Kettles," *Country Life*, 28 December 1951.

Hughes, G. Bernard and Therle, *Three Centuries of English Domestic Silver, 1500-1820* (New York: Wilfred Funk, 1952 and 1968).

Hughes, G. Bernard, "Old English Candlesticks," 2 parts, *Apollo*, vol. 57, February and April 1953, pp. 53-55, 124-26.

—————, "Silver Casters and Cruets," 3 parts, *Apollo*, vol. 59, January and February 1954, pp. 12-14, 65-67, vol. 60, July 1954, pp. 12-13.

—————, "Saucers and Sauce-Boats," *Country Life*, 2 December 1954, p. 2015.

—————, "An Unique Ensemble," *Connoisseur*, August 1955.

—————, "Georgian Silver Milk Jugs," *Country Life*, 15 September 1955, p. 562.

—————, "Silver Salt Cellars," *Country Life*, 13 October 1955, p. 804.

—————, "Wine Cisterns and Cellarettes," *Country Life*, 8 December 1955, p. 1381.

—————, "Silver Chamber Candlesticks," *Country Life*, 5 January 1956, p. 1.

—————, "Silver Stirrup Cups," *Country Life*, 19 January 1956, p. 106.

—————, "Old English Wine Coasters," *Country Life*, 10 May 1956, p. 1003.

—————, "Georgian Milk and Cream Jugs," *Apollo*, vol. 63, June 1956, pp. 199-206.

—————, "Old English Silver Beakers," *Country Life*, 8 August 1956, p. 293.

—————, "Tea Chests for the Georgian Hostess," *Country Life*, 5 September 1957, p. 439.

—————, *Small Antique Silverware* (New York: Bramhall House, 1957).

—————, "Georgian Silver Inkstands," *Country Life*, 7 February 1957, p. 230.

—————, "The Georgian Vogue of the Tea Urn," *Country Life*, 25 October 1962, p. 1026.

—————, "Vogue for Footed Salvers," *Country Life*, 21 October 1965, pp. 1020-21.

—————, "Strawberries from a Silver Dish," *Country Life*, 3 June 1965, pp. 1375, 1377.

—————, "Elaboration by Candlelight," *Country Life*, 7 October 1965, pp. 899, 901.

—————, "Elegance of Georgian Wine Coolers," *Country Life*, 15 February 1968, pp. 366, 369-70.

—————, "Dual Purpose Elegance at Breakfast," *Country Life*, 4 April 1968.

—————, "Soy Frames for Georgian Sauces," *Country Life*, 1 August 1968, pp. 296-97.

—————, "Keeping Georgian Food Hot," *Country Life*, 26 December 1968, p. 1702.

—————, "Stands for Georgian Egg-Cups," *Country Life*, 21 November 1968, pp. 1334-35.

—————, "The Escallop Shell in Silver," *Country Life*, 6 November 1969, pp. 1180-81.

—————, "Honey for the Georgian Breakfast," *Country Life*, 1 March 1973, pp. 528-29.

—————, "Silver Candlesticks from the Factory," *Country Life*, 12 April 1973, p. 1063.

Indianapolis, *Silver by Paul Storr in American Collections* (Indianapolis: Indianapolis Museum of Art and Dayton Art Institute, 1972) (cat. by Mark A. Clark).

Inglis, Brand, *The Arthur Negus Guide to British Silver* (London: Hamlyn, 1980).

Ivon-Jones, Brian, "The Achilles Shield," *Apollo*, vol. 101, April 1975, pp. 447-452.

Jackson, Charles James, *An Illustrated History of English Plate, Ecclesiastical and Secular*, 2 vols. (London: *Country Life* Limited, 1911).

—————, *English Goldsmiths and their Marks, A History of the Goldsmiths and Plate Workers of England, Scotland and Ireland* (Los Angeles: Borden 2nd ed. 1921).

Jervis, Simon/Tomlin, Maurice, *Wellington Museum, Apsley House* (London: Victoria and Albert Museum, revised ed. 1990).

Jones, E. Alfred, *Old English Gold Plate* (London: Bemrose and Sons, 1907).

————, "Some Old Plate in the Possession of Lord Mostyn," *Burlington*, vol. 11, February 1907, pp. 68-77.

————, *Illustrated Catalogue of the Collection of Old Plate of J. Pierpont Morgan, Esquire* (London: Bemrose, 1908).

————, *The Gold and Silver of Windsor Castle* (Letchworth: Arden Press, 1911).

————, "The Duke of Cumberland's Collection of Old English Plate," *National Review*, January 1920, pp. 679-85.

————, "The Duke of Cumberland's English Plate," *Burlington*, vol. 44, January 1924, pp. 41-42.

————, *Catalogue of the Collection of Old Plate of William Francis Farrer at No. 7 St. James's Square* (London: St. Catherine Press, 1924).

————, *Old Silver of Europe and North America from Early Times to the Nineteenth Century* (London: B. T. Batsford, 1928).

————, "An Historic Silver Inkstand," *Connoisseur*, vol. 98, 1936, pp. 140-41.

————, et. al., *The Plate of Eton College* (London: Saint Catherine Press, 1938).

————, *Catalogue of the Plate of Oriel College* (London: Oxford University Press, 1944).

Jones, William Ezelle, *Monumental Silver: Selections from the Gilbert Collection* (Los Angeles: Los Angeles County Museum of Art, 1977).

Jrg, C. J. A., *Porcelain and the Dutch China Trade* (The Hague: M. Nijhoff, 1982).

Kaellgren, C. Peter, "The Tea-Picker Design on English Rococo Silver Tea Caddies, *Antiques*, vol. 121, February 1982, pp. 484-89.

Kennedy, Mary L., *The Esther Thomas Hoblitzelle Collection of English Silver* (Austin: privately printed, 1957).

Kent, Dorothy Hill, *Greek and Roman Metalwork* (Baltimore: Walters Art Gallery, 1976).

Kirby, Thomas Frederick, *Annals of Winchester College* (London: H. Frowde, 1892).

Kolbert, John Murray, *The Sneyds, Squires of Keele* (Keele: University of Keele, 1976).

Kris, E., "Der Stil 'Rustique'. Die Verwendung des Naturabgusses bei Wenzel Jamnitzer und Bernard Palissy," *Jahrbuch der Kunsthistorischen Sammlungen in Wien*, vol. 1, 1926, pp. 137-208.

Kris, Ernst/von Falke, Otto, "Beitrge zu den Werken Christoph und Hans Jamnitzers," *Jahrbuch der preuszischen Kunstsammlungen*, vol. 47, 1926, pp. 185-207.

Kris, Ernst, "Zum Werke Peter Fltners und zur Geschichte der Nrnberger Goldschmiedekunst, II, Ein Pokal von Jacob Frolich," *Pantheon*, vol. 9, 1932, pp. 28-32.

La Marche, Bonita, *Pottery with Pretensions: The Marriage of Ceramics and Silver* (Detroit: Detroit Institute of Arts for the Mid-States Ceramic Study Group, 1991).

Lambert, ed., *Pattern and Design, Designs for the Decorative Arts 1480-1980 with An Index to Designer's Drawings in the Victoria and Albert Museum* (London: Victoria and Albert Museum, 1983).

Lane, Roger, *The Mercers' Company Plate* (London: Mercers' Company, 1985).

Lawrence, David, *English Silver from the Sixteenth to the Nineteenth Century* (Melbourne: Oxford University Press, 1968).

Le Corbeiller, Clare, "Miss America and Her Sisters: Personifications of the Four Parts of the World," *The Metropolitan Museum of Art Bulletin*, vol. 19, April 1961, pp. 209-23.

Lever, Christopher, "Garrard & Co.," *Connoisseur*, vol. 186, June 1974, pp. 94-99.

————, *Goldsmiths and Silversmiths of England* (London: Hutchinson, 1975).

Levy, Percy R., *Plain Dealing Fellows, A Second Chat About the Broderers' Company* (London: Worshipful Company of Broderers, 1986).

Lightbown, R. W., "Christian van Vianen at the Court of Charles I," *Apollo*, vol. 87, June 1968, pp. 426-39.

Lillywhite, Bryant, *London Coffee Houses: A Reference Book of Coffee Houses of the Seventeenth, Eighteenth, and Nineteenth Centuries* (London: George Allen and Unwin Ltd., 1963).

London, 1929, *Catalogue of A Loan Exhibition of Old English Plate and Decorations and Orders at 25 Park Lane, London in Aid of the Royal Northern Hospital*, 1929.

Luddington, John, *Antique Silver; A Guide for Would-be Collector's* (London: Pelham Books, 1971).

Lumley, Benjamin, *Reminiscences of the Opera* (New York: De Capo Press, 2nd ed. 1976).

Lynch, John, ed., *The Coffee Table Book of Astrology* (New York: Viking Press, 1969).

M. H. de Young Memorial Museum, *Three Centuries of European and American Domestic Silver* (San Francisco: de Young Memorial Museum, 1938).

Macquoid, Percy," The Plate of Winchester College," *Burlington*, vol. 2, June-August 1903, pp. 149-62.

Mantz, Paul, "Recherches sur l'Historie de L'Orfevèrie Francaise, V, Periode moderne," *Gazette des beaux arts*, vol. 14, 1863, pp. 534-50.

Marks, Richard/Blench, Brian J. R., *The Warwick Vase* (Glasgow: The Burrel Collection for the Glasgow Museum of Art Galleries, 1979).

Matz, Frederich, *Die Dionysischen Sarkophage*, 4 vols. (Munich: Deutsches Archologisches Institut, 1968-1969, 1975).

McFadden, David Revere/Clark, Mark A., *Treasures for the Table, Silver from the Chrysler Museum* (New York: Hudson Hills Press, 1989).

McNab Dennis, Jessie, "London Silver in a Colonial Household," *The Metropolitan Museum of Art Bulletin*, vol. 26, December 1967, pp. 174-79.

————, *English Silver* (London: Studio Vista, 1970).

————, *Silver* (New York: Cooper-Hewitt Museum, 1981).

Miles, Elizabeth B., *The Elizabeth B. Miles Collection: English Silver* (Hartford: Wadsworth Atheneum, 1976).

Minneapolis, *French, English and American Silver* (Minneapolis: Minneapolis Institute of Arts, 1956).

Minneapolis, *English and American Silver in the Collection of The Minneapolis Institute of Arts* (Minneapolis: Minneapolis Institute of Arts, 1989) (contributions by Francis J. Puig, Judith Banister, Gerald W. R. Ward and David McFadden).

Moss Collection of Paul Storr Silver 1771-1843, exhib. cat. (Memphis: Brooks Memorial Art Gallery, 1966).

Müller, Hannelore, *The Thyssen-Bornemisza Collection: European Silver* (London: Sotheby's, 1986).

Murdoch, Tessa, "Harpies and Hunting Scenes: Paul Crespin (1694-1770), Huguenot Goldsmith," *Country Life*, 29 August 1985, pp. 556-58.

————, "Exhibition Reviews: London, Goldsmiths' Hall, Paul de Lamerie," *Burlington*, vol. 132, July 1990, pp. 506-07.

Museum of London, *The Quiet Conquest. The Huguenots 1685-1985* (London: Museum of London, 1985).

Musgrave, Clifford, "The Regency Exhibition at Brighton," *Connoisseur*, October 1951, pp. 90-95.

————, "Masterpieces of Regency Taste," *Country Life*, 8 August 1952, p. 404.

National Gallery of Victoria, *European Decorative Arts* (Melbourne: National Gallery of Victoria, 1980).

Newman, Harold, *An Illustrated Dictionary of Silverware* (London: Thames and Hudson, 1987).

Norman-Wilcox, G., *English Silver Cream-Jugs of the 18th Century, Munro Collection* (Los Angeles: Los Angeles County Museum of Art, 1952).

North, A. R. E., "Royal Goldsmiths, The Heritage of the House of Garrards," *Apollo*, vol. 133, May 1991, pp. 353-54.

Nyberg, Dorothea, ed., *Oeuvres of J. A. Meissonnier* (Bronx: Benjamin Bloom, 1969 reissue).

Oliver, Andrew Jr./Luckner, Kurt, *Silver for the Gods* (Ohio: Toledo Museum of Art, 1977).

Oman, Charles C., "English Silver Milk Jugs in the 18th Century," *Apollo*, vol. 14, July 1931, pp. 14-18.

————, "English Eighteenth-Century Silver Tea-Caddies," *Apollo*, vol. 14, September 1931, pp. 132-37.

————, "Andrew Fogelberg, and the English Influence on Swedish Silver," *Apollo*, vol. 45, June 1947, pp. 158-60.

————, *The Wellington Plate* (London: Victoria and Albert Museum, 1954).

Oman, C./Hayward, J., *Catalogue of An Exhibition of Royal Plate from Buckingham Palace and Windsor Castle* (London: Victoria and Albert Museum, 1954).

Oman, Charles C., "The Winchester College Plate," *Connoisseur*, vol. 149, January 1962, pp. 2-11.

————, *English Silversmiths' Work, Civic and Domestic: An Introduction* (London: Victoria and Albert Museum, 1965).

————, "A Problem of Artistic Responsibility: The Firm of Rundell, Bridge and Rundell," *Apollo*, vol. 83, March 1966, pp. 174-83.

————, "Plate and Prestige," *Apollo*, vol. 89, January 1969, pp. 40-43.

————, *Caroline Silver, 1625-1688* (London: Faber and Faber, 1970).

————, "The Plate at the Wellington Museum," *Apollo*, vol. 98, September 1973, pp. 197-205.

————, *English Engraved Silver, 1150-1900* (London: Faber and Faber, 1978).

Ormond, Richard, "Silver Shapes in Chelsea Porcelain," *Country Life*, 1 February 1968, pp. 224-26.

Oswald, Arthur, "Okeover Hall, Staffordshire" *Country Life*, 4 parts, 23 and 30 January and 12 and 19 March. 1964, pp. 172-76, 224-28, 568-72, 645-49.

Parshall, Peter W., "The Print Collection of Ferdinand, Archduke of Tyrol," *Jahrbuch der kunsthistorischen Sammlungen in Wien*, vol. 78, 1982, pp. 139.

Pascal, Georges, *Largilliérre* (Paris: Les Beaux-Arts, Éditions d'etudes et de documents, 1928).

Pechstein, Klaus, "Wenzel Jamnitzer Silberglocken mit Naturabgüssen," *Anzieger des Germanischen Nationalmuseums*, 1967, pp. 36-43.

Peck, Harry Thurston, ed., *Harper's Dictionary of Classical Literature and Antiquities* (New York: Cooper Square, 1965).

Penzer, Norman M., *Paul Storr, The Last of the Goldsmiths* (London: William Clowes and Sons, 1954).

———, "The Warwick Vase," 3 parts, *Apollo*, vol. 62, December, 1955, pp. 183-88, vol. 63, January 1956, pp. 18-22, vol. 63, March 1956, pp. 71-75.

———, "The Jerningham-Kandler Wine Cooler," *Apollo* vol. 64, September and October 1956, p. 111-15, 80-82.

———, "The Great English Wine Coolers," *Apollo*, vol. 66, August and September 1957, pp. 3-7 and 39-46.

———, "Mustard and the First Silver Mustard Pots," *Antique Collector*, vol. 38, October 1957, pp. 186-92.

———, "The Plate at Knole-I," *Connoisseur*, vol. 147, April 1961, pp. 84-91.

———, "An Exhibition of Silver at the Minneapolis Institute of Arts," *Apollo*, vol. 64, 1976, pp. 133-36.

Percier, C./Fontaine, P. F. L., *Recueil de Décorations Intérieures Comprenant Tout Ce Qui A Rapport A L'Ameublement . . . Exécuté Sur Leurs Dessins* (Paris: P. Didot L'Aîné, 1812).

Petit Palais, *Exposition N. de Largilliérre* (Paris: Petit-Palais, 1928).

Phillips, Philip A. S., *Paul de Lamerie, Citizen and Goldsmith of London: A Study of His Life and Work A.D. 1688-1751* (London: Holland Press, 1968).

Pickford, Ian, *Silver Flatware: English, Irish and Scottish 1660-1980* (London: Antique Collectors' Club, 1983).

Piranesi, Giovanni Battista, *Coupes, Vases, Candélabres, Sarcophages, Trépids, Lampes et Ornements Divers* (Paris: Auguste Vincent, 1905 ed.).

Portland Art Museum, *The Lipton Collection, Antique English Silver Designed for the Serving of Tea* (Portland: Portland Art Museum, 1954).

Praz, Mario/Pavanello, Giuseppe, *L'opera completa del Canova* (Milan: Rizzoli, 1976).

Queen's Gallery, Buckingham Palace, *Treasures from the Royal Collection* (London: Queen's Gallery, 1988).

———, *Carlton House: The Past Glories of George IV's Palace* (London: Queen's Gallery, 1991).

Radice, Betty, *Who's Who in the Ancient World* (New York: Stein and Day, 1971).

Ramsey, L. G. G., "A Taste for Splendour and Mr. Francis Stonor," *Connoisseur*, vol. 144, January 1960, pp. 212-17.

Read, C. H., *The Waddesdon Bequest, Catalogue of the Works of Art* (London: British Museum, 1902).

Read, C. H./ Tonnochy, A. B., *Catalogue of the Silver Plate, Medieval and Later, Bequeathed to the British Museum by Sir Augustus Wollaston Franks, K.C.B.* (London: British Museum, 1928).

Reilly, Robin, *Wedgwood*, 2 vols. (London: Stockton Press, 1989).

Robinson, J. C., *Catalogue of the Special Exhibition of Works of Art of the Mediaeval, Renaissance and More Recent Periods on loan to the South Kensington Museum, June 1862* (London: G. E. Eyre and W. Spottiswoode for Her Majesty's Stationery Office, 1863).

Roland Michel, Marianne, *Lajoue et l'art rocaille* (Paris: Athens, 1984).

Rosenberg, Marc, *Jamnitzer: Alle erhaltenen Goldschmiedearbeiten, verloren Werke, Handzeichnungen* (Frankfurt-am-Main: J. Baer, 1920).

Roth, Linda, ed., *J. Pierpont Morgan Collector: European Decorative Arts from the Wadsworth Atheneum* (Hartford: Wadsworth Athenaeum, 1987).

Rowe, Robert, "Neo-Classical Silver in England," *The Society of Silver Collectors*, University of Leeds, 11 May 1962, pp. 1-13 (typescript article).

———, *Adam Silver* (London: Faber and Faber, 1965).

Royal Academy of Arts Bicentenary Exhibition (London: Royal Academy of Arts, 1969).

Royal Academy, *John Flaxman R.A.*, ed. David Bindman (London: Royal Academy, 1979).

Ruck, R., "Robert Garrard, Crown Jeweller," *Art and Antiques*, 1 December 1973.

Savage, George, *18th-Century English Porcelain* (London: Rockliff, 1952).

St. James's Court, *Catalogue of the Exhibition of Silversmiths' Work of European Origin in Aid of the Funds for the Great Ormond Street Hospital for Sick Children* (London: Chiswick Press, 1902).

Scheicher, E., "Der Spanische von Schloß Ambras," *Jahrbuch der kunsthistorischen Sammlungen in Wien*, vol. 35, 1975, p. 86.

Schrijver, "Europe's Earliest Silver Teakettle," *Connoisseur* vol. 166, 1967, pp. 81-84.

Schroder, Timothy B., *The Dowty Collection of Silver by Paul de Lamerie* (Cheltenham: Cheltenham Art Gallery and Museums, 1983).

———, "English Gold," *Grosvenor House Antiques Fair Handbook*, 1986, pp. 8-15.

———, *The Gilbert Collection of Gold and Silver* (Los Angeles: Los Angeles County Museum of Art, 1988a).

———, *The National Trust Book of English Domestic Silver 1500-1900* (London: Viking, 1988b).

———, Ltd., *Fine Silver and Works of Art: An Inaugural Exhibition, 1989* (London: Timothy B. Schroder, Ltd., 1989).

———, "Paul de Lamerie, London Goldsmith," *Antiques*, vol. 137, June 1990, pp. 1368-79.

Schwartz, Marvin D., "Treasures in English Silver from the Morrison Collection," *Antiques*, vol. 85, May 1964, pp. 570-74.

Selway, N. C., *James Pollard, 1792-1867; Painter of the Age of Coaching* (Leigh-on-Sea: F. Lewis, 1965).

Sheppard, F. H. W., "An Early Chelsea Salt-Cellar," *Apollo*, vol. 57, January-February 1953, p. 44.

Shulsky, Linda R., "Kensington and De Voorst, Two Porcelain Collections," *Journal of the History of Collections*, vol. 2, 1990, pp. 47-62.

Skerry, Janine Ellen, "Paul Storr Silver at the Yale University Art Gallery," *Yale University Art Gallery Bulletin*, vol. 38, Fall 1980, pp. 16-25.

Smith, H. Clifford, "The Harewood Plate at the Regency Festival Exhibition at Brighton," *Apollo*, vol. 54, August 1951, pp. 41-44.

Snelgrove, Dudley, *Sport in Art and Books, The Paul Mellon Collection, British Sporting and Animal Prints 1658-1874*, vol. 3 (London: Tate Gallery for the Yale Center for British Art, 1981).

Sneyd Family Papers consisting of a "List of Plate at Keele Hall April 1854." MS, Sneyd Papers, Box 79, Manuscript Collection, Keele University, Staffordshire; copy in Department of Collections, Colonial Williamsburg Foundation, Virginia.

Snodin, Michael/Baker, Michael, "William Beckford's Silver," 2 parts, *Burlington*, vol. 122, November and December 1980, pp. 735-48, 820-34.

Snodin, Michael, "J. J. Boileau: A Forgotten Designer of Silver," *Connoisseur*, vol. 198, June 1978, pp. 124-33.

———, "Drawings for Silverwork" in: *John Flaxman, R.A.*, ed. David Bindman (London: Royal Academy, 1979), pp. 149-51.

———, "The Achilles Shield" in: *Art at Auction: The Year at Sotheby's*, 1983-1984, pp. 274-83.

Sparling, Tobin Andrews/Rowe, Laura C., *The Great Exhibition: A Question of Taste* (New Haven: Yale Center for British Art, 1982).

Stone, Jonathan, "English and Irish Cream Jugs," *Antiques*, vol. 87, January 1965, pp. 94-98.

———, "English Inkstands in Silver and Sheffield Plate," *Antiques*, September 1966, pp. 342-46.

Strong, D. E., *Greek and Roman Gold and Silver Plate* (Ithaca: Cornell University Press, 1966).

Symonds, R. W., "Lighting the Eighteenth Century Home," *Country Life*, Annual, 1958.

Tait, Hugh, "The Stonyhurst Salt," *Apollo*, vol. 79, April 1964, pp. 270-78.

———, "Huguenot Silver Made in London (c. 1690-1723): The Peter Wilding Bequest to the British Museum," 2 parts, *Connoisseur*, vol. 180, August 1972, pp. 267-71, vol. 181, September 1972, pp. 25-36.

———, "The Advent of the Two-handled Cup: The Croft Cups," *The Proceedings of the Silver Society*, vol. 2, 1982, pp. 202-10.

———, *Catalogue of the Waddesdon Bequest in the British Museum, II, The Silver Plate* (London: British Museum, 1988).

Tallis, J. and Co., *Tallis's History and Description of the Crystal Palace*, 3 vols. (London: Tallis and Co., 1851).

Tatham, Charles Heathcote, *Designs for Ornamental plate, Many of Which Have Been Executed in Silver, from Original Drawings* (London: John Barfield, 1806).

Taylor, Gerald, *Silver* (Harmondsworth: Penguin, 1965 ed.).

————, *Burghley House, Stamford: Silver Exhibition* (Stamford: Burghley House Preservation Trust, 1984).

ter Molen, J. R., "The Van Vianen Family, Utrecht Silversmiths of International Renown," *The International Silver and Jewellery Fair and Seminar Handbook*, London, 1986, pp. 22-31.

The Crystal Palace and Its Contents: An Illustrated Cyclopaedia of the Great Exhibition of 1851, 3 vols. (London: W. M. Clark, 1852).

The Crystal Palace Exhibition, Illustrated Catalogue (London: Dover, 1970 unabridged republication).

The New Encyclopaedia Britannica, vol. 2 (Chicago: Encyclopaedia Britannica, 15th ed., 1990).

The Proceedings of the Society of Silver Collectors 1970-1972, Autumn 1975, p. 9 ("Some Pieces from Members' Collections").

The Victoria and Albert Museum Album 2, 1983, p. 13, no. 1.

Theime-Becker, "Antonio Canova," vol. 5 (Leipzig: E. A. Seeman, 1911), pp. 515-21 (entry by P. Paoletti).

————, "Eisler, Caspar Gottlieb," Vol. 10 (Leipzig: E. A. Seeman, 1914), pp. 438-39 (entry by Th. Hampe).

————, "Jean-Valentin Morel," vol. 25 (Leipzig:, E. A. Seeman, 1931), p. 134.

Thornton, Peter, *Seventeenth-Century Interior Decoration in England, France and Holland* (New Haven: Yale University Press, 1978).

Tipping, H. Avray, "The Silver Plate of the Sneyds of Keele Hall," *Country Life*, 21 June 1924, pp. 1023-24.

————, "The Silver Plate of the Duke of Cumberland," 2 parts, *Country Life*, vol. 56, 1 November 1924, pp. 681-83, vol. 56, 8 November 1924, pp. 701-03.

Toronto, *English Silver; A Catalogue to an Exhibition of Seven Centuries of English Domestic Silver* (Toronto: Royal Ontario Museum, 1958).

Truman, Charles, "The Portland Font" in: *Christie's Review of the Season 1985*, pp. 312-13.

Turner, Eric, *An Introduction to English Silver from 1660* (London: Her Majesty's Stationery Office, 1985).

Udy, David, "Neo-Classical Works of Art," in: *Grosvenor House Exhibition Catalogue*, 1966, no. 7.

————, "The Influence of Charles Heathcote Tatham," *The Society of Silver Collectors, The Proceedings 1970-1972*, vol. 2, August 1975, pp. 104-05.

————, "Piranesi's 'Vasi,' the English Silversmith and His Patrons," *Burlington*, vol. 120, December 1978, pp. 820-837.

Ukers, William H., *All About Coffee* (New York: The Tea and Coffee Trade Journal, 1935).

University of Texas at Austin, *One Hundred Years of English Silver* (Austin: University Art Museum, 1969).

Victoria and Albert Museum, *Mid-Georgian Domestic Silver* (London: Victoria and Albert Museum, 1952).

————, *Pattern and Design: Designs for the Decorative Arts, 1480-1980*, ed. Susan Lambert (London: Victoria and Albert Museum, 1983).

————, *Rococo: Art and Design in Hogarth's England*, ed. Michael Snodin (London: Victoria and Albert Museum, 1984).

Virginia Museum of Fine Arts Bulletin, vol. 48, no. 4, March/April 1988.

von Bothmer, Dietrich, "A Greek and Roman Treasury," *The Metropolitan Museum of Art Bulletin*, vol. 42, Summer 1984, pp. 4-73.

Wainwright, Clive, *The Romantic Interior, The British Collector at Home 1750-1850* (New Haven: Yale University Press, 1989).

Waldron, Peter, *The Price Guide to Antique Silver* (Woodbridge: Antique Collectors' Club, 2nd ed. 1982).

Wardle, Patricia, *Victorian Silver and Silver Plate* (New York: T. Nelson, 1970).

Wark, Robert R., *British Silver in the Huntington Collection* (San Marino: Huntington Library, 1978).

Washington, National Gallery of Art, *The Treasure Houses of Britain: Five Hundred Years of Private Patronage and Art Collecting*, ed. by Gervase Jackson-Stopps (Washington: National Gallery of Art, 1985).

Watts, W. W., *Catalogue of English Silversmiths' Work (with Scottish and Irish) Civic and Domestic* (London: Victoria and Albert Museum, 1920).

————, *Old English Silver* (New York: Scribner, 1924).

————, *Catalogue of a Loan Exhibition of Silver Plate Belonging to the Colleges of the University of Oxford* (Oxford: Clarendon Press, 1928).

Weber, Ingrid, *Deutsche, Niederländische und Französische Renaissanceplaketten 1500-1650*, 2 vols. (Munich: Bruckman, 1975).

Wenham, Edward, *Domestic Silver of Great Britain and Ireland* (London: Oxford University Press, 1931).

————, "Paul Crespin," *Antique Collector*, November and December 1945, p. 202.

————, "Silver Toilet Services," *Antique Collector*, May and June 1948, p. 102.

Wilding, Peter, *English Silver* (New York: Pellegrini and Cudahy, 1951).

Wills, Geoffrey, *Silver for Pleasure and Investment* (London: John Gifford, 1969).

————, *Candlesticks* (London: David and Charles, 1974).

————, *The Guinness Book of Silver* (Enfield: Guinness Superlatives, 1983).

Winokur, Ronald L., "Recent Acquisitions of English Silver," *Bulletin of the Detroit Institute of Arts*, vol. 52, 1973, pp. 93-105.

Wyatt, M. Digby, *Industrial Arts of the Nineteenth Century, at the Great Exhibition*, 2 vols. (London: Day and Son, 1851-1852).

Young, Hilary, "Sir William Chambers and John Yenn: Designs for Silver," *Burlington*, vol. 128, January 1986, pp. 31-35.

————, "A Note on J. J. Boileau, 'A Forgotten Designer of Silver'," *Apollo*, vol. 124, October 1986, pp. 334-37.

INDEX